KORAI
ARCHAIC GREEK MAIDENS
by G · M · A · Richter

PHAIDON

KORAI

ARCHAIC GREEK MAIDENS

BY G·M·A·RICHTER

A STUDY OF
THE DEVELOPMENT OF THE KORE TYPE
IN GREEK SCULPTURE
WITH 800 ILLUSTRATIONS,
INCLUDING 400 FROM PHOTOGRAPHS BY
ALISON FRANTZ

PHAIDON

© 1968 PHAIDON PRESS LTD · 5 CROMWELL PLACE · LONDON SW7

PHAIDON PUBLISHERS INC · NEW YORK
DISTRIBUTORS IN THE UNITED STATES : FREDERICK A. PRAEGER · INC
III FOURTH AVENUE · NEW YORK · N.Y. 10003
LIBRARY OF CONGRESS CATALOG CARD NUMBER : 68-18904

SBN 7148 1328 1

MADE IN GREAT BRITAIN
TEXT PRINTED BY R. & R. CLARK LTD · EDINBURGH
ILLUSTRATIONS PRINTED BY V.S.K. PRINTERS · BASLE

CONTENTS

PREFACE

THIS book is intended to be a companion volume to my *Kouroi, Archaic Greek Youths* (1960). That is, I have here tried to trace the evolution of the Standing Kore type, the Archaic Maiden, from early to late archaic times. For this purpose I have selected over 200 examples from various localities which seemed adequately to illustrate the different stages in the evolution from primitive, conventional renderings to more naturalistic representations; and I have included not only single statues but parts of groups (e.g. from pediments) and statuettes in different materials, as well as occasionally reliefs; and I have added drawings from related vase-paintings in the text— to show the universality of the type. The book is of course not intended to be a corpus of korai, but I have tried to include the most significant extant examples—as far as this proved possible.

In the kouroi the chronological sequence is indicated by the gradual progression in the knowledge of anatomy, from the superficial observations during the seventh century B.C. to the detailed understanding of the structure of the human body attained during the fifth century. The korai, on the other hand, being draped, supply a consecutive series in which the development of the rendering of drapery can be studied step by step from stiff enveloping masses to sensitively modelled surfaces, enriched by folds and assuming the forms of the body beneath.

In a prologue I have added a few geometric statuettes to show from what primitive conceptions the sculptors of the korai started, and how their outlook gradually changed, at first influenced by contact with the old civilizations of the Orient, and then proceeding on their independent path. In an epilogue I have illustrated a few 'successors' of the archaic korai to show the new world of form that was opened up to the artists of the later generations. For naturalistic representations of drapery— always, however, composed as artistic designs—were evolved by the Greeks for the first time in history, and are the precursors of all subsequent renderings.

The much discussed question of 'schools' comes up with the korai as it did with the kouroi. Is it possible to assign the extant statues of Maidens to various geographical centres, as many have courageously attempted to do? In my opinion this is even more difficult with the korai than it is with the kouroi. It must be remembered that the attribution to specific localities—except the general distinction between East and West—is complicated by the known fact that Greek sculptors obtained commissions not only in their own cities but elsewhere. They travelled extensively, and so local peculiarities were apt to become merged in a common style (cf. pp. 1 ff.); and the relatively small differences that exist may be due to the personal styles of the individual artists.

I have, therefore, confined myself to trying to trace a stylistic development and have classified the selected examples of korai in six successive groups—approximately those I used for the kouroi —and have named each group after its most prominent members. In the large fifth group, which contains the majority of the Akropolis korai, I have, for the sake of clarity, subdivided the examples according to the places in which they were *found*; and their basic similarity is in itself revealing.

I have not tried to attribute my korai to individual sculptors, except in the rare instances in which this is indicated by the signature of the artist (cf. nos. 67, 68, 110). In view of the multitude of names of sculptors known to have been active in Athens and elsewhere during the archaic period of whom no work has survived (cf., e.g., the long list I gave in the *Encyclopedia of World Art*, vol. II (1960), cols. 95 f., and the references there cited), this seemed to me precarious.

Each of my six groups is preceded by an account of what evidence exists regarding absolute dating; and based on this evidence—scanty though in many cases this alas! still is—I have assigned tentative dates to each group through stylistic comparisons with such dated sculptures and vase-paintings.

Since the korai are products of human beings, not machines, and since artists do not generally change their style every few years, I have made each of my groups last about twenty to thirty years (as I did in *Kouroi*); for I think only in this way can one approach accuracy. To further show the tentative nature of my chronological assignments, I have sometimes made the dates of the various groups overlap. In the descriptions of the individual korai I have, however, occasionally given more specific dates—for better or for worse.

In my assignments of dates I have inevitably sometimes differed from my colleagues. But as polemics are apt to be tedious, I have confined myself to stating the reasons for my own dates, and to giving the titles of the books and articles with other opinions in my bibliographies. I was glad, however, to find that in a memorable session I had with Hermine Speier, E. Langlotz, A. Greifenhagen, and T. Dohrn, in April 1966, there was general agreement with my chronological series. And this was also the case in another—briefer—session I had with my colleagues in the British Museum, in July 1966: D. Haynes, R. Higgins, and D. Strong, as well as with A. D. Trendall here in Rome in November 1966. To each of these friends I owe many a valuable suggestion

For every kore included in this survey I have given a brief description, with a short bibliography. From the various publications I have taken the measurements, the finding place, and the material—though assignments of marbles are now proving to be doubtful (cf. p. 15). In addition I have, in a general introduction, discussed the aspects which apply to all the korai—that is, the type, its meaning, the garments worn and their decoration, the technique, and the locations. The costume of the korai is of special interest, and so is the often extensive decoration and polychromy. For especially the Maidens found on the Akropolis of Athens can give us a better idea than almost any other Greek sculptures of the manner in which Greek statues were painted. Incidentally, these decorated draperies supply evidence of the appearance of the actual garments worn by Greek women. I have, therefore, reproduced, in black and white, many of the coloured patterns on the Akropolis korai included in Lermann's *Altgriechische Plastik* (1906). Though in the last sixty years these patterns have considerably faded, in checking several of them (in the spring of 1966) I found Lermann's plates reasonably accurate, conforming for the most part to the descriptions by Dickins (1912) and Langlotz (1939). Since, however, the colours have in the course of time not only faded but changed (blue, for instance, becoming green), it seemed best to reproduce the decorations in black and white, thereby avoiding an erroneous impression of their original appearance. Moreover, as the colours used in archaic times were limited to relatively few—red, blue, black, and white, more rarely green and yellow, all applied solid without gradations—it is not difficult to reconstruct them in our imagination.

In addition to the coloured ornaments on the garments, there were often found traces of colour on other surfaces—principally red on the hair and lips, black on the irises of the eyes, etc. These follow the general practice current in all Greek sculptures, and are therefore not specifically mentioned in my text.

I have many colleagues to thank for help—for information regarding new discoveries not yet published and for the photographs used for illustrations. For the latter I am especially indebted to Miss Alison Frantz, who, in spite of her many obligations, undertook to photograph the korai

which I had selected from Greece (Athens, Eleusis, Delphi, Olympia, Delos, Samos), Italy (Rome, Palermo), Paris, London, and Berlin. Her photographs lend distinction to this book. Some of the back views which it was not possible for her to photograph on account of the immobility of their present setting, have had to be reproduced from old negatives and publications.

For the remaining photographs I have to thank the directors and curators of the museums where the korai I have included reside. I should like especially to mention Messrs. Haynes, Higgins, and Strong in the British Museum; Messrs. Charbonneaux and Devambez of the Louvre; Mr. Kunze of the German Archaeological Institute at Athens; Mr. Daux and Mr. Bruneau of the French Institute at Athens; Mr. H. A. Thompson and Mr. Heyl of the Agora Museum; Mr. Greifenhagen, Mr. Blümel, and Miss Rohde of Berlin; Mr. and Mrs. Karouzos and Mrs. Touloupa of the National Museum of Athens; the authorities of the Metropolitan Museum in New York and of the Museum of Fine Arts in Boston; Mr. Stucchi, who procured for me the photographs of the korai in Cyrene; and many others. I owe to Mr. Hanfmann several important references, including those for the korai from Klaros, and from Erythrai; to Mr. Eckstein several other references; and to Mr. Vallet information regarding Sicilian finds. I also want to express my gratitude to the various soprintendenti of antiquities in Italy for their always courteous attention to my needs. In reproducing the inscriptions on the korai I have again relied on the help of my friend Margherita Guarducci. G. Scichilone has kindly helped me in the checking of the references.

In writing this book I have of course greatly profited from the three books which deal specifically with the korai from the Athenian Akropolis—G. Dickins' *Catalogue* (1912), H. Payne and G. Mackworth Young's *Archaic Marble Sculptures* (1936), and Langlotz's chapter on the korai in Schrader's *Marmorbildwerke* (1939) (cf. also my p. x). During my researches in the library of the American Academy in Rome Mrs. Longobardi and her efficient staff have helped at every turn; and I have also received valuable assistance from the library of the German Institute in Rome. The Phaidon Press has, as usual, facilitated my work by its generosity and helpful understanding of an author's vagaries. Finally I want to thank again the American Philosophical Society for its grant to defray Miss Frantz's expenses in photographing her contingent of the korai.

G. M. A. R.

DIRECTIONS FOR THE USE OF THIS BOOK

I USE the word kore (Greek κόρη, girl, maiden) to signify the draped standing Greek maiden of the archaic period, as has become customary today.

For the different garments worn by the korai I use the terms described in my text on pp. 6 ff. without reiterating their derivations and explanations. That is, I use the words peplos, chiton, short Ionic himation, epiblema, paryphe, taenia, polos, etc., without further descriptions. Cf. also the Glossary, p. x.

The renderings of the folds of the chiton and of the short Ionic himation during the period discussed are curiously uniform. The chiton is regularly shown in its upper portion by crinkly folds—either incised or in relief—and often with buttons on the shoulder that is left free by the obliquely draped Ionic himation; in the lower portion it is regularly indicated by incised folds (only occasionally in low relief) radiating in the direction of the hand which grasps the garment. The Ionic himation is represented by heavier, stacked folds, descending vertically and diagonally, front and back. As these renderings are clearly visible in my copious illustrations, I have spared the reader their constant repetition, confining myself to mentioning the more significant details and variations.

In the bibliographies included in the descriptions of the individual korai I have generally only cited the first mention of the kore, that is, its discovery or acquisition, and references, in the case of the Akropolis korai, to Dickins', Payne's, and Langlotz's volumes. Occasionally I have, however, amplified my lists by giving references to such recent, more general, publications as Matz's *Geschichte der griechischen Kunst*, Langlotz and Hirmer, *Die Kunst der Westgriechen*, etc., as well as to specific articles. In citing the titles of these various books and periodicals I have often used abbreviations, mostly those in current use, or easily recognizable; in case of need the reader may refer to the full titles given in my General Bibliography (cf. pp. 307 f.), where an extensive list of publications is included.

Throughout, for more detailed descriptions and bibliographies, the reader is referred to Langlotz's admirably full accounts—including the colour traces—in his *Koren*, which will always remain the fundamental source book for the study of the Akropolis Maidens.

The illustrations of the individual korai described in this book are arranged on consecutive, unnumbered plates, with their figure numbers in Arabic numerals. The illustrations for the comparative and chronological material—cited in the introductions of the various chapters—are arranged on plates I-XXII, with letters of the alphabet as figure numbers.

GLOSSARY OF GREEK WORDS AND ANATOMICAL TERMS

Apparel

Chiton: a light tunic, generally of linen. Cf. p. 7.

Diploidion: overfold of the chiton or peplos. Cf. p. 7.

Ependytes or chitoniskos: an informal, short garment worn over the chiton. Cf. p. 9.

Epiblema: a shawl-like wrap. Cf. pp. 8-9.

Ionic himation: a short, pleated mantle. Cf. pp. 7-8.

Kolpos: a pouch formed by pulling up the tunic over the belt. Cf. p. 7.

Meniskos: a metal crescent mounted on a metal spike added to the skull of statues to protect them from birds. Cf. p. 13. No actual crescent has been preserved, but the word and use suggest its shape.

Peplos: a heavy tunic, generally of wool. Cf. p. 7.

Paryphe: an ornamental strip running down the lower part of the chiton. Cf. p. 7.

Polos: a high, cylindrical headdress. Cf. p. 12.

Stephane: a diadem, generally of curving outline, either surrounding the whole head or the front only. Cf. pp. 11-12.

Taenia: a plain circlet or fillet, worn in the hair. Cf. p. 12.

Anatomical terms

Tibia, fibula, tarsus, metatarsus, phalanges: cf. the illustration of a foot on p. 20.

Supination, pronation, metacarpal bones: cf. the illustration of a forearm and hand on p. 19.

Helix, antihelix, concha, lobe, tragus, antitragus: cf. the illustration of the ear on p. 19.

Lachrymal caruncle and canthus: cf. the illustration of the eye on p. 19.

GENERAL INTRODUCTION

The Kore Type

THE kore type of a standing maiden is the female equivalent of the kouros or standing youth. Like the kouros it makes its appearance at the beginning of Greek monumental sculpture, *c.* 660-650 B.C., and continues to the end of the archaic period, *c.* 480 B.C. That is, politically the korai span the time from the aristocratic regimes of the Eupatrids, etc., to the reforms of Solon, to the rules of the tyrants—Peisistratos, Periander, Polykrates and the rest—and finally to the establishment, in Attica at least, of a democratic regime under Kleisthenes; whereupon came the cataclysm of the Persian wars, which marks a turning point.

During this long period of almost 200 years the type of the kore remained basically the same; that is, a draped female figure was represented standing erect, either with feet close together, or one leg, usually the left, a little advanced, the arms either hanging by the sides, or one brought close to the front of the body, or extended and holding an offering, the other lowered and clasping a fold of the drapery. But though the general type remained constant, one can observe here—as in all archaic Greek art—the evolution from conventional to naturalistic forms. This progression is observable in the rendering of the drapery, supplemented by the changing forms of the features, of the hands and feet, as well as, to some extent, of the hair.

Uniform Development in Different Localities

In this successive development from conventional towards naturalistic forms it is an important and perhaps curious fact that one can observe the identical all-over composition and the identical evolution in the rendering of details all over Greece. The korai, whether they come from Delos or Athens, from continental Greece or the Islands and Asia Minor, or from the West, show the same progressive development within the same formalized scheme. Just as in the kouroi, so in the korai, the type remained constant all over the Greek world, but step by step a greater degree of naturalism was attained. Only after this achievement was the type dissolved, since it had served its purpose. It was in fact in this way that the Greek mind always worked, not only in sculpture but in all branches of art. Changes and experiments were worked out within a recurring scheme.

This uniformity must have resulted from the fact that Greek artists in archaic, as well as in later times, travelled extensively, received orders from near and distant places, and intermingled constantly. For this circumstance there is abundant evidence both from the statements of ancient authors and from inscriptions (cf. *Kouroi*[2], p. 6): We hear of Theodoros of Samos working for Sparta (Paus. II, 12, 10), and advising on a temple at Ephesos (Diog. Laert. II, 103); of Endoios of Athens working for Tegea (Paus. VIII, 46, 1, 5) and for Ephesos (Athenag., *Libellus pro christ.* 17, p. 19, ed. Schwartz); of Smilis of Aigina working for Samos (Paus. VII. 4, 4), Argos (Athenag., op. cit. 17, p. 19), and Olympia (Paus. V, 17, 1); of Dipoinos and Skyllis, Cretans by birth, going to Sikyon (Pliny, *N.H.* XXXVI, 9), proceeding to Aitolia (ibid.), working for Ambracia (Pliny XXXVI, 14), Argos (ibid. and Paus. II, 22, 5), Kleonai (Pliny XXXVI, 14 and Paus. II, 5, 1), and Tiryns (Clem. Al., *Protr.* IV, 42). We are told of work by the Lacedemonians Theokles and Dorykleidas at Olympia (Paus. V, 17, 2

and VI, 19, 8; V, 17, 1); that the Lacedemonian Medon worked for the Megarians (Paus. V, 17, 2 and VI, 19, 12, 14), Bathykles of Magnesia at Amyklai (Paus. III, 18, 9), and Cheirisophos of Cyrene at Tegea (Paus. VIII, 53, 8).

Interesting in this connection is also the story told by Philostratos, in his *Life of Apollonios of Tyana*[1] (V, ch. xx): Apollonios at one time wished to go to Egypt from Athens. So he went down to the Piraeus, and found there a ship ready to start for Ionia. But the owner refused to take him, because he had a cargo of statues, ἀγάλματα, 'some of gold and stone, others of ivory and gold', in order to sell them. Apollodoros was indignant at the owner's refusal to let him travel with the statues, and told him that 'the makers of statues of old did not behave in this way, nor did they go round the cities selling their gods. All they did was to export their own hands and their tools for working stone and ivory; and they provided the raw materials and plied their handicraft in the temples themselves', ἡ δὲ ἀγαλματοποιΐα ἡ ἀρχαία οὐ τοῦτο ἔπραττεν, οὐδὲ περιῄεσαν τὰς πόλεις ἀποδιδόμενοι τοὺς θεούς, ἀλλ' ἀπάγοντες μόνον τὰς αὐτῶν χεῖρας καὶ ὄργανα λιθουργὰ καὶ ἐλεφαντουργά, ὕλην τε παρατιθέμενοι ἀργὸν ἐν αὐτοῖς τοῖς ἱεροῖς τὰς δημιουργίας ἐποιοῦντο. (Translation and text by P. C. Conybeare in the Loeb edition.) We do not know the exact period that Philostratos, writing in the early Roman Empire, meant by 'the sculptors of old'; but travelling and 'seeing places' was in the blood of every Greek at all times.

Inscriptions, moreover, tell the same story. Signatures of artists from various localities have been found all over Greece; cf., e.g., Raubitschek, *Dedications*, passim, and nos. 9 (Chios), 85 (Aigina), 133 (Crete), all found on the Athenian Akropolis; Marcadé, *Recueil des signatures*, passim; Loewy, *Inschriften*, passim; etc.

With such intercourse—East, West, South, and North—native differences would tend to disappear. There is generally only apparent—as there is in the kouroi—a broad division between the heavier, softer Eastern types and the slenderer, sturdier Western. And this is no doubt in part due to the physical difference between the two races. One may quote, for instance, Hermippos' remark about the people of Abydos, a colony of Miletos: 'To judge from your look, soft of body you are, with your long locks of foppish youth, and your plumpness of arm', τὰ μὲν πρὸς ὄψιν μαλακῶς ἔχειν ἀπὸ σώματος, κόμῃ τε νεανικῇ, σφρίγει τε βραχιόνων (Athenaios, XII, 524f-525a; tr. C. B. Gulick).

It is true that regional divisions have proved possible in the field of archaic Greek vases. But with pottery we have the great advantage of possessing hundreds and thousands of examples as against comparatively isolated speciments of archaic korai and kouroi. Moreover, the various styles of archaic vase-paintings are generally much more diverse than those observable in Greek sculptures, and their differentiation is therefore easier. Perhaps this was due to potters travelling less than sculptors—since their equipment was more difficult to transport?

One must also take into account, as I have said (cf. p. VII), the personal styles of individual artists, to which certain superficial differences may be due. They would surely account more effectively for certain variations than the places in which the artists happened to have been born.

To show the great difficulty in regional assignments of archaic statues one may cite the constantly varying attributions made by different authorities, as well as two revealing incidents of recent date. The kore of Lyons (no. 89) was long considered a characteristic example of Ionia, imported from Asia Minor, until Payne identified the lower part of this statue among the sculptures found on the Athenian Akropolis—whereupon it has become Athenian. The karyatid of the Siphnian Treasury

[1] Quoted by Barnett in his article on Greek and Oriental Ivories, *J.H.S.*, LXVIII, 1948, pp. 1 f., and by me in *Ancient Italy* (1955), p. 41.

at Delphi (no. 104) has been thought by some to be a typical Island product; but now that the inscriptions on the frieze of that Treasury have been claimed to be Attic (cf. M. Guarducci, *Studi in onore di Luisa Banti* (1965), pp. 167 ff.), should not the sculptures follow suit?

Since, therefore, the division of our korai into regional groups is still fraught with difficulties, it seemed best in this book to group the Maidens according to their stylistic development, which is, after all, their fundamental interest, both artistically and historically. For in this study we can watch the draperies evolve from stiff, foldless, enveloping masses to differentiated surfaces with tentative indications of folds, which presently become stylized schemes of great beauty and elaboration, until finally more or less naturalistic representations are achieved. And this evolution can be observed concurrently in the general stance of the figure, in the features of the head, and in the modelling of the feet and hands, which undergo the same development as in the contemporary kouroi.

The Meaning of the Kore Type

What was the meaning of these female statues, of those at least which were single figures and had been placed in sanctuaries, for instance in the Heraion of Samos and on the Akropolis of Athens? Did they represent the deity to whom the statue was dedicated, or the dedicant, or neither? Curiously enough, in most cases we do not know.[2] Most of the korai found in Samos or on the Athenian Akropolis can obviously not represent Hera or Athena (or Artemis or Pandrosos, who also had sanctuaries on the Akropolis hill), for they do not have the appropriate attributes.[3] Nor can they, in many cases at least, represent the dedicant, for some of the korai were dedicated by men— Nearchos, for instance (cf. no. 110), set up the kore by Antenor, and Euthydikos dedicated the kore no. 180. On the other hand, in the case of the group signed by Geneleos in Samos (nos. 67, 68), we definitely know by the inscriptions that it is the dedicant and her family who are represented.

It has been thought by some that the korai might represent priestesses. But their general appearance of youthful graciousness might seem inappropriate for such staid individuals.[4] On the other hand, one must remember that the character of a dedication in Greece did not always conform to our modern ideas. For instance, we know from inscriptions that a fisherman dedicated a kore to Poseidon after a successful catch,[5] and that a seller of bread dedicated a shield to Athena:[6] Φρυγία ἀνέθηκεν τῇ ’Αθηναίᾳ ἡ ἀρτόπωλις. So perhaps anybody, man or woman, could dedicate a kore, and such an offering would have been thought appropriate by his contemporaries.

One may ask do the habitual gestures of the korai shed light on their significance? That is, does the fact that they are generally represented with one arm laid in front of the body, or with one arm extended and holding an offering, help to explain the intention of the artist? The gesture of placing one forearm against the front of the chest has been interpreted as signifying gratitude to a deity for a favour conferred,[7] and the gesture of holding out a flower, etc., as also marking gratitude or a

[2] Cf. on this whole subject the remarks by Langlotz, in Schrader, *Marmorskulpturen*, p. 8.

[3] For occasional exceptions where a head is shown wearing a helmet and should therefore represent Athena, cf., e.g., no. 131.

[4] In mythology there were of course also young priestesses, e.g., Hero and Iphigeneia. But would they have had statues erected to them? The only priestesses recorded as having been commemorated by statues on the Akropolis were old women: Lysimache, 'who had been a priestess of Athena for 64 years' (cf. Pliny, xxxiv, 76), and a 'handmaid of Lysimache', who is referred to as πρεοβῦτις (cf. Pausanias, xxvii, 4). On the inscribed base and sculptures tentatively associated with these statues cf. my *Portraits of the Greeks*, i, pp. 155 f.

[5] Cf. Lolling, *Arch. Deltion*, 1890, p. 146, no. 5. [6] Cf. De Ridder, *Bronzes trouvés sur l'Acropole*, no. 264.

[7] Cf. now G. Neumann, *Gesten und Gebärden*, p. 81.

greeting.[8] But as these gestures are not confined to the korai, they hardly help in an identification.

That the korai did not represent well-known individuals is indicated by the fact that practically all of them are nameless. On the extant bases only the dedicant, or the artist, or the deity to whom the offering is made is cited. In the few cases where a kore is given a name, as in the Geneleos group (cf. nos. 67, 68), she is a young member of a family.

It seems best, therefore, in trying to understand the meaning of our korai not to be too precise, and merely to surmise that the person who in archaic times passed a kore on the Akropolis of Athens or elsewhere would have recognized in her an appropriate dedication to any female deity, since she represented a beautiful girl, a παῖς καλή, in the service of the goddess.

The Influence of Egypt and Mesopotamia

The kore type, like that of the kouros, derived inspiration from Egypt, and—to a less extent—from Mesopotamia (cf. *Kouroi*², pp. 2 f.).[9] In Egyptian statues and statuettes, especially in those of the New Kingdom, we find the exact prototypes for the stance of the Greek kore, i.e. figures standing with the left foot a little advanced, and with both arms adhering to the sides, or with one arm lowered, sometimes grasping a fold of the garment, the other brought to the front of the body, often holding some object (cf. plate I, a–f). Moreover, in Egyptian and some Mesopotamian sculptures one can see exactly the same renderings of folds in the drapery that were at first adopted by the sculptors of the korai, that is, parallel, oblique, and radiating incisions and ridges, as well as the arch-like openings at the bottoms of the garments, with feet protruding (cf. pl. I, c–f). For Anatolian parallels one may cite the bronze handle attachments of bowls datable around 700 B.C. in Istanbul and Ankara, and particularly the bronze statuette recently acquired by the Ny Carlsberg Glyptothek.[10]

This strong Oriental influence is in fact another instance of the well-known Greek custom of freely borrowing from the arts of the ancient civilizations their initial representations and then presently, stage by stage, transforming what they had taken into something typically their own.

The Influence of Ionia on Attica and Continental Greece

Much has been written about the influence of Ionia on Attic art. That there was such an influence there can be no doubt. Artistically it is indicated by the basic difference between the Berlin kore (no. 42) and the Moschophoros on the one hand and the later korai on the other. Something of the joyous spirit of Ionia has entered into the artistic outlook of Attic artists. More concretely this influence is shown by the adoption in Attica of the chiton with short mantle, which first makes its appearance in Ionia, and presently ousts the peplos as the current costume for Attic female statues (cf. p. 9).

Historically this close relationship with Ionia is made probable by the affiliations of Peisistratos with his Eastern fellow tyrants. Under such conditions it is also probable that Ionian sculptors came to

[8] Cf. Neumann, op. cit., p. 41.

[9] Whereas the influence of Egypt on the kouros type has been universally recognized, the Egyptian prototypes of the Greek kore have not been equally stressed; but I think my figs. a–e on pl. I are revealing.

[10] Cf. Kunze, *Kretische Bronzereliefs*, pp. 26 ff.; Akurgal, *Die Kunst Anatoliens*, pp. 35 ff.; V. Poulsen, *Meddelelser fra Ny Carlsberg Glyptotek*, XXIII, 1966, pp. 1 ff., figs. 1–4.

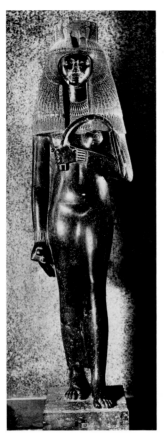

I–a. Egyptian granite statue of
Queen Teye, mother of Rameses II.
Vatican Museum

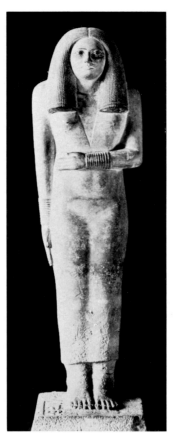

I–b. Egyptian limestone statue of
Nesa. Louvre

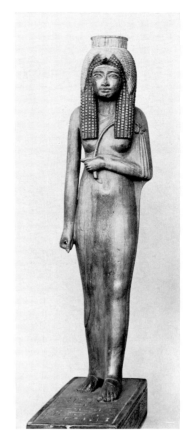

I–c. Egyptian wooden statue of
Queen Ahmes Nefertari. Louvre

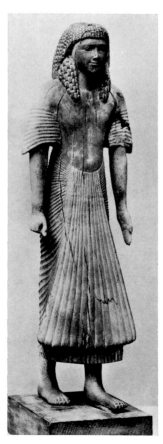

I–d. Egyptian wooden figure of
a high official. British Museum

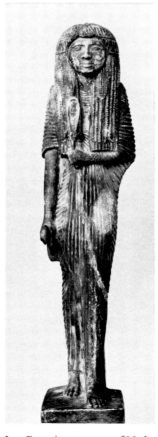

I–e. Egyptian statuette of Nasha.
Louvre

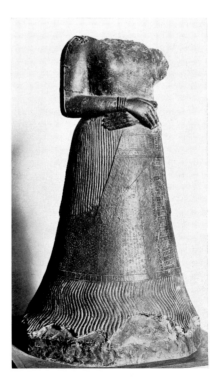

I–f. Statue of Napir-Asou, Queen of Elam.
Louvre

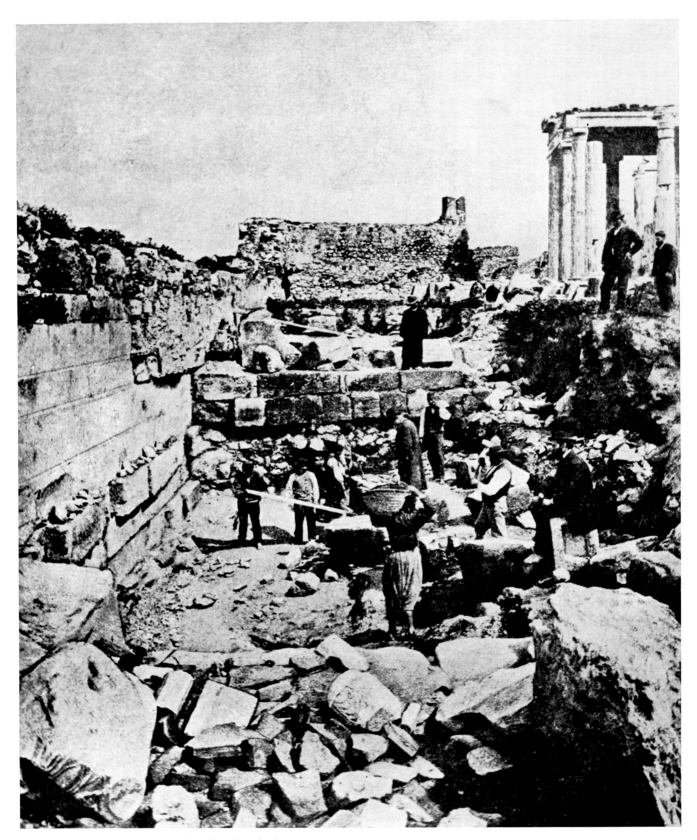

II. The discovery of the Korai on the Akropolis of Athens, 1885–1886

Athens, as did the poets Simonides and Anakreon; for Athens, as we know, had become an important artistic centre under Peisistratos and his sons.

But it is also obvious that the Ionic and Attic trends in art soon became merged, and to distinguish between the two styles becomes difficult—in sculpture, as it is in Attic vase-painting. Attica had taken over from Ionia what she found congenial, and then developed a style of her own, which presently became internationally Greek.

That Greece in her turn influenced the kore type of Anatolia is indicated by the limestone female statue discovered in 1957 at Bogazköy by K. Bittel (*Mitt. d. Deutsch. Orient-Gesellschaft*, 91, 1958, pp. 64 ff., and *Antike Plastik*, II, 1965, pp. 7 ff., pls. I ff.; Akurgal, *Kunst Anatoliens*, 1961, pp. 95 ff., figs. 55, 58, 59). As Bittel and Akurgal point out, this figure—and others such as the relief of Kybele, also from Bogazköy (figs. 60, 61)—were evidently influenced by such Samian products as the statues dedicated by Cheramyes (cf. my nos. 55, 56), and may be dated in the second half of the sixth century B.C.

The Discovery of the Korai on the Akropolis of Athens

The discovery of the statues of korai on the Akropolis of Athens is one of the most dramatic events among the many in our archaeological history. After the liberation of Greece from Turkish rule in 1833 it was decided first to clear the Akropolis of the many Turkish buildings that had sprung up— including a mosque inside the Parthenon—and then to dig down to the classical level. This and the partial restoration of some of the ancient buildings (the Parthenon, the Erechtheion, and the Propylaia)—often carried out with slender means—naturally took considerable time. It was not until 1885, when Kavvadias was appointed ephor-general, that it was determined to dig down not only to the classical level but to the native rock of the Akropolis area, and to do this systematically, starting on the north-west side of the Akropolis, east of the Propylaia, and continuing eastward along the north wall as far as the Belvedere, and then along the south wall as far as the Beulé gate.

It was then that the earth yielded up the treasures it had hidden for over two millennia. For the next fifteen years one great discovery succeeded another, not only sculptures in marble and limestone, some brilliantly coloured, but bronze and terracotta statuettes, pottery, coins, and inscriptions.

The first object found, in November 1885, was the bronze statuette, my no. 136, which was regarded as a good omen sent by Athena. This omen was soon fulfilled. In February 1886 fourteen of the finest korai were found packed together in a hole north-west of the Erechtheion (cf. pl. II). East and west of the Parthenon more statues came to light in artificial pockets. Others were found west of the Erechtheion and near the south wall.

All these sculptures, after being temporarily housed in the Propylaia and in the adjoining regions, were subsequently displayed in a newly built museum east of the Parthenon. And in recent years, after the 1939-1945 war, the Akropolis Museum has been partly rebuilt and rearranged.

In the arduous task of the restoration of the broken statues many archaeologists were active— especially Studniczka, Winter, Lechat, Heberdey, Brückner, Wolters, Dörpfeld, and, above all Schrader, to whose perspicacity are due many joins of pieces found far from one another. Furthermore, the subsequent studies by Dickins, Payne, Langlotz, and others have added to our understanding of archaic korai.

B

The discoveries were published with exemplary promptness by Kavvadias in the *Ephemeris archaiologike* of 1886 ff., and the *Arch. Deltion* of 1888 ff., and then, more comprehensively, in the large volume entitled *Die Ausgrabungen der Akropolis* (1906), by P. Kavvadias and G. Kawerau, with text in modern Greek and German. Accounts of the excavations also appeared in the *Ath. Mitt.* 1886 ff., by Wolters and others; in the *B.C.H.*, 1888 ff., mostly by H. Lechat; and in the *J.H.S.*, 1889, by Ernest Gardner; for the epoch-making discoveries naturally aroused the greatest interest throughout Europe. In 1906 appeared the book Μνημεῖα τῆς ῾Ελλάδος, in which the most important korai were illustrated.

The vast material occupied archaeologists for many years. The sculptures were published as time went on in the three standard books which I have already cited, by Dickins, Payne, and Langlotz. The pottery appeared in Graef and Langlotz, *Die antiken Vasen von der Akropolis zu Athen*, I (1925). The inscriptions were published by Lolling, in his *Katalogos tou Epigr. Mouseiou*, vol. I (1899), and, specifically the dedications by Raubitschek, in *Oest. Jahr.*, XXXI, 1939, Beiblatt, cols. 21 ff., and in his well-known *Dedications from the Athenian Akropolis*, 1949. The terracotta statuettes appeared in the second volume of the *Catalogue of the Acropolis Museum*, pp. 349 ff., with text by D. Brooke (1921), as well as by Winter, in his *Typen figürlicher Terrakotten*, I (1903), pp. 44 ff., and *Arch. Anz.*, 1893, cols. 140 ff. Finally the bronzes were published by de Ridder, in his *Catalogue des bronzes trouvés sur l'acropole d'Athènes*, 1896.

It is perhaps salutary to remember that, had it not been for what might be termed an accident, our supply of korai would be relatively small. But fortunately for us, the Athenians, returning to their city after the devastations by the Persians in 480 and 479 B.C. (cf. Herod. VIII, 53: τὸ ἱρὸν συλήσαντες ἐνέπρησαν πᾶσαν τὴν ἀκρόπολιν), decided to enlarge the area of the Akropolis and used the broken statues which they found to fill up the sloping ground. For, to judge by the present evidence,[11] the kore was not as popular a dedicatory offering as was the kouros. But, for some reason, a female statue was a favourite dedication in Athens during the second half of the sixth century B.C., that is, under Peisistratos and his sons; and it is these many female statues that now constitute the majority of the extant statues of that type. We have here in fact a striking example of how accident plays a part in the survival of statues, and how tentative our deductions from what has survived must accordingly be.

The Costume of the Korai

An understanding of the garments worn by the archaic korai is essential for a proper realization of their basic forms. Some are the same as the familiar draperies of classical and post-classical times; others differ in several respects. Furthermore, archaic conventions and limitations often add to possible misunderstandings. Consequently, a short discussion of these garments must here be included. I shall give them the Greek names customary in our archaeological literature, though it is well known that the Greeks did not always apply the same name to the same garment. Thus, a peplos is sometimes referred to as a himation or a chiton; the chiton (kithon, kiton) as a coat-of-mail, the himation and epiblema as any kind of cover. For Greek garments consisted of rectangular pieces of cloth and so had many uses. A similar Greek practice of calling the same object by various names can be observed in Greek furniture and pottery (cf. my *Furniture*[2], pp. 13, 33, and passim).

[11] Several fresh discoveries have, however, recently been announced—at Klaros, Erythrai, Chios and Cyrene.

The garments observable on the Greek korai are:

(1) The peplos, πέπλος, a heavy tunic.

(2) The chiton, χιτών, a light tunic.

(3) The Ionic himation, ἱμάτιον, a short, pleated mantle.

(4) The epiblema, ἐπίβλημα, a shawl-like wrap, either long or short.

(5) The ependytes, ἐπενδύτης, an informal short garment worn over the chiton. It does not appear on statues, only occasionally in late archaic vase-paintings.

It will be observed that during the almost two hundred years, from c. 650 to 480 B.C., occupied by our korai, fashions changed, apparently due to political events (cf. infra).

(1) The *peplos* is of the canonical variety, reaching from neck to ground, made of wool, wrapped round the body, mostly from left to right, and fastened on each shoulder with a pin or brooch. On one side it is, therefore, closed, on the other open, or sewn. It was generally belted at the waist, and sometimes it was provided with an overfold (diploidion) along its upper edge. Cf. Bieber, *Griechische Kleidung*, pls. 1 ff., pp. 17 f., where the dimensions are given as c. 1 by 3 metres. By increasing the width, however, it could be provided with sleeves, as is the case in a number of early examples of our korai (cf., e.g., nos. 23 ff.).[12]

The peplos was considered to be the typically Doric (or Corinthian) dress, that is, the garment worn in continental Greece as against that worn in Ionic Asia Minor.

(2) The *chiton* also resembles that worn in later times; that is, it was evidently made of a lighter material than the peplos—of linen instead of wool—and reached from neck to ground. It was generally wide enough to allow for sleeves, which were fastened along the upper arms with buttons (or sometimes with brooches?), and often long enough to be pulled over the belt, right and left, or in the middle, creating respectively a deep central pouch (κόλπος, kolpos), or two side pouches. It could be made of a single piece of cloth, or of two sewn together. Along its upper edge it generally has an ornamental band, and a belt is often visible front and back. Cf. Bieber, *Gr. Kl.*, pp. 19 ff., pls. VII ff.

In the korai the upper part is generally designated by delicately carved wavy ridges, giving a crinkly appearance; in the lower part, where the hand generally pulls the garment to one side, the folds are indicated by incised lines or ridges, radiating in the direction of the hand. The part where the hand holds the garment often consists of a vertical border—either a painted strip, or a set of bunched folds, called the paryphe, παρυφή, from παρυφαίνειν, 'to weave along or beside', i.e. a border woven alongside. Pollux describes the chiton (VII, 49) as 'the linen tunic reaching to the feet which the Athenians wore and also the Ionians', λινοῦς ὃν Ἀθηναῖοι ἐφόρουν ποδήρη καὶ αὖθις Ἴωνες.

(3) The *himation* worn by the korai differs from the familiar one of later times in several respects. Its form was for a long time the subject of controversy.[13] It normally appears draped obliquely from the right shoulder to below the left armpit—only occasionally from the left shoulder to below the right armpit—or hanging from both shoulders. That it was made of a heavier material

[12] In our archaeological literature the peplos is regularly described as being sleeveless; but M. Bieber, whom I consulted, agrees with me that a number of archaic representations show that it sometimes had sleeves. On cold days—and there are many such during a Greek winter—sleeves would surely have been welcome. Furthermore, this garment is sometimes referred to by modern authorities as a chiton. And it is indeed difficult to distinguish a peplos from a chiton during this early period when artists had not yet learned to indicate folds. In my descriptions, however, I call the heavy garments worn by the earliest korai peploi; for history bears out this identification (cf. p. 10). [13] Cf. the references given by C. Picard, *Manuel*, I (1935), p. 284.

than the chiton beneath it is indicated by its substantial folds as against the more delicate ones of
the chiton. The question arises did the drapery that envelops the legs—generally pulled to one side
by one of the hands—belong to the himation or to the chiton?

At first glance, accustomed to the voluminous himatia of classical times, one might think that the
lower part belonged to the himation, especially as in some cases the colouring of the upper part of
the chiton (on the free shoulder) does not correspond to that of the lower part. However, that this
is not the case, and that we are here confronted by a *short* himation worn over a *long* chiton has been
successfully shown by careful analyses and practical demonstrations. I reproduce here two illus-
trations from experiments made on a living model by A. von Netoliczka,[14] which make the con-
struction of the garment crystal clear (cf. plate III, a, b).

It evidently consisted, like the later himation, of a rectangular piece of cloth, about 1 by 3 metres,
but folded over lengthwise, and generally draped obliquely from one shoulder to the opposite
armpit, then fastened along the shoulder and upper arm by a series of buttons, and finally hanging
freely down in long, stacked folds, with an open space between the two parts. (The ends of the
stacked folds are often missing.) Miss Netoliczka's demonstration also explains what is at first puz-
zling, why the folds which descend from the (higher) shoulder are longer than those which hang
down from the (lower) armpit.

Along the upper edge of this short himation is a crossband, over which the himation is often
pulled up, causing little pleats. Whether the vertical folds hanging down beneath were sewn along
this crossband, to hold them in place, or whether they should be explained as an artistic convention
is uncertain. In a few cases the long stacked folds hanging down on one side do not show the normal
free space between the two ends (cf., e.g., my no. 181). Some have thought that in these few cases
the ends were sewn together. At the farther end of the crossband of the himation there often appear
a few vertical or oblique folds, which evidently indicate the slack of the chiton sleeve.

If then the drapery covering the legs belongs to the chiton, it may be asked why does its decoration
and colour sometimes not correspond with the part of this garment visible above? In no. 123, for
instance, the upper part is painted green, the lower has borders similar to those on the himation.
Perhaps the best answer to this pertinent question is that in the korai we are after all confronted
with works of art, not with living human beings, and so the compositional scheme played its part
in the mind of the artist. To have the whole bottom part of the statue a solid colour must not have
been to his liking; for we find throughout that surfaces painted in solid colours were used sparingly
in marble sculptures, as against those in poros. It was preferred to let the beautiful surface of the
marble show, variegated only by painted borders and scattered ornaments. Furthermore, as Dickins
said, it is not absolutely excluded that the top part of the chiton and the bottom part were
sometimes differently decorated in reality.

At all events, in the terracotta statuettes of korai, contemporary with the marble statues, and
likewise in late archaic vase-paintings, the difference between the long chiton and the short himation
is made convincing by the identical treatment of the upper and lower parts of the chiton.

(4) The *epiblema* (ἐπίβλημα, from ἐπιβάλλω, to throw on) is a kind of shawl 'thrown over' both
shoulders, covering back and sides. In a way it corresponds to the later himation, in that it hangs

[14] Die Manteltracht der archaischen Frauenfiguren, *Oest. Jahr.* XV, 1912, pp. 253 ff., figs. 169-171. Cf. also E. B. Abrahams, *Greek
Dress*, 1908, pp. 77 ff.; M. Bieber, *J.d.I.* XXXII, 1917, pp. 99 ff.; Picard, op. cit., pp. 284 ff., and the references there cited; J. Heuzey,
'Le costume féminin en Grèce à l'époque archaïque', *Gazette des Beaux-Arts*, 1938, 1, pp. 127 ff.

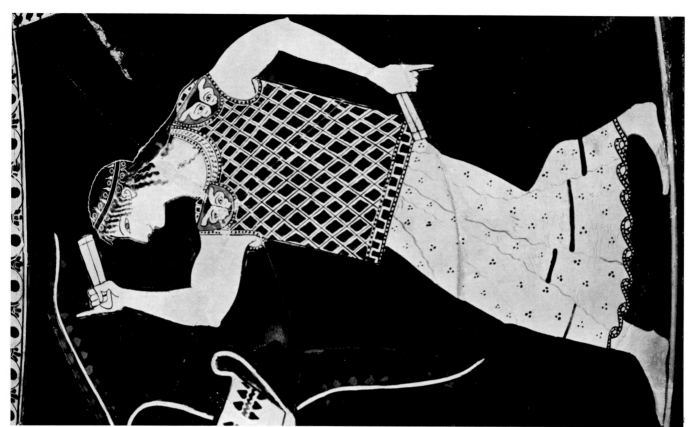

III–c. Dancing Maenad wearing chitoniskos, on an amphora by the Andokides Painter.
New York, Metropolitan Museum

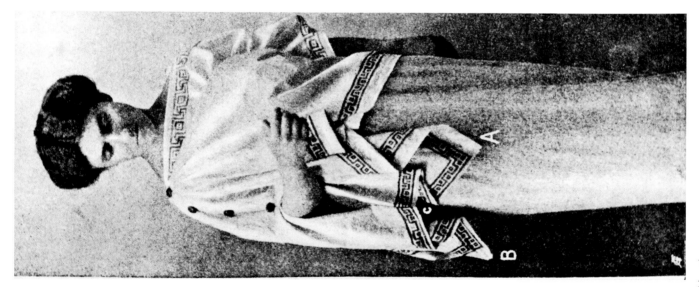

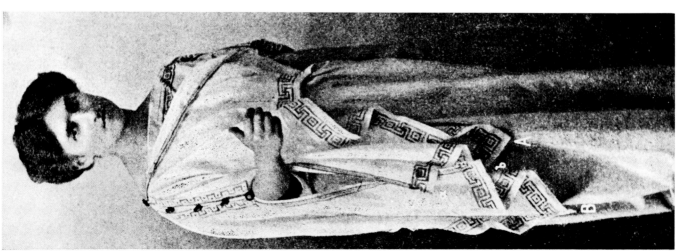

III–a, b. Living model wearing chiton and short Ionic himation

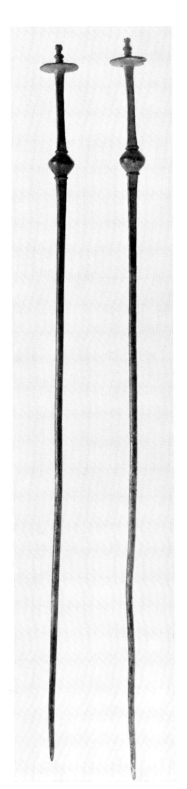

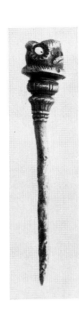

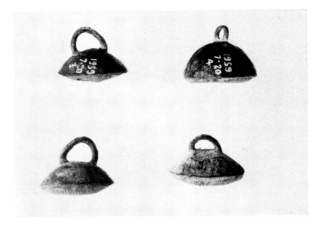

IV–c. Four Greek buttons. British Museum

IV–b. Greek pin.
British Museum

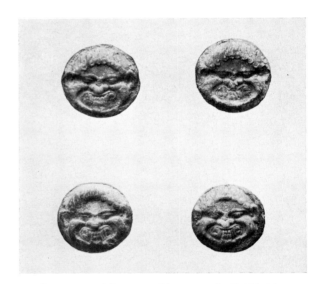

IV–d. Four Greek buttons with gorgoneia. British Museum

IV–a. Two long pins from Lake Kopais.
British Museum

IV–e. Two bronze eye-lashes. Athens, National Museum

down freely, and that it is even sometimes pulled over the back of the head, cf., e.g., nos. 70 f., 80, 98, 205, as the mantle was so often in later times. Sometimes, on the other hand, it is worn covering the chest, with the ends hanging down the back (cf. pl. viii, c). The epiblema could be long, trailing on the ground (cf. no. 164), or quite short (cf. no. 18).

(5) The *ependytes* (ἐπενδύτης), from ἐπενδύω, 'put on over', i.e. 'the garment worn over another', seems to have been the name given to a garment, belted or unbelted, *worn over* the chiton, and generally reaching from the neck to the knees or merely to the waist. It is perhaps equivalent to the 'little chiton', the χιτωνίσκος, a term which several times occurs in the inscriptions listing the garments dedicated to Artemis Brauronia (cf. *I.G.*², no. 1514, lines 45, 51, 52). The terms ependytes and chitoniskos are in fact equated by Eustathios (*Commentarii ad Homeri Iliadem*, p. 1226, vs. Σ 595).

Such an ependytes or chitoniskos does not appear on the archaic statues of korai, but it does on representations of female figures on vases of the later sixth and the early fifth century (cf. pl. iii, fig. c, which shows a Maenad on an amphora by the Andokides Painter in the Metropolitan Museum).[15] This little over-garment, which, as Thiersch (*Ependytes und Ephod*, p. 2) aptly said, corresponded to our pull-over, would have been a welcome addition on cold days. It was particularly adapted for indoor wear, i.e. less cumbrous than the himation or epiblema; and such an informal garment might well have been thought inappropriate for the statues dedicated in sanctuaries, and so was not there represented.

All these garments were decorated with patterns, either in the form of borders, or of single ornaments scattered over the larger surfaces, or—notably in vase-paintings—covering the whole surface (cf., e.g., pl. x, d, e).

These then are the garments worn by the archaic korai. It will be observed that during their tenure, i.e. during the period from *c*. 660 to 480 B.C., fashions changed. At first—both East and West—the peplos is the usual dress, shown hanging down from both shoulders in a heavy foldless mass, regularly belted at the waist, and occasionally provided with sleeves or a diploidion. Cf. p. 7.

It is generally the only dress worn. Sometimes, however, a shawl-like wrap, the epiblema, was added, descending from the shoulders; cf. nos. 18, 19, 22. Then, during the first half of the sixth century—particularly during the second quarter—one sees that instead of the peplos, a chiton appears. It is distinguishable by its lighter weight and by the regular presence of sleeves, fastened by little buttons along the upper arms, instead of with the former pins. And over it is often worn the short himation, mostly draped obliquely from one shoulder to the opposite armpit. The single chiton, or oftener the two garments together, are first seen on the korai from Eastern Greece, i.e. Asia Minor, and especially on those from Samos, from where has fortunately come a rich contingent (cf. pp. 46 ff.). So this form of dress was evidently specifically Ionian.

Presently this Ionian fashion makes its appearance on the korai from Attica, both in sculpture and vase-painting. On the François vase the women still wear the peplos, fastened on the shoulders with long pins (cf. pl. xii, a, b). Soon afterwards they shed the Doric peplos and adopt the Ionic chiton and the short himation (cf. figs. 277-279).

The change must have been due to the Ionic influence during the time of Peisistratos and his sons, *c*. 560 to 510 B.C., who had close connections with their Eastern fellow-tyrants. In the korai

[15] Cf. v. Bothmer, *MMA Bull.*, Feb. 1966, pp. 204, 209, figs. 4, 11. Though the chiton sleeves are not here indicated under the chitoniskos, that the latter is a separate garment is shown by the two separate borders round the neck.

C

from the Akropolis of the middle and the second half of the sixth century, down to the early fifth, these two garments are the regular apparel, and the representations of them become ever richer and more luxurious, without doubt reflecting contemporary customs.

As we view these korai daintily lifting their long chitons to one side we are reminded of Sappho's reproof to one of her young girls, who had apparently not been taught 'to gather her dress to the ankles with the proper grace'.[16] The Maidens from the Akropolis were evidently high-bred, and lifted up their chitons with faultless elegance.

These luxurious Peisistratid days terminate with the Persian wars. As a reaction from Eastern customs the Ionic form of dress became unpopular and the Doric, or rather the continental, peplos returned to favour. Cf. pp. 108 f.

This is what the extant korai teach us. And these changes in fashions are borne out by some statements of ancient authors. First by the colourful story told by Herodotos (v, 87 ff.), about the only survivor of the fateful Athenian expedition against the Aeginetans (in c. 560 B.C.), who was killed on his return by the enraged, widowed women who, we are told, gathered round him and 'struck him with the pins by which their dresses were fastened, each, as she struck, asking him where he had left her husband', κεντεύσας τῇσι περόνῃσι τῶν ἱματίων εἰρωτᾶν ἑκάστην αὐτέων ὅκου εἴη ὁ ἑωυτῆς ἀνήρ. (Evidently the pins were of considerable length; cf. pl. IV, a, b). Whereupon, Herodotos proceeds, the Athenian husbands were so horrified that they changed the women's (Doric) dress into the Ionian, i.e. 'the linen chiton which does not require brooches', τὸν λίνεον κιθῶνα, ἵνα δὴ περόνῃσι μὴ χρεῶνται. The husbands apparently thought it best to prevent their wives from having such dangerous weapons to hand.

This story has by some been thought to be an invention by Herodotos, but the fact remains that it is borne out by the archaeological evidence—which has only comparatively recently come to light. For when Herodotos wrote, the korai of the Akropolis, with their Ionic costume, all dating after the Aeginetan expedition, were already buried in the Persian debris of 479 B.C.

The readoption of the peplos in the early classical period (cf. p. 108) was, it has been thought, referred to by Thucydides (I, 6) when he said that 'not long ago the men gave up wearing tunics of linen', οἱ πρεσβύτεροι . . . οὐ πολὺς χρόνος ἐπειδὴ χιτῶνάς τε λινοῦς ἐπαύσαντο φοροῦντες. But this change from the Ionic chiton to the Doric peplos on our korai occurred, as we saw, more than a generation before Thucydides' time, and concerned women not men. Nor does Thucydides give the possible explanation of the change as a reaction from things Eastern after the termination of the Persian wars. As a matter of fact the chiton, for both men and women, reappears again in the second half of the fifth century; but never again the short, Ionic mantle. The himation is always the voluminous one, hanging down freely in large, substantial folds.

[16] Fragment 70 :
τίς δ' ἀγροϊῶτίς τοι θέλγει νόον,
οὐκ ἐπισταμένα τὰ βράκε' ἕλκην ἐπὶ τῶν σφυρῶν;
'What country girl charms thee,
However fair her face,
Who knows not how to gather
Her dress with artless grace?' (tr. by H. Thorton Wharton).

The Jewellery

In addition to the garments the korai wear jewellery: necklaces, bracelets, and earrings, as well as a stephane or a taenia, or spirals or a polos on the head (cf. infra). The forms of the *necklaces* were those current during the different periods, generally a string with either a single or several elongated pendants. Cf., e.g., nos. 42 f., 106, 202. Furthermore, long chains sometimes appear hung across the chest and fastened on the shoulders (cf. the statue from Delos, my no. 148, and the terracotta statuettes nos. 47, 49, as well as those figured by Winter, *Typen*, I, pls. 27 ff.). For such an actual example in gold, cf. that illustrated in the new Guide of the *Museo Arqueológico Nacional, Madrid* (1965), pl. V, 1 (seventh century B.C.).[17]

The *bracelets* are either of spiral form or circular, and were painted, or carved in relief, or added in metal.

Earrings. The korai of the seventh century generally have their ears covered by the hair, or when they were visible no earrings appear. One of the earliest Greek korai with a recognizable earring is the statue in Berlin (no. 42), where it consists of a ring or hook with an elongated pendant, similar to the pendants hanging from her necklace.

Then, in the middle of the sixth century B.C., on the Lyons kore (no. 89) appears an earring consisting of a ring or disk, with pendants; whereas on the contemporary Ephesian ladies (nos. 82-85) only a large disk earring is shown. Subsequently, such a disk earring, often decorated with a painted rosette (cf., e.g., nos. 123, 143, 183), regularly appears on the korai of the later archaic period of the second half of the sixth and the early fifth century. Sometimes the rosette is perforated in the centre, evidently for the addition of a central metal ornament, or a pendant.

This type of disk earring apparently stemmed from Ionia, and was ultimately borrowed from Egypt, where it appears, e.g., on a relief with a representation of Rameses II, and on a painting from Beni Hassan (cf. Perrot and Chipiez, I, p. 706, fig. 474, p. 794, fig. 525).

It is a curious circumstance that such disk earrings without pendants, so common on the extant late archaic sculptures, have not yet actually been found in excavations; whereas disks with pendants are common (cf. Hadaczek, *Ohrschmuck*, pp. 11 ff.). This difference was perhaps due to the fact that the carving of the pendants in marble, hanging freely from the lobe, presented difficulties, and was therefore dispensed with (cf., e.g., the rather awkward rendering on the Lyons kore (no. 89)). At least in vase-painting, where the indication of pendants of course presented no difficulties, we find them hanging from disk earrings as early as on the François vase (cf. plate XII, b) and then regularly later (cf., e.g., plate XV, d, by the Andokides Painter). A specially large and elaborate earring appears on the limestone head from Cyprus (no. 155).

The *stephane*, or diadem, generally, but not always, ends in a point in the middle of the front, and was often enriched with painted patterns, as well as with various metal ornaments, as shown by the surviving holes for their attachment. The Greek word στεφάνη, or στέφανος, is derived from στέφω, στεφανόω, 'to put round', and is applied to anything surrounding something else; but it occurs specifically as a woman's headdress in Homer (cf., e.g., *Iliad*, XVIII, 597); in Hesiod

[17] On such chains cf. also H. Hoffmann, *Greek Gold*, p. 5, and Amandry, *Collection Hélène Stathatos*, III, pp. 210 ff., figs. 114-116 (fig. 114 shows a Thessalian woman of today wearing such a chain).

(*Th.* 578); and in Aristophanes (*Eccl.*, 1034); as well as in inscriptions (*I.G.* II², 126-131). In modern usage it is generally used for the ornament of curving outline, worn in the front of the head, in distinction of the *taenia, ταινία*, a fillet, which is a simple circlet lying close to the head. Sometimes a kore wears a wreath instead of a stephane or a taenia. And occasionally a kore appears wearing a *polos*, a high, circular crown, which is worn both by deities and by human beings.

Spirals. In the little Ephesian kore of ivory (no. 81) what look like spirals appear in the hair, above each ear. Their function evidently was to keep the hair in place, just as a woman nowadays uses clasps or hairpins for this purpose.

Accessories. Of the various metal accessories added to the marble korai few have survived—or have been identified. In the Karapanos Collection in the National Museum, Athens, however, there are a number of bronze eyelashes, used for insertion into hollow eye-sockets of statues (see Plate IV, e).

Pins and Buttons

The loosely hanging Greek garments naturally needed some fastenings, in addition to the belts that helped to keep them in place. On the nature of these fastenings—fibulae, brooches, stick-pins, buttons—there has been a considerable, sometimes controversial, literature, for contradictory factors have to be taken into account. On this subject cf. especially: Thiersch, in Furtwängler, *Aigina, Das Heiligtum der Aphaia*, pp. 397 ff., 404 ff.; Kate McK. Elderkin, 'Buttons and their Use on Greek Garments', *A.J.A.*, XXXII, 1928, pp. 333 ff.; Jacobsthal, *Greek Pins* (1956), passim; Higgins, *Greek and Roman Jewellery* (1961), pp. 131 f., and passim; D. E. L. Haynes, *British Museum Quarterly*, XXIII, 1960-61, pp. 48 f. Many actual examples have been found on different sites, especially at the Argive Heraion, cf. Waldstein, *Argive Heraeum*, pls. LXXVIII ff.

The evidence supplied by our korai suggests that in the early archaic period the peplos was fastened with stick-pins, sometimes of considerable length; cf., e.g., the women on the François vase (*c.* 570 B.C.), plate XII, b, which seem to be the earliest clear representations of such pins; for in the korai of the seventh and early sixth century the shoulders are either hidden by an epiblema or by the 'daedalid' hair, or no fastenings are indicated (cf., e.g., my nos. 2, 5, 12, 19). We may assume, however, that pins were then in regular use, for the actual examples which have survived of this early period bear this out: cf. plate IV, a, b. Plate IV, c, shows a silver pin, 6.5 cm. long, said to have been found in Greece and now in the British Museum (1959.7-20.6). It has an ornamental head terminating in the head of a lion; cf. D. E. L. Haynes, op. cit., p. 48 (there dated *c.* 500 B.C.).

Around the second quarter of the sixth century, both in Ionia and in Attica, buttons appear as fastenings of the chitons along the shoulders (cf., e.g., my nos. 67, 68). They are the prototypes of what has served as the standard fastening ever since, for their advantage over the dangerous and impractical stick-pins was obvious. Of course an old custom was slow to die out completely, and pins occasionally appear on red-figured vase-paintings down to the end of the fifth century and beyond (cf. the list given by Jacobsthal, *Pins*, pp. 107 f.). Plate IV, c, d, illustrate four actual examples of buttons of the late archaic period, said to be from Greece, and now in the British Museum (59.7-20.2, 3, 4, 5; *c.* 2 cm. in diameter). They evidently formed a set and consist of bronze 'cups' or 'frames', provided with little loops on the convex under side and with gilt terracotta inserts

ornamented with gorgoneia in relief on the convex upper side.[18] The buttons were inserted either into button holes or loops. Strangely enough, actual examples of buttons have not often been recorded, perhaps, as has been suggested, because they were either of perishable material such as wood, or precious material such as gold, and so have disappeared. It may also be possible that objects which have been interpreted as spindle-whorls, etc., were really buttons (cf. K. Elderkin, op. cit.).

The Hair

The hair is of course worn in what must have been the current fashion, observable also in other contemporary sculptures and in vase-paintings. In the seventh-century korai it hangs down at the back and sides in solid masses (cf. nos. 12, 13). But as time went on these masses of hair are differentiated into tresses, kept in a mass at the back but separated both in front and on either side; Above the forehead the hair is often elaborately dressed in zigzag or wavy curls, sometimes in two registers, and with side coils right and left. On the skull above the stephane or taenia, it is indicated either by parallel or radiating ridges, or it is left plain. This fashion is amazingly uniform, lasting throughout later archaic times. Since today (1966) it has also become the fashion to have long locks descending on either side of the face, and since these locks are often artificial (obtainable in shops), the question arises whether the Greek korai with their abundant hair also added some artificial tresses to their own limited supply? This might help to explain the uniformity of the fashion.

Ornaments in the hair were regularly added in metal, as their extant holes indicate. Furthermore, some of the locks, or parts of them, were occasionally made in metal and added to the marble ones; cf., e.g., nos. 124, 147, 150. The presence of a *meniskos*, μηνίσκος, to guard the statue from birds perching on their heads (cf. Aristophanes, *Birds*, 1114), has been deduced by the central hole in the skull of statues, as well as by actual remains of the metal spikes (cf. nos. 110, 114, 116, 117, 119; also Daremberg and Saglio, *Dictionnaire*, s.v. meniskos). Presumably only those korai which stood out in the open needed this protection, not those which were placed inside a sanctuary; and it is noteworthy that the statues not provided with meniskoi often have their colours preserved better than the others.

Footwear

In the earlier periods the korai as a rule wear shoes, with details not differentiated (cf., e.g., nos. 14, 48, 57, 120). Later the footwear generally consists of sandals. Exceptionally no. 120 has red shoes. The straps of the sandals are either worked in relief, or painted, in which case the colour has now partly or totally disappeared. Sometimes there is a hole in the centre strap for the addition of a metal latchet. The soles of the sandals are carved in one piece with the feet. Occasionally, but not often, a kore has bare feet (cf., e.g., no. 60).

[18] D. E. L. Haynes, *British Museum Quarterly*, XXIII, 1960-61, pp. 48 f. As Mr. Haynes points out, the gorgoneia on these buttons closely resemble those on the coins of Thracian Neapolis (*B.M.C.*, Macedonia, etc., p. 84).

The Polychromy and Decoration

Unless one remembers the vivid polychromy of the korai, one cannot obtain an adequate idea of the impression that they must have made. It is now no longer necessary to argue for the prevalent custom in Greek times of colouring their sculptures—not only those of limestone, not only the architectural ones on pediments, metopes, and friezes, but all sculptures, in the round and in relief, large and small. The debate on this important question lasted a considerable time, but as more and more evidence came to light, the polychromy of Greek sculptures is now commonly accepted.[19]

When the korai of the Akropolis were found in the eighties of the last century (cf. p. 5), they must have created great surprise also for their colours, some of which were then still in pristine condition. And even now they constitute one of the chief sources for our understanding of the Greek use of colour on their sculptures. We learn that—in contrast to those of poros—the marble statues were not wholly covered with paint, but only partly so. The white surface was allowed to remain in certain portions (perhaps toned with 'ganosis'), but it was enriched with variegated designs—borders of various patterns (cf. infra) and single ornaments scattered over the broad surfaces. On the other hand, the hair, the lips, the eyes, the diadems, i.e. the smaller surfaces, were mostly painted solid. In other words, just as the various parts of the statue were designed in a harmonious composition, so the applied colours were carefully planned to add to the harmonious effect of the whole.

The chief colours used were red and blue (now often turned green); also yellow, brown, black, and white, and green. That is, the same palette that was used in Egypt was adopted by the Greeks. The mediums were gum, glue, and white and yolk of egg, all of which can be dissolved in water; and this explains the temporary nature of the colour, for 'while serving to attach pigment, they do not really protect it from attack by air or moisture or prevent its easy removal' (Laurie, *Greek and Roman Painting*, p. 18).

The patterns which appear on the korai may be seen in the drawings appended in the text to the descriptions of the individual statues. They are taken from Lermann's *Altgriechische Plastik*, but reproduced in black and white instead of in colour (cf. p. VIII).[20]

[19] Cf. the extensive bibliography given by P. Reuterswärd, *Studien zur Polychromie der Plastik, Griechenland und Rom*, 1960, pp. 9-27, starting with Winckelmann's *Geschichte der Kunst des Alterthums*, 1763-1768, and brought down to Koch's *Studien zum Theseustempel in Athen*, 1954. (To this valuable list may be added: L. V. Solon, *Polychromy, Architectural and Structural Theory and Practice*, 1924.)

For the books and articles treating in particular with the colours on the korai see:

H. Lechat, Observations sur les statues archaïques de type féminin du Musée de l'Acropole, VII, Polychromie, *B.C.H.*, XIV, 1890, pp. 553-572.

M. Collignon, 'La polychromie dans la sculpture grecque', *Revue des Deux Mondes*, 127, 1895, pp. 823-848.

H. Lechat, 'Au Musée de l'Acropole d'Athènes, Études sur la sculpture attique avant la ruine de l'Acropole lors de l'invasion de Xerxès, *Annales de l'Université de Lyon*, N. S., II, 10, 1903, chapter on polychromy: pp. 243-263.

A. Furtwängler, *Aegina*, 1906, pp. 304-308.

W. Lermann, *Altgriechische Plastik*, 1907, pp. 34 f., 76-98 (with coloured illustrations of the painted decorations on a number of the korai on the Akropolis).

H. Lechat, 'Note sur la polychromie des statues grecques', *Revue des études anciennes*, 1908, pp. 161-168.

G. Dickins, *Catalogue of the Acropolis Museum*, I, Archaic Sculpture, 1912, pp. 40 f. (gives descriptions of the colour traces on the various korai).

E. Langlotz, in H. Schrader, *Die archaischen Marmorbildwerke der Akropolis*, 1939, Die Koren (descriptions of the colour traces).

P. Dimitriou, *The Polychromy of Greek Sculpture to the beginnings of the Hellenistic Period*. Diss. Columbia University, New York, 1947 (publication forthcoming).

[20] A few other coloured copies were made by Mr. Gilliéron, reproduced in the *Eph. arch.* of 1887, and in Schrader, *Marmorbildwerke* (1939).

It will be seen that the patterns familiar from Greek vases of the archaic period[21] recur on the korai—the maeander, the wave, the lotus and palmette, zigzags, rectangles, rosettes; but they are infinitely varied, each artist creating his own designs within the prevalent types. Moreover, these often sumptuous decorations evidently reproduced those on the actual garments worn at the time. Weaving and embroidery were major accomplishments of Greek women.[22] Their beautiful handi-work has perished, but we can obtain some idea of it from the painted decorations on the statues of the korai, as well as from the designs drawn on the garments on Greek vases. The tradition has persisted, and even today, and quite generally in the Greek garments in vogue some generations ago, colourful patterns—continuous borders and scattered single ornaments—appear woven or embroidered on the light ground of the material.

As we view these korai, those especially of the second half of the sixth century B.C. found on the Akropolis, we must therefore add in our imagination not only the missing parts, but the ornaments and the colours with which they were enriched. They represent the *grandes dames* of the Peisistratid age, aristocrats in appearance and bearing, the best witnesses we have today of the brighter side of the age of the tyrants in Athens. No female statues of the subsequent ages can approach them in comeliness. But by their very nature they were ephemeral. They disappeared when other tastes became prevalent.

The Technique

For detailed descriptions of the technique of archaic Greek sculptures, fundamental of course for their understanding, cf. especially: C. Blümel, *Griechische Bildhauerarbeit*, 1929; English edition entitled *Greek Sculptors at Work*, 1955. S. Casson, *The Technique of Early Greek Sculpture*, 1933; especially pp. 93-126. G. M. A. Richter, *The Sculpture and Sculptors of the Greeks*, 1950 edition, pp. 135-158; *Kouroi*[2], 1960, pp. 7-16. Sheila Adam, *The Technique of Greek Sculpture in the Archaic and Classical Periods*, 1967.

The following is a short résumé of the procedure as applied to the korai.

The *material* of the korai included in this book is mostly marble for the statues and reliefs, rarely limestone (cf., e.g., no. 154). Bronze, terracotta, and ivory statuettes, as well as some representations on vases, have been added to round out the picture. The marble is mostly Island, sometimes Pentelic or Hymettan. But the distinction of the various Greek marbles has become more and more difficult since mineralogists tell us that they are indistinguishable! In this book I have taken the various names from the publications. The *tools* used are of course the same as in other Greek sculptures— the hammer for the preliminary blocking out; then, successively, the point (punch), the claw chisel, the flat chisel, and the gouge; finally, the rasp, and other abrasives.

[21] Cf., e.g., H. B. Walters, *History of Ancient Pottery*, II (1905), pp. 209 ff.; Jacobsthal, *Ornamente griechischer Vasen* (1927).

[22] For the adequacy of the Greek loom, and the use of the heddle, cf. now D. L. Carroll, *A.J.A.*, LXX, 1966, p. 185.

Piecing

The korai were often not carved out of a single block of marble, but, when parts projected, as in an extended arm, they were separately made, provided with a tenon, and inserted into a corresponding mortice. For the attachment metal dowels were used, some of which are still preserved, or their former presence is indicated by the holes in which they were inserted. Occasionally such piecing is due to a later repair, and in a few cases a different marble was then used from that of the rest of the statue (cf. nos. 118, 128). Heads too were now and then made separately—evidently when the block of marble was not of sufficient height. In some instances two blocks of marble were used for the body, with a join at the knees (cf., e.g., no. 116). *Accessories* in other materials are also common. Thus the eyeballs were sometimes made of glass in a metal case and inserted into the hollow eye-sockets (cf. no. 110); and the eyelashes were made separately of bronze and inserted. (Plate IV, e shows two—out of several—such bronze eyelashes from the Karapanos Collection in the National Museum, Athens, nos. 113-137.) Also the attributes held by the korai were occasionally of metal—though mostly of marble. The jewellery was also sometimes of metal, as were the ornaments added on the stephane.

Mounting

The statues were as a rule worked in one piece with a small plinth—rectangular, round, or of irregular shape, cut approximately round the feet. The plinth was inserted into a large base, provided with a dedicatory inscription and sometimes with the name of the sculptor. But the original bases have mostly been lost, presumably having later served for other uses, and also because of the difficulty of identifying the few extant ones. For the plinth only loosely fitted into the hollow of the base, the join having been secured by molten lead, which sometimes occupied considerable space (cf. p. 70). From the few instances, however, when a kore could be combined with its base (cf., e.g., nos. 110, 180), and from approximately contemporary and later other ensembles, we learn that the bases were often in the form of columns of considerable height. The capitals were either Ionic or round, and the columns either fluted or unfluted. Inscriptions appear on the abacus of the capital, or were engraved, vertically or horizontally, on the shafts of the columns. Cf. Raubitschek, *Dedications*, pp. 3 ff. Whereas a number of colossal kouroi have survived there are practically no colossal korai, though quite a number are larger than life. Several are life-size. Many, however, are small, about half life-size. One supposes the size depended on the taste—and purse—of the dedicator.

Location

It is not known just where and how the korai were placed on the Akropolis hill. Were they erected in groups or singly, in certain localities or in several? That at least some korai were placed out-of-doors is indicated by the presence of meniskoi on their heads (cf. p. 13); and that others were presumably placed inside a sanctuary—against a wall—is suggested by their unfinished backs (cf., e.g., nos. 44, 123). In other sanctuaries we also find statues placed both inside and outside buildings. In the precinct of Hera in Samos, for instance, we know of statues placed inside the temple and of

others erected in the open. That the Akropolis of Athens was in continuous use during the whole of antiquity as well as in modern times, and that it underwent countless vicissitudes is of course responsible for the fact that all traces of the original locations of the korai have disappeared.

Chronological Sketch

In the introductions to the various groups in which the korai have been placed in this book will be found discussions of the external evidence from which absolute dates can be deduced. It will be seen that at first these are tentative, but later become more reliable. The upper limit of the series is suggested by the opening up of Egypt to the Greeks during the reign of Psammetichos I (cf. Herodotos, II, 154), after which monumental sculpture in Greece begins; and so the first group of korai may be started *c.* 660-650 B.C. Comparisons with Proto-Corinthian, early Corinthian, and early Attic pottery supply further evidence, as do also the contemporary kouroi.

For the second group of korai one can turn for help to the Orchomenos–Thera group of kouroi, to the Delphian Sphinx, and to the vases by Sophilos and his contemporaries, as well as to the heads on Middle Corinthian pyxides.

Then, for the third group, one can use the heads on Late Corinthian pyxides, the Tenea–Volomandra group of kouroi, and the vases datable in the second quarter of the sixth century—though these do not yet have the indication of folds observable in the statues.

For the fourth group there is the testimony of some of the figures on the column drums of the temple of Kroisos in Ephesos, the (now) headless karyatids of the Knidian Treasury at Delphi, and the kouroi of the Melos group, as well as, to some extent, the vase-paintings by Lydos and others.

For the fifth group outside evidence is fairly reliable. For its upper limit we have the sculptures of the Siphnian Treasury at Delphi, which includes two karyatids and two female figures on the pediment. For its lower limit one can use the sculptures of the Alkmeonid temple of Apollo at Delphi, and some of the figures on the metopes of the Athenian Treasury at Delphi. (The evidence for the dating of these monuments is given at length on pp. 63 ff.). Also useful are the many vase-paintings of this period, which now effectively show the current designs adopted for folds.

Finally, for the sixth group external evidence for absolute dating is supplied from various reliable sources—from the late members of the Ptoon 20 group of kouroi, including the Kritios Boy and the Blond Head, both assignable to just before 480 B.C.; from the Tyrannicides, securely dated 477-476 B.C.; from the two Athenas of the temple of Aphaia at Aigina; and from the vase-paintings of the early fifth century B.C.

Furthermore, throughout one must take into consideration the gradual development from conventional to naturalistic renderings, which characterizes the whole of archaic Greek art, and forms our securest and most obvious chronological criterion. Consequently, one must allow sufficient time for one group to develop into the next—always bearing in mind, however, that it is the style that counts, not necessarily the propensities of the individual artist, who might be a progressive or a conservative.

D

Summary of Stylistic Analyses

In tracing the development of the kore type, the rendering of the drapery is naturally the most salient factor. In addition, the forms of the features, especially of the eye, mouth, and ear (the nose is mostly missing) furnish useful clues, as do also the arms, hands, and feet, and, to some extent, the rendering of the hair.

DRAPERY. At first (in group I) the drapery is shown as a stiff, enveloping mass, with the lower part, from the waist downward, generally of columnar or plank-like form, and with no folds indicated. Presently (in groups II and III) folds and ornaments are tentatively added by incisions and by shallow ridges, in vertical, oblique, and radiating directions, occasionally with zigzag edges. Gradually (in groups IV, V, VI) the folds multiply, and—especially those of the Ionic himation—assume greater depth, until the renderings become ever more complicated, with some of the folds carved in the round. Moreover, the forms of the body, especially of the legs, are progressively shown beneath the drapery.

HEAD. In the head the skull is at first (in group I) flat at the top and back. Starting with group II it becomes more and more spherical.

EYE. At first (in group I) the eye is large and flat, the two lids being indicated by prominent ridges, carved more or less in one plane. The eyeball often protrudes. Gradually (beginning in group II and progressively later) the roundness of the eyeball is shown, and the upper lid is given a corresponding curve. The upper lid is often strongly arched. Beginning occasionally in group II, more frequently in group III, and regularly later, the recess at the inner corner (the lachrymal caruncle) is marked, at first by a groove, then by a loop. Finally (in groups V and VI) the eye assumes a more naturalistic form, and the canthus is sometimes added in the recess at the inner corner (cf. drawing on p. 19).

MOUTH. At first (in groups I, II) the lips are carved more or less in the same plane; they are practically horizontal, undifferentiated, and do not meet at the corners. Presently (in group III), the lips curve upward, but they do not meet at the corners; instead, they are carved deeply into the face so that deep depressions appear between their corners and the cheeks—resulting in the so-called archaic smile. In group IV the upper and lower lips are differentiated, and the groove at the corners becomes less marked. As time went on (in groups V, VI) the transition between the corners of the mouth and the cheeks is made more gradual, and so the 'archaic smile' tends to disappear.

EAR. In group I the ear is rendered in one flat plane, and is stylized into the form of a volute. Presently (in groups II, III), the ear is less stylized, and attempts are made to render its various parts: the tragus sometimes appears in the form of a knob, either as a separate protuberance, or as an excrescence from the lobe. Gradually (in group IV) the tragus assumes a more natural shape and the antitragus is sometimes tentatively indicated, though often wrongly placed. Finally (in groups V, VI), the helix, tragus, and antitragus are correctly rendered and the ear thereby assumes its natural form (cf. drawing on p. 19).

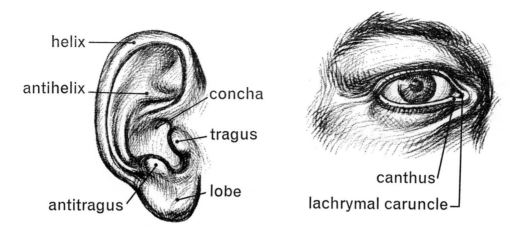

NECK. The construction of the neck is at first generalized. Only gradually (beginning with group IV) are the sterno-mastoids and the swelling of the throat indicated. In some examples the neck is abnormally long (cf., e.g., no. 127).

ARM. At first (in groups I-III) the arms, when lowered, adhere more or less to the body (especially in the stone examples). Moreover, the forearm, when lowered, is supinated, i.e. directed forward, whereas the hand is directed towards the body (cf., e.g., fig. 150). Gradually (from group IV onward) the arms are carved free from the body, and the forearm is more or less correctly semi-pronated.

HAND. In groups I and II the hand is generally clenched, the fingers are parallel to one another and more or less of equal lengths, except for the thumb, which is often large and prominent. The all-over form is angular. Gradually (beginning with group III), the fingers are differentiated, and the hand begins to loosen up. Both action and shape are studied. In groups V and VI the hand and the fingers assume more natural forms and the metacarpal bones are indicated.

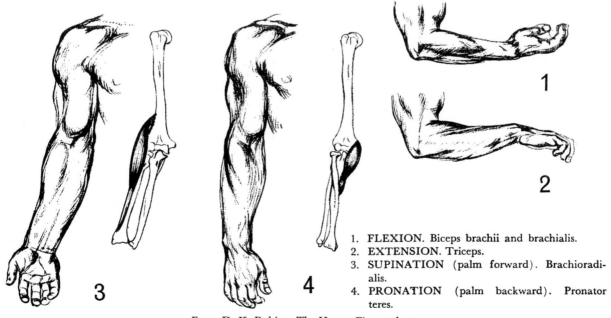

1. FLEXION. Biceps brachii and brachialis.
2. EXTENSION. Triceps.
3. SUPINATION (palm forward). Brachioradialis.
4. PRONATION (palm backward). Pronator teres.

From D. K. Rubins, *The Human Figure*, pl. 53.

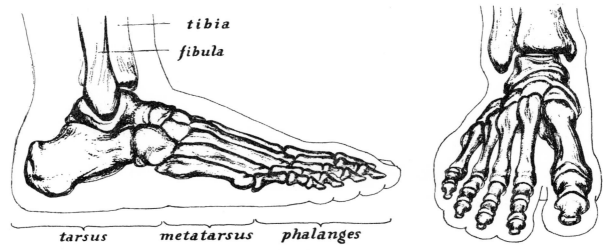

tibia

fibula

tarsus *metatarsus* *phalanges*

From D. K. Rubins, *The Human Figure*, pl. 85.

FOOT. In the early examples (in groups I, II) the front parts of the feet (often shod) are seen projecting from arch-like openings at the bottom of the chiton. They are placed close together. Presently (beginning with group III) the left is generally shown more advanced than the right. The toes are at first (in groups I, II, III) more or less parallel to one another, and their ends, as they touch the ground, recede along a continuous curve, the big toe projecting further than the second one. Presently (in group IV) the toes are no longer parallel, and do not recede along a continuous curve, the second toe projecting further than the big toe, and the little one slanting inward. The metatarsal bones begin to be indicated in group V, when the toes are often carved with undulating contours, and the little toe is given a strong inward curve, with a marked projection on its outer side.

HAIR. The hair is at first (in group I) rendered as a stiff mass, descending at the back and sometimes on either side in front, with horizontal and vertical divisions. Gradually (from group II onward) these masses become looser through being differentiated into globular or band-like tresses. The scheme then (in groups V, VI) becomes curiously constant, consisting of a mass of parallel tresses descending at the back and ending below in a quadrangular or rounded contour, while separate tresses are brought to the front on either side. Above the forehead and temples, below the stephane or taenia or polos, which are generally worn, the hair is at first (in groups I, II, III) indicated by wavy ridges, mostly in a horizontal direction. Gradually (from group IV onward) the rendering becomes more varied, consisting of vertical curls terminating in spirals, or in horizontal ridges, with or without a central parting, or in zigzag ridges, or in a combination of two such designs in superimposed tiers. To add to this elaboration side coils are often introduced (in groups V and VI). On the skull the hair is either left flat, with no details indicated; or it is rendered by concentric waves; or by ridges radiating from the vertex; or by ridges going in a downward direction, continuous with the tresses at the back. All these various designs appear in the coiffures of the korai of groups V and VI.

PROLOGUE: THE FORERUNNERS

WE shall see that in contrast to the kouroi, of which only isolated large stone examples have survived from the third quarter of the seventh century B.C. (cf. *Kouroi*[2], pp. 27 ff.), there are many korai that may be placed in that period and a little later. So, whereas in the kouroi we started our survey with the Sounion group of *c.* 615-590 B.C., we can begin our study of the korai as early as *c.* 650 B.C., and find examples safely assignable to the whole of the second half of the seventh century.

But also the stone korai naturally had antecedents. Here too one finds that the standing female figure makes its appearance in bronze, terracotta, and ivory statuettes, as well as in vase-painting, during the geometric epoch of the eighth century B.C.—though curiously enough the maidens are less numerous than the youths.

Figs. 1-15 show a few examples from various localities. Some have bell-like bodies with painted decorations on their garments closely corresponding to those on geometric vases[1] (cf. figs. 1-8). The proportions are unnatural, the forms are angular, the contours pleasing, all is comparable to the familiar figures on the pottery of the geometric age. Figs. 9-12 show one of the few bronze korai of that time, found at Thermon, now in the National Museum in Athens.[2] It has prominent breasts and wears a garment; otherwise its angular form closely corresponds to that of the many bronze male figures found at Olympia and elsewhere. Another interesting example is furnished by a nude geometric kore found at Delphi,[3] again with the familiar angular forms current at the time (figs. 13-15).

Lastly there are the ivory statuettes found in a grave near the Dipylon in Athens, together with geometric pottery assigned to the middle and second half of the eighth century.[4] They are now exhibited in the National Museum, Athens, one, the best preserved, no. 776, in a case by itself (figs. 16-19), the others, nos. 777, 778, 779, with the pottery with which they were found; cf. figs. 20-22. Each wears a polos and stands erect, with feet level, and legs close together. In fig. 20 the arms descend along the sides, with the hands held open and touching the thighs. In fig. 21 the right forearm is raised. In contrast to the geometric figures, their forms are not angular but rounded, and they are represented nude.

They have long been considered an anomaly in Greek art, and it has been tempting to explain them as importations from the Orient, as has actually been suggested for no. 779 by Barnett (*Palestine Exploration Quarterly*, 1939, p. 5, note 3, and *J.H.S.*, LXVIII, 1948, pp. 4, 5). But, though evidently connected with Eastern prototypes, one feels that there is something distinctly Greek in these figures. A nude bronze statuette found on the Akropolis of Athens and now in the National Museum (no. 6503;[5] cf. figs. 23-24) is related in style, for it has the same rounded forms as the ivory statuettes

[1] In the Louvre: CA623, found at Thebes, height 33 cm., and CA573, height 39.5 cm. Cf. Besques-Mollard, *Cat.*, I, B53, B52, with references to previous publications. For similar examples cf. Winter, *Typen*, I, pl. 6, nos. 2, 3; Higgins, *Greek Terracottas*, pl. 9, E, p. 23.

[2] Inv. 14.494. Height 22 cm. Cf. Rhomaios, *Deltion*, 1915, p. 271, fig. 39; Lamb, *Bronzes*, p. 43, pl. XVII, a.

[3] Amandry, *B.C.H.*, LXIX, 1944/45, pp. 38 f., no. 3, pl. I, 1; Hermann, *J.d.I.*, LXXIX, 1964, pp. 47 f., figs. 33-35.

[4] Brueckner and Pernice, *Ath. Mitt.*, XVIII, 1893, pp. 127 ff.; Perrot, *B.C.H.*, XIX, 1895, pp. 273 ff.; Kunze, *Ath. Mitt.*, LV, 1930, pp. 147 ff.; Himmelmann-Wildschütz, *Bemerkungen zur geometrischen Plastik*, 1964, p. 20, figs. 24-27.

[5] De Ridder, *Bronzes de l'Acropole*, p. 293, no. 771, fig. 279; Kunze, *Ath. Mitt.*, LV, 1930, p. 155; Matz, *Gesch. d. griech. Kunst*, p. 81; Ohly, *Goldbleche*, pp. 110, 148, pl. 29; Hermann, *J.d.I.*, LXXIX, 1964, p. 50, figs. 36-38; Himmelmann-Wildschütz, *Bemerkungen zur geometrischen Plastik* (1964), p. 16, figs. 34-36.

and is also nude. Though the period of the Dipylon ivories has been claimed to be the middle of the eighth century, is it possible that they are later, and both ivories and bronze statuette are products of the late eighth[6] or even of the early seventh century? Such a possibility would place these figures in their chronological context. Future discoveries may throw light on this interesting problem.

[6] On recent datings of 'later' geometric pottery cf. J. N. Coldstream in *J.H.S.*, 83 (1963), pp. 212 f., and the references there cited, as well as the forthcoming publication of his diss., Bedford College, London, where he will date the pots found with the ivory statuettes *c.* 735-720 B.C.

GROUP I: THE NIKANDRE—AUXERRE GROUP

(about 660-600 B.C.)

General Survey and External Chronological Evidence

IN spite of the still tentative character of the early chronology of Greek sculpture, a fairly reliable sequence can now be proposed for our korai. Fundamental throughout must of course remain the gradual development toward naturalistic form, which runs throughout archaic Greek sculpture, and for which sufficient allowance of time must be made for one style to develop into the next. Since the successive styles in archaic Greek sculpture presumably run parallel with those observable in vase-paintings and other branches of Greek art, and since, also presumably, Corinthian, Attic, and Eastern representations progress stylistically in the same manner, helpful indications may be obtained from all these sources. And for this relative chronology a few pieces of evidence for absolute chronology can be gleaned. It is evident that this early chronology is still tentative, but it is also evident that it is based on a few reliable data.

Perhaps the most helpful single piece of information we have for dating the beginning of monumental Greek sculpture in stone is the opening up of Egypt to the Greeks. According to Herodotos (II, 154) Psammetichos I, in recognition of the help given him in the conquest of Egypt, gave the Ionians and Carians 'places to dwell in called The Camps, opposite to each other on either side of the Nile', and 'the Ionians and Carians dwelt a long time in these places', and through this intercourse the Greeks 'who were the first men of alien speech to settle in that country, obtained exact knowledge of the history of Egypt from the reign of Psammetichos onward'. Psammetichos reigned from 660 to 609 B.C.; that is, he conquered Egypt *c.* 660 with the help of Ionian soldiers.

It is not difficult to imagine what effect this contact with the old civilization of Egypt had on the early Greek artists. Having heretofore produced works in relatively small dimensions in bronze, terracotta, ivory, and wood, they must have opened their eyes wide when they saw the Egyptian statues in hard stone, life-size and colossal. Fortunately they had gleaming white marble in their own country ready to hand. It is to this very time then that the earliest monumental Greek sculptures in stone may be assigned, that is to the beginning of Psammetichos' reign, when Greeks were given 'places to dwell in' in Egypt, as a reward for services rendered.

Stylistically the statue of Nikandre (no. 1) is one of the earliest life-size stone sculptures that have survived from Greece; and the inscription incised on its side is one of the earliest extant Greek inscriptions on stone. A date, therefore, around 650 B.C. seems indicated. This assignment is corroborated by the more or less independent chronology derived from pottery, which furnishes not only vase-paintings that can be assigned to the middle and third quarter of the seventh century B.C., but also a few precious plastic heads and figures combined with these paintings. Thus, we have the late Protocorinthian pot in the Louvre (plate V, a-d; cf. Payne, *Necrocorinthia*, pl. 1, 8-11), decorated with painted battle scenes on the body and surmounted by a little head in the round. And with this may be associated the terracotta statuettes found in the sanctuary of Apollo at Metapontum, also assignable to the middle and third quarter of the seventh century (cf. Zanotti-Bianco, *J.H.S.*, LIX, 1939, p. 220, fig. 5). From the Athenian Kerameikos has come an early Attic vase with a painted prothesis on the body and mourning women in the round on the shoulder (plate VI, a-c).

23

Useful comparisons with our earliest korai are also supplied by the farouche Artemis on an early Melian vase in Athens, assigned to the middle of the seventh century (plate VI, d; cf. Schefold-Pfuhl, *Tausend Jahre*, fig. 108). In all these representations the form is plank-like or columnar, the garments are shown in stiff, enveloping masses, with no folds marked, the forms of the body beneath them are not even faintly indicated, and the features are strictly stylized.

For the latter part of the seventh century one may use for comparison with the korai first of all, the heads and the procession of women on an Early Corinthian pyxis in Berlin (plate VII, a-e), which has been assigned to the end of the century, and which has furnished an approximate date for the kouroi of the Sounion group (cf. *Kouroi²*, pp. 38 f., and infra); and so, for the renderings of the nude parts, it may also be utilized for what seem to be the later members of our first group of korai. Furthermore, comparisons with vase-paintings which have been assigned to the later seventh century are helpful; for instance, the procession of women, the πομπὴ κορῶν, on the vase from Anagyros (plate VIII, a; cf. S. Karouzou, *Aggeia tou Anagyrontos*, 1963, pp. 11 ff., pls. F23, 24); the so-called Ariadne on the neck of a vase from Arkhades (Afrati) in Crete, and now in the Museum of Heraclion (plate VIII, b; D. Levi, *Annuario*, X-XII, 1927-1929, p. 340, fig. 443, d); a plate from Thera with women in lively conversation (plate VIII, c; Schefold-Pfuhl, fig. 103); and the two women standing behind Apollo (?), engraved on a bronze cuirass (plate VIII, d) found in the river Alpheios at Olympia and now in a private collection (*Olympia*, IV, pp. 153 f., pl. LVIII, no. 980; Matz, *Gesch. d. Gr. Kunst*, p. 461, fig. 34; Dörig, 4. Beiheft zu *Antike Kunst*, 1967, pp. 102 ff.). In these representations, the forms are similar to those above mentioned, but there is a slight loosening of the former stiffness, an occasional fold appears, the features are less strictly stylized, evincing some interest in the delineation of their actual forms, and, above all, the expressions show some animation.

The first group of korai may accordingly be divided into two categories, the first datable *circa* 650 to 625 B.C., the second *c.* 625-600. I have, therefore, in the text—very tentatively—tried to make this distinction.

At the head of the first category may be placed, as we have said, the well-known statue from Delos (no. 1), dedicated by Nikandre, who proudly calls herself ἔξοχος ἄλλων, 'distinguished among other women'. She with her plank-like form clearly stands at the head of Greek monumental sculpture. Related should be a statue from the sanctuary of Apollo Ptoios (no. 2), and, apparently, the (as yet unpublished) marble statue found at Klaros in 1960 (no. 1a). Here belong also the terracotta mourners on a vase from the Athenian Kerameikos (no. 3 and plate VII-b), as well as the supporter of a thymiaterion from the same locality (no. 4). Related are the remarkable figures on the water-basins (perirrhanteria), from various localities (nos. 5 ff.), the two terracotta receptacles from Foce del Sele and Rhodes (nos. 12, 13), the recently discovered ivory plaque from Megara Hyblaia (no. 15), the primitive bronze statuette from Boeotia in Baltimore (no. 14), the famous bronze statuettes from Dreros (nos. 16, 17), and a noteworthy terracotta statuette at Palermo (no. 15a).

To the second category should belong the limestone figure, once at Auxerre, now in the Louvre (no. 18), the relief from Malessina, also in the Louvre (no. 20), and the relief from Mycenae, now in Athens (no. 19), where the features, particularly the eyes and mouth, are rendered in what may be termed a more advanced manner. We may also place here the fragmentary statue from Samos (no. 21), in which the rendering of the hair resembles that of Kleobis and Biton (*Kouroi²*, figs. 78 ff.).

With these stone sculptures one may associate the terracotta plaque no. 22 and the interesting

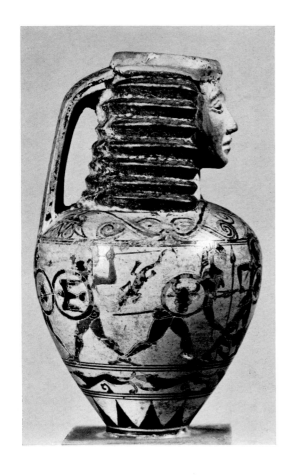

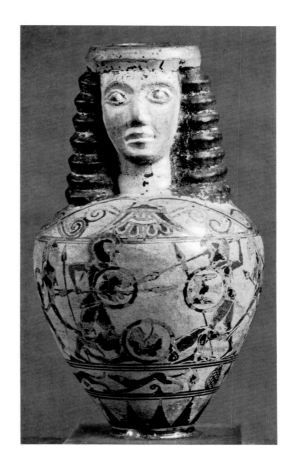

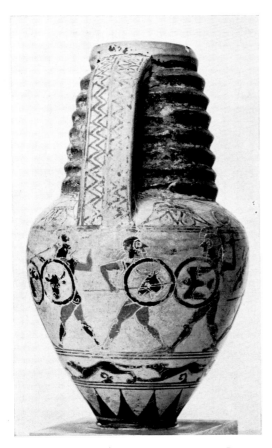

V. Late Protocorinthian pot, c. 640–630 B.C. Louvre

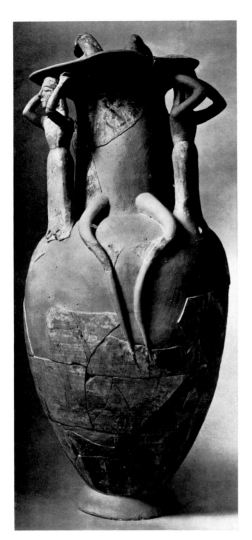 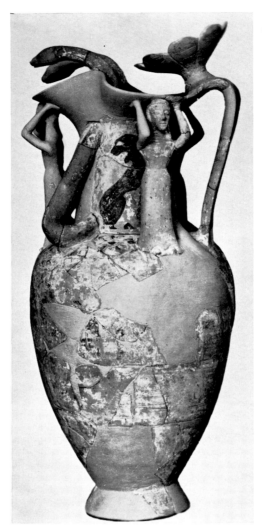 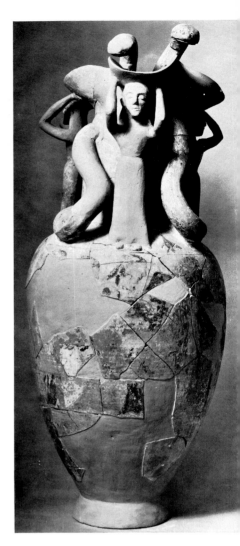

VI–a, b, c. Oinochoe from the Dipylon, c. 650–625 B.C. Athens, Kerameikos Museum

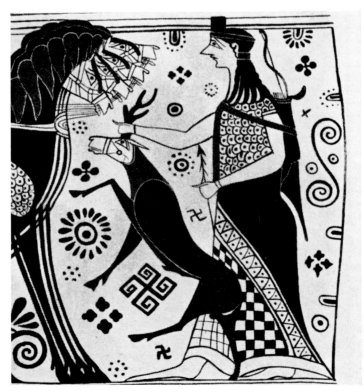

VI–d. Artemis, on an amphora from Melos, c. 650 B.C.
Athens, National Museum

VII–a. Early Corinthian pyxis, c. 615–600 B.C. Berlin, Staatliche Museen

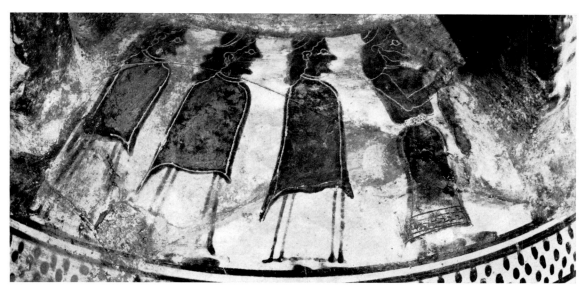

VII–b. Procession of women, from the pyxis reproduced above

VII–c, d, e. Heads from the pyxis reproduced above

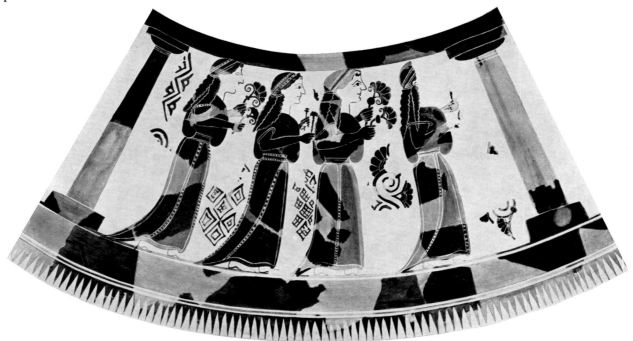

VIII–a. Procession of women, on a vase from Anagyros. Late seventh century B.C. Athens, National Museum

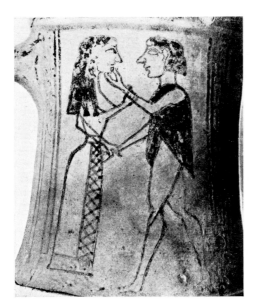

VIII–b. Group on a vase from Afrati (Arkhades).
Late seventh century B.C. Heraclion

VIII–c. Group on a plate from Thera, c. 620 B.C.
Thera, Museum

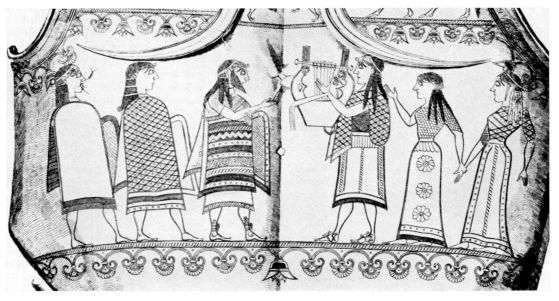

VIII–d. Apollo, (?) two women, and three men, on a cuirass from Olympia, 650–600 B.C. Private Collection

series of terracotta statuettes of mourners, with their sometimes surprisingly expressive faces—combined, however, with columnar bodies (cf. nos. 23-27). And also here one may place a number of statuettes and reliefs in bronze, ivory, wood, and gold, which likewise combine relatively stiff bodies with animated gestures (cf. nos. 28-35). All the figures in this group, both in sculpture and vase-painting, wear heavy tunics, occasionally with an epiblema added. The tunics are sometimes long and trailing. Presumably they are peploi, and it is noteworthy that sometimes they have sleeves (cf. p. 7).

Chronology of Corinthian Vases

It should be noted that recently there has been a tendency to lower the dating of Early Corinthian vases a little.[1] As this affects the dating of my early korai, I shall set forth the chronological evidence as I see it, but have listed similar—as well as contrary—opinions in footnote 1.

The chief new fact that has emerged since Payne's *Necrocorinthia* of 1931 is that in the rearrangement of the material from the sanctuary of Demeter Malophoros at Selinus, Protocorinthian and Transitional vases have been found, and that consequently the foundation date of that city must be pushed back to *c.* 650 B.C. That is, the date given by Diodoros (XIII, 59, 4) and others should be preferred to that of 628 given by Thucydides and adopted by Payne; cf. Vallet and Villard, *B.C.H.*, LXXVI, 1952, pp. 318-321; *B.C.H.*, LXXXII, 1958, pp. 16 ff.

This does not, however, necessarily affect the assignment of Early Corinthian pottery to the last quarter of the seventh century; for this has been confirmed by the excavations at Massalia (Marseilles), which is said to have been founded *c.* 600 B.C. (cf. Wackernagel, *R.E.*, XIV, 2, 1930, s.v. Massalia, cols. 2130 f.), and where hardly any Early Corinthian vases were found, only Middle and Late Corinthian; as well as by the excavation of Kamarina, founded in 598 B.C., where so far only Middle Corinthian ware has come to light (cf. Villard, *Mélanges d'archéologie et d'histoire de l'École française de Rome*, LX, 1948, pp. 29 ff.; Vallet and Villard, *B.C.H.*, LXXXII, 1958, p. 24).

Furthermore, as Messrs. Vallet and Villard have pointed out, one must allow sufficient time for Late Protocorinthian (whether we date it *c.* 650 B.C., or somewhat earlier) to develop first into the

[1] Langlotz, *Gnomon*, 1934, pp. 421 f. (Inclined to date Early Corinthian after 600 B.C., in the time of Periander.)

Homann-Wedeking, *Archaische Vasenornamentik* (1938), p. 40, note 1. (Follows Langlotz in dating Early Corinthian after 600 B.C.).

Hopper, *B.S.A.*, XLIV, 1949, p. 180. (Proposes 620 or 615 to 590 B.C. for Early Corinthian.)

Dunbabin, *B.S.A.*, XLV, 1950, p. 195, note 6: 'I see no reason to depart from Payne's dating of Corinthian vases' (i.e. *c.* 625-600 B.C. for Early Corinthian).

J. L. Benson, *Geschichte der korinthischen Vases* (1953), p. 72. (Places the beginning of Early Corinthian *c.* 615 B.C.: 'Dies ist das späteste Datum welches auf Grund der bisherigen Ergebnisse der Gräberfunde möglich ist'.)

Viermeisel and Wagner, *Ath. Mitt.*, LXXXIV, 1959, pp. 64 f. (Would start Early Corinthian *c.* 600 B.C. from the evidence derived from Samian excavations.)

Kübler, *Kerameikos*, VI, I (1959), pp. 109 ff. (Based on excavation data, the dates proposed are: For Late Protocorinthian 665/60-640/615; for Transitional 640/35-620/15; for Early Corinthian 620/615-595/590; beginning of Middle Corinthian 595/590.)

L. Banti, Corinzi Vasi, in *Enciclopedia dell'Arte Antica*, vol. II (1959), p. 848, dates Early Corinthian *c.* 620/615-595/590 B.C., and in vol. VI (1965), in her article on Protocorinzi Vasi, p. 507, gives still other references for the dating of the *end* of the Transitional style.

R. M. Cook, *Greek Painted Pottery* (1960), p. 50, dates the Transitional style *c.* 640-625 B.C., i.e., the beginning of Early Corinthian 625 B.C.

E. B. Harrison, Archaic and Archaistic Sculpture, *The Athenian Agora*, XI, 1965, pp. 3 ff., and 12. (Assigns the Sounion group of kouroi—the dating of which is based on that of Early Corinthian pottery—to 600-580 B.C.)

R. Arena, 'Le Iscrizioni Corinzie su Vasi', *Memorie della Accademia Nazionale dei Lincei*, CCCLXIV, 1967, pp. 57 ff. (on p. 70 dates Early Corinthian 615-600 B.C.).

Mr. Amyx, who is at work on a book on Corinthian Vase-Painting, told me (in Paris in 1966) that so far he is keeping approximately the same dates as those proposed by Payne in *Necrocorinthia*, viz., for Early Corinthian *c.* 625-595; for Middle Corinthian 595/590-570; for Late Corinthian 570-550.

Transitional style, and then into Early Corinthian; and 20-25-30 years is none too long for such changes (cf. *B.C.H.*, 1958, p. 26).

It seems to me, therefore, that the dating of the Sounion group of kouroi, and the later members of the korai of our first group may safely be assigned to *c.* 615-590 B.C., or, if one prefers, to 610-590. In any case, the difference between the dates proposed in *Kouroi* (1960) and those recently advanced by some authorities is small; and is it not hazardous to narrow down an artist's active career to a few years? Would it not seem better to allow a certain leeway for the development of his style and that of his contemporaries?

In this connection I may quote the wise words of Dunbabin (loc. cit.): 'It might be possible to bring down the beginning of Early Corinthian by a few years, to *c.* 620-615. . . . But this is a vicious precision, suggesting greater accuracy than the evidence shows.'

Korai 1-35

1 : Figs. 25-28

ATHENS, NATIONAL MUSEUM, I.

Marble statue dedicated by Nikandre. Height of figure 1.75 m.; with base 2 m.
Island marble. Surface weathered. Worked in one piece with the plinth and a large tenon.
Found in 1878 at Delos, in the sanctuary of Artemis.
A piece of the right arm has been added subsequently; cf. Marcadé, loc. cit.

The form is plank-like. Both arms are lowered and adhere closely to the body for most of the way. The hands are clenched, with the thumbs placed in front. In both hands are holes for the holding of objects.
She wears a tight-fitting peplos, girded at the waist. The shod feet protrude at the bottom of the garment beneath an arch-like opening. Her long hair falls down the back in a solid mass, and is brought to the front on each side of the head in four tresses, with pointed ends. On the left side of the statue is an inscription, incised vertically, boustophedon:

Νικάνδρη μ' ἀνέθεκεν h⟨ε⟩κηβόλοι ἰοχεαίρηι Κόκη Δεινο-
δίκηο τὸ Ναhσίο ἔhσοχος ἀλήον Δεινομένεος δὲ κασιγνέτη
Φhράhσο δ' ἄλοχος ν[ῦν].

'Nikandre dedicated me to the goddess, far-shooter of arrows, Nikandre, the daughter of Deinodikos of Naxos, distinguished among women, sister of Deinomenes and wife of Phraxos.'

About 650 B.C.

I.G., XII, 5, 2, p. XXIV.
Homolle, *B.C.H.*, III, 1879, pp. 3 ff., pl. I., *De antiquissimis Dianae Simulacris*, 1885, pp. 15 ff., pl. I.
Kastriotes, *Glypta*, no. 1.
S. Karouzou, *Guide*, p. 19, no. 1.
Lippold, *Griech. Plastik*, p. 43, pl. 11, no. 2.
Marcadé, *B.C.H.*, LXXIV, 1950, p. 182, pl. XXX.
Jeffery, *Local Scripts*, pp. 47, 291, 303, no. 2, 311, pl. 55, no. 2.
Guarducci, *Epigrafia greca*, I, pp. 153 ff., figs. 38, a-c.

1a: SMYRNA, MUSEUM

I have been told that a similar statue, also dedicated to Artemis, was found at Klaros, Asia Minor, in 1960, and is now in the Museum of Ismir (Smyrna). The publication rights are reserved for P. Devambez, but I repeat here the descriptions given by the excavator L. Robert in *Türk Tarih Arkeoloji Dergisi*, 10, part 1 (1960), p. 59, and (translated into English) by M. J. Mellink in *A.J.A.*, LXV, 1961, p. 49.
'North of the great altar . . . stood a second smaller altar. . . . Against its north side we found a headless very archaic kore, of natural size. The lower part of the body is cylindrical. One hand hangs down alongside the body, the other rests on the breast; a belt tightly encircles the narrow waist. The statue has strong affinities to the kore of Auxerre in the Louvre. The statue, altar and small temple are all identified by an inscription on the left side of the statue: "Timonax, son of Theodoros, dedicated me to Artemis, having been the first priest" (τὸ πρῶτον ἱρεύσας).'
Judging from a small photograph which I was able to see, the 'affinities' seem to me to be with Nikandre's statue rather than with the Auxerre kore.

2 : Figs. 29-30

ATHENS, NATIONAL MUSEUM, 2.

Limestone statue. Height with base 1.45 m.
Recently reconstructed from two separate pieces. Much of the lower part is restored. Remains of red colour.
Found in the sanctuary of Apollo Ptoios, Boeotia.

Four-sided body. She wears a belted peplos and shoes. The feet protrude at the bottom of the garment beneath an arch-like opening. Her long hair is arranged in Daedalic fashion with horizontally divided masses descending on each side of the head.

Above the feet, on the drapery, is the inscription, written boustrophedon:

[--]ρον ἀνέθεκε τôι Ἀπόλονι τôι Πτοιεῖ. [--]οτος ἐποίϜεσε.

'--ron dedicated it to Apollo Ptoios, --otos made it.'

The beginnings of both names are missing.

Second half of the seventh century B.C.

Holleaux, *B.C.H.*, x, 1886, pp. 77 ff., pl. VII, left.
Kastriotes, *Glypta*, no. 2.
S. Karouzou, *Guide*, no. 2. p. 20.
Jeffery, *Local Scripts*, p. 92.

3 : Figs. 31–32

ATHENS, KERAMEIKOS MUSEUM, 143.

Three terracotta statuettes standing on the shoulder of an oinochoe. Total height of vase 51 cm.; hts. of statuettes *c.* 15.5 cm.

Found in a sacrificial area 'erste Opferrinne' of the Dipylon, Athens.

On the body of the vase is painted a prothesis and on the neck are lions in Orientalizing, early Attic style. The statuettes on the shoulder are conceived as mourning women, with arms raised in lamentation. Each wears a peplos, closely adhering to the body, with two arch-like openings at the bottom, from which the two feet protrude.

The hair falls down the back in a solid mass. The features are primitive.

Probably around the middle of the seventh century B.C. The prothesis has been called the earliest post-geometric representation of the subject.

Kübler, *Arch. Anz.*, 1933, cols. 268 f., fig. 8.
Karo, *An Attic Cemetery*, p. 14, pl. 15.
Matz, *Geschichte d. griech. Kunst*, I, pp. 319, 330, pls. 218–220.

4 : Figs. 33–34, 36

ATHENS, KERAMEIKOS MUSEUM, 145.

Terracotta statuette of a mourning woman, acting as the support of a thymiaterion. Height of upper part 14.1 cm.; total height, as reconstructed, 43 cm.; ht. of statuette 35 cm.

Only the head with neck, part of the thymiaterion, and the columnar bottom, with feet protruding, remain.

The rest has been restored with the help of a second, similar figure (without head).

Found in the Kerameikos.

She evidently wore the usual foldless and belted peplos. The hair descends in a solid mass to the level of the shoulders. The primitive features resemble those of no. 3. On the face are traces of red colour to indicate the bloodstained cheeks.

Probably middle of the seventh century B.C.

Kübler, *Arch. Anz.*, 1933, col. 268, fig. 7 (before the reconstruction with the lower part).

PERIRRHANTERIA or APORRHANTERIA
= basins containing water, used for cult purposes.

The word is derived from ῥαίνω, sprinkle, and ἐπιρραίνω or ἀπορραίνω, sprinkle upon. The word ἀπορραντήρια occurs in Euripides' *Ion*, ll. 434 f. in a context which makes its function of pouring or sprinkling water clear:

ἀλλὰ χρυσέαις | πρόχοισιν ἐλθὼν εἰς ἀπορραντήρια | δρόσον καθήσω,

'But I will go to the aporrhanteria with the golden ewers to pour the water.' Cf. also *C.I.G.*, nos. 137, 140, 141, where aporrhanteria appear in lists of votive objects.

These basins were apparently also placed in temples in order to wash one's hands before entering. So, for instance, Lucian, *On Sacrifices*, 13:

καὶ τὸ μὲν πρόγραμμά φησι μὴ παριέναι εἰς τὸ εἴσω τῶν περιρραντηρίων ὅστις μὴ καθαρός ἐστιν τὰς χεῖρας,

'and the notice says that nobody is to be allowed within the sanctuary (= beyond the perirrhanteria) who has not clean hands';

and in Plutarch, *Sulla*, XXXII, is the following passage:

. . . τὴν μὲν κεφαλὴν ἐν ἀγορᾷ καθεζομένῳ τῷ Σύλλᾳ προσήνεγκε, τῷ δὲ περιρραντηρίῳ τοῦ Ἀπόλλωνος ἐγγὺς ὄντι προσελθὼν ἀπενίψατο τὰς χεῖρας,

'Then Catiline . . . killed a certain Marcus Marius . . . and brought his head to Sulla as he was sitting in the forum, and then going to the perirrhanterion of Apollo, which was near, washed the blood off his hands' (tr. B. Perrin).

Cf. also the articles in Daremberg and Saglio, *Dict.*, on lustratio and on turibulum.

The following basins, or parts of basins, have convincingly been interpreted as such lustral bowls or perirrhanteria, aporrhanteria. They have been found in sanctuaries all over the Mediterranean, both East and West—in Rhodes, Samos, Isthmia, Olympia, Boeotia, Athens, and Delphi.

Why figures of women were regularly chosen to form supports of such basins is not clear, unless we interpret them as priestesses?

5 : Figs. 35, 37

CORINTH, ARCHAEOLOGICAL MUSEUM.

Marble perirrhanterion. The missing parts have been restored in plaster.
Found at Isthmia in 1957.
Total restored height, including poros base, 1.26 m.; height of each kore, from the top of the head to the bottom of the drapery, *c.* 50 cm.; diam. of basin 1.17 m. (inside), 1.235 m. (outside).

It consists of a large basin resting on a ring from which rams' heads project and to which the heads of four korai are attached; each kore stood on a lion, holding in one hand its tail, in the other a leash; the lions, in their turn rested on a plinth. Cf. the reconstruction by O. Broneer, *infra.*
Only one of the korai is well preserved. She has a columnar body and wears a long, belted peplos. The two arms adhere to the sides most of the way. Her hair descends as a solid mass down her back, and as two curving solid masses on each side. On the head is a cushion-like support.

About 650-625 B.C.

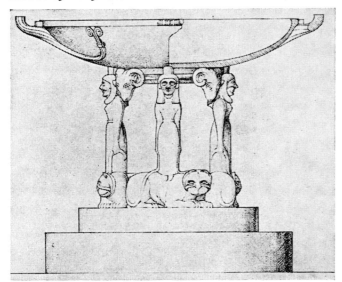

Reconstruction of the perirrhanterion No. 5.
From Broneer, *Hesperia*, XXVII.

For further pieces of perirrhanteria—mostly of terracotta—recently found at Isthmia cf. Broneer, *Archaeology*, XIII, 1960, p. 105. One has a chariot race engraved on the rim.

Broneer, *Hesperia*, XXVII, 1958, pp. 24 ff., pls. X, a, b, XI, a; *Archaeology*, XIII, 1960, pp. 105, 107.
Ducat, *B.C.H.*, LXXXVIII, 1964, pp. 585 ff., no. 2, figs. 8-10.

6 : Figs. 38-40, 44

BERLIN, STAATLICHE MUSEEN, inv. 1747.

Marble perirrhanterion. Height 52 cm., ht. of plinth 7 cm.
Greyish-white marble.
Found in the Heraion of Samos.
Remains of red colour at back and in hair of korai.

The ensemble consists of a quadrangular base with two recumbent lions and three standing female figures. The korai have columnar bodies. Each wears a belted peplos and holds in one hand the tail of a lion, with the other the end of the leash which is wound round the lion's neck. The hair is rendered as a solid mass at the back and as curving, solid masses on either side of the head. About 650-625 B.C.

Buschor, *Altsamische Standbilder*, V, pp. 74 f., figs. 317 f., 321 ff.
Blümel, *Arch. griech. Skulpturen*, no. 33, figs. 90-93.
Ducat, *B.C.H.*, LXXXVIII, 1964, pp. 582 ff., no. 1, figs. 6-7.

7 : Figs. 41-43

RHODES, ARCHAEOLOGICAL MUSEUM.

Marble perirrhanterion. 'Total height, when complete, must have been less than 1 m.' (Jacopi).
Greyish-blue marble.
The basin is missing. Some parts have been restored in plaster.
Found in 1933 on the akropolis of Kameiros.

It consists of a central supporting column, surrounded by three female figures, each standing on a recumbent lion, the whole mounted on a hexagonal base. Each kore has a columnar body and wears a belted peplos and shoes. Both arms descend along the sides, with one hand holding the end of the lion's tail, the other the end of the leash which is tied round each lion's neck. The hair falls down the back in a solid mass, and in a thick, spirally twisted tress on either side of the head; above the forehead it is rendered by spiral curls. The eyes are large and staring; the lips are straight; the ears volute-shaped, with neither tragus nor antitragus indicated.
Third quarter of the seventh century B.C.

Jacopi, *Illustrated London News*, May 20th, 1933; *Boll. d'Arte*, XXX, 1936-37, pp. 443 ff., figs. 9-13.
Matz, *Gesch. der griech. Kunst*, pl. 246, b, pp. 196, 382.
Ducat, *B.C.H.*, LXXXVIII, 1964, pp. 589 f., no. 3, fig. 11.

8 : Figs. 45-48

OLYMPIA, ARCHAEOLOGICAL MUSEUM.

Marble statuette which once served for the support of
a perirrhanterion. Height 48 cm.
Much weathered. The missing bottom is restored.
Found at Olympia.

Belonging to the same ensemble are fragments of two
other female figures and the forepart of a lion on a
rounded plinth (cf. Ducat, op. cit., fig. 16). The body
of the well-preserved figure is columnar. She wears a
sleeved, tight-fitting garment and a sort of polos on
her head. Both arms are lowered and adhere closely to
the body. In one hand she holds the end of a lion's tail,
in the other the end of the leash; the clenched hands
are angular, with the long thumb brought forward (as
in the early kouroi).
Her hair descends at the back as a solid mass, and at the
sides in two thick tresses; above the forehead is a row of
vertical curls ending in spirals.
The lips are straight, and not differentiated. The irises
were inserted separately and are missing. The ears are
volute-shaped, again as in the earliest kouroi (cf., e.g.,
Kouroi², fig. 37).
Second half of the seventh century B.C.

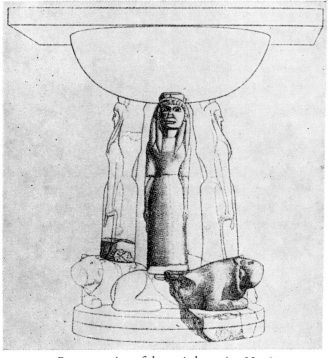

Reconstruction of the perirrhanterion No. 8.
From Treu, *Olympia*, III.

For further pieces of such perirrhanteria recently found
at Olympia cf. Kunze, *Arch. Deltion*, 1961-62, p. 123.

Treu, *Olympia*, III, pp. 26 ff., fig. 24 (reconstruction), pl. v, 4, 5.
Jenkins, *Dedalica*, p. 73, no. 5.
Lippold, *Griech. Plastik*, p. 31, pl. IX, 2.
H. Kenner, 'Luterion im Kult', *Oest. Jahr.*, XXIX, 1935, pp. 140 f.
Matz, *Gesch. d. griech. Kunst*, I, pls. 120, 246, a, pp. 196, 382.
Ducat, *B.C.H.*, LXXXVIII, 1964, pp. 591 ff., no. 5, figs. 15, 16.

9 : Figs. 49-52

ATHENS, NATIONAL MUSEUM, 4.

Marble statuette, perhaps from a perirrhanterion (see
below). Height as preserved 42 cm.
Bottom missing and restored in plaster.
Found in the Ptoan sanctuary in Boeotia.

The body is columnar. Both arms descend along the
sides, adhering closely to the body, with palms held
open. She wears a tight-fitting, belted peplos. Her hair
is arranged at the back in a solid mass, flanked on each
side by a globular tress, and with two thick tresses de-
scending in front, on either side of the neck. The fingers
of the hands are vertical and parallel to one another.
Third quarter of the seventh century B.C.
It has been suggested that this figure was also part of a
perirrhanterion, and that to it belonged a head in the
Museum of Thebes, also from the Ptoan sanctuary, and
with a hole at the top of its head (cf. Ch. Karouzos,
To Mouseio tes Thebas Odegos, p. 13, no. 16; Grace,
Archaic Sculpture in Boeotia, p. 51, fig. 66; height 10 cm.).
To the same ensemble may also belong the fragment of
another female figure, from waist to above the knees,
placed in the same room, no. 3443 (Ducat, op. cit., p.
581, fig. 4), as well as perhaps a fragment of a lion which
Jean Ducat found reproduced on an old photograph by
M. Holleaux.

Holleaux, *B.C.H.*, IX, 1885, pp. 520 f.
S. Karouzou, *Guide*, p. 21, no. 4.
Kastriotes, *Glypta*, no. 4.
Matz, *Geschichte d. gr. Kunst*, I, p. 196, pl. 119, b.
Ducat, *B.C.H.*, LXXXVIII, 1964, pp. 577-582, 594, no. 6, figs. 1-5
(argues for the several pieces belonging together).

10 : Figs. 53-55

OXFORD, ASHMOLEAN MUSEUM. Gift of A.
Lefroy of All Souls College in 1771.

Limestone perirrhanterion. Height 66 cm.; ht. of (best
preserved) female figure, from the top of the polos to
the feet, 47.9 cm.
Said to have been found in Corinth.
The surface is much weathered.

Three korai are represented standing on three lions,
around a central support, the whole mounted on a
circular plinth. Each kore has a more or less columnar

body and wears a belted peplos, on which vertical folds are indicated. Both arms are lowered, with one hand holding the end of a lion's tail, the other the end of the leash.

On each head is a taenia. The hair is rendered as a solid mass at the back, with three globular tresses descending in front on each side. Above the forehead it is rendered by wavy bands, arranged horizontally to the right and left from a central parting.

Though the type of this ensemble is the same as in the preceding examples, there is a mixture of early archaic and later renderings, e.g., in the faces, the indication of folds in the drapery, and in the heads of the lions. This has been explained as due to later reworking, either in ancient or comparatively modern times. It is noteworthy that the parts which are evidently in the original condition, e.g. the backs and hands, are early archaic in style, presumably of the second half of the seventh century B.C.

P. Gardner, *J.H.S.*, XVI, 1896, pp. 275 ff., pl. XII.
Ashmolean Museum, Summary Guide, 1931, p. 19, no. 237.
Matz, *Gesch. d. griech. Kunst*, I, p. 526, note 444.
Ducat, *B.C.H.*, LXXXVIII, 1964, pp. 590 f., no. 4, figs. 13, 14.

11 : Fig. 56

DELPHI, Museum.

Marble fragments of a perirrhanterion. Mostly restored. Total height, as reconstructed, about 1 m.
Found at Delphi.

All that remains is the capital-like crowning of the central support and fragments of the three female figures which were evidently attached to its under side. Of one figure are preserved the top of the head with a cushion-like support and a row of spiral curls, as well as a piece of the body beneath the waist. This is columnar in shape and shows that the left arm was lowered and adhered closely to the body, with the hand laid flat against the side. No lions have been preserved.

To judge by what remains, and discounting the restorations, this example should also belong to the second half of the seventh century B.C.

Homolle, *B.C.H.*, XXXII, 1908, p. 232, fig. 17.
De La Coste-Messelière and Picard, *Fouilles de Delphes*, IV, 2, pp. 191 f., figs. 76, 77.
Matz, *Gesch. d. gr. Kunst*, I, pl. 247, a, p. 382.
Ducat, *B.C.H.*, LXXXVIII, 1964, pp. 595 f. (not ill.).

12 : Figs. 57-59

PAESTUM, Museum.

Terracotta receptacle, supported by four standing women. Height 17 cm.

Found in the Heraion of Foce del Sele in 1958, buried under the foundations of the archaic temple (Thesauros I), in a 'stipe'.
Put together from many pieces.

In form it resembles a perirrhanterion, that is, it consists of a basin with a broad rim, supported by a central column and four figures of standing women; but there are no lions and the size is much smaller.

The women wear foldless, girded peploi, and place both hands below their breasts. The hair falls down the back in a mass divided horizontally, with similar, but triangular, masses brought to the front on each side. Above the forehead the hair is rendered by vertical ridges.

The rim is decorated with rows of herringbone and tongue patterns, and with female heads in high relief, similar to those of the standing figures.

Second half of the seventh century B.C., perhaps around 620 B.C.

Various suggestions have been made concerning the purpose for which this object (and the similar one in the Louvre, my no. 13) served. The form of the upper part is not unlike that of a 'kothon', which was interpreted as an incense burner by E. Pernice (*J.d.I.*, XIV, 1899, pp. 60 ff.), and as a lamp by Burrows and Ure (*J.H.S.*, XXXI, 1911, pp. 72 ff.). Pottier, in his *Vases antiques du Louvre*, I, p. 17, A396 (1), pl. 13, called the example in the Louvre a *brûle-parfums*. P. Zancani Montuoro (loc. cit.), following Burrows and Ure, thought that the receptacle from Foce del Sele might be a temple lamp, with a floating wick—since there are no nozzles. Recently I. Scheibler (*J.d.I.*, LXXIX, 1964, pp. 72 ff.), advanced the theory that the object was an ointment-jar, an exaleiptron (from ἀλείφω, to anoint).

The shape, with its incurving rim and its rather deep basin, would be appropriate for holding liquids—either water for sprinkling for cult purposes, like the perirrhanteria, or oil for burning—for which theory Mrs. Zancani has made out a good case, now enforced by the fact that receptacles of this general shape—but without the female figures—have turned up in tombs, since this suggests an object also in daily use; cf. Zancani, op. cit., vol. VI-VII, 1965-1966, p. 85, pl. XVIII, d. So it seems possible that the perirrhanterion shape was sometimes used for lamps.

For an ointment-holder the incurving rim would hardly be appropriate?

Zancani Montuoro, 'Lampada arcaica dello Heraion alla Foce del Sele', *Atti e memorie, Magna Grecia*, N.S., vol. III, 1960, pp. 69 ff., pls. XVI, XVII, a, vol. VI-VII, 1965-1966, pp. 84 f., pl. XIX.
Zanotti-Bianco and von Matt, *Grossgriechenland*, fig. 27.
Scheibler, *J. d. I.*, LXXIX, 1964, p. 76.

13 : Figs. 63-65

PARIS, Louvre, 3906 (AM 104). Acquired in 1888.

Terracotta receptacle, supported by four standing women. Height 18 cm. Depth of basin 4.5 cm.
Said to have been found in Rhodes.
Similar to the preceding.
Two of the heads are missing. A few (undecorated) parts have been restored.
Second half of the seventh century B.C., perhaps around 620 B.C.?

Pottier, *Vases antiques*, I, p. 17, A396 (1), pl. 13.
Studniczka, in *Antike Plastik Amelung dargebracht*, pp. 252 f., figs. 7, 8.
Barnett, *Irak*, II, 1935, pl. XXVII, 3.
Zancani Montuoro, *Atti e memorie, Magna Grecia*, III, 1960, pp. 69 ff., pl. XVII, b.

14 : Figs. 60-62

BALTIMORE, Walters Art Gallery, 54.773.

Bronze statuette. Height 21 cm.
From the Tyskiewicz Collection. Said to have been found in Boeotia.

The body is columnar. Both arms are bent at the elbow, with forearms extended; the right hand is held open, the left is clenched, with a central hole, so both evidently held objects. She wears a foldless, tight-fitting, sleeved peplos, belted at the waist, descending to the ground, with an arch-like opening at the bottom, from which the shod feet protrude. The hair is worked in a single, solid mass, divided into horizontal layers, on each of which are vertical ridges. The eyes are round and prominent; the mouth small, with two prominent horizontal ridges; the face is angular.
Third quarter of the seventh century.
It has been suggested that this figure formed part of a perirrhanterion, that is, that it supported a basin together with other similar figure. But there evidently were no lions, and the extended hands holding objects would be exceptional in such an ensemble. The style, on the other hand, conforms with that of the seventh-century perirrhanteria.

Sale Catalogue of the Tyskiewicz Collection, Paris, 1898, no. 134, pl. XIII.
Lamb, *Bronzes*, p. 76, pl. 22, b.
H. Goldman, in *Festschrift für James Loeb*, 1930, pp. 70 ff.
F. Grace, *Sculptures from Boeotia*, p. 49, fig. 64.
D. K. Hill, *Journal of the Walters Art Gallery*, II, 1939, pp. 25 ff., figs. 1-3.
Kaulen, *Daidalika*, p. 187, note 85, figs. 4, 5.

15 : Figs. 66-67

MEGARA HYBLAIA, Antiquario.

Ivory plaque, with the figure of a woman in relief. Probably part of a fibula. Height 9.3 cm.
Found at Megara Hyblaia, Sicily.

The form is plank-like. She wears a tight-fitting, foldless peplos, girded at the waist, an epiblema which falls down her back, and a polos on her head. Both arms descend along the sides, adhering closely to the body. Four globular tresses are brought to the front on either side of the face; above the forehead is a row of globular curls. The face is pointed, the eyes large, with prominent eyeballs, the lids rendered by ridges more or less in one plane, surmounted by arching eyebrows. The mouth is small, with slightly curving lips.
The peplos, belt, and polos are decorated with incised patterns.
About 650 B.C., contemporary with the statue of Nikandre.
One may compare the ivory or bone figures in relief, found at Perachora (Dunbabin and others, *Perachora*, II, p. 406, no. A6, pl. 172) and at Sparta (Dawkins, *Artemis Orthia*, pl. 30, 7, and pl. 31, 3), as well as the terracotta plaque from Crete in the Louvre (Besques-Mollard, *Cat.*, I, B167, pl. XXI).

Vallet and Villard, *Mélanges d'archéologie et d'histoire*, LXXVI, 1964, pp. 35 f., no. 6 (illustrated on p. 32).

15a : Figs. 68-69

PALERMO, in the Fondazione 'I. Mormino' del Banco di Sicilia.

Terracotta statuette. Height 16.7 cm.
The exact provenance is not known, but the statuette is thought to have been found in the region of Gela, and to have been associated with aryballoi of the Early Corinthian period (Tusa).
The front is moulded; the back is flat.

She wears a tight-fitting, foldless, belted peplos, decorated with ornamented little squares, a polos, once decorated with similar squares (now abraded), and an epiblema, which descends down her back and is decorated with zigzags along the sides. Both arms are lowered, adhering closely to the sides, with hands held open.
The hair descends on either side in three globular tresses, and above the forehead is rendered in a row of curls.
The eyes are large, with prominent eyeballs and arching eyebrows; the lids are indicated by ridges placed more or less in one plane.

Around the middle of the seventh century B.C.

V. Tusa, *Una statuetta di terracotta di tipo dedalico*, Fondazione 'I. Mormino' del Banco di Sicilia, 1964.

16, 17 : Figs. 70-75

HERACLION, ARCHAEOLOGICAL MUSEUM.

Two bronze statuettes. Height *c.* 40 cm.
Sphyrelaton technique. Somewhat restored; for a view of them before restoration, cf. Marinatos, op. cit., fig. 2. Found at Dreros, Crete, in 1935, 'on the bench of a small archaic temple'.

The body is columnar. Both arms adhere to the sides. Each wears a belted peplos and over it a mantle (epiblema) draped over the back and both shoulders. On the head is a polos. The hair is rendered by straight, vertical ridges, descending at the back and sides to about the top of the neck. A similar straight fringe appears above the forehead. The eyeballs were inserted separately and are missing. The lips are more or less straight.
Down the front of the garment, and along its bottom are guilloche and dotted patterns.
Third quarter of the seventh century B.C.

Marinatos, *Arch. Anz.*, 1936, cols. 217 ff., figs. 2, 3.
Lippold, *Griech. Plastik*, p. 22, pl. 3, nos. 1, 3.
Platon, *Guide to the Museum of Heraclion*, 1955, p. 142.

18 : Figs. 76-79

PARIS, LOUVRE, 3098. Deposited by the Museum of Auxerre, to which it came as a gift from Louis David.

Small limestone statue, mounted on a quadrangular base. Height, with base, 75 cm.; without base, 65 cm. Of unknown provenance.

Columnar body, The right hand is placed between the breasts, the left arm descends along the side, separated from the body at the waist; the forearm is supinated, whereas the hand is laid flat against the side. She wears a peplos with a broad belt, and an epiblema covering the shoulders. Down the front of the garment, and along its bottom are incised patterns of maeander.
The hair is arranged in Daedalic fashion; at the back descend six tresses, divided horizontally and terminating in knobs; four similar tresses are placed on either side of the face. The portion between back and side hair is also divided horizontally. Above the forehead is a row of spiral curls.
The feet protrude at the bottom of the peplos, within an arch-like opening; they are flat, and the toes are

parallel to one another, their ends forming a continuous curve. The fingers are also parallel to one another, with the small one almost as long as the others and the thumb much smaller.
The remaining eye is carefully carved, with the upper lid protruding over the lower. The lips are broad and do not meet at the corners.
It is evident that the rendering, especially of the features, is more advanced than in nos. 1-10, 13-17. So, if we place the latter in the third quarter of the seventh century, this statue should belong to the last quarter; that is, contemporary with the heads on Early Corinthian pyxides (cf. pp. 25 f.).

Collignon, *Mon. Piot*, XX, 1913, pp. 5 ff., pls. 1, 2.
Catalogue sommaire (1922), p. 40, no. 3098, pl. XXIII.
Lippold, *Griech. Plastik*, p. 22, pl. 2, no. 3.
Charbonneaux, *Guide du visiteur*, 1963, pp. 1 f. (ill.).

19 : Fig. 84

ATHENS, NATIONAL MUSEUM, 2869.

Upper part of a limestone relief, with a broad architectural border at the top. Height, as preserved, 40 cm. Found at Mycenae with other fragments in 1886 and 1897.

She is represented frontal, wearing a peplos, and over it an epiblema, descending from the top of her head to her chest and of which she holds one end in her right hand. The hair is arranged in Daedalic fashion, with horizontal divisions on each side of the face and rosette-like curls above the low forehead. The eyes are elongated, with the lids rendered as ridges, but slightly differentiated from each other. The lips are full and have vertical cuts at the corners.
Last quarter of the seventh century B.C., perhaps *c.* 630-620.
One may compare the antefix from Kalydon, in Athens, dated in the period of early Corinthian pottery; cf. Payne, *Necrocorinthia*, pp. 234 ff., pl. 47, no. 11.
This relief and the others found with it were thought to be parts of metopes of the temple of Athena on the summit of the akropolis of Mycenae; but more recently they have been interpreted as decorations of an altar belonging to a nearby sanctuary; cf. Wace, *J.H.S.*, LIX, 1939, p. 40.

Tsountas, *Praktika*, 1886, pp. 59 f.
Kouroniotes, *J.d.I.*, XVI, 1901, p. 18.
S. Karouzou, *Guide*, p. 23, no. 2869,
Jenkins, *Dedalica*, pp. 45, 50, pl. VI, 7.
Rodenwaldt, in *Corolla L. Curtius*, pp. 63 ff., pls. 7-10.
Lippold, *Griech. Plastik*, p. 25, pl. 4, no. 3.
Lullies and Hirmer, *Greek Sculpture*, no. 7, pp. 36 f.

20 : Fig. 81

PARIS, Louvre, 3099.

Limestone relief, with the head of a woman within an architectural framework. Height, as preserved, 37 cm. Considerably weathered. Parts of top and bottom are missing.

From Malessina, Lokris.

The hair is indicated in Daedalic fashion with three rope-like tresses brought to either side of the face, and with a row of spiral curls above the forehead. The eyes are flat and oblong, with hollow irises.

Last quarter of the seventh century B.C.

Collignon, *Mon. Piot*, XX, 1913, pp. 28 ff., pl. III.
Catalogue sommaire (1922), p. 41, no. 3099.
Jenkins, *Dedalica*, p. 71, no. 3.
Charbonneaux, *Guide du visiteur* (1963), p. 7 (ill.).

21 : Figs. 80, 82, 83

SAMOS, Museum of Vathy.

Fragments of a marble female figure. One and a half times life-size.

The fragments consist of: (1) Shoulder with ends of tresses at back, (2) bottom of peplos, with shod feet protruding within an arch-like opening, and mounted on a plinth with a tenon for insertion in a base, all worked in one piece. (3) To these may belong a piece of the upper left thigh of the figure, inscribed ... $\epsilon\theta\eta\kappa\epsilon\nu$ (ht. 34 cm.).

Found at Samos.

She wore a peplos of which the top edge is visible at the neck.

The hair is rendered at the back in ten vertical tresses, terminating in somewhat pointed members; four similar tresses, divided horizontally, are brought to each side in front.

Last quarter of the seventh century B.C.

The tresses with somewhat pointed ends recall those of Kleobis and Biton (*Kouroi*², figs. 78-83), but are less mobile.

Buschor, *Altsamische Standbilder*, II, p. 23, figs. 72, 73, 75; V, p. 79, figs. 328-330.

22 : Fig. 85

NEW YORK, Metropolitan Museum of Art, 14.146.3, a, b.

Terracotta plaque, with a prothesis and mourning women, executed in relief. Black, red, and white applied colours. Height 44.6 cm.

E

Said to be from Olympos, Attica.
Put together from a number of fragments.

The women wear peploi and epiblemata. The dead woman has a polos on her head. The mourners raise one hand to their heads and grasp their hair with the other. The skull is flat, the hair is arranged in horizontal layers, the noses are large, the lips straight, the ears volute-shaped.

Second half of the seventh century B.C., perhaps around 630 B.C.

Richter, *M.M.A. Bulletin*, X, 1915, pp. 208 f., fig. 1 (shown with alien piece inserted); ibid., *Bulletin*, new series, vol. I, 1942, pp. 81 ff., figs. 4, 6; *M.M.A. Handbook* (1953), p. 31, pl. 26, f. (shown with alien piece removed).
Boardman, *B.S.A.*, L, 1955, pp. 51, 58.

23 : Figs. 86-89

ATHENS, National Museum, inv. 4157. 'Confiscated.'

Terracotta statuette of a mourning woman. Height 24.2 cm.

Provenance not known.

The body is thrown and turned on the wheel, the head and arms are modelled by hand. Black 'glaze' on the garment, white engobe on face, arms, belt, eyes with black iris. The body is columnar. She wears a belted peplos with short sleeves.

Both hands are brought up to the top of the head, in the usual attitude of mourning. The hair is rendered in an undifferentiated mass descending to about the level of the shoulders.

Second half of the seventh century B.C.

For Mycenaean and geometric prototypes of mourning women, represented in similar attitudes, cf., e.g., Daux, Chronique, *B.C.H.*, LXXXV, 1961, p. 853, figs. 7, 8 (from Naxos); Brock, *B.S.A.*, XLIV, 1949, pp. 19 ff. (from Siphnos).

Amandry, *Collection Hélène Stathatos*, III, p. 117, fig. 51b.

24 : Figs. 90-93

PARIS, Louvre, inv. CA295. Acquired in 1890.

Terracotta statuette of a mourning woman. Height 18.5 cm.

From Tanagra.

The body is thrown and turned on the wheel; head and arms are modelled by hand. Yellowish white engobe on nude parts; black 'glaze' on drapery.

The body is columnar. Both arms are raised to the head. She wears a close-fitting, foldless peplos with short sleeves, belted at the waist.

Second half of the seventh century B.C., perhaps toward the end.

Pottier, *Bulletin des Musées*, III, 1892, p. 143.
Winter, *Typen*, I, pl. 32, 5B.
Besques Mollard, *Cat.*, I, B100, pl. XIII.
Amandry, *Collection Hélène Stathatos*, III, p. 117, fig. 51, a.
Higgins, *Greek Terracottas*, pl. 19, F.

25 : Figs. 94-97

PARIS, LOUVRE, inv. MNB535. Acquired in 1874.

Terracotta statuette of a mourning woman. Height 22.7 cm.
From Tanagra.

The body is thrown and turned on the wheel; the arms and head, with neck, are modelled by hand. Yellowish-white engobe on arms, face, and hair, and on belt; black 'glaze' on drapery. One arm is raised to the head, the other is laid on the front of the chest.
The body is columnar. The head is slightly raised.
Like nos. 23 and 24 she wears a close-fitting, foldless, belted peplos with short sleeves.
Second half of the seventh century B.C., perhaps toward the end, to judge by her expressive face.

Pottier, *Bulletin des Musées*, III, 1892, p. 143.
Winter, *Typen*, I, pl. 32, no. 3A.
Charbonneaux, *Terres-cuites grecques* (1936), fig. 7.
Besques Mollard, *Cat.*, I, B99, pl. XIII.

26 : Figs. 98-100

ATHENS, NATIONAL MUSEUM, Hélène Stathatos Collection.

Terracotta statuette of a mourning woman. Height 24.5 cm.
Probably from Boeotia.

The body is thrown and turned on the wheel; the head and arms are modelled by hand. Black colour on garment, hair, and irises; white on face, hands, and wrists. The body is columnar. She wears a foldless, tight-fitting, sleeved peplos, girded at the waist. The hair falls down in an undifferentiated mass at the back, and is rendered in a row of spiral curls above the forehead.
Second half of the seventh century B.C.

Daux, in Chronique, *B.C.H.*, LXXIX, 1955, p. 210, pl. XII.
Amandry, *Collection Hélène Stathatos*, III, pp. 116 ff., no. 67, pls. 20, 21.

27 : Figs. 101-102

SANTORIN, MUSEUM.

Terracotta statuette of a mourning woman. Height 32 cm.
From Thera.

Columnar body thrown and turned on the wheel, with the arms and head modelled by hand. White engobe on head and arms, and blackish 'glaze' on drapery. One arm is raised to the head, the other hand is brought to the face.
Last quarter of the seventh century B.C.

Winter, *Typen*, I, pl. 22, no. 8.
Dragendorff, *Thera*, II, p. 24, fig. 56.
Kondeleon, *Ath. Mitt.*, LXXIII, 1958, Beilage 83, p. 119.
G. Neumann, *Gesten und Gebärden*, p. 86, fig. 43.
Higgins, *Greek Terracottas*, pl. 15, H.

28 : Figs. 104-107

OLYMPIA, MUSEUM, inv. B.3400.

Bronze statuette, cast solid. Height 8.8 cm.
Found in 1956, during the German excavations, southeast of building C, in an archaic deposit.

The missing head was evidently repaired in antiquity, for there is a dowel hole in the neck. Two defects in casting were also repaired with patches, which had become loose but were refound and reattached.
She stands with feet level, the right forearm extended, with closed hand, in which she probably held something, the left arm somewhat lowered, also with hand closed. She wears a long, girded, sleeved peplos, decorated over its whole surface with various incised ornaments.
The hair descends at the back in five thick tresses, with horizontal incisions, and in front, on either side, are two similar tresses.
The feet protrude at the bottom of the peplos, within an arch-like opening; the toes are level, and their ends form a continuous curve.
There is a slight attempt to indicate the forms of the body beneath the drapery, e.g., the buttocks and hips.
Last quarter of the seventh century B.C.
Kunze compares the 'lost' statuette, also of bronze, from Sikyon, Gerhard, *Ant. Bildwerke*, pl. 309, 6; Johansen, *Vases sicyoniens*, p. 142, fig. 108; Langlotz, *Bildhauerschulen*, p. 30, no. 1.

Kunze, VII. *Olympiabericht*, 1961, pp. 166 ff., fig. 98, pl. 69.

29 : Fig. 108

PARIS, Louvre, MNC1091.

Bronze relief, serving as the handle of a mirror. Height of kore 16.2 cm. Total height 19 cm.
Found in Corinth in 1889.

The back is smooth. At the bottom is a ring handle. The disk which was formerly attached to the figure did not belong, and was removed after the last war. Only a small fragment of the original disk remains.
She stands with the left foot advanced and the right arm lowered, holding a ring-like wreath in her hand.
She wears a close-fitting, belted peplos, of which the upper part is decorated with an incised scale pattern, the lower with incised designs, including a flying eagle and a cock, inside squared compartments.
On her head is a taenia and a polos. She wears a necklace and shoes. The hair falls down the back in a curving mass, horizontally divided into ridges; two tresses, in low relief, descend over the shoulder. Above the forehead is a row of globular curls.
The eye is large and prominent, with the eyelids rendered as mere ridges. The lips are straight and do not meet at the corners. The ear is flat and stylized.
Last quarter of seventh century B.C.

Pottier in Dumont and Chaplain, *Les Céramiques de la Grèce propre*, II, 1890, pp. 250 f., no. 16.
Reinach, *Répertoire*, II, p. 327, no. 7.
De Ridder, *Catalogue des bronzes du Louvre*, II, no. 1684, pl. 76 (shown with alien mirror disk).
Lamb, *Bronzes*, p. 127, pl. XLIV, a.

30 : Fig. 103

ATHENS, National Museum, 15131.

Bronze sheathing, with a repoussé relief. Height 23.5 cm.
Part of the bottom is missing.
From Prosymna, near Argos.

Two women are represented, the one on the left attacking the other with a sword, the other raising both her arms in horror or supplication. Both wear the usual peplos, sleeved, belted, foldless, with an arch-like opening at the bottom from which the feet protrude. They have long hair descending to the shoulders in tresses beneath a taenia; the top of the skull is plain. Some of the details are indicated by incisions.
At the top and bottom of the panel are borders of dots and guilloche.
Last third of the seventh century B.C.
The two women have been interpreted as Klytemnestra and Kassandra.

Blegen, *A.J.A.*, XLIII, 1939, pp. 415 ff., fig. 6.
G. Neumann, *Gesten und Gebärden*, p. 104, fig. 46.

31 : Figs. 109-112

SYRACUSE, Museo Archeologico, 47134.

Wooden statuette, carved in one piece with the plinth. Height 16.7 cm.
Found in 1934 in a votive ensemble at Palma Montechiaro, Sicily.
Surface has suffered.

She wears the usual belted peplos, from which the feet protrude within an arch-like opening. Both arms are bent at the elbows, with forearms extended; they were carved separately and are now missing.
The hair descends in a long, undifferentiated mass at the back, and is rendered in front on either side in a number of tresses. Over the forehead it is shown as a row of spiral curls. On the head is a polos. The ears are large and stylized. The eyeballs were inserted separately and are missing.
Late seventh century B.C.

Horn, *Arch. Anz.*, 1936, col. 542, fig. 38.
Caputo, *Mon. ant. dei Lincei*, XXXVII, 1938, p. 631, fig. 38, pls. IA, IIA (Persephone?).
Zanotti-Bianco, *J.H.S.*, LVIII, 1938, p. 249, fig. 2.
Richter, *Archaic Greek Art*, p. 56, fig. 82.

32 : Fig. 113

LONDON, British Museum, 1128.

Gold plaques with figures of a winged Artemis. Height of plaque 4.2 cm.
Found in a tomb at Kameiros, Rhodes.

Each is shown frontal, with both arms outstretched and hands clenched. On either side of her is a lion.
She wears the usual, belted, close-fitting peplos, decorated with various patterns.
Her hair is arranged in Daedalic fashion, with a mass, horizontally divided, descending on either side of her head.
Such plaques have been thought to belong to a necklace or a belt.
Second half of the seventh century B.C., 'perhaps around 630-620' (Higgins).
Such jewellery is said to have been found with a scarab of Psammetichos I (663-609 B.C.).

F. H. Marshall, *Catalogue of Jewellery*, no. 1128, pl. XI.
Jenkins, *Dedalica*, p. 60, pl. XI, 3.
Higgins, *Jewellery*, p. 112 pl. 20.

33 : Figs. 115-116

ONCE AT SAMOS. Destroyed (disintegrated) during the last war.

Wooden relief, representing Zeus and Hera. Height 19.5 cm.
Found at Samos.

Hera stands slightly turned toward Zeus, but with head frontal.
She wears a peplos with a decorated border running down the front of the skirt and an epiblema covering her shoulders; on her head is a low 'polos'.
The hair is rendered as a shortish mass with vertical incisions (only on her left side), against which the ear is laid. The latter is stylized and has the form of a volute. The right ear and hair are hidden by the eagle.
The eyes are large with arched brows (double in Hera); the lids are differentiated. The lips curve upward and do not meet at the corners; instead there is a vertical depression.
Last quarter of the seventh century B.C.
For the poses Akurgal compares a Hittite gravestone, op. cit., pl. 97, no. 10.

Ohly, *Ath. Mitt.*, LXVIII, 1953, pp. 77 ff., Beilage 13-15.
Akurgal, *A.J.A.*, LXVI, 1962, p. 375, pl. 97, nos. 8, 9.
G. Neumann, *Gesten und Gebärden*, pp. 64 ff., fig. 30.

34 : Fig. 114

ATHENS, NATIONAL MUSEUM, inv. 15502.

Ivory plaque with rivet-holes for attachment to a fibula. Height 8.3 cm.

Found in the Sanctuary of Artemis Orthia, Sparta (with Laconian I pottery).

The female figure is represented frontal, with both arms lowered and holding a bird by the neck. A smaller bird is perched on each of her shoulders.
She wears a sleeved peplos, girded at the waist, and decorated over its whole surface with incised patterns. At the bottom are shown her two feet, in profile to the right and left.
Tresses with herring-bone patterns descend on either side of the head, and a flat row of curls is shown above the forehead.
Last quarter of the seventh century B.C.

Dawkins, *Artemis Orthia*, pp. 207 f., pl. XCVIII, 2.

35 : Fig. 117

PARIS, LOUVRE, no. 2645.

Bust acting as the finial on a bronze handle. Total height of handle 17.5 cm.; ht. of bust 6.5 cm.
From Greece. Acquired in 1895.

The hair hangs down on each side in four long tresses, and over the forehead it is rendered by spiral locks, directed to the right and left from a central parting. On the head is a polos, decorated with leaves.
Last quarter of the seventh century B.C.

De Ridder, *Catalogue des bronzes du Louvre*, II, no. 2645, pl. 96.
Matz, *Geschichte der griech. Kunst*, pl. 258, a, pp. 439 f., 530, note 559.

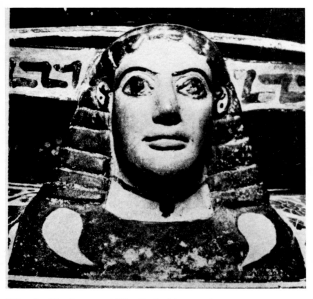 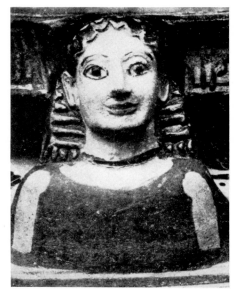

IX–a, b. Head on a middle Corinthian pyxis, c. 600–575 B.C. Berlin, Staatliche Museen

IX–c. Head on a middle Corinthian pyxis, c. 600–575 B.C. British Museum

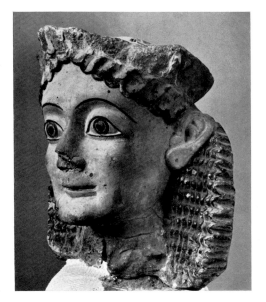 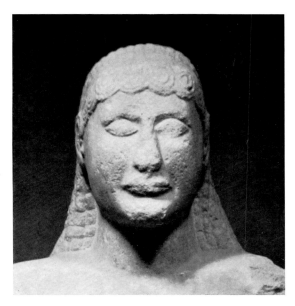

IX–d. Head of a sphinx from Kalydon, c. 600–580 B.C. Athens, National Museum

IX–e. Head of the Orchomenos kouros, c. 590–570 B.C. Athens, National Museum

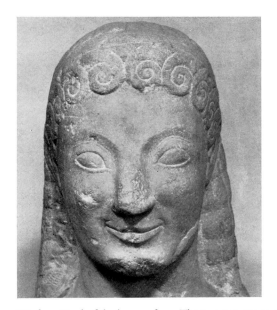 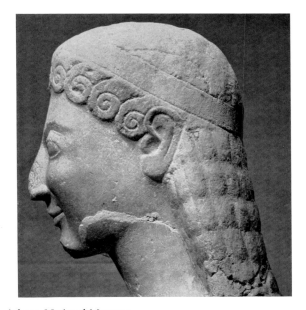

IX–f, g. Head of the kouros from Thera, c. 590–570 B.C. Athens, National Museum

X–a, b, c. Vase and komast, 600–575 B.C. Louvre

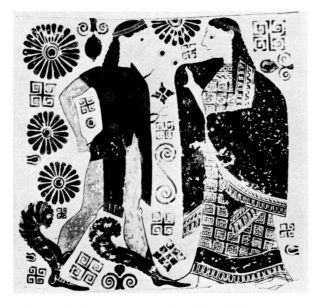

X–d. Female figures on an amphora from Melos, c. 600 B.C. Athens, National Museum

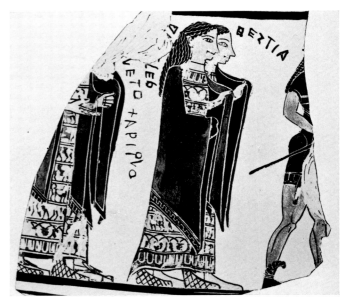

X–e. Hestia and Demeter, by Sophilos, c. 580 B.C. Fragment from the Akropolis. Athens, National Museum

GROUP II: THE OLYMPIA HERA—BERLIN KORE—
AKROPOLIS 593 GROUP
(about 600-570 B.C.)

General Survey and External Chronological Evidence

FOR the dating of our second group of korai one can make a few helpful comparisons. First one may mention the heads on Middle Corinthian pyxides, datable *c.* 600-575 B.C. (cf. plate IX, a, b, c, which shows examples in Berlin and London; cf. Payne, *Necrocorinthia*, nos. 882, 887). These heads share with the korai of this group a certain stolidity, the massive, post-Daedalic style of hair, and the forms of the stylized features.

Useful also for comparison of the features of the korai are the members of the Orchomenos–Thera group of kouroi, datable 590-570 B.C., which have the same serious expressions, comparatively flat skulls, large eyes, and horizontal mouths (cf., e.g., plate IX, e, f, g=*Kouroi*[2], figs. 182, 183, 138).

Likewise revealing is a comparison with the head of a sphinx from Kalydon (plate IX, d), datable early in the first quarter of the sixth century B.C. (cf. Payne, *Necrocorinthia*, p. 239, pl. 49, nos. 1, 2), which bears a striking resemblance to the head from Olympia (no. 36) in the rendering of the features. A useful comparison may also be made with the head of the komast from Thebes in the Louvre (plate X, a-c), assigned to the first quarter of the sixth century (cf. Payne, *Necrocorinthia*, p. 176, pl. 44, no. 5).

For the draperies worn by the korai the representations on vase-paintings supply a few comparisons. I illustrate here, for the beginning of the series, datable *c.* 600 B.C., the stately woman on a Melian vase (plate X, d; cf. Schefold-Pfuhl, *Tausend Jahre*, fig. 109); and for the later limit, datable *c.* 580 B.C., the Demeter and Hestia on a fragmentary dinos by Sophilos, Akr. 587 (plate X, e; cf. Beazley, *A.B.V.*, p. 39, no. 15).

With these independently dated works the korai of our second group share not only the renderings of the features, but also of the arms, hands, and feet. The lips do not meet at the corners and are separated from the cheeks by vertical cuts. In the eyes the upper lid is strongly arched, but there is little indication of its curvature over the eyeball; instead, both lids are indicated by prominent ridges. The ears are generally laid in front of the hair at the sides, making them appear unduly prominent. The tragus is rendered as an excrescence from the lobe, and there is no indication of the antitragus. The hands are still stiff, but the fingers begin to be differentiated. In the feet the toes are parallel to one another, and their ends form a continuous curve, the second toe being made smaller than the big toe. When the forearm is preserved, it is supinated, that is, directed forward, whereas the hand is directed toward the body, making an unnatural transition between the two parts —a rendering which regularly appears in the kouroi of the Orchomenos–Thera group, *c.* 590-570 B.C. (cf. *Kouroi*[2], figs. 138, 141, 154, 178).

The basic dress is the peplos, sometimes with the addition of an epiblema. One can here study the first tentative renderings of folds in varying depths.

The Daedalid form of hair is waning. Tresses often appear descending on the sides.

First in this second group of korai may be placed the head of Hera from Olympia (no. 36), which, though it presumably belonged to a seated statue, is included in our series since it furnishes one of

the few extant female heads of the time. The fragmentary, headless statues from Chios (nos. 37, 38), Attica (no. 40), and Aigina (no. 39), all with engraved patterns embellishing the foldless garments, should belong here. Also, perhaps somewhat later, a limestone head in Syracuse (no. 41). Towards the end of the series one may place the superb kore from Attica in Berlin (no. 42), preserved almost entire; the headless kore holding a pomegranate found on the Akropolis (no. 43); and the limestone Hydrophore (no. 44), also from the Akropolis. In all three statues appear the first tentative renderings of folds. A number of statuettes, in terracotta and wood, may likewise be assigned to the first quarter of the sixth century (cf. nos. 47-54).

As a provincial work from Sicily I have included no. 46, and as a contemporary Etruscan rendering the Poledrara statue (no. 45).

Korai 36-54

36 : Figs. 118-121

OLYMPIA, MUSEUM.

Colossal limestone head of Hera (?). Height 52 cm.
The material is probably local.
Found at Olympia, in the Heraion.

She wears a polos with a leaf pattern, a fillet, and an epiblema, of which a small piece is preserved.
The eyes are large with the upper lid strongly arched, and the lower placed lower than the upper; the iris and pupil are incised. The lips are straight and there is a rounded depression at the outer corners. The ear (only one, considerably damaged, is preserved) is placed low. The hair is rendered above the fillet by vertical ridges, and above the forehead by wavy curls.
About 600 B.C.
The head evidently belonged to the cult statue of Hera, who, according to Pausanias (v, 17, 1), was represented seated on a throne, with Zeus standing by her side. They are described by him as ἔργα ἁπλᾶ, 'simple (or crude) works', an interesting commentary on the taste of Greek sculpture prevalent during the second century A.D.
Though the head apparently belonged to a seated statue, it is included here as an outstanding example of a female head of this early period. For other theories concerning the identity of this head cf. those enumerated by Searls and Dinsmoor, loc. cit.

Furtwängler, *Arch. Ztg.*, XXXVII, 1879, p. 40.
Treu, *Olympia*, III, pp. 1 ff., pl. 1.
Searls and Dinsmoor, *A.J.A.*, XLIX, 1945, pp. 74 ff.
Riemann, *J.d.I.*, LXI-LXII, 1946/47, pp. 51 ff.
Lippold, *Griech. Plastik*, p. 26, pl. 8, no. 1.
Matz, *Gesch. d. griech. Kunst*, I, pp. 203 ff., pls. 130c, 131.

37, 38 : Figs. 122-128

CHIOS, MUSEUM, 225, 226.

Two marble torsos, from neck to waist. Height, of no. 225 = 55 cm.; of no. 226 = 62 cm.
Found presumably in Chios, though the exact place is not known. Said to come from Atsiki, near A. Ioannis. Attention to these two pieces was first drawn by Conze (loc. cit.), who had seen them in 1858, in Chora.

No. 225. Both arms are bent, with the hands brought to the front of the shoulders.
She wears a chiton, fastened along the forearms with buttons, forming incised radiating folds on either side. In front, on the sides, and at the back the folds are indicated by incised wavy lines.
The hair descends at the back and in front in tresses, divided horizontally.
No. 226. Similar to the preceding, except for the action of the arms. The right hung down the side; the left was bent, with the (missing) hand laid on the chest, between the breasts, presumably holding something. Where the hand was attached there is now a large, square hole, surrounded by smaller round holes, in which scraps of lead survive. This may have been due, it is thought, to an ancient repair.
The date should be toward the end of the first third of the sixth century B.C., when attempts were made to indicate folds in the drapery, not yet in depth by ridges, but by incisions. The wearing of the chiton instead of the peplos points to the same period; that is, the statues should antedate somewhat, but not too much, the statues of the Cheramyes group.

Conze, *Ath. Mitt.*, XXIII, 1898, pp. 155 f.
Langlotz, in Schrader, *Marmorbildwerke*, pp. 35 f., figs. 4-7.

Kyparissis and Homann-Wedeking, *Ath. Mitt.*, 63/64, 1938/39, pp. 160 f.

Matz, *Geschichte d. griech. Kunst*, pp. 197 f., pls. 122, 123.

Boardman, Two archaic korai in Chios, *Antike Plastik*, I, pp. 43 ff., pls. 38-44.

39 : Figs. 129-131

ATHENS, NATIONAL MUSEUM, 73.

Marble torso, from neck to waist. Height 42 cm.
Surface weathered. 'Parian marble.'
Found in Aigina.

The upper arms adhere closely to the body. She wears a chiton or peplos, fastened along the upper arms, as indicated by three incised lines running along the juncture of the two parts.
Down the front of the garment descends an incised pattern of maeanders.
First quarter of the sixth century B.C.

Heydemann, *Antike Marmorbildwerke*, (1874), no. 156.
Sybel, *Katalog*, (1881), no. 19.
Kastriotes, *Glypta*, no. 73 (there said to be from the Dipylon).
Langlotz, in Schrader, *Marmorbildwerke*, p. 41.
Kyparissis and Homann-Wedeking, *Ath. Mitt.*, 63/64, 1938/39, p.161.
Welter, *Arch. Anz.*, 1938, cols. 529 f., figs. 44-47.

40 : Figs. 132-134

ATHENS, NATIONAL MUSEUM, 3859.

Marble torso, from below neck to waist. Height 41 cm.
Found at Moschato, Attica. Formerly placed in the Theseion.

The left forearm is laid against the front of the body, below the breasts, the right arm was presumably lowered.
She wears a chiton, fastened along the upper arms with buttons. Running down the front is an incised pattern.
The hair descends in serried tresses at the back, and on the sides in more widely spaced, globular tresses.
First third of the sixth century B.C.

Kyparissis and Homann-Wedeking, *Ath. Mitt.*, 63/64, 1938/39, pp. 160 f., pls. 62-64.

41 : Figs. 135-138

SYRACUSE, MUSEO NAZIONALE ARCHEOLOGICO.

Limestone head, probably of a goddess. Height 58.8 cm.
Found at Laganello near Syracuse; not from Africa, sa

was once thought. Battered. Originally there was a stucco layer over the stone, on which colours were added.

She wears a polos. The hair falls down the back and sides in large, globular tresses, and is rendered in front, over the forehead, by a series of spiral curls. The ears are laid against the bulging mass of hair; they are large and have the tragus shown as a separate protuberance; the lobe is flat; there is no antitragus.
The eyes are large, with strongly arching upper lids.
About 580-570 B.C.
In spite of its battered condition, it is a highly impressive head. It is one of the oldest Greek sculptures found in Sicily.

Petersen, *Röm. Mitt.*, VII, 1892, p. 181.
Arndt, *Einzelaufnahmen*, nos. 752, 753.
Orsi, Daedalica Siciliae, *Mon. Piot*, XXII, 1916, pp. 131 ff., pl. XIV.
Pace, *Arte e civiltà della Sicilia antica*, II, 1938, p. 6, fig. 5.
Langlotz and Hirmer, *Die Kunst der Westgriechen*, no. 3, pp. 55 f.

42 : Figs. 139-146

BERLIN, STAATLICHE MUSEEN, inv. 1800. Acquired in 1924 from a dealer.

Marble statue. Height, with plinth, 1.93 m.; ht. of plinth 10-10.5 cm.
Broken across the neck, waist, and above the knees.
Said to have been found near Keratea, in Attica, wrapped in a sheath of lead—hence presumably its good condition.
Extensive traces of red, yellow, and blue colour.

She stands erect with the feet about level.
In the right hand she holds a pomegranate in front of her body, the left is laid across the chest.
She wears a sleeved peplos, the folds of which are rendered by vertical ridges, and which has two arched openings at the bottom, from which the feet protrude. Also an epiblema, draped at the back and hanging down in front on both sides; its folds are indicated by prominent ridges, arched at the back, vertical in front, with the stacking indicated at the bottom by zigzags; tassels are added at the four corners.
The hair falls down the back, without side tresses. It is rendered in wavy grooves and ridges, and is tied at the bottom a number of times to form a long tuft; above the ears, at the back, it is held in place by a fillet. On the head is a polos, decorated with incised patterns of maeander and lotus. She also wears sandals, a necklace with pendants, and earrings with similar pendants, and a spiral bracelet on her left arm.

The nose is pronounced, the eyes bulge, the lips are angular and do not meet at the corners, in the ear the tragus is rendered as a separate protuberance, and there is no indication of the antitragus.

In the feet the toes are directed downward, and are more or less parallel to one another. In the hands the fingers are also shown parallel to one another. The right forearm is supinated, with an inward twist.

The indication of folds with stacked ends, the forms of the eyes and ears, the parallel toes, the forms of the jewellery all point to a date around 580 to 570 B.C. For the coiffure interesting parallels are furnished on contemporary gravestones, one in Athens (cf. my *Archaic Gravestones of Attica*, fig. 77), the other in Berlin (ibid., fig. 79; Blümel, *Arch. griech. Sk.*, no. 2, fig. 9).

Wiegand, *Ant. Denk.*, IV, pls. 11-18.
Buschor, *Ath. Mitt.*, LII, 1927, p. 212.
Lippold, *Griech. Plastik*, pp. 37 f., pl. 10, no. 2.
Blümel, *Katalog*, II, 1, no. A, 1, pls. 1-8; *Arch. griech. Skulpt.*, no. 1, pls. 1-8.
Lullies and Hirmer, *Griechische Plastik*, p. 39, pls. 18-21.

scattered ornaments

epiblema

43 : Figs. 147-150

ATHENS, AKROPOLIS MUSEUM, 593.

Headless marble statue. Height 99.5 cm.
Found in 1887 east of the Erechtheion.
The marble has scaled on the chest. Head and feet are missing.
There are traces of painted patterns on the peplos and the epiblema (cf. drawings).

The right arm is lowered and holds a ring-like wreath, the left is brought to the front of the body and holds a pomegranate.

She wears three garments: 1) a chiton, now visible only along the upper right arm, where it is fastened with three buttons, but probably once also indicated at the missing bottom of the statue; 2) a peplos with overfold (apotygma), and a belt, which has hanging, tasselled ends; and 3) a shawl-like epiblema, hanging down the back, over the left arm, and down the right side; down the front it forms vertical folds with zigzag edges and with tassels at its four corners. The interrelation of the folds of these various garments is not consistently carried out.

The hair is rendered at the back as a quadrangular mass, with a tress on either side; in front, on each side, descend three similar tresses.

She wears a necklace with pendants of the same form as those in the Berlin kore no. 42; also perhaps earrings (slight traces on the neck).

bottom of peplos

Ornaments on No. 43.

The right forearm is supinated, that is, directed forward, whereas the palm of the hand is directed toward the body, forming the unnatural transition current in early archaic times (cf. my *Kouroi*[2], pp. 20, 24).

At the back are traces of the claw chisel—one of the earliest instances of the use of that tool in Greek sculpture (cf. my *Sculpture and Sculptors* (1950), p. 144). About 480-470 B.C.

Petersen, *Ath. Mitt.*, XII, 1887, p. 145, no. 3.
Sophoules, *Eph. arch.*, 1891, col. 156, pl. XI.
Lermann, *Altgriech. Plastik*, pl. I.
Dickins, *Cat.*, pp. 126 ff., no. 593.
Payne and Young, *Archaic Marble Sc.*, p. 9, pl. 12.
Langlotz, in Schrader, *Marmorbildwerke*, pp. 43 ff., no. 2, pl. II.

44 : Figs. 151-154

ATHENS, Akropolis Museum, 52.

Limestone statue, from a pedimental relief representing a building with olive trees. Height 80 cm.
Found in 1888 on the Akropolis, opposite the east front of the Parthenon.
Reconstructed from several fragments. The lower part is missing; the back is not finished.

The right arm (evidently left unfinished being of rectangular form) is held across the body, the left is raised. On her head is a round cushion-like support, which has been interpreted as being a pad for carrying a hydria, hence she is often referred to as a hydrophore.
She wears a tight-fitting, belted peplos and an epiblema, draped over both shoulders and indicated in front by stacked folds.
Her hair falls down her back in an undifferentiated, angular mass, with three globular tresses, divided horizontally, descending in front, on either side.
The mouth is straight; the eyeballs protrude; the lids are slightly modelled, with the lower lid placed lower than the upper; the ear is large and has the tragus indicated as a separate protuberance.
About 580-570 B.C.
The figure was evidently intended to be seen from the front.
Besides this figure there was found part of a second female figure.
The scene has been variously interpreted—as a representation of the old Erechtheion, Troilos at the fountain, the rape of the Athenian maidens from the Enneakrounos, etc. The interpretation remains problematical.

Kavvadias, *Arch. Deltion*, 1888, p. 11, B.
Wiegand, *Porosarchitektur*, p. 197, figs. 214 ff., pl. XIV.
Dickins, *Cat.*, pp. 69 ff.
Heberdey, *Altattische Porosskulptur*, pp. 18 f.
Lippold, *Ant. Plastik*, p. 36, with note 4.

The body is four-sided; the top of the head flat. Both forearms are extended and must have held offerings; the right hand is held open, the left is closed, and pierced for a pin, traces of which remain. (The dove formerly attached to it has now been removed.) The flat, sandalled feet protrude from an arch-like opening at the bottom of the garment; the toes are parallel to one another and their ends form a continuous curve, the second being shorter than the first.
She wears a peplos, belted, with a clasp in front, and an epiblema, which falls down her back and over both shoulders and upper arms. Both garments are decorated with borders. S. Haynes (loc. cit.) aptly compares the lotus pattern with those appearing on vases of the first half of the sixth century B.C.
The eyes are large, with lids indicated merely by ridges, and the upper arched. The pupil is incised. The ear is large and has the tragus rendered as an excrescence from the lobe; there is no antitragus. The lips are more or less straight, and a curving depression surrounds their outer corners.
The hair falls down the back in nine tresses, grooved with herring-bone patterns, and is confined by a ribbon wound round it eleven times; the tresses diminish in thickness on their downward course, and become plain and parallel below the ribbon. In front, on either side, descend two thick tresses, with horizontal divisions. Above the forehead is a row of spiral curls, flanked by a short tress. Round the head is a fillet, and above it the hair is plain.
Etruscan, first quarter of the sixth century. The anatomical forms—of the head, hands, feet, ear, eye—are those found in the Greek korai and kouroi of this period. Though Etruscan, it so closely resembles Greek works in style that it is included here.

Braun, *Annali dell' Inst.*, 1843, p. 351; *Bull. dell' Inst.*, 1844, p. 106.
Pryce, *British Museum Cat.*, I, 2, pp. 156 ff., D1.
Banti, *Il mondo degli Etruschi*, pp. 302 f., pl. 33.
V. Poulsen, in Boethius, *Etruscan Culture*, figs. 347-349, p. 366.
S. Haynes, *Antike Plastik*, IV, pp. 15 ff., pls. 6-8.

45 : Figs. 159-162

LONDON, British Museum, D1.

Statue of 'gypsum', mounted on a quadrangular plinth. Height 89 cm., with base, which is *c*. 4 cm. high.
Found in 1839 by the excavators of Prince Cannino, in the Poledrara cemetery, in the tomb known as the grotto of Isis, at Vulci.

There are traces of colour and gilding. On the top of the head is a hole, perhaps for the attachment of a polos. Part of the bottom is restored.

46 : Figs. 155-158

SYRACUSE, Museo Nazionale Archeologico.

Upper part of a limestone figure, in high relief. Height 45 cm.
From Monte Casale.

At the back is a thick slab, and at the top a roof-like cover, 'perhaps added for protection' (Langlotz).

The missing right arm was worked in a separate piece and fitted into the extant angular hole. The left arm was lowered and holds a dove against the front of her body.

She wears a tight-fitting, foldless garment.

The hair descends in front and along the shoulders in globular tresses. Above the forehead it is indicated by a row of angular members.

The eyes are cursorily worked. The lips consist of two prominent ridges. The ear is stylized in the form of a volute, with the tragus marked as a separate protuberance. The lobe is hidden by the disk earrings.

First third of the sixth century B.C.?

As a provincial Sicilian work, in date not far removed from the Berlin kore, no. 42, the piece has a special interest.

Langlotz and Hirmer, *Die Kunst der Westgriechen*, no. 28, pp. 63 f.

47 : Figs. 163-165

PARIS, Musée du Louvre, CA 1923.

Terracotta statuette of a woman with a ram. Height 15.3 cm.
From Acarnania.

Columnar body. Both arms are bent, with hands clenched.

She wears a belted peplos, from the bottom of which the shod feet protrude; also a cloth wound several times round her head, forming a kind of polos. A chain is stretched across her chest, and fastened on the shoulders with large disk brooches. Her hair falls down her back in a solid mass, and in tresses in front on either side. Above the forehead and temples it is rendered in a series of vertical spiral locks.

There is no indication of the curvature of the upper lid in the eye. The lips are straight and undifferentiated, with deep hollows surrounding them. The ears are stylized.

First quarter of the sixth century B.C.

Bull. des Musées, 1914, p. 20.
Mollard-Besques, *Cat.*, I, B137, pl. XVIII.

48 : Figs. 166-167

ATHENS, National Museum, 10125. Formerly in the Archaeological Society, no. 2309.

Terracotta statuette. Height 16 cm.
Put together from three pieces.
From Skillous, Peloponnese.

Both arms are lowered and adhere closely to the body, with palms laid flat against the sides.

She wears a belted peplos, from which the feet protrude at the bottom beneath an arch-like opening. Also an epiblema, draped down her back and shoulders. Her hair falls down her back in an undifferentiated mass, and is brought to the front on either side in a bulging mass of six tresses. The stylized ears are laid obliquely against the tresses, and appear frontal. The eyes protrude. On the head is a polos, on the feet shoes.

Early sixth century B.C. About contemporary with Kleobis and Biton.

Not before published?

49 : Figs. 168-169

LONDON, British Museum, 61.4-25.37.

Terracotta statuette, on a low base. Height 17 cm.
The head is moulded, the rest built. A few parts are missing.
Found at Kameiros, Rhodes.

The form is columnar, but flattened at the sides. Both arms were extended. She wears a peplos, girded at the waist, and a polos. Two chains are stretched across her chest, of which the upper one has four disk pendants; the lower is largely missing. The hair descends at the back in a solid mass, with tresses brought to the front on either side.

Early sixth century B.C. Higgins aptly compares the plastic heads on Middle Corinthian pyxides (cf., e.g., my pl. IX, a-c).

Winter, *Typen*, I, pl. 33, no. 2.
Walters, *Cat. of Terracottas, British Museum*, B136.
Higgins, *Terracottas in the British Museum*, I, p. 243, no. 898, pl. 130.

50, 51 : Figs. 170-172

ATHENS, Kerameikos Museum, 45.

Two terracotta statuettes of mourning women. Heights 11.7 and 12 cm.
Found in the Dipylon, in a sacrificial deposit.
Hair and drapery are covered with blackish glaze; the nude parts with white engobe. The bodies are columnar.

No. 50. She raises both hands to her head, in the usual attitude of mourning. Her garment consists of a sleeved peplos, ungirded. The hair falls down her back in a solid, undifferentiated mass, and two globular tresses descend on either side of her head in front.

No. 51. Similar to the preceding, except that only the left hand is placed on the head, whereas the right is bent, with the forearm laid against the chest.

The date should be somewhat later than that of the mourning women, nos. 23-27, for the style is more advanced; the serious, farouche expression of early days has given place to a kindlier, more gracious look.

First quarter of the sixth century B.C.

Kübler, *Arch. Anz.*, 1933, col. 279, fig. 16 (dated early sixth century B.C.).
Karo, *An Early Attic Cemetery*, p. 14, pl. 16.
Amandry, *Collection Hélène Stathatos*, III, pp. 117 f., fig. 52.
Higgins, *Greek Terracottas*, pl. 17D.

52 : Figs. 173-174

LONDON, BRITISH MUSEUM, inv. 75.3-9.19.

Terracotta statuette. Height 28 cm.
The body is built, the face moulded.
Said to be from Tanagra.

Flat front and back, with spreading base. The arms are rendered as stumps.

She wears a peplos, with what may have been intended as an overfold, covered with black and red decorated patterns. No folds are indicated.

The hair hangs down the back and sides in solid masses, and is parted in the middle above the forehead.

The eyes are large and wide open, with the upper lid strongly arched. The lips are straight. The ears are stylized, with no tragus or antitragus marked.

The large black eyes give the face a lively expression. Late in the first quarter of the sixth century B.C.

Winter, *Typen*, I, pl. 9, no. 3.
Walters, *Cat. of Terracottas*, Br. Mus., B57.
Grace, *Archaic Sculpture in Boeotia*, p. 32, fig. 23.
Higgins, *Terracottas in the British Museum*, I, p. 206, no. 768, pl. 102.

53, 54 : Figs. 175-182

SYRACUSE, MUSEO NAZIONALE ARCHEOLOGICO, inv. 47136.

Two wooden statuettes, mounted on plinths. Height 17.2 cm.
Found at Palma Montechiaro (with no. 31).
The surface has suffered; the wood has split.

They stand with feet close together and forearms extended (both were made in separate pieces and are missing).

Each wears a peplos and a polos, also apparently shoes. The hair falls down the back in an undifferentiated mass, flanked by tresses on either side. Above the forehead it is indicated by a row of wavy curls.

First quarter of the sixth century B.C.

Pace, *Arte e civiltà della Sicilia Antica*, II, chapter I, La plastica arcaica, pp. 3 ff.
Horn, *Arch. Anz.*, 1936, col. 542, fig. 38.
Caputo, *Mon. Ant. d. Lincei*, XXXVII, 1938, pp. 638 ff., pl. I, B, C, pl. II, B, C.
Zanotti-Bianco, *J.H.S.*, LVIII, 1938, p. 249, fig. 2.
Richter, *Archaic Greek Art*, p. 56, fig. 84.

GROUP III: THE CHERAMYES—GENELEOS GROUP
(about 575-555 B.C.)

General Survey and External Chronological Evidence

FOR the absolute dating of our third group of korai one may again use the heads on Corinthian pyxides, this time of the Late Corinthian period, *c.* 575-550 B.C. (cf. plate XI, a, b, c), i.e. the specimens in St. Louis (Payne, *Necr.* pl. 35, nos. 1, 4), and New York (*M.M.A. Bull.*, 1936, pp. 104 f., figs. 1, 2). They have the same alert expressions as our korai, the same curving lips, slanting eyes, and wavy masses of hair.

Contemporary should be the Tenea–Volomandra group of kouroi, *c.* 575-550 B.C., which have similar features; compare, e.g., the head of the Tenea kouros in Munich (plate XI, d, e) with the head Akropolis 654 (my no. 65).

Helpful for dating are moreover a few statuettes found at Ephesos below the foundation of the temple of Kroisos, that is, before *c.* 550. Cf. my nos. 78, 80, 81.

An important, approximately contemporary, sculptural work, in good preservation, is the famous Naxian Sphinx at Delphi (plate XI, f-h). Its arched brows, slightly rounded skull, differentiated lips with deep grooves at the corners, globular tresses, and still somewhat stylized ears (with no antitragus marked) place it between our groups II and III, that is, about 570 B.C. And around this time also belongs the famous Moschophoros, found on the Akropolis, with similarly carved features.

For the rendering of folds during this period comparisons with vases are unfortunately not helpful, for the experiments observable in sculptures mostly antecede those on the vases, where elaborate embroideries take their place. Cf., e.g., the women on the François vase datable *c.* 570 B.C., where no attempts at indication of folds can be observed. The decorations on the garments made, one may suppose, the representations of pleats difficult at this period. At all events, it was not until well in the second half of the sixth century that the vase-painter tried his hand in this field (cf. p. 62). In general appearance and bearing, however, the women painted by Kleitias (plate XII, a, b) are not unlike their sculptured sisters. They have the same quiet modesty and charm as Philippe (no. 67) and Ornithe (no. 68). Contemporary are also the women bidding goodbye to Amphiaraos on the late Corinthian krater in Berlin (plate XII, c; Payne, *Necr.*, pp. 139 ff., no. 1471; Pfuhl-Schefold, *Tausend Jahre*, fig. 179).

In our third group of korai we can accordingly place the rich contingent unearthed by the German excavators at Samos, supplemented by statues and fragments from other regions. Life begins to stir in these statues. Though the bodies are still columnar, plentiful folds now appear, and the various garments are differentiated in depth. Both incisions and ridges are used for their renderings. The features also begin to soften. The statues from Samos being headless, one has to turn to a few preserved heads from elsewhere for their realization (cf. infra).

In the eyes is observable the first realization of the proper curvature of the upper lid over the eyeball. The lips are still parallel to each other, with vertical depressions at the corners, but their shapes begin to be differentiated. The ears are stylized, with the tragus indicated, but not the antitragus. The hair now falls down the back in a quadrangular mass, as before, but the tresses in front evince a certain freedom in their undulating contours. The hands are stiff, with long thumbs. The feet

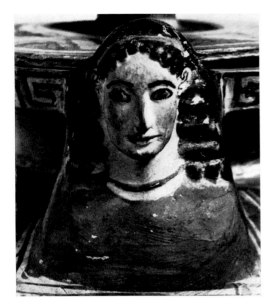

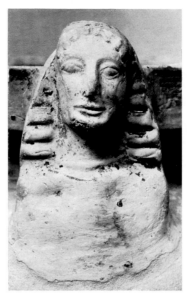

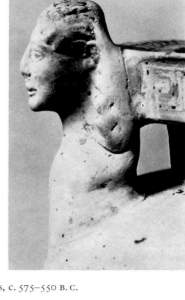

XI–a. Head on a late Corinthian pyxis,
c. 575–550 B.C. St. Louis, City Art Museum

XI–b, c. Head on a late Corinthian pyxis, c. 575–550 B.C.
New York, Metropolitan Museum

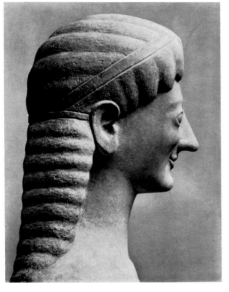

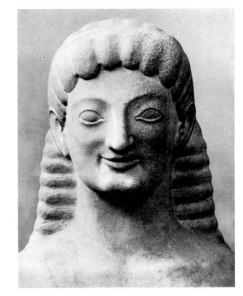

XI–d, e. Head of the Tenea kouros, c. 575–550 B.C. Munich

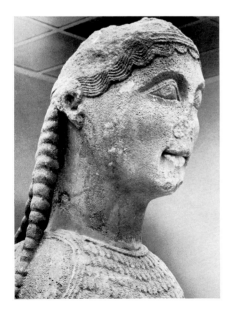

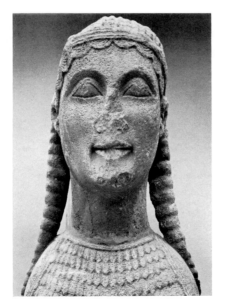

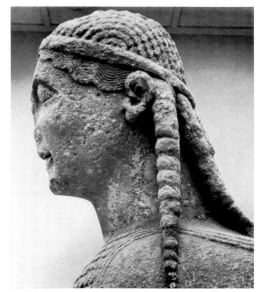

XI–f, g, h. Head of the Sphinx from Delphi, c. 570 B.C. Delphi, Museum

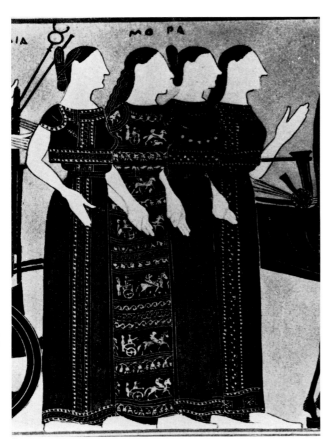

XII–a. The 'Moirai' on the krater signed by Kleitias and Ergotimos, c. 570 B.C. Florence, Archaeological Museum

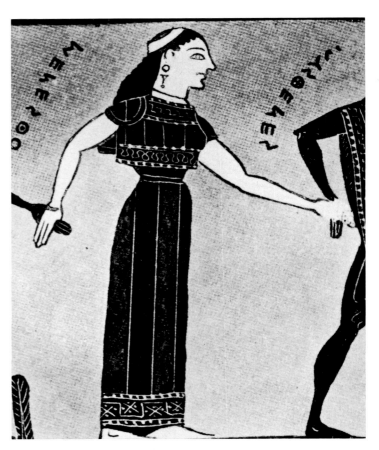

XII–b. Woman, on the same krater as XII–a

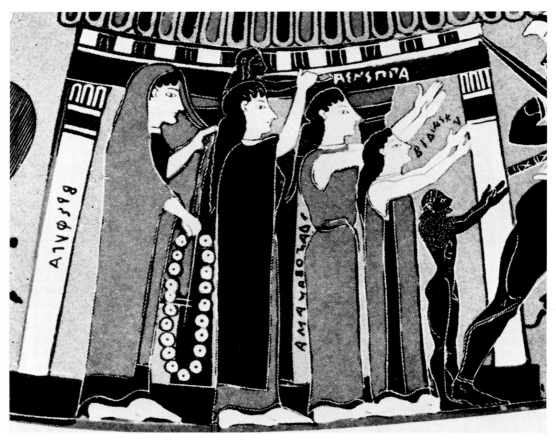

XII–c. Women bidding farewell, on a Corinthian krater, c. 570 B.C. Berlin

have their toes parallel to one another, with ends forming a continuous curve. The forearm is mostly correctly semi-pronated.

First in the series should come the two dedications by Cheramyes in the Louvre (no. 55) and Berlin (no. 56), both from Samos. With them may be associated the similar statues and fragments of statues from Samos (nos. 60, 61, 64), Miletos (no. 57), Sardes (no. 62), Cyrene (p. 46), and Athens (nos. 58, 59). All are headless, except the one found on the Athenian Akropolis (no. 59), which fortunately enables us to picture the lost features of the other figures. Contemporary, but of a rather different type, should be the fine head from the Akropolis (no. 65), and a head of a kore or sphinx found at Aigina (no. 66).

Perhaps a decade or so later one may place the two girls from the group in Samos, signed by the sculptor Geneleos, with their names inscribed: Philippe and Ornithe (nos. 67, 68). Comparable are another statue from Samos, of less exquisite workmanship (no. 69); the upper part of a statue from Chalkedon (no. 73); and two reliefs from Miletos (nos. 70, 71). One may also place here a headless statue from Eleusis (no. 75), a statue from Lindos in Istanbul (no. 76), to which is said to belong a head now in Copenhagen (no. 77), and fragments of a perirrhanterion from Athens (no. 74). To about the same period should belong several statuettes, among them the two famous ivory figures from Ephesos (nos. 80, 81), charming examples of Eastern beauties, and also helpful for supplying approximately fixed dates (cf. supra). The more farouche bronze statuette no. 78, found like the ivory figures beneath the floor of Croesus' temple, should be earlier—on the border line of Groups II and III?

It is noteworthy that the Samian and other Eastern statues are mostly shown wearing the short Ionian mantle over the chiton (cf. nos. 55-57), whereas the few examples from continental Greece still wear the peplos (cf., e.g., no. 75)—except two korai from the Athenian Akropolis—no. 59, generally considered to be an importation from Samos, and no. 58, where the rendering of the Ionic himation seems to be somewhat misunderstood. And this is the case also in the contemporary representations on vase-paintings (cf. plate XII, a–c), where the peplos is the garment worn. This bears out the theory that the Ionic fashion of the short mantle, obliquely draped, was not introduced in Attica—and continental Greece—until about the middle of the sixth century (cf. pp. 9 f.). As we have seen (cf. p. 10), this change is recorded also in our historical records, there illustrated by a dramatic incident related by Herodotos.

The korai of this group from Ionia—Samos, Miletos, Sardes, Ephesos, etc.—have, therefore, considerable historical interest; for they antedate the Ionic influence which presently was to penetrate into Attica and continental Greece. And they recall the lines preserved for us by the poet Asios about the Samian women: 'And they, even so, whene'er they had combed their locks, would hie them to the precinct of Hera, swathed in beautiful vestments, with snowy chitons that swept the floor of the wide earth', οἱ δ' αὔτως φοίτεσκον ὅπως πλοκάμους κτενίσαιντο | εἰς Ἥρας τέμενος, πεπυκασμένοι εἵμασι καλοῖς, | χιονέοισι χιτῶσι πέδον χθονὸς εὐρέος εἶχον· (cf. Athenaios XII, 525, f; text and translation by C. B. Gulick in the Loeb ed.). The Ionian korai of the third group represent, in fact, the soft style of East Greece which was presently to intermingle with the sturdier style of continental Greece—resulting in the matchless achievements of Athenian art during the succeeding periods.

Korai 55-81

55 : Figs. 183-185

PARIS, Louvre, inv. 686.

Headless statue. Height 1.92 m.
Large-grained, white marble. Worked in one piece
with the round plinth.
Considerably over life-size.
Found about 1875 in the sanctuary of Hera at Samos.
The head and most of the left arm are missing.

The right arm is lowered and grasps a fold of the drapery;
the left was bent, with the hand laid against the chest.
Both arms adhere closely to the body.
She wears a chiton, girt at the waist, and over it a short,
Ionic himation, draped from the right shoulder to below
the left armpit; also an epiblema, which hangs down her
back and along the sides, and one edge of which is
grasped by the right hand, another is tucked into the
belt.
The folds of the chiton are indicated by delicate ridges;
those of the himation by deeper, more widely spaced
ones, going in different directions; the epiblema is
foldless.
The feet, which protrude from an arch-like opening at
the bottom of the chiton, have parallel toes, the ends of
which form a continuous curve. The hands are angular,
with the thumb placed in front.
Along the edge of the epiblema, in front, is inscribed,
vertically, the dedication: Χηραμύης μ' ἀνέθηκεν τῆρηι
ἄγαλμα, 'Cheramyes dedicated me to Hera as an offer-
ing'.
Second quarter of the sixth century B.C.

Girard, *B.C.H.*, IV, 1880, pp. 483 ff., pls. 13-14.
Catalogue sommaire, (1922), p. 41, no. 686.
Buschor, *Altsamische Standbilder*, II, pp. 25 ff., figs. 86-89, 107; in
Festschrift für B. Schweitzer, 1954, pp. 96 f.
Langlotz, *Frühgr. Bildh.*, pp. 119 ff., pl. 57, b.
Lullies and Hirmer, *Griech. Plastik*, pls. 30, 31, pp. 41 f.
Jeffery, *Local Scripts*, p. 328, pl. 63, no. 4.
Guarducci, *Epigrafia greca*, I, p. 442.

56 : Figs. 186-189

BERLIN, Staatliche Museen, inv. 1750.

Headless statue, of marble, worked in one piece with
the round plinth. Height, with plinth, 1.67 m.; ht. of
plinth 7 cm.
Found in the temenos of Hera, at Samos.
Surface considerably weathered.

The right arm is lowered, with the hand holding a fold
of the drapery; the left is bent, with the forearm laid
across the chest and the hand holding a hare on the
open palm.
She wears a chiton, belted, and over it a short, Ionic
himation, draped from the right shoulder to the left
armpit; also a shawl-like epiblema, hanging down the
back and the left side, with one end tucked into the belt.
Along its edge appears the inscription Χηραμύης μ' ἀν-
έθηκε θῆι περικαλλὲς ἄγαλμα. 'Cheramyes dedicated me
to the goddess, a beautiful offering'.
Of the feet only the toes are visible, protruding from an
arch-like opening at the bottom of the chiton. As in
no. 55, the toes are parallel, with the ends forming a
continuous curve.
Second quarter of the sixth century B.C., contemporary
with the other dedication by Cheramyes, no. 55.
The goddess to whom the offering was made is thought
to be Aphrodite, on account of the hare. Whether the
statue represents Aphrodite, or the dedicator, or neither,
is uncertain (cf. pp. 3 f.). It is known that a new temple
was dedicated to Aphrodite in 560-555 B.C.; cf. Buschor,
Ath. Mitt., LXXII, 1957, p. 82. So, this statue may be con-
temporary with that event (Blümel).

Buschor, *Altsamische St.*, IV, p. 67, V, pp. 83 f., figs. 341-344;
Festschrift für B. Schweitzer, p. 98.
Blümel, *Arch. griech. Skulpt.*, no. 34, figs. 94-98.

56a, 56b: CYRENE, Museum.

Two korai of the same general type as nos. 55, 56 have
recently been found at Cyrene during modern construc-
tion work, and are now in the Archaeological Museum
of Cyrene. They came to light—with other archaic pieces
—in an ancient quarry, which was apparently used as a
sort of dump after they had been mutilated in some
catastrophe. Both korai are headless, but otherwise in
fair condition. The chief difference between them and
the statues dedicated by Cheramyes is that they wear
only the chiton, without the short Ionic himation, re-
sembling in this respect Geneleos' Philippe and Ornithe
(cf. nos. 67, 68).
The whole ensemble will presently be published by
Messrs. R. G. Goodchild, J. G. Pedley, and D. White in
an article entitled 'Recent Discoveries of Archaic
Sculpture at Cyrene, A Preliminary Report', in *Ancient
Libya*. By the kindness of Mr. Goodchild I have been
allowed to see photographs and descriptions of the korai,
and to make this brief mention of them here.

57 : Figs. 190–193

BERLIN, STAATLICHE MUSEEN, inv. 1791.

Headless marble statue. Height, with plinth, 1.43 m.; ht. of plinth 6 cm.
Worked in one piece with the round plinth.
Found at Miletos.

The right hand is lowered, adhering to the side, with hand closed; the left is bent, with the forearm laid across the chest and the hand holding a bird ('partridge').
She wears a chiton and a short Ionic himation, draped from the right shoulder to below the left armpit; also an epiblema which covers the back and the left lower side. The folds are indicated by ridges; along one edge of the himation are stacked, wavy folds.
The shod feet protrude from below an arch-like opening at the bottom of the chiton. The right hand is angular with the thumb placed in front.
Second quarter of the sixth century B.C.

Wiegand, *Berliner Museen*, XLVIII, 1917, pp. 63 f., fig. 3.
Buschor, *Altsamische St.*, V, pp. 87, 89, fig. 352; *Festschrift für B. Schweitzer*, p. 97.
Blümel, *Arch. griech. Skulpt.*, no. 47, figs. 129–132.

58 : Figs. 194–197

ATHENS, AKROPOLIS MUSEUM, 619.

Headless marble statue. Height 1.43 m.
'Naxian' marble.
Found in 1887 east of the Erechtheion.

The right arm, with closed hand, hangs down, closely adhering to the side. The left arm is mostly missing, but its traces show that it was bent and held against the chest, with the hand holding a round object.
She wears a chiton and a short Ionic himation, draped from the right shoulder to below the left armpit. The folds of both are indicated by shallow ridges going in different directions. The himation on the right shoulder, and the chiton on the left are fastened by buttons.
The right hand is angular, with the long thumb brought forward; the forearm is no longer supinated, but is turned toward the body, i.e. pronated.
Second quarter of the sixth century B.C.
It is noteworthy that on the left side the folds of the himation are indicated by curving instead of by vertical and oblique lines—a misunderstood Attic rendering of the new Ionic costume?

Sophoules, *Eph. arch.*, 1888, pp. 109, 112, pl. VI.
Dickins, *Cat.*, pp. 150 f., no. 619.
Payne and Young, *Archaic Marble Sc.*, p. 9, pl. 20.

Buschor, *Altsamische St.*, II, p. 25, figs. 78, 79.
Langlotz, in Schrader, *Marmorbildwerke*, pp. 63 f., no. 22, pl. 33.

59 : Figs. 198–200

ATHENS, AKROPOLIS MUSEUM, 677.

Upper part of a marble statue. Height 54.5 cm.
'Naxian' marble.
Found in 1886, on the Akropolis, west of the Erechtheion.
Put together from six pieces. Parts of the left arm are restored.

The right arm was lowered; the left is bent, with the forearm laid across the chest, and the hand holding a pomegranate.
She wears a chiton, and over it a short Ionic himation, draped from the right shoulder to below the left armpit. Both garments are fastened with buttons along the respective shoulders. The folds of both are indicated by ridges, those of the himation being deeper and more widely spaced than those of the chiton. Encircling the hair is a fillet, knotted at the back, with two long, tasselled ends. The hair falls down the back in a series of straight tresses, divided horizontally. On top of the skull, and above the forehead, it is rendered by wavy ridges. The eyes have strongly arched upper lids, with an indication of its curvature by the addition of two curving incised lines. The lips are straight, and have a depression at the corners. In the ear the tragus is indicated by a separate knob, but not the antitragus.
Second quarter of the sixth century B.C.

Kavvadias, *Eph. arch.*, 1886, p. 82.
Lechat, in *Mnemeia tes Hellados*, p. 91, pl. XXIV, middle.
Dickins, *Cat.*, pp. 219 f., no. 677.
Buschor, *Altsamische St.*, II, p. 24, figs. 80–83.
Langlotz, in Schrader, *Marmorbildwerke*, pp. 64 f., no. 23, pl. 34.

60 : Figs. 201–203

BERLIN, STAATLICHE MUSEEN, inv. 1743.

Two fragments of a statue of grey-white marble: (1) from below the neck to above the waist, (2) the bottom with the plinth. Heights, respectively 31 cm., and 28 cm. The whole statue, without the head, must have been about 1.55 m. high.
Found in Samos.
The surface is considerably weathered.

In (1) the right arm was evidently lowered, the left held against the chest, holding some object. She wears

a chiton, and over it a short, foldless Ionic himation, draped from the left shoulder to below the right armpit. At the back are remains of an epiblema. The chiton and the himation were fastened with buttons along their respective shoulders, creating, in the case of the chiton, two groups of incised folds, running down the chest. (2) The second piece shows the bottom of the chiton, with folds indicated by prominent ridges, arranged in a series of groups, from which the feet protrude (only the left is preserved), within an arch-like opening. The toes are parallel, and their ends form a continuous curve. Second quarter of the sixth century B.C.

Blümel, *Arch. griech. Skulpt.*, no. 35, a, b, figs. 99-101.

61 : Figs. 204-205

SAMOS, HERAION, APOTHEKE.

Fragment of the lower part of a statue. Height 25 cm.; of plinth 10 cm.
Found in the sanctuary of Hera in Samos.

The fragment consists of the front part of a plinth, with two feet protruding from the bottom of a chiton, within an arch-like opening.
The folds of the chiton are rendered by ridges; the toes (now battered) are parallel to one another and their ends evidently formed a continuous curve.
Second quarter of the sixth century B.C. The statue must have resembled the one in the Louvre, dedicated by Cheramyes, no. 55.

Buschor, *Altsamische Standbilder*, II, pp. 26, 29, fig. 85.

62 : Fig. 206

MANISA, MUSEUM.

Lower part of a marble statue, mounted on a plinth. Height 40 cm.
Found in a mass of rubble masonry fallen from the north wall of the Synagogue, in Sardes.

What remains is the lower part of the chiton, from the bottom of which protrude two feet within an arch-like opening. At the top, beneath the break, are remains of a right hand, which was evidently lowered, whereas the left was perhaps laid against the chest, as in nos. 56-59.
The folds of the chiton are rendered by prominent, vertical grooves.
The two hanging bands with pointed ends probably belonged to a belt; cf. no. 43.
Second quarter of sixth century B.C.

D. G. Mitten, *Bulletin of the American Schools of Oriental Research*, no. 174, April 1964, p. 39, fig. 24.

63 : Figs. 207-208, 210

BERLIN, STAATLICHE MUSEEN.

Lower part of a statue, of large-grained marble. Height 71 cm.
Found at Miletos, in the courtyard of the bouleuterion of the Hellenistic town.
Broken in two pieces and reattached. Battered. The statue was evidently hewn into a required shape when used as building material.

What remains is the lower part of the chiton, with a pair of shod feet protruding from an arch-like opening. Descending on the left appears a thick fold, probably belonging to an epiblema, a part of which was held by the right hand (at the top, immediately below the break, where a fracture is visible). The statue must in fact have been similar to the one in the Louvre, no. 55, except for the omission of the rendering of the folds by ridges. One may surmise that they were indicated in colour. The left arm was presumably held against the chest with some offering.
On the plinth is the inscription, from left to right:

['A]ναξιμάνδρο = 'Anaximandro(u)', in the genitive; or ['A]ναξίμανδρο(s) in the nominative.

At one time the statue was thought to represent the philosopher Anaximander, who died in 547 B.C. But as the statue evidently represented a female figure, that theory has had to be given up.
The date should be the same as that of the similar statues, nos. 61, 62, i.e. the second quarter of the sixth century B.C.—in spite of the late form of ξ : Ξ.

Kurze Beschreibung, Berlin Museum[3], p. 109, no. 1599.
Wiegand, *Milet*, I, 2, p. 112, no. 8, fig. 103.
Loewy, *Oest. Jahr.*, XII, 1909, p. 294, note 202.
Blümel, *Arch. griech. Skulpt.*, no. 42, figs. 120-122.
Darsow, *J.D.I.*, LXIX, 1954, pp. 101 ff.
Jeffery, *Local Scripts*, p. 334, pl. 64, no. 26.

64 : Figs. 209, 211

BERLIN, STAATLICHE MUSEEN, inv. 1740.

Fragment of the lower part of a marble statue. Height 35 cm.
From Samos.

All that remains is the lower part of a foldless chiton, with a pair of shod feet protruding from an arch-like opening, worked in one piece with a plinth. On the latter, in front, is inscribed, boustrophedon: ἀ]νέθηκεν Νύμφη[ι]σιν | ὁ Μάνδριος, 'Mandrios dedicated it to the Nymphs'.

The inscription was dated by Klaffenbach in the second quarter of the sixth century B.C., which date conforms with the style.

Blümel, *Arch. Anz.*, 1964, cols. 87 ff., figs. 1, 2. The piece was not included in Blümel's *Archaische griech. Skulpt.*, 1963, for, as Blümel explains, the box containing the piece, when it returned from the Soviet Union, was by mistake taken to the Egyptian department of the Berlin Museum, and only subsequently recovered.

65 : Figs. 212, 213

ATHENS, AKROPOLIS MUSEUM, 654.

Front part of the head of a kore or sphinx (?). Height 11.7 cm.
'Parian' marble.
Found before 1829 near the Erechtheion.
Traces of colour.

On the head are remains of a polos, decorated with incised ornaments. The hair is indicated above the forehead by a series of broad, wavy ridges. The eyes are elongated, with prominent eyeballs and lids. The lips curve upward, with a pronounced depression at the corners and a deep hollow below the lower lip. The ear has the tragus rendered as a separate knob; there is no antitragus.
Second quarter of the sixth century B.C.
One may compare the similar head of a kouros from the Athenian Akropolis, no. 617, of the Tenea–Volomandra Group. c. 575–550 B.C. (cf. *Kouroi*², no. 65, figs. 219, 220).

Milchhöfer, *Ath. Mitt.*, IV, 1879, pp. 76 f., pl. VI, 1.
Lechat, in *Mnemeia tes Hellados*, pl. XXXI, no. 4.
Sybel, *Kat.*, no. 5135
Dickins, *Cat.*, p. 192, no. 654
Payne and Young, *Archaic Marble Sc.*, pp. 4, 6, 19, pl. 11.
Langlotz, in Schrader, *Marmorbildwerke*, p. 127, no. 85, pl. 94.

66 : Figs. 214–216

ATHENS, NATIONAL MUSEUM, 1939.

Head of a marble kore or sphinx (?). Height 22 cm.
Found in 1902 in a cistern on the site of the temple of Aphaia at Aigina.

F

The hair is indicated, on the skull above a taenia, in wavy bands, which continue down the back in globular tresses, with three similar tresses brought to the front on either side. Above the forehead it is rendered in wavy ridges passing from ear to ear.
The eyes are slanting, with protruding eyeballs, and an incision at the inner corners; there is a slight indication of the curvature of the upper lid. The lips curve upward and do not meet at the corners, where there is a vertical groove.
In the ear the tragus is indicated as an excrescence from the lobe. There is no antitragus.
Second quarter of the sixth century B.C.
The head evidently does not come from the pediments of the temple of Aphaia, but perhaps from a votive statue.

Furtwängler, *Aegina*, pp. 359 f., pls. 82, 83.
Kastriotes, *Glypta*, no. 1939.
S. Karouzou, *Guide*, p. 36, no. 1939.

67 : Figs. 217–220

SAMOS, MUSEUM OF VATHY.

Marble statue of Philippe, from the group signed by Geneleos. Height 1.60 m.
Mounted on a plinth.
Found in Samos.

Both arms are lowered; the left hand is closed with the thumb directed forward, the right hand grasps a fold of the drapery.
She wears a long, girded chiton pulled over the belt right and left to form deep pouches (kolpoi), and fastened with buttons along both upper arms. The folds are indicated by delicate incisions, forming ridges of different widths and going in different directions. At the bottom of the chiton the feet protrude. The surviving left one has parallel toes, of which the ends form a continuous curve.
The hair descends at the back in a quadrangular mass, divided into globular tresses.
The name Φιλίππη, Philippe, is inscribed on the drapery, on the right side.
The round plinth fits into one of the six openings on the upper face of a long base, which contained the seated Phileia at one end, with the inscription ἡμᾶς ἐποίησε Γενέλεος, 'Geneleos made us', the recumbent dedicator, inscribed: [. . .]όχη εἰμὶ [ἥ] κἀν[έ]θηκε τῆι Ἥρηι, 'I am . . .oche, who has also dedicated it to Hera', at the other end, and between them four standing figures: Three girls: Philippe who stood in the centre, Ornithe

(no. 68), and a third of whom only fragments have been found (cf. Buschor, *Altsam. St.*, II, p. 28, figs. 97, 98). The fourth figure, now lost, was presumably male, perhaps a husband or brother. The base with the surviving Phileia, Philippe, and . . .oche, has now been set up in the Museum.

Second quarter of the sixth century B.C. Perhaps around 560.

Buschor, *Altsamische St.*, II, pp. 27 f., figs. 92-95; V, pp. 84 f., figs. 349, 350.
Jeffery, *Local Scripts*, pp. 73, 329.

68 : Figs. 221-224

BERLIN, STAATLICHE MUSEEN, inv. 1739.

Marble statue of Ornithe, from the same group as Philippe, no. 67. Height, with plinth, 1.68 m.; ht. of plinth 7 cm.
Found in the sanctuary of Hera, Samos.
The head, the feet, and most of the plinth are missing.

She stands, like Philippe, with both arms lowered, the left hand closed, and the right grasping a fold of the drapery.
Also like Philippe she wears a chiton, pulled over a belt to form pouches right and left, and fastened with buttons along the upper arms. The folds are likewise indicated in groups of incised lines forming ridges going in different directions. The hair, however, is treated differently; for though at the back it also falls down in a quadrangular mass of tresses, eight tresses are brought to the front and hang down four on either side.

The name 'Ορνίθη, Ornithe, 'little bird', is inscribed on the drapery, in the same place as is 'Philippe', i.e. halfway down the front, beneath the right hand.

Second quarter of the sixth century B.C., perhaps around 560.

Buschor, *Altsamische St.*, V, pp. 85 f., figs. 345-350; *Festschrift für B. Schweitzer*, p. 96.
Blümel, *Archaische griech. Sk.*, no. 36, figs. 102-105, 123.

69 : Figs. 225-227

SAMOS, MUSEUM OF VATHY.

Headless marble statue. Height 1.45 m.; height of plinth 6 cm.
Found in the Heraion of Samos.

Both arms are lowered, the right grasping a fold of the drapery, the left closed. She wears a chiton, pulled over the belt on either side to form pouches, and an epiblema, which covers the back. From the bottom protrude the two feet, the left a little advanced; the toes are parallel and their ends form a continuous curve. The folds are similar to those of Philippe and Ornithe, going in various directions, but executed with less care and refinement. There is no inscription. It is therefore excluded that the statue belonged to the Geneleos group, quite apart from the fact that the style is somewhat different. The date may be, however, in the same vicinity, that is, toward the end of the second quarter of the sixth century B.C.

Buschor, *Altsam. St.*, II, p. 32, figs. 112-114.

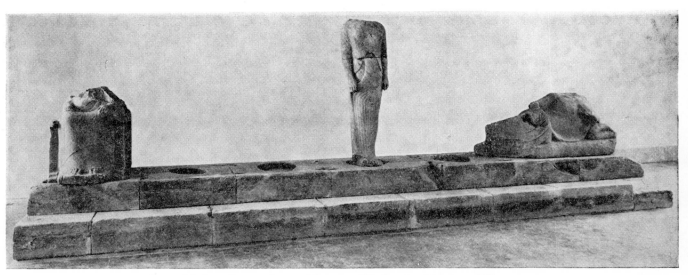

Base with three figures. Samos, Museum of Vathy. See No. 67 and Figs. 217-220.

70 : Fig. 228

BERLIN, Staatliche Museen, inv. 1792.

Votive relief of a young woman. Height, as preserved, 47 cm.
Greyish-white marble
Bottom missing.
From Miletos.

The figure is shown inside a niche-like frame, standing with both arms lowered and holding objects. She wears a chiton, drawn up above the belt on either side to form two kolpoi, and with three vertical folds running down between the legs. Also an epiblema, draped over her head and descending over both shoulders. On top of it is placed a broad cloth (?).
The head is large. The narrow eyes are incised, but with a slight indication of the curve of the upper lid. The nose is broad, and the mouth straight.
Second quarter of the sixth century.

Wiegand, *Berliner Museen*, XLVIII, 1927, pp. 62 f., fig. 2.
F. Poulsen, *Acta Arch.*, V, 1934, p. 52, fig. 5.
Blümel, *Arch. griech. Sk.*, no. 45, fig. 127.

71 : Fig. 229

BERLIN, Staatliche Museen.

Votive relief of two young women. Height 65 cm.
Greyish-white marble.
Found at Miletos.
Surface weathered.

The two figures are shown in front view, surrounded by a frame-like niche, made for insertion in a base; the tenon remains in part.
Each wears a chiton, pulled over a belt on the sides to form two kolpoi, and over it a short Ionic mantle, draped from the right shoulder to below the left armpit, and hanging down on the right side; also an epiblema descending from the back of the head over both shoulders.
The right arm is lowered, with the hand brought to the front and holding an object. The left arm is bent, with the forearm laid against the chest and the hand holding an object.
The feet appear at the bottom of the chiton, protruding within an arch-like opening.
The eyes are narrow, the nose broad, the mouth straight.
Second quarter of the sixth century B.C.

Berlin Museum, *Kurze Beschreibung*[3], p. 113, no. 1647.
Lippold, *Griech. Plastik*, p. 47. note 11.
Blümel, *Arch. griech. Sk.*, no. 44. fig. 126.

72 : Figs. 230, 231

BERLIN, Staatliche Museen, inv. 1898.

Upper part of a marble statuette. Height 15 cm.
Provenance not known.

Both arms were evidently lowered.
She wears a chiton, girded at the waist, and over it a short Ionic himation, draped from the right shoulder to below the left armpit. The hair descends in twelve, slightly wavy tresses at the back, and in front in two somewhat longer ones.
No folds are indicated.
The forms are slightly modelled beneath the drapery.
Second quarter of the sixth century B.C.

Blümel, *Arch. griech. Sk.*, no. 43, figs. 124, 125.

73 : Figs. 232-234

BERLIN, Staatliche Museen, inv. 1651.

Upper part of a marble statue. Height 29.5 cm.
The marble is greyish-white.
Found at Kalchedon, on the Bosphorus. Acquired by Berlin in 1907 in the antiquity market.

The left arm was lowered, the right is bent, with the hand laid flat against the chest.
She wears a chiton and a short Ionic himation, draped from the right shoulder to below the left armpit, and buttoned along the upper right arm.
On top of the head is a (battered) polos, decorated with a maeander pattern.
The hair falls down the back in an undifferentiated quadrangular mass, and three globular tresses descend in front on either side. Above the forehead it is rendered by broad ridges, directed downward.
The eyes have protruding eyeballs, with prominent ridges, and no indication of the curvature of the upper lid. The mouth curves slightly upward and has a vertical cut at the corners. The lower parts of the ears are hidden by large disk earrings which are decorated by a rosette pattern. The tragus is indicated.
Second quarter of the sixth century B.C.

Kurze Beschreibung[2], p. 113, no. 1651.
Schröder, *Arch. Anz.*, 1919, p. 93, no. 8.
V. Poulsen, *From the Collections*, II, 1938, pp. 108 f., fig. 31.
Blümel, *Staatliche Mus., Berlin, Kat.*, II, 1, no. A19, pl. 44; *Arch. griech. Sk.*, no. 27, figs. 74-76.

74 : Fig. 235

ATHENS, AKROPOLIS MUSEUM, no. 592.

Marble perirrhanterion. Height 43 cm.; ht. of best pre-
served kore *c.* 33.4 cm.
Put together from a number of fragments.
Found in 1888, south-west of the Parthenon. There
were apparently fragments of two perirrhanteria.

The ensemble consists of a circular, moulded base, on
which stood six female figures supporting a large bowl.
Of the latter fragments have also survived, two with
remains of inscriptions (cf. *C.I.G.*, IV, 373, 157).
The women wear belted garments, on which folds are
indicated, above the belt in a herring-bone pattern,
below in a strictly vertical scheme. The hair descends
on the sides in three thick tresses, divided horizontally.
The backs of the figures are left smooth. No head of a
kore remains. The feet are kept close together, with the
toes differentiated, the second longer than the big toe,
and the little toe curving inward.
The presence of the folds on the garment and the render-
ing of the feet suggest a later date than that of nos. 5 ff.;
perhaps around 580 to 570 B.C.

(Wolters), *Ath. Mitt.*, XIII, 1888, p. 440.
Lechat, *B.C.H.*, XIII, 1889, p. 142.
E. Gardner, *J.H.S.*, X, 1889, p. 265.
Dickins, *Cat.*, no. 592.
Payne and Young, *Archaic Marble Sc.*, p. 12, pl. 21.
Schuchhardt, in Schrader, *Marmorbildwerke*, pp. 325-330, figs. 375-
382.
Matz, *Gesch. d. gr. Kunst*, I, pl. 247, b, p. 382, figs. 28a, b.
Ducat, *B.C.H.*, LXXXVIII, 1964, pp. 596 f.

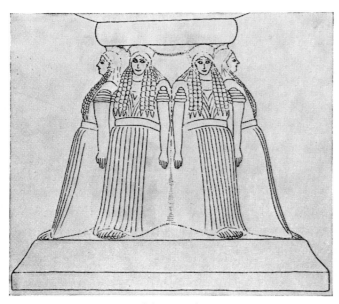

Reconstruction of the perirrhanterion No. 74.
From Schrader, *Marmorbildwerke*.

75 : Figs. 236-239

ATHENS, NATIONAL MUSEUM, 5.

Headless, marble statue. Height 28 cm.
Found at Eleusis.
The missing piece at the bottom has been restored.

The left arm was lowered as indicated by remains of the
attachment on that side. The right was evidently bent
at the elbow, and probably held an offering.
She wears a peplos, with overfold, belted at the waist,
with the ends of the belt hanging down in front. Also
an epiblema, of which the edges are shown along either
side in front.
The hair descends at the back as a solid mass, divided
horizontally, and in front, on either side, in three
globular tresses.
Early in the second quarter of the sixth century B.C.?
The general type is the same as in nos. 5 ff., but the style
is more advanced.

Philios, *Eph. arch.*, 1884, p. 179, pl. VIII, 1, 1a.
Von Lücken, *Ath. Mitt.*, XLIV, 1919, p. 80.
Kastriotes, *Glypta*, no. 5.
S. Karouzou, *Guide*, p. 21, no. 5.

76 : Figs. 249-252

ISTANBUL, ARCHAEOLOGICAL MUSEUM, 2357.
Acquired in 1910.

Headless marble statue. Height, as preserved, 62 cm.
Found at Lindos, Rhodes, during the excavations of
Kinch and Blinkenberg.
The middle portion of the left arm, and parts of the belt
have been restored in plaster.

Both arms descend along the sides, adhering closely to
the body, except for a short distance at the waist.
She wears a tight-fitting, belted, and sleeved peplos,
with no folds indicated. The hair falls down the back in
globular tresses, with three spirally twisted tresses
brought to the front on either side.
Since the form is similar to that of the perirrhanteria
nos. 5 ff., it has been surmised that this figure was part
of such an ensemble (cf. V. Poulsen, loc. cit.). The style
of this piece is, however, later than the perirrhanteria
from Isthmia, Rhodes, etc., perhaps nearer in date to
that from the Akropolis (my no. 74) and the figure from
Eleusis (my no. 75); for the forms of the body are
somewhat modelled, though retaining the columnar
all-over form. And if the head no. 77 belongs to this
body, as was thought by the excavator Kinch, then the
body could hardly be earlier than about 575 B.C.

Mendel, *Catalogue des sculptures, Musées Impériaux Ottomans*, III, no. 1396.

Blinkenberg, De Danske Ugravninger i Lindos, *Festskrift til Frederik Poulsen*, 1941, p. 10, fig. 7.

Lippold, *Griech. Plastik*, p. 18, note 3.

V. Poulsen, in Blinkenberg and Kinch, *Fouilles de l'Acropole, Lindos*, III, 1960, pp. 539 ff., figs. 1-7.

77 : Figs. 244-247

COPENHAGEN, NATIONAL MUSEUM, inv. no. 12199.

Marble head. Height 20 cm.
Found at Lindos, Rhodes, during the Danish excavations.

She wears a taenia and large disk earrings. The taenia is knotted at the back. The hair is arranged in band-like tresses on the skull, which then continue down the back. Above the forehead and temples it is rendered in wavy ridges passing from ear to ear, with a parting in the middle. The eyes are deep-set and obliquely placed, with the lids slightly differentiated. The lips curve upward, with deep grooves at their corners, and a hollow between the under lip and the chin. The skull is rounded. In the ear neither the tragus nor the antitragus is indicated.

Second quarter of the sixth century B.C.

'D'après une note dans les archives de la Mission de Lindos, le Dr. Kinch constata en 1918, à Copenhagen, que cette tête appartient au torse d'une femme revêtue d'un chiton ionien, envoyé au Musée de Constantinople' (V. Poulsen). Cf. my no. 76. Fig. 248 shows a cast in the National Museum of Copenhagen with this head and the body in Constantinople combined.

V. Poulsen, in Blinkenberg and Kinch, *Fouilles de l'Acropole, Lindos*, III, 1960, pp. 558 ff. figs. 33-38.

78 : Figs. 253-256

ISTANBUL, ARCHAEOLOGICAL MUSEUM. There is a facsimile in the British Museum.

Bronze statuette. Height 10.5 cm.
Found at Ephesos, beneath the floor of Croesus' temple. The surface has suffered, and some details are difficult to make out.

Both arms are lowered and adhere closely to the body, with the hands held open against the sides.
She wears a tunic, belted at the waist, in front of which are indicated vertical folds. The form is rigid, the head abnormally large, with large features. The eyeball protrudes; the lids are rendered by ridges. A curving groove

appears at the corners of the lips. The ear is stylized and placed obliquely. The hair hangs down as a solid, quadrangular mass at the back, and is also kept smooth over the rounded skull; above the forehead it is rendered by a row of large spirals.

Early in the second quarter of the sixth century B.C.? The face retains much of the farouche character of the seventh century, but the rendering of the folds suggests a date not far removed from that of the Berlin kore (no. 42).

Hogarth, *Excavations at Ephesos*, pp. 35 ff., pl. XIV.
Jacobsthal, *J.H.S.*, LXXI, 1951, p. 91.
Matz, *Geschichte d. griech. Kunst*, I, p. 162, pl. 70, a, p. 516, note 140.

79 : Figs. 240-243

ATHENS, NATIONAL MUSEUM, 4308. Acquired by purchase.
Terracotta statuette. Height 25.6 cm.
Provenance not known, but said to be from Tanagra (Winter).

Both forearms are extended and probably held offerings. The body is columnar. She wears a belted, foldless peplos, which covers her whole body and arms, and is decorated with painted patterns; also a wreath on her head.

The hair falls down her back in an undifferentiated mass, with two long tresses brought to the front on either side. Over the forehead it is rendered in several superimposed wavy ridges, with a parting in the middle. In the eyes the lids are indicated by ridges, with no indication of the curvature of the upper lid. The mouth curves upward, with a vertical groove at each corner. The nose is large. The ears are hidden by the hair.

Late in the second quarter of the sixth century B.C.

Winter, *Typen*, I, 32, no. 2.
Grace, *Archaic Sculpture in Boeotia*, pp. 38 f., fig. 42.

80 : Figs. 257-258

ISTANBUL, ARCHAEOLOGICAL MUSEUM.

Ivory statuette. Height 11.8 cm.
From Ephesos.

Both arms are lowered with the hands laid flat against the body. She wears a sleeved chiton, pulled over the belt on either side to form two small kolpoi. The breasts are prominently modelled beneath the drapery. An epiblema descends from the head, covering the entire back, and hiding the hair.

G

The eyes are roundish, with a slight indication of the curvature of the upper lid. The lips are straight and do not meet at the corners. In the ear the tragus is indicated as an excrescence from the lobe.

Second quarter of the sixth century B.C.

Hogarth, *Excavations at Ephesos*, p. 158, pl. XXIV, 3.
Jacobsthal, *J.H.S.*, LXXI, 1951, p. 93, pl. XXXVI, f.
Akurgal, *Die Kunst Anatoliens*, 1961, p. 200, figs. 160, 161.
Greifenhagen, *Jahrbuch der Berliner Museen*, VII, 1965, pp. 136 f., fig. 8.

81 : Figs. 259-262

ISTANBUL, ARCHAEOLOGICAL MUSEUM.

Ivory statuette, surmounted by a rod, terminating in the figure of a hawk. Height of statuette 10.7 cm.
Found at Ephesos. The ivory has split in places.

Both arms are lowered, adhering closely to the sides; the right hand holds a ewer, the left a basin, both of which she grasps by their handles.

She wears a sleeved chiton, pulled up on both sides front and back, to form small kolpoi. Decorative borders appear round the neck and along the arms; and down the middle of the front vertical ridges indicate folds. At the bottom the two feet protrude within an arch-like opening; they are set a little apart and have the toes parallel to one another, with the ends forming a continuous curve.

The hair descends at the back in a quadrangular mass, covered with delicately incised vertical lines. Two thick, undulating tresses descend in front on either side. In the ear are disk earrings, and above them sprial clasps in the hair. The eyes are long and narrow, with only a slight indication of the curvature of the upper lid. The lips curve upward and do not meet at the corners.

Second quarter of the sixth century B.C.

Since she holds a ewer and bowl or basin, she is presumably about to make a libation, and so has been interpreted as a priestess.

Hogarth, *Excavations at Ephesos*, pl. XXI, 6, pl. XXII, 1 a-e, pp. 156 f.
Langlotz, *Bildhauerschulen*, p. 119, no. 23, pl. 69, a.
Jacobsthal, *J.H.S.*, LXXI, 1951, p. 92, pl. XXXIV, f-h.
Akurgal, *Die Kunst Anatoliens*, pp. 204 ff., figs. 169-173; *A.J.A.*, LXVI, 1962, p. 376.
Greifenhagen, *Jahrbuch der Berliner Museen*, VII, 1965, pp. 137 f., figs. 9-12.

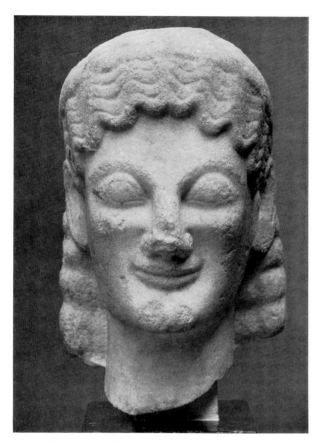

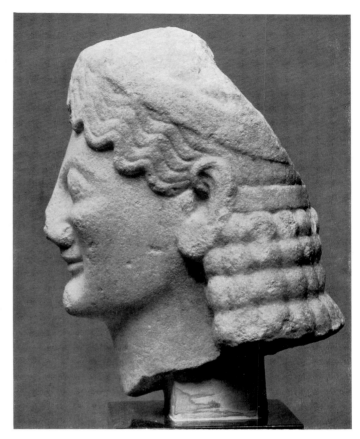

XIII–a, b. Head of a kouros from Thasos, c. 555–540 B.C. Copenhagen, Ny Carlsberg Glyptotek

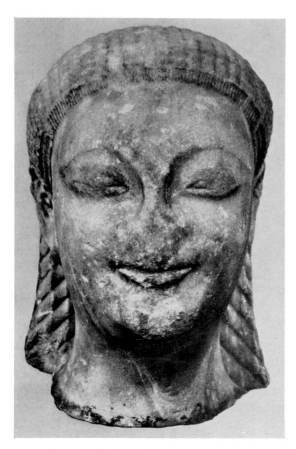

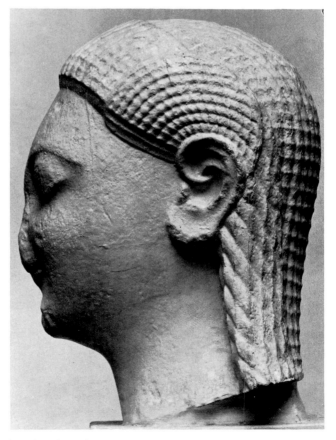

XIII–c, d. Head of a kouros from Samos, c. 555–540 B.C. Istanbul, Archaeological Museum

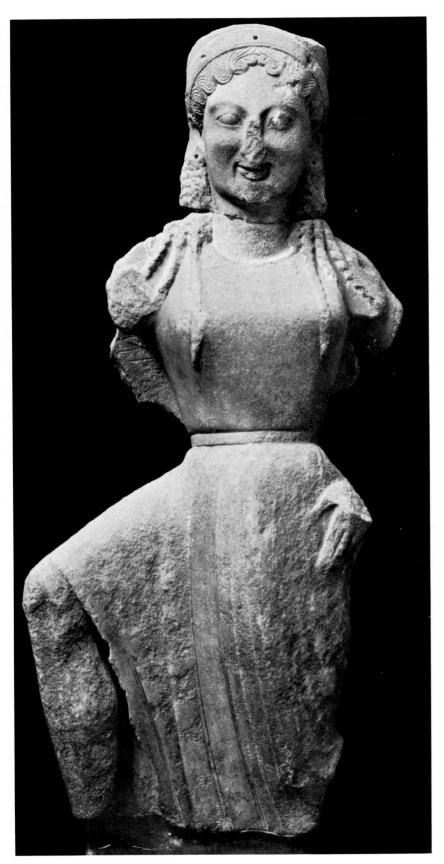

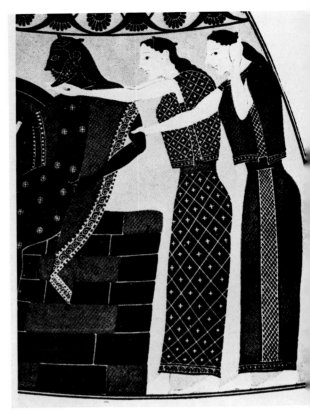

XIV–b. Women, on an amphora by Lydos, c. 550 B.C. Berlin

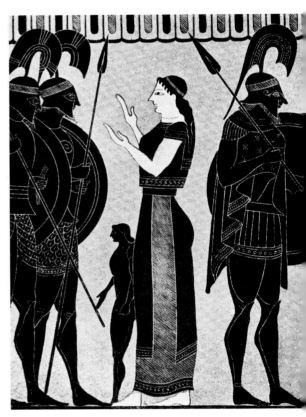

XIV–a. Nike from Delos, c. 550 B.C. Athens, National Museum

XIV–c. Woman, on an amphora by a painter of Group E, c. 540 B.C. Würzburg

GROUP IV: THE LYONS KORE—EPHESOS GROUP
(about 555-535 B.C.)

External Chronological Evidence and General Survey

FOR the dating of our fourth group of korai one can use an important piece of external evidence, namely the reliefs on one of the column drums of the temple of Kroisos at Ephesos; cf. nos. 82, 83, figs. 263-266, 269. Though this temple took a number of years to build, the sculptures in the earliest style may be assigned to *c.* 550 B.C., for Kroisos reigned 561-547. Furthermore, the head of the ex-Knidian karyatid (no. 86), being earlier in style than the Siphnian (cf. no. 104), which is securely dated a little before 525 B.C. (cf. infra), brings us to the same period of *c.* 550-535 B.C.

That is, this group of korai should be contemporary with the kouroi of the Melos group (*c.* 555-540 B.C.); and there is indeed a marked similarity between their features—in the forms of the eye (with the upper lid curving somewhat over the eyeball), the upward curving lips (with grooves surrounding them), the ear (with tragus marked but not yet the antitragus), and in the rendering of the hair (cf. plate XIII, a-d, and *Kouroi*[2], figs. 276-278, 302-311, 324-325, 328-329, 369-370[1]). Here too belongs the well-known Nike from Delos (plate XIV, a), also assigned to the middle of the sixth century.

A comparison with the contemporary vase-paintings is also helpful, though, as we have observed in the previous group, vase-painters were slower than sculptors to attack the problem of representing folds in drapery. And again it is interesting to note that the women by Lydos and other mid-sixth-century potters mostly wear the peplos, instead of the Ionic himation over the chiton (cf. my plate XIV, b, c; Beazley, *A.B.V.*; p. 109, no. 24 (Lydos); p. 134, no. 17 (Group E); Schefold, *Tausend Jahre*, figs. 241, 298). We shall see that not until the following period did the Eastern costume become general in Attica (cf. pp. 66 ff.).

One can observe in the examples of the korai of the fourth group many new factors, all in the direction of naturalism, though still within a strictly conventionalized scheme. Early in the group should come the Ephesian contingent, consisting of several heads and an important fragment of drapery (nos. 82-85); the 'ex-Knidian' head (no. 86); the headless karyatids of the Knidian Treasury of Delphi (nos. 87, 88); the kore of Lyons (no. 89); and the fragment signed by the sculptor Phaidimos (no. 91). And here should also belong, it would seem, the much discussed and differently dated metope from temple C of Selinus (no. 90).

Somewhat later one may place several heads from Anatolia and Samos (nos. 93-98); the limestone head from Sikyon in Boston (no. 99); and perhaps the little votary on the relief from Chrysapha (no. 92). These stone sculptures are supplemented by a number of bronze and terracotta statuettes (nos. 100-103), stemming from different localities.

[1] The head in Istanbul (my pl. XIII, c, d, and *Kouroi*[2], figs. 369-370) has now been shown to belong to a statue from Samos (cf. Buschor, *Altsamische St.*, IV, figs. 271-274, p. 68; Eckstein, *Antike Plastik*, I, pp. 47 ff., pls. 45-54; H. Walter, *Bauwerk und Bildwerk*, fig. 66).

Korai 82-103

82 : Figs. 263-265

LONDON, BRITISH MUSEUM, B91.

Marble head, from one of the columns of the archaic temple of Ephesos. Height 30.5 cm.
Traces of red paint in the hair.
Found by J. T. Wood during his excavations upon the site of the Temple of Artemis at Ephesos, 1869-1874.

She wears a stephane and disk earrings.
The hair is rendered on the skull and at the back by globular tresses, some of which are brought to the front on either side. Above the forehead it is arranged in wavy strands, directed right and left from a central parting. The upper eyelid is marked by two incised lines, and its curvature is indicated; there is no indication of the lachrymal caruncle. Enough remains of the lips to show that they curved upward, and that there was a groove at the corners. A deep hollow appears also right and left of the broad nostrils. In the ear the tragus has the form of a roundish protuberance.
About 550 B.C., the period of king Croesus: cf. Herod. I, 92, who states that 'most of the columns ($\tau\hat{\omega}\nu$ $\kappa\iota\acute{o}\nu\omega\nu$ $\alpha\acute{\iota}$ $\pi\circ\lambda\lambda\alpha\acute{\iota}$) were presented by king Croesus'. His reign is dated 560-546 B.C. or 555-541 B.C.

A. H. Smith, in Hogarth, *Excavations at Ephesos* (1908), p. 296, no. 29, 6, Atlas, pl. XVI, left.
Langlotz, *Zeitbestimmung*, p. 14.
Pryce, *Br. Mus. Cat.*, I, I, pp. 51 f., no. B91, pl. V.

83 : Fig. 266

LONDON, BRITISH MUSEUM, B88.

Left side of a marble female head, in relief. From one of the sculptured drums of the archaic temple of Ephesos (cf. under no. 82). Height 24 cm.
Traces of colour on lips.

She was turned in three-quarter view to the left, and wears a taenia across the forehead and a veil over her head. Between taenia and veil appears a thick, wavy band to indicate the hair.
The eye is long and narrow, with a distinction between the two lids, and some indication of the curvature of the upper one.
The lips do not meet at the corners, and there is a deep oblique groove between them and the cheek. Of the ear is still visible the large disk earring, with a tress of hair beneath.

About 550 B.C.

A. H. Smith, in Hogarth, *Excavations at Ephesos*, p. 296, no. 34, Atlas, pl. XVI, 7.
Pryce, *Br. Mus. Cat.*, I, I, B88, p. 50, fig. 40.

84 : Figs. 267-268

LONDON, BRITISH MUSEUM, B89.

Fragment of a marble head. Height 19 cm.
Only part of the face is preserved.
Found near the temple of Artemis at Ephesos. Not certain that it belonged to one of the drums.

The head was turned in three-quarter view to the left. The nose is broad with large nostrils. The eyes are long and narrow, and set obliquely; the two corners are differentiated, but the curvature of the upper lid over the eyeball is barely indicated.
The lips are long and narrow, and do not meet at the corners; the upper is longer than the lower.
About 550 B.C.

A. H. Smith, in Hogarth, *Excavations at Ephesos*, p. 296, no. 33, Atlas, pl. XVI, 6.
Langlotz, *Bildhauerschulen*, pp. 103, 107, pl. 61.
Pryce, *British Museum Cat.*, I, I, B89, pl. IV.
Lullies and Hirmer, *Griech. Plastik*, p. 43, figs. 38, 39.
Himmelmann-Wildschütz, *Istanbuler Mitteilungen*, XV, 1965, pp. 37 f., pl. 18.

85 : Fig. 269

LONDON, BRITISH MUSEUM, B119.

Fragmentary female figure, in relief. Height 35 cm.
From one of the columns of the archaic temple of Artemis, at Ephesos (cf. under no. 82).
Traces of a painted maeander pattern on the lower part of the chiton.

She wears a chiton, pulled up a little over a broad belt to form bunched folds, and over it a short Ionic himation, obliquely draped from the right shoulder to beneath the left armpit.
Middle of the sixth century B.C.
The fragment was formerly combined with the head B91 (my no. 82) in a reconstructed column, put together by A. S. Murray; cf. A. H. Smith, *Brit. Mus. Catalogue of Sculpture*, I (1892), pl. I; but the fragments have since

been separated, for they could not be proved to have belonged together.

A. H. Smith, in Hogarth, *Excavations at Ephesos*, p. 296, no. 31, Atlas, pl. XVI, 26.
Langlotz, *Bildhauerschulen*, p. 173.
Pryce, *Brit. Mus. Cat. of Sculpture*, I, I (1928), p. 58, B119, fig. 61.

86 : Figs. 270-274

DELPHI, Museum.

Marble head of a karyatid. Height, with polos and capital, 84 cm.; ht. of head 40 cm.
Marble said to be Parian.

The head was formerly thought to belong to the fragmentary statue of a karyatid belonging to the Knidian Treasury (cf. no. 87); but on the discovery of fragments which joined at the top of that statue and showed a different rendering of hair from that of this head, the theory had to be abandoned (cf. under no. 87). The head must, therefore, have belonged to a karyatid of some other building.

Beneath the polos is a fillet, encircling the hair. Above it the hair is rendered in overlapping wavy bands (divided into two sections along the middle), which then continue below the fillet down the back. Above the forehead are horizontal wavy ridges, surmounted by vertical ones. The eyeballs were inlaid separately and are missing. The lips curve upward and there is a deep groove at the corners.

In the ear the tragus is rendered as a modelled form: disk earrings are carved on the lobes; in the centre of the disk is a hole for the attachment of an ornament, presumably of metal. Holes are also visible on the taenia, at the bottom of the polos, and at the top of the front fringe of hair—all for the insertion of ornaments.

The head has been associated with the capital shown in fig. 270. The forms of the features place the head around the middle of the sixth century, contemporary with some of the heads from the Croesus column (cf. nos. 82, 83), the Nike of Delos (cf. pl. XIV, a), and the kouroi of the Melos group—that is, two decades or so before the Siphnian karyatid (no. 104).

And this dating is substantiated by the style of the figures on the polos (fig. 274) which include a Hermes with a 'split chiton', a representation current in the middle and third quarter of the sixth century, but not later; cf. Richter, *B.C.H.*, LXXXII, 1958, pp. 92 ff.

Picard and De La Coste Messelière, *F.d.D.*, IV, 2, 1928, pp. I ff., figs. I-3, pls. hors texte I, II, pl. XXII.
De La Coste Messelière, *B.C.H.*, LXII, 1938, pp. 285 ff., and LXXVII, 1953, pp. 346 ff.; *Rev. arch.*, 1940, 2, pp. 103 ff.; *Delphes*, 1957, pp. 319 f., pls. 56-59.

Lippold, *Gr. Plastik*, p. 64, pl. 15, 3.
Darsow, *Mitt. des Deutschen Archäologischen Instituts*, LXXV, 1950, pp. 119 ff.

87, 88 : Figs. 282, 283

DELPHI, Museum, 1526.

Two fragmentary marble Karyatids of the Knidian Treasury of Delphi.

87. The right arm is lowered and grasps a fold of the drapery. The left is missing, but was apparently also lowered.

She wears a chiton, and over it a short Ionic himation, draped over both shoulders and hanging down in vertical, stacked folds of some depth. The folds of the chiton, on its lower portion, are rendered by incisions, radiating toward the right hand.

Above the right wrist is a spiral bracelet.

88. Similar to the preceding, but with the action reversed, that is, grasping the drapery with the left instead of the right hand.

To this fragment were added some pieces of the body and legs formerly attributed to the pediment of the Temple of Apollo; cf. *F.d.D.*, IV, 2, p. 8, fig. 7.

Around the middle of the sixth century B.C.

The head no. 86 used to be connected with the statue no. 87, since stylistically it seemed to fit. In 1938, however, the top fragment of this statue was found and later another fragment with the hair at the back, not of the same type as that on the head; so head and body have become independent of each other.

De La Coste Messelière and C. Piccard, *F.d.D.*, IV, 2, p. 7, fig. 5, p. 8, fig. 7; IV, 3, p. 53, no. XLVII, f., p. 65, no. IX (hors texte, VII, fig. 9).
De La Coste Messelière, *B.C.H.*, LXII, 1938, pp. 285 ff., pl. XXIX.
De La Coste Messelière and Marcadé, *B.C.H.*, LXXVII, 1953, pp. 346 ff., pl. XLI, fig. I.

89 : Figs. 275-281

LYONS, Musée (upper part) and ATHENS, Akropolis Museum, 269+163+164 (lower part).

Marble statue. Height of upper part 62 cm.; of lower 65 cm.; ht. of whole *c.* 1.13 m.
Marble said to be Pentelic.

The upper portion was known in Marseilles as early as 1719, and has been in the Museum of Lyons since 1810. The exact provenance is not definitely known—though in a catalogue of 1887 it is said to have been found 'in Marseilles, in the rue des Consuls'. That the upper and lower portions—and two pieces of the left arm—belonged together was discovered by Humfry Payne (cf. loc. cit.).

The left arm was lowered, with the hand placed against the upper leg and grasping a fold of the drapery. The right arm is bent and brought to the front of the body, with the hand holding a dove.

She wears a chiton with long, tight sleeves, and over it a short Ionic himation, draped from the left shoulder to considerably below the right armpit, forming stacked folds in two directions, with zigzag edges at the bottom. On her head is a polos.

The hair falls down the back in a mass of globular tresses, and three similar tresses descend in front on either side. Above the forehead it is rendered by wavy grooves and ridges. At the back appears a triple fillet.

In the eye the curvature of the upper lid is indicated, and the lower lid is in a lower plane than the upper. The full lips are straight, with a vertical groove at the corners. In the rather cursorily worked ear the tragus is marked, but not the antitragus. To the lobe is attached an earring with pendants (cf. p. 11).

Middle of the sixth century B.C.

For a detailed account of the early history of the statue in Lyons cf.:

Lechat, *Aphrodite archaïque*, Lyon, 1919; Michon, *Comptes rendus de l'Académie des inscriptions et belles-lettres*, 1936, pp. 367 ff.; Grosson, *Recueil des antiquités et monuments*, Marseille, 1773, p. 171, no. 2, p. 25, 2.

P. Dissard, *Catalogue sommaire des Musées de la ville de Lyon*, 1887, p. 121, no. 1.
Payne and Young, *Archaic Marble Sc.*, pp. 14 ff., pls. 22-26.
Langlotz, in Schrader, *Marmorbildwerke*, pp. 66 f., no. 25, pl. 21, nos. 36, 37.

90 : Figs. 286, 287

PALERMO, Museo Nazionale.

Athena, on a metope from temple C at Selinus, with Perseus cutting off the head of Medusa. Height of metope 1.47 m.
Of tufa.
Put together from many pieces.
Most of the neck and parts of the body are restored in plaster.
Found on the site of the temple in 1822 by the English architects S. Angell and W. Harris.

She stands with head frontal and feet in profile to the right; the left arm is extended, the right brought to the chest.

She wears a peplos with overfold, open along the right side, with asymmetrically stacked folds hanging down below, and with a large central fold decorated with a painted maeander; also an epiblema, visible on the left shoulder, with hanging ends.

The hair is indicated above the forehead by wavy ridges. The eyes are large, with strongly arched upper lids, and with a broad groove between them and the eyebrows. The mouth is straight and the lips do not meet at the corners, where grooves are carved at the juncture with the cheeks.

The date assigned to this metope has fluctuated from early in the sixth century to late in that century; and indeed the renderings combine early with some late features, such as the symmetrically stacked folds of Perseus' chiton, which, according to representations in vase-paintings, do not appear until the last quarter of the sixth century (cf. Langlotz, *Zeitbestimmung*, p. 37). On the other hand, the forms of the features and the stance of the Athena can hardly be dated later than about 540 B.C. Moreover, 'the architectural design of temple C seems to be of the middle of the sixth century B.C.'; cf. Dinsmoor, *The Architecture of Ancient Greece*, p. 80. We may, therefore, assume that 'the erection of the temple occupied a rather long period, from about 550 to about 530 B.C.' (cf. Dinsmoor, op. cit., p. 83), and also that perhaps the late rendering of Perseus' symmetrically stacked folds was due to a later recarving,[1] in the same 'effort to modernize' which is shown in some architectural features (cf. Dinsmoor, op. cit., p. 80).

P. Pisani, *Memoria sulle opere di scultura scoperte ultimamente in Selinunte* (Palermo 1823).
Benndorf, *Die Metopen von Selinunt*, pp. 44 ff., pl. 1.
Picard, *Manuel*, I, pp. 351 f., fig. 99.
Lippold, *Griech. Plastik*, p. 91, pl. 29, no. 1.
Also Dinsmoor and Langlotz, locc. cit.

[1] This possibility was first pointed out to me by Mr. Ross Holloway, but I have not been able to re-examine the surface from this viewpoint.

91 : Figs. 284-285

ATHENS, National Museum, 81.

Feet of a marble statue, mounted on an inscribed base signed by the sculptor Phaidimos. Height, with base, 1.35 m.
Found in a cemetery at Vourva in Attica.

The feet are mounted on a plinth, which in turn was mounted on a three-stepped limestone base, of which the top block bears a dedicatory inscription. The two lower blocks have been reconstructed from a base of similar shape found on the Akropolis (cf. S. Karouzou, loc. cit.).

On the feet are sandals with high soles and straps. The toes point downward; they have knobby joints and slender phalanges. The second toe is shorter than the big toe.

The inscription reads: [σῆμα τόδ -∪∪-] γε Φίλες ꞉ παιδὸς κατέθεκεν ꞉ καλὸν ἰδὲν ἀϜυτὰρ ꞉ Φαιδίμος ꞉ ἐργάσα[το, '. . . set me up as a monument, beautiful to behold, of his daughter Phile; and Phaidimos made me'.

About 540 B.C.

On the inscription see now the publication by M. Guarducci, in her appendix of my *Archaic Gravestones of Attica*, p. 157, fig. 200, with numerous references, including Peek, *Griech. Versinschriften*, I, no. 74; *Grabgedichte*, 1960, p. 66, no. 52. On the sculptor Phaidimos, see M. Guarducci, op. cit., pp. 157 f.; Karouzos, *Epitymbion Tsounta*, 1941, pp. 542 f., 572.

Arch. Deltion, 1890, p. 103, no. 18.
Kastriotes, *Glypta*, no. 81.
Collignon, *Statues funéraires*, p. 34, fig. 14.
Eichler, *Oest. Jahr.*, XVI, 1913, pp. 98 ff.
S. Karouzou, *Guide*, p. 23, no. 81.
Jeffery, *Local Scripts*, pp. 72 f., 77, no. 23.
Guarducci, loc. cit.
Dörig, 'Phaidimos', *Arch. Anz.*, 1967, pp. 15 ff.

92 : Fig. 288

BERLIN, Staatliche Museen, inv. 731.

Female votary, on a hero relief of greyish-blue marble. Height of the relief 87 cm.
She stands behind a male votary, both approaching two seated figures.
Found south of Chrysapha, near Sparta.

She is shown in profile to the left, holding a lotus bud in her right hand, a pomegranate in her left. She wears a sleeved chiton with overfold, buttoned along the upper arm, and a taenia on her head. The hair descends in a single tress down her back, with a short tress shown in front of the ear.
The eye is elongated; the lids are indicated by ridges. The lips do not meet at the corners. In the ear the tragus is marked, but not the antitragus.

About 540 to 530 B.C.

Rhomaios, *Ath. Mitt.*, XXXIX, 1914, p. 224.
Dressel and Milchhöfer, *Ath. Mitt.*, II, 1877, p. 307, pl. 20.
Tod and Wace, *Catalogue of the Sparta Museum*, p. 102, fig. 1.
Blümel, *Staatl. Museen, Berlin, Kat.*, II, 2, no. A12, pls. 22, 24; *Arch. griech. Sk.*, no. 16, figs. 42-44.

93 : Figs. 289-290

BERLIN, Staatliche Museen, inv. 1852.

Marble female head. Height 25 cm.
Much battered.
Said to be from Anatolia. Acquired by T. Wiegand in 1932 in the antiquity market, and presented to the Berlin Museum.

The hair hangs down at the back in an undifferentiated mass, and at the sides in three rope-like tresses. Over the forehead it is arranged in wavy ridges. The eyes are deep-set. The mouth is more or less straight, with a hollow at each corner.
About 550-540 B.C.

Blümel, *Arch. griech. Sk.*, no. 28, figs. 77-80.
Himmelmann-Wildschütz, *Istanbuler Mitteilungen*, XV, 1965, p. 39, pl. 20.

94 : Figs. 291-292

BERLIN, Staatliche Museen, inv. 1634.

Marble head. Height 21 cm.
Much battered.
Found at Miletos.

The hair is rendered in a series of strands, divided horizontally, the two middle ones strictly vertical, the others veering to the right and left. Above the forehead and temples are four rows of small, circular curls, with a parting in the middle. In the ear the tragus is rendered as a large knob; the lobe is hidden by the disk earring. The heavy features are typically Eastern.
Middle of the sixth century B.C.

Blümel, *Arch. griech. Sk.*, no. 57, figs. 156-158.

95 : Figs. 293-295

BERLIN, Staatliche Museen, inv. 1631.

Marble head. Height 21 cm.
Not certain whether it came from a standing or a seated statue.
Found at Miletos, near the temple of Athena.

She wears a veil (probably an epiblema) over her head, through which the outlines of the ears are visible, but which hides the hair above the forehead and at the back. The eyes are long and narrow, with a slight indication of the curvature of the upper lid over the eyeball. The lips curve a little upward and are carved deeply into the face, with hollows surrounding them.
About 540 B.C.

Wiegand, *Ant. Denk.*, III, p. 52, fig. 8.
Langlotz, *Bildhauerschulen*, p. 123, pl. 70, b.
Lippold, *Griech. Plastik*, p. 54, note 9.
Blümel, *Arch. griech. Sk.*, no. 58, figs. 159-61.
Akurgal, *A.J.A.*, LXXVI, 1962, p. 376, pl. 100, fig. 19.
Himmelmann-Wildschütz, *Istanbuler Mitteilungen*, XV, 1965, pp. 38 f., pl. 16.

96, 97 : Figs. 296-300

BERLIN, STAATLICHE MUSEEN, inv. F724, F725.

Two marble heads—one with part of the upper portion of the body—carved in marble, in high relief. Heights 55 cm. and 27 cm.
Found at Didyma, on the south side of the temple of Apollo. They formed part of the decoration of the base of a column.

96. She wears a chiton, and an epiblema which hangs from the back of her head over her shoulders. On her head is a thick double taenia, from which descend spiral bands on either side. The eyes are long and narrow, with some indication of the curvature of the upper lid over the eyeball. The nose has broad nostrils. The mouth is carved into the face with surrounding hollows.
97. Similar to the preceding, but with nothing of the body preserved.
Together with these two pieces were found two further fragments, one from the top of a head, the other from the bottom of a column, with the foot of a standing figure; cf. Blümel, loc. cit., figs. 167, 168.

Wiegand, *Didyma*, I, pp. 123, 190, 196-198, pl. 214.
Greifenhagen, *Antike Kunstwerke*, Berlin, 1961, p. 1, pl. 1.
Akurgal, *A.J.A.*, LXXVI, 1962, pp. 376 f., pl. 100, fig. 20.
Blümel, *Arch. griech. Sk.*, no. 59, a, b, figs. 162-166.
Lullies and Hirmer, *Griech. Plastik*, fig. 40, p. 43.
Gruber, *J.d.I.*, LXXVIII, 1963, pp. 106 ff.
Hahland, *J.d.I.*, LXXIX, 1964, pp. 168 f., figs. 21-24.
Himmelmann-Wildschütz, *Istanbuler Mitteilungen*, XV, 1965, p. 38, pl. 19, 1, 2.

98 : Figs. 304-305

BERLIN, STAATLICHE MUSEEN, inv. 1874

Marble head. Height 11 cm.
Found in the Heraion of Samos.

She wears an epiblema, which covers her head and hung down from the shoulders. Through it the outlines of the ears are visible, but the hair is hidden.
The eyes are set obliquely, with strongly marked lids, and little indication of the curvature of the upper one. The lips do not meet at the corners and there are hollows surrounding them.
About 550-540 B.C.

Buschor, *Altsam. St.*, V, p. 97, figs. 395, 396.
Blümel, *Arch. griech. Sk.*, no. 41, figs. 118, 119.

99 : Figs. 301-303

BOSTON, MUSEUM OF FINE ARTS, 04.10. Henry L. Pierce Fund, 1904.

Limestone head. Height 17.5 cm.
Found at Sikyon.
Traces of colour.

She wears a stephane and disk earrings.
The hair radiates in ridges from a horizontal groove on the skull, and then falls down at the back and sides in tresses, divided horizontally; above the forehead and temples it is rendered in a series of vertical ridges terminating in spirals.
The eyes are slanting; there is little indication of the curvature of the upper eyelid. The lips curve upward. In the ears the tragus is indicated, but not the antitragus.
Middle of the sixth century B.C.

Burlington Fine Arts Club, Exhibition of Greek Art, 1904, p. 80, no. 49.
L. D. Caskey, *Cat.*, no. 5.
Chase, *Guide*, 1950, p. 30, fig. 35.

100 : Figs. 306-308

BERLIN, STAATLICHE MUSEEN, 7933.

Bronze statuette. Height 21.6 cm.
Served as part of some utensil, of which the capital-like top remains.
From Sparta.

The right arm is bent and holds a lotus bud in the hand; the left arm is lowered, with the hand grasping a fold of the drapery.
She wears a chiton and a short Ionic himation (?), draped obliquely from the right shoulder to well below the left armpit, but without the upper band and without the more or less vertically stacked folds, and also with no indication of folds at the back.
The hair falls down the back in a solid mass of tresses, with several similar ones brought to the front on either side.
The eyes are elongated and slightly slanting, with no indication of the curvature of the upper lid over the eyeball. The lips curve upward, and do not meet at the corners. In the ear the tragus is indicated but not the antitragus.
Around the middle of the sixth century B.C.
If the mantle was intended for a short Ionic himation, it would be an early example of the wearing of this garment in continental Greece. It seems to be either a misunderstood version of this Ionic costume, or was intended for a simple himation, draped like the Ionic, i.e. obliquely, and hanging down in stacked folds on one side.

Neugebauer, *Berliner Museen*, XLV, 1924, p. 31.
Führer, Berlin Museum, Bronzen, 1924, p. 31, no. 7933, pl. 5.
Charbonneaux, *Les bronzes grecs*, p. 70, pl. VIII, 2.

101 : Figs. 309-312

BERLIN, Staatliche Museen, no. 8622.

Bronze statuette; once the support of a mirror? Mounted on a base. Height 17 cm.
The surface is much weathered.
Said to have been found in Athens, on the northern slope of the Akropolis.

The right hand is brought to the front of the chest and holds an object; the left arm is lowered, with the hand grasping a fold of the drapery.
She wears a chiton, of which the folds are indicated by incised lines.
The hair hangs down her back.
Around the middle of the sixth century B.C.

Pernice, *Arch. Anz.*, 1904, pp. 22 ff., no. 3.
V. Müller, *Berliner Museen*, XLIII, 1922, p. 31, fig. 31.
Führer, Berlin Mus., Bronzen, 1924, p. 31, no. 8622, pl. 14.
Buschor, *Altsamische St.*, v, pp. 94 f., figs. 380-383.

102 : Figs. 313-314

LONDON, British Museum, inv. 75.3-9.20.

Terracotta statuette. Height 25 cm.
The body is built, the face moulded.
Said to be from Tanagra.
Flat front and back, with spreading base. The arms are rendered as triangular stumps.
She wears what is apparently intended for a peplos with overfold, and a polos; also a necklace with a central pendant. Black decorative patterns are added on both garment and polos. No folds are indicated.
The hair falls down the back in five tresses, and three similar ones are brought to the front on either side. Over the forehead it is indicated by wavy bands. In the eyes the curvature of the upper lid is not marked. The lips curve upward, and are undifferentiated. The ears are stylized.
Around the middle of the sixth century B.C.

Winter, *Typen*, I, pl. 9, no. 2, g.
Walters, *Cat. of Terracottas, Br. Mus.*, B58, pl. XVI.
Grace, *Archaic Sculpture from Boeotia*, p. 37, fig. 37.
Higgins, *Terracottas in the British Museum*, I, p. 208, no. 779, pl. 104; *Greek Terracottas*, pl. 18, E.

103 : Figs. 315-316

PARIS, Louvre, inv. 1643.

Terracotta statuette. Height 21.3 cm.
The body is built, the face moulded.
Found at Thisbe in Boeotia.

Flat front and back, with spreading base. The arms are rendered as triangular stumps, and the breasts as protruding rosettes.
She wears a peplos with what seems to be intended as an overfold, and a necklace with pendant; on her head is a polos. Black decorative patterns take the place of folds.
The hair falls down the back and sides in black tresses. There is no indication of the curvature of the upper lid in the eye; the undifferentiated lips curve slightly upward; the ears are stylized.
Around the middle of the sixth century B.C. Similar to no. 102.

Winter, *Typen*, I, pl. 9, 2, c.
Collignon, *Histoire de la sculpture grecque*, I, p. 109, fig. 54.
Grace, *Archaic Sculpture from Boeotia*, p. 38, no. 3, fig. 45.
Besques-Mollard, *Catalogue*, I, B64, pl. VIII.

GROUP V: THE SIPHNIAN TREASURY—TEMPLE OF APOLLO GROUP

(about 535-500 B.C.)

General Survey and External Chronological Evidence

IN the last third of the sixth century the korai begin to multiply, for the excavations on the Athenian Akropolis have yielded a large number of examples, and they have been supplemented by others from elsewhere. Since their number is so large, I have—exceptionally—in this section divided them into a number of groups, according to where they were *found*. A comparison between them seems to me very instructive; for they appear to be essentially uniform, from whatever region they emanate.

Compared with the korai of the previous groups a new freedom may be observed. There is an increasing depth in the carving of the folds; they go in many different directions, giving animation to the general effect, and their composition becomes more and more elaborate.

Concurrently the features—the eye, mouth, and ear—have assumed more naturalistic forms.

For the absolute dating of this fifth group there are several important indications. For its upper limit there is the karyatid of the Siphnian Treasury at Delphi (no. 104), and the two female figures from its pediment (no. 105), as well as the Athena from the old Athena temple on the Athenian Akropolis (c. 520; cf. Schrader, *Marmorbildwerke*, pp. 345 ff., pls. 185-188, 190; Lippold, *Gr. Plastik*, p. 75, pl. 21, no. 1). For the lower limit one can use the korai on the pediment of the temple of Apollo at Delphi (no. 106), and some of the figures from the metopes of the Athenian Treasury, also at Delphi (no. 108). (On the dating of these monuments cf. infra.)

Moreover, a comparison between the heads of the korai of this group and those of the earlier members of the Ptoon 20 group of kouroi (cf., e.g., plate xv, a-b) shows striking similarities: The skull is spherical. In the ear the tragus assumes its natural shape and the antitragus is regularly indicated. The lips are well shaped, and the transition between their corners and the cheeks is no longer abrupt. In the eyes the lachrymal caruncle is often indicated, and the curvature of the lids is finely rendered.

Helpful comparisons can also be made with the vase-paintings of the last third of the sixth century, where the folds of draperies are now indicated, and the forms of the bodies beneath are often suggested. One may cite some of the works of Exekias (cf. plate xv, c; Beazley, *A.B.V.*, p. 145, no. 13), by the Andokides Painter (plate xv, b; cf. Beazley, *A.R.V.²*, p. 3, no. 1); by Psiax (plate xv, e; cf. Beazley, *A.R.V.²*, p. 7, no. 3); and the cup signed by the potter Chelis (plate xvi, a; cf. Beazley, *A.R.V.²*, p. 112, no. 1). And then, a little later, the paintings by the early Berlin Painter (plate xvi, b; cf. Beazley, *A.R.V²*, p. 204, no. 109); by Euphronios (plate xvi, d; cf. Beazley, *A.R.V²*, p. 14, no. 2); by the Kleophrades Painter (plate xvi, c; cf. Beazley, *A.R.V²*, p. 182, no. 4); by Sosias; and others.

We find there a rich variety of folds, both of the chitones and of the short Ionic mantles, rendered by vertical, oblique, radiating, wavy, and zigzag lines, in great profusion, comparable to those on the sculptured korai of this group. The length of the chiton worn by the women is graphically

XV–a, b. Head of a kouros from the Ptoan Sanctuary in Boeotia, c. 520–500 B.C. Athens, National Museum

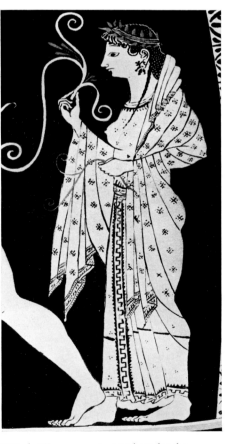

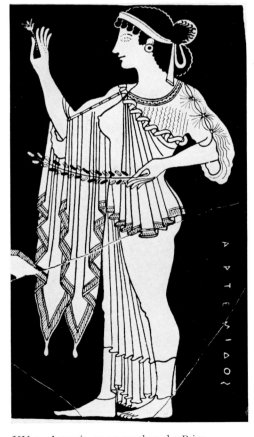

XV–c. Leda, on an amphora by Exekias, c. 530 B.C. Vatican

XV–d. Woman, on an amphora by the Andokides Painter, c. 520 B.C. Berlin

XV–e. Artemis, on an amphora by Psiax, c. 520 B.C. Philadelphia

XVI–a. Maenad, on a kylix by the Chelis Painter, c. 510 B.C. Munich

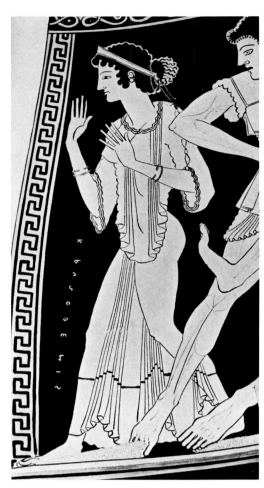

XVI–b. Chrysothemis, on a pelike by the early Berlin Painter, c. 500 B.C. Vienna

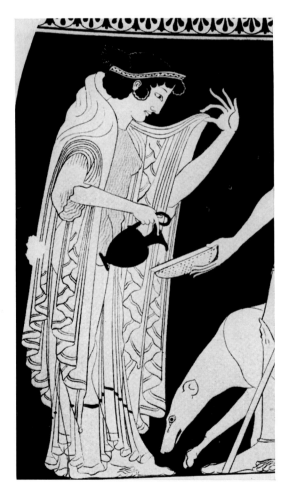

XVI–c. Woman, on an amphora by the Kleophrades Painter, c. 500 B.C. Munich

XVI.–d. Woman, on a kalyx krater by Euphronios, c. 505 B.C. Louvre

indicated by that of the Maenad, pl. xvi, a, where a satyr has grasped one end of it. No wonder this garment had to be lifted by one hand, as shown in our korai. And that this should be done gracefully is impressed on us by Sappho's remark to one of her young girls (cf. p. 10).

The Dates of the Siphnian Treasury, the Temple of Apollo, and the Athenian Treasury at Delphi

As the dates of some of the monuments above cited, that is, the Treasury of the Siphnians, the Temple of Apollo, and the Athenian Treasury at Delphi, have been disputed, and as they must serve as cornerstones for the dating of the late archaic korai, I will reiterate the rather complicated evidence, and add here and there a new argument.

The Siphnian Treasury

According to Herodotos (III, 57, 58) a mysterious adverse oracle was given to the Siphnians 'when they enquired whether their present prosperity was likely to last a long time, while they were building their treasury at Delphi', ὅτε ὦν ἐποιεῦντο τὸν θησαυρόν, ἐχρέωντο τῷ χρηστηρίῳ εἰ αὐτοῖσι τὰ παρεόντα ἀγαθὰ οἷά τε ἐστὶ πολλὸν χρόνον παραμένειν. And this oracle was fulfilled by a Samian attack in which the Siphnians were worsted and had to pay 100 talents to the Samians. The Samian attack is dated in 525 B.C. through its connection with Kambyses' attack on Egypt, which took place in the fifth year of Kambyses' reign, i.e. in the spring of 525 B.C. (cf. Gauthier, *Le Livre des rois d'Égypte*, IV, pp. 135 ff.). Some have accordingly dated the Siphnian Treasury in the year 525; but, as the Treasury must have taken some time to build, and nowhere shows an unfinished state, it must surely be dated *before* 525, though probably not long before that date, let us say *c.* 530–525.

One must also remember that Pausanias (x, 11, 2) gives a different version from that of Herodotos: 'The Siphnians too made a Treasury, the reason being as follows. Their island contained gold mines, and the god ordered them to pay a tithe of the revenues to Delphi. So they built the Treasury, and continued to pay the tithe, until greed made them omit the tribute, when the sea flooded their mines and hid them from sight.' . . . οἱ δὲ τὸν θησαυρὸν ᾠκοδομήσαντο καὶ ἀπέφερον τὴν δεκάτην. ὡς δὲ ὑπὸ ἀπληστίας ἐξέλιπον τὴν φορὰν ἐπικλύσασα ἡ θάλασσα ἀφανῆ τὰ μέταλλά σφισιν ἐποίησεν. Here a certain interval is implied between the building of the Treasury and the calamity that befell the Siphnians—whatever its cause. So we are again led to a date *before* 525 B.C. for the sculptures of this Treasury.

The Temple of Apollo

The date of the Alkmeonid temple at Delphi has fluctuated from *c.* 515 B.C. to after 510 B.C., according to whether one puts one's faith in the statements of Herodotos (v, 62) and Aristotle (*Constitution of Athens*, 19, 3-4), who both state that the Alkmeonids undertook the building of the temple after the battle of Leipsydrion (*c.* 513 B.C.) and finished it with a marble front instead of the specified one of poros; or if one believes Philochoros (Fr. 115) who would have this happen after 510 (cf. Jacoby, *Frag. griech. Hist.*, Teil III B, Supplement vol. I, 1954, no. 328 (Philochoros), pp. 449 f. (Fr. 115).

Perhaps I can add to the philological arguments advanced in the discussion of these passages, a

small archaeological one. The pediment of this temple of Apollo contains in addition to the two korai nos. 106, 107, several kouroi. Anatomically the latter can be placed in the Ptoon 20 group (520-485 B.C.), but *early* in this group (cf. *Kouroi*², pp. 130, 140, no. 162, figs. 500-503), for they combine the advanced anatomical renderings typical of this group with such earlier renderings as level flanks and a fairly narrow arch for the lower boundary of the thorax (cf. plate XVII, a).

The korai on this pediment may, therefore, be dated *c.* 510 B.C., hardly later. The difference in the proposed dates is of course small; but we are approaching a period when the style of Greek sculptors changed more rapidly than before—and our absolute dates are more firmly established—so even a decade or so must be taken into account.

The Athenian Treasury

For the date of the Athenian Treasury at Delphi one has also to choose between two assignments, both vigorously expounded by their sponsors: a) after the establishment of the Athenian democracy in 507 B.C., and b) after 490 B.C., that is, after the battle of Marathon. The later date is that favoured by the French excavators (cf. Picard and De La Coste Messelière, *F.d.D.*, IV, 4, 1957, pp. 51 ff.; Audiot, *F.d.D.*, II, 1933, on the architecture and topography of the Treasury; De La Coste Messelière, *Delphes*, 1957, pp. 322 ff.). Their reasons are: (1) the statement by Pausanias (X, 11, 5) that the Athenians built their Treasury at Delphi 'from the spoils taken from the army that landed with Datis at Marathon'; and (2) the inscription on a base on the south flank of the building, which records that 'the Athenians (dedicated it) to Apollo from the booty taken from the Medes at the battle of Marathon'.

The earlier date is chiefly based on stylistic considerations, for it has been thought that 'the date of 490 or soon afterwards seems far too late for the sculpture, the painted ornament, and the non-Athenian imported material' (Dinsmoor, *The Architecture of Ancient Greece*, p. 117, note 1; cf. also his article 'The Athenian Treasury as dated by its Ornament', *A.J.A.*, L, 1946, pp. 86 ff., and Schleif's important topographical discussion in *Gnomon*, XI, 1935, pp. 67 f.). The inscribed base would then be a later addition, referring to the armour not to the Treasury; and Pausanias must have been misled by its presence on this spot.

To the arguments advanced in favour of the earlier date I may add another, based on an anatomical rendering, which seems to me revealing.

As is well known, the representation of the torsion of the human figure was a subject of absorbing interest to the artists of the late sixth and the early fifth century B.C., when we find them again and again trying to correlate correctly (that is according to nature) the chest with the rectus abdominis in a figure in torsion. Instead of showing the whole trunk of the body in front view and the head and legs in profile, as had long been customary, some artists tried something new. Though they still showed the pectorals in front view, they shifted the rectus abdominis to one side and placed it obliquely—an epoch-making innovation. As examples one can cite the athletes on the statue base in Athens, no. 3476 (plate XVII, d), the helmeted warrior on a relief in Athens, no. 1959 (plate XVII, b), and the youth by Oltos in the British Museum, E8 (plate XVII, c; cf. Beazley, *A.R.V.*², p. 63, no. 88)—all assigned, more or less securely, to the period of *c.* 510-500 B.C. In the statue base in Athens the sculptor is clearly experimenting. In three figures he has retained the old strictly frontal,

XVII–a. Kouros from the East pediment
of the Temple of Apollo at Delphi,
c. 510 B.C. Delphi, Museum

XVII–b. Running warrior.
Relief from Athens, c. 510–500 B.C.
Athens, National Museum

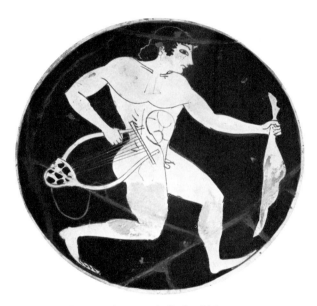

XVII–c. Boy running, on a kylix by Oltis, c. 520–510 B.C.
British Museum

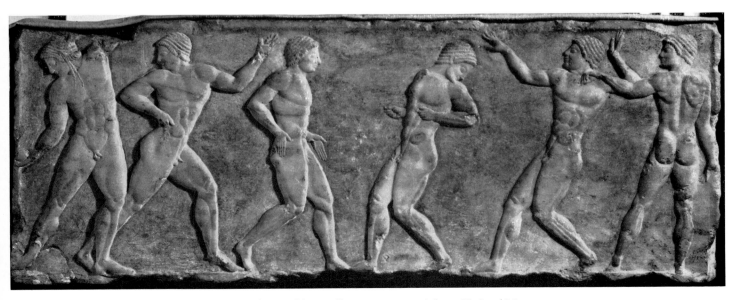

XVII–d. Ball players on a statue base found in the Themistoklean wall, c. 510–500 B.C. Athens, National Museum

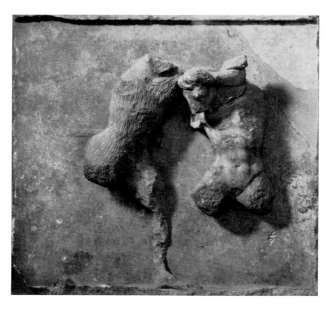
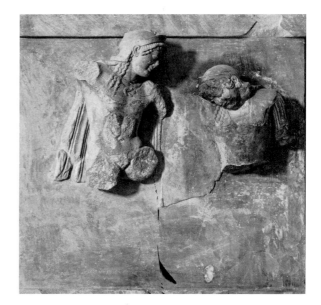

XVIII–a, b, c, d. Four metopes from the Athenian Treasury at Delphi, c. 510–500 B.C.: Theseus and the Minotaur, Theseus and Antiope, Herakles and Kyknos, Greek downing an Amazon. Delphi, Museum

XVIII–e. Man, on a kylix by the Brygos Painter, c. 490 B.C. Würzburg

XVIII–f. Satyrs, on a kylix by the Brygos Painter, c. 480 B.C. British Museum

profile, and back views, but in three other figures he has attempted to place the rectus abdominis obliquely—without however succeeding in interrelating it with the pectorals, which are still shown frontal. The same stage is reached in the relief of a running warrior (plate XVII, b) and in the youth by Oltos (plate XVII, c). Here too the pectorals are frontal, with the rectus abdominis shifted to one side, and placed obliquely.

Then, in the first two decades of the fifth century B.C. the anatomy of a figure in three-quarter view in torsion is nearing a more satisfactory solution. The rectus abdominis, instead of being in a strange, isolated position, is made to connect with the lower end of the sternum, while the pectorals are still frontal. This stage is reached by the Brygos Painter in his kylix in Würzburg (plate XVIII, e; cf. Beazley, *A.R.V²*, p. 372, no. 32), and in his satyrs on the kylix in London, E65 (plate XVIII, f; cf. Beazley, *A.R.V²*, p. 370, no. 13)—all dated *c.* 490 or later. In the reclining figures of the West pediment of the temple of Aphaia at Aigina (500-490 B.C.), the abdominal muscle is not yet in its correct position in relation to the pectorals, whereas in the reclining warrior of the East pediment (490-480 B.C.) the difficult twist is rendered more correctly (cf. my *Sc. and Sc.*, fig. 114). And after 480 of course the naturalistic representation of the body in torsion no longer presented difficulties.

What stage in this steady progression have the sculptors of the metopes of the Athenian Treasury reached? In several of the figures, for instance in the Theseus and the Minotaur (my plate XVIII, a), or in the Theseus and Antiope (my plate XVIII, b) (*Delphes*, pls. 116, 118) the old convention of showing the whole trunk in front view and the head in profile is retained. In a few an effort is made to try something new. Thus in the metope with Herakles and Kyknos (my plate XVIII, c; cf. *Delphes*, pl. 120), though the pectorals are frontal, the rectus abdominis muscle is shifted to one side, and in the metope with a Greek downing an Amazon (my plate XVIII, d; cf. De La Coste Messelière, *Delphes*, pl. 111) he has actually placed this muscle obliquely, and has shifted the serratus magnus toward the middle, while retaining the pectorals in front view. In other words he has reached the same stage as had the sculptors and vase-painters of 510-500 B.C.

If then we want to place the metopes of this Treasury in relation to its contemporaries, the last decade or so of the sixth century seems indicated.

The sections into which I have divided the korai of my fifth group—according to the places in which they were found—are:

(1) The female figures on the Delphian monuments discussed above.

(2) The famous series from the Athenian Akropolis (nos. 109-136), which constitutes by far the most numerous class and comprises marble statues (two with their inscribed bases), heads and feet broken from such statues, and a bronze statuette of similar type—Mr. Kavvadias' first find (no. 136). Many of the painted patterns on the marble statues are reproduced (in black and white) in my text (see p. VIII), and will give some idea of the splendour of their original appearance.

(3) In a third group come the korai from Attica (outside of the Akropolis) and from the rest of continental Greece. They include the girl on the 'Megakles' stele (no. 137); two headless statues and a head from Eleusis (nos. 139, 140, 142); a strikingly similar head from Boeotia (no. 143); and a few bronze and terracotta statuettes (nos. 144-146), one of them the well known bronze from Elis, inscribed with a dedication by Chimarides to the 'Daidalean' goddess (i.e. Artemis).

(4) The next group presents the korai from the Islands—Delos (nos. 147-150) Paros (no. 151), Andros (no. 152), Samos (nos. 153, 157), and Cyprus (nos. 154, 156). They are mostly headless, but

are supplemented by three more or less complete statuettes in terracotta from Rhodes (nos. 158-160), and a well preserved limestone head from Cyprus (Cesnola Collection), which, being life-size (no. 155), assumes a special importance.

(5) Then comes the contingent from Asia Minor, comprising statues, heads, and reliefs, from Miletos (no. 161), Didyma (no. 162), Sardes (no. 164), and Klazomenai (no. 163), etc. They are followed by two examples from Cyrene (nos. 168, 169)—so like their Greek sisters that they bear further testimony to the Greek character of their homeland during the archaic period—and by a rather provincial work from Memphis, Egypt (no. 170).

(6) Lastly come a few examples from the West—from Italy, Sicily, Albania, and Spain. They include the two unfinished korai from Tarentum (nos. 171, 172); one of the beautiful metopes representing running maidens found at Foce del Sele, and now in the Museum at Paestum (no. 173); a terracotta head from Medma near Reggio (no. 174); a fine terracotta statuette found not long ago at Gela (no. 175); a bronze statuette found 'near Rome' (no. 176); another from Albania (no. 177); an Etruscan inscribed bronze statuette in Berlin (no. 178); and finally a bronze statuette in Granada, Spain (no. 179).

Practically all these korai, from whatever locality, wear the Ionic dress, i.e. a long chiton, gracefully lifted up by one hand in the prescribed manner (cf. p. 10), and over it the short, pleated himation, obliquely draped from one shoulder to beneath the opposite armpit. The only exceptions are the 'Peplos kore' from the Akropolis (no. 113), which is datable early in the series, when perhaps the Ionic fashion was only gradually penetrating continental Greece, and the statuettes from such 'outlying' districts as Elis (no. 144), or Boeotia (no. 145), or Albania (no. 177).

It is indeed a curious phenomenon that this rather peculiar—and, as we shall see, short-lived—Ionian fashion was adopted throughout the Mediterranean, East and West. It bears further testimony to the close-knit character of the Greek civilization also in archaic times.

Group V, 1

Korai from the Siphnian Treasury, the Temple of Apollo, and the Athenian Treasury, at Delphi

Korai 104-108

104 : Figs. 317-320

DELPHI, MUSEUM.

Upper part of a marble statue of a karyatid, from the Siphnian Treasury. Total height, as preserved, with polos, *c.* 1.65 m.
Surface battered. Some parts have been restored in plaster.
Both arms are missing from the shoulders.

She wears a chiton and a short Ionic himation, draped from the left shoulder to beneath the right armpit, and hanging down in stacked folds of considerable depth, with zigzag edges. Part of the mantle has been pulled over the top band, where it forms a series of rounded, zigzag folds.
On her head is a stephane, reaching down to the ears; and on top of the skull is a polos decorated with figures, in lively action, carved in relief.

The hair descends down the back in a mass of superimposed wavy ridges, on each of which appear smaller wavy ridges, rendered with great delicacy. Four tresses are brought to the front on each side. Above the forehead appears a wavy mass, with a zigzag edge and a parting in the middle; it is diversified, as in the back hair, by superimposed, delicate ridges.

In the eyes the curvature of the upper lid is shown, and the lachrymal caruncle is carved at the inner corner.

The lips are straight, but are differentiated. At each corner is an oblique hollow to form the transition to the cheeks.

In the ears both tragus and antitragus are indicated. The lobes are pierced for the addition of metal earrings. Further metal ornaments were added to the front fringe of hair and to the stephane, as indicated by a series of holes.

The date is indicated as being before 525 B.C. by the statements of Herodotos (III, 57 f.) and Pausanias (x, 11, 2). On this important evidence cf. p. 63. If we, therefore, date the Siphnian karyatid around 530-525 B.C., we may not be far wrong.

De La Coste Messelière and C. Picard, *F.d.D.*, IV, 2, pp. 60 ff., figs. 31-34, pls. 18-20, *Delphes*, 1957, p. 320, pls. 63-65; *B.C.H.*, LXVIII/ IX, 1944/45, pp. 5 ff.
Langlotz, *Zeitbestimmung*, pp. 17 ff.; *Bildhauerschulen*, pp. 137 f., pls. 84, a, 85, a.

105 : Fig. 321

DELPHI, MUSEUM.

Two marble statues of female figures, from the Eastern pediment of the Siphnian Treasury. Height of pediment at centre 1.648 m.

The figure on the right, standing behind Apollo, should be Artemis or Leto. The other has not been identified. Both qualify as korai.
Found in April 1894.

'Artemis' wears a close-fitting chiton, reaching to the ground, and over it a short, Ionic mantle. Both her arms are extended toward Apollo. She has a stephane, and long hair falling down her back, with tresses on the sides.

Little remains of the surface of her face, shoulder, and breast.

She has a bracelet on her right arm, carved in the stone. Metal ornaments must have been fastened beneath her stephane, to judge by the remaining holes. Furthermore, metal earrings were attached to the lobes of the ears.

The other woman, turning her back on Artemis, grasps a fold of her drapery with the left hand, and wears a chiton and an Ionic mantle, draped from the left shoulder to beneath the right armpit; also a bracelet on her left forearm. The feet of both are bare.

About 530-525 B.C.

For the evidence that the inscriptions on the frieze of this treasury are Attic, cf. p. 3.

De La Coste Mellière, *F.d.D.*, IV, 1, pl. XVII; *Delphes*, 1957, pl. 90, p. 322.

106, 107 : Figs. 322-326

DELPHI, MUSEUM.

Two marble statues from the Eastern pediment of the temple of Apollo at Delphi. Height (of no. 106), 1.16 m. (of no. 107), 1.25 m.

Both have been put together from several pieces.

Only one (no. 106) retains a piece of the head (with the neck restored), which has been added since the publication in *F.d.D.*, IV, 2 (1928), but appears in that of *F.d.D.*, IV, 3 (1931).

No. 106. The right forearm was extended, the left arm is lowered and grasps a fold of the drapery.

She wears a chiton, and over it a short Ionic himation, draped over both shoulders and descending in heavy stacked folds with wavy edges; above the top band it is pulled up to form a short strip of wavy folds. Below her right arm the folds of the himation hang down vertically, but below the left they radiate toward the left hand which holds an edge of it, together with the chiton, of which the folds also radiate toward that hand.

Her hair descends in a mass at the back, with three tresses brought to the front on either side; they are decorated with vertical waves. Round the neck is a necklace with pendants.

No. 107. Similar to no. 106, but with differences: The Ionic himation is worn draped from the right shoulder to beneath the left armpit, the left hand grasps only the chiton; the slack of the left chiton sleeve is indicated under the left armpit; the front tresses are double and triple, not single.

About 510 B.C.; cf. pp. 63 f.

Since these two korai markedly resemble the one associated with a base signed by Antenor (cf. no. 110), it has been thought that they were carved by the same sculptor. But of course the type was current during the last third of the sixth century.

Picard and De La Coste Messelière, *F.d.D.*, IV, 2, pl. XXXIV, IV, 3, pp. 49 ff., pls. VIII, IX, XI, hors texte; *Delphes*, 1957, pp. 324 f., pl. 141, (no. 106), and p. 30, fig. 19 (no. 107).

108 : Fig. 327

DELPHI, MUSEUM.

Athena, on a marble metope from the southern side of the Treasury of the Athenians at Delphi; represented with Theseus. Height of metope 67 cm.

She stands in a three-quarter pose, with the left leg a little advanced, the left arm extended, the right (made in a separate piece and missing), lowered along the body, as indicated by the surviving dowel holes. She wears a belted chiton, a short Ionic himation, and an aegis. The stacked folds of the himation hang down on her right side, with zigzags along the edges; so it was evi-

dently draped, as usual, from the right shoulder to below the left armpit. The lower part of the chiton has a central paryphe of stacked folds.

The belt had a central ornament, for the fastening of which a large rectangular dowel hole served.

On the feet are sandals, of which the straps must have been indicated in colour. The holes along the edge of the aegis were evidently for the attachment of metal snakes; and the hole at the throat must have been for the attachment of the ornament of a necklace.

About 510 B.C. (cf. pp. 64 f.).

De La Coste Messelière, *F.d.D.*, IV, 4 (1957), pp. 51 ff., pls. 15-18, 31; *Delphes*, 1957, pl. 113, p. 323.

Group V, 2

Korai from the Akropolis of Athens

As I have said, the korai found on the Akropolis in the eighties of the nineteenth century constitute the largest contingent of marble statues of this type that have survived. Most of them belong to the last third of the sixth century B.C., that is, to the Peisistratid era. In their quasi-pristine condition, retaining, as some of them do, their original colours, they can give a good idea of what Greek sculpture originally looked like.

The korai of this series are practically uniform in stance, gestures, costume, and decorations. As, however, they show some progression in style—i.e. in the rendering of the features, in the elaboration of the garments, and in the depth of the carving of the folds, I have—very tentatively—divided the series of statues into three groups:

(1) early (*c.* 535-530 B.C.): Akr. 669, 681, 671, 678, 679, 660.

(2) middle (*c.* 530-510 B.C.): Akr. 598, 682, 673, 672, 670, 683, 613, 680.

(3) late (*c.* 510-495 B.C.): Akr. 675, 594, 615, 696, 674, 643 + 307, 616, 648, 661, 136, 510, 465, 475.

The divisions are of course merely based on what seems to be their relative, not the absolute, chronology. For the progressive artist working in 530 B.C. may approximate the style of the conservative working in 515.

Korai 109-136

109 : Figs. 328-335

ATHENS, AKROPOLIS MUSEUM, 669.

Upper part of a marble statue. Height 68 cm.
'Parian' marble.
Found in 1887, east of the Erechtheion.
Put together from several pieces. A few missing parts are restored in plaster (visible in the illustrations). Traces of colour (cf. p. 69).

The left arm was evidently lowered, presumably to

grasp a fold of the drapery, and the right perhaps extended. Enough remains of the left forearm to show that it was supinated.

She wears a chiton and the short Ionic himation, draped from the right shoulder to below the left armpit. On the head is a round, ornamented stephane (cf. p. 69), with holes along the upper edge for the addition of metal ornaments. She also had a metal necklace as shown by the holes along the neck.

The hair falls down the back in superimposed wavy

Ornament on No. 109: *stephane*.

tresses, and similar tresses appear on each side in front; on the left breast remain holes with metal inserts, indicating that the ends of the tresses were made in separate pieces. Above the forehead are vertical, wavy tresses ending in spirals. The top of the skull is smooth, with a central hole for a meniskos.

In the eye the lachrymal caruncle is indicated, as well as a slight curvature of the upper eyelid. The mouth (much injured) had oblique depressions at the corners. The ear is flat, with the tragus rendered as an excrescence from the lobe. The lobes are pierced for the addition of metal earrings.

The date should be not far removed from that of the Antenor kore, no. 110, that is, about 530 B.C. or so.

To this upper part of a kore has been thought to belong a fragmentary lower part, consisting of the right side of a lower torso with deeply cut vertical folds, and much of the legs. (Height 1.01 m.) They were connected by Schrader, on account of 'the identity of scale and a similar rendering of the drapery'. But it seems doubtful that the two parts belong together, for the deeply cut folds in the lower part suggest a date nearer the end of the century, whereas the somewhat primitive features of the upper part, and the supinated forearm point to an earlier date. In the new arrangement of the Akropolis Museum (1966) the two parts are no longer shown together.

Wolters, *Ath. Mitt.*, XII, 1887, pp. 264 f.
Schrader, *Arch. Marm.*, p. 26, figs. 22-26.
Lermann, *Altgriech. Plastik*, p. 85, pl. II.
Dickins, *Cat.*, p. 204 f., no. 669.
Payne and Young, *Arch. Marble Sc.*, pp. 22 ff., pls. 27, 28.
Langlotz, in Schrader, *Marmorbildwerke*, pp. 68 ff., no. 28, pls. 38-40.

110 : Figs. 336-340

ATHENS, AKROPOLIS MUSEUM, 681.

'The Antenor kore.' Height, including plinth, 2.155 m.; ht. of plinth 4 cm. Larger than life.
Marble statue, worked in one piece with a plinth, and perhaps belonging to an inscribed base with the signature of Antenor.
'Island' marble.

The greater part of the statue and the inscribed base were found in February 1886, north-west of the Erechtheion. The feet and plinth, which were found earlier, were connected by Studniczka, as was also the inscribed base. The fragment between feet and torso was found later and added by Wolters.

Put together from numerous pieces and with some restorations in plaster, viz., piece of the left forearm, the greater part of the legs, a piece of the neck, the middle of the shoulder locks on each side, the greater part of the stacked folds hanging from the left hand, and a piece of the plinth.

On the traces of coloured patterns cf. below.

paryphe

neck border of chiton

scattered

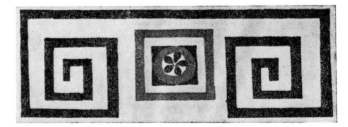

stephane

Ornaments on No. 110.

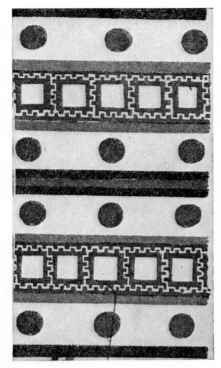

left sleeve

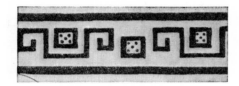

himation

Ornaments on No. 110.

The left leg is a little advanced; the right forearm (missing) was brought forward, the left is lowered to grasp a fold of the drapery.

She wears a chiton and over it a short Ionic himation, descending in heavy, stacked folds, with zigzag edges; over the top band it is pulled up a little, forming little wavy folds.

On her head is a stephane, to which metal ornaments must have been added, as indicated by a series of holes. Above the stephane, on the crown of the head, the surface is kept smooth, but below it, at the back, the hair is rendered in a roughly quadrangular mass, divided horizontally and vertically in a chequer pattern; on the front at either side, descend four angular tresses. Above the forehead and temples are three rows of spiral curls. There are remains of a bronze meniskos. On the left forearm is a bracelet.

The eyeballs were made separately, of purple glass, and set in a metal case (the left one is preserved), on which lashes were probably added (cf. p. 12). The curvature of the upper lid is indicated. The lips do not meet at the corners, where a vertical groove separates them from the cheeks. In the ear the tragus is indicated, but not the antitragus. The lobe is pierced for the attachment of a metal earring.

The plinth is cut to the shape of the feet. The toes are missing.

On the base is the inscription:

Νέαρχος ἀνέθεκε[ν ho κεραμε]
ὺς ἔργον ἀπαρχὲν τἀθ[εναίαι]
Ἀντένορ ἐπ[οίεσεν h]—
ο Εὐμάρος τ[ὸ ἄγαλμα].

'Nearchos, the . . ., dedicated it from the first-fruits to Athena. Antenor, the son of Eumares, made the statue.' It has been thought that Nearchos was the potter of whom signatures survive. But of kerameus only the last two letters are preserved.

The name Nearchos is fairly common; cf. Pape, *Eigennamen*, s.v. Nearchos, who mentions several—from Athens, from Crete, and elsewhere. On the other hand, the fact that the potter Nearchos' extant works antedate the statue is not necessarily against the identity; for one can assume that Antenor grew rich enough in his later years to dedicate this splendid statue.

There has been much discussion as to whether the base actually belongs to the statue. The plinth certainly fits nicely into the opening at the top of the base, with plenty of leeway for the molten lead to be added round it—which is not unusual.

About 530 B.C.

Lechat, *Mnemeia tes Hellados*, pl. xv.
Kavvadias, *Eph. arch.*, 1886, col. 81, pl. vi, no. 4.
Studniczka, *J.d.I.*, ii, 1887, pp. 135 ff., pl. x, 11.
E. Gardner, *J.H.S.*, x, 1889, pp. 278 ff.
Lermann, *Altgriech. Plastik*, pl. xii, p. 87.
Dickins, *Cat.*, pp. 228 ff., no. 681.
Payne and Young, *Archaic Marble Sc.*, pp. 31 ff., 63 ff., pls. 51-53, 124, no. 5.
Raubitschek, *Bull. Bulgare*, xii, 1938, pp. 139, 141; *J.H.S.*, lx, 1940, pp. 50 ff.; *Dedications*, no. 197.
Langlotz, in Schrader, *Marmorbildwerke*, pp. 80 ff., no. 38, pls. 50-52, 109.
Kirchner, *Imagines Inscr. Att.*, pl. v, 10.
Jeffery, *Local Scripts*, p. 75.

111 : Figs. 341-344

ATHENS, AKROPOLIS MUSEUM, 671.

Marble statue. Height 1.67 m.
Marble said to be Pentelic.

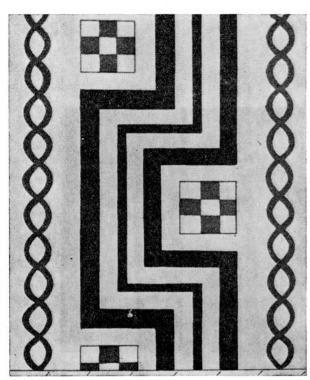

Ornaments on No. 111.

paryphe

stephane

himation

scattered

Found in 1886 west of the Erechtheion.
Put together from several pieces.
For the traces of painted ornaments above.

The left leg is advanced. The right forearm was brought forward and the left arm lowered, without, however, grasping a fold of the drapery. Both forearms were made in separate pieces and dowelled.

She wears a chiton, pulled over the belt to form a pouch (kolpos), and over it a shawl-like mantle (epiblema), draped over both shoulders and arms, and hanging down in heavy, vertical folds. In the middle of the lower part of the chiton a paryphe descends vertically between the legs.

On the head is a curved stephane. On the skull the hair is kept smooth, and then falls down the back in wavy tresses, partly hidden by the mantle. Three separate wavy tresses are brought to the front on either side. Above the forehead the hair is rendered in a wavy mass, with side coils at each end. There are remains of a meniskos.

The eyeballs protrude; both canthus and lachrymal caruncle are indicated. The lips meet at the corners, with a vertical groove between them and the cheeks. In the ears both tragus and antitragus are indicated. The lobe is pierced for the addition of an earring.

About 530-525 B.C.

Wolters, *Ath. Mitt.*, XI, 1886, p. 452.
Lechat, in *Mnemeia tes Hellados*, p. 87, pl. XXI.
Lermann, *Altgriech. Plastik*, pl. III.
Dickins, *Cat.*, no. 671, pp. 207 ff.
Payne and Young, *Arch. Marble Sc.*, p. 40, pl. 42, nos. 2, 3, pl. 43. no. 1.
Langlotz, in Schrader, *Marmorbildwerke*, pp. 56 f., no. 14, pls. 25, 26.

112 : Figs. 345-348

ATHENS, AKROPOLIS MUSEUM, 678.

Marble statue. Height 97 cm.
Marble said to be Parian.
Found in 1886 west of the Erechtheion.
The back of the top left calf was added by Schrader.
The left leg is a little advanced. The right arm was lowered, with the hand grasping a fold of the drapery. The left forearm was doubtless brought forward and held some offering.

She wears a belted chiton, and over it a short Ionic himation, draped from both shoulders and descending in vertical stacked folds, front and back. Both edges are marked at the top, below the neck, but the stacked folds of the himation are omitted on the shoulders, and there is no opening on either side.

The hair falls down at the back in a mass of angular, wavy tresses, with three similar tresses brought to the front on either side. On the crown of the head it is rendered by descending zigzag tresses, and above the forehead by three tiers of wavy ridges. At the back the hair is confined by a fillet, and encircling the head is a beaded chaplet, with some holes beneath it for the addition of metal ornaments.

In the eyes the lachrymal caruncle is marked, as also the curvature of the upper lid. The lips are differentiated, with vertical grooves at the corners. In the ear the tragus is indicated, and there is a slight swelling to mark the antitragus; the lobe is pierced for the addition of a metal earring. Remains of a painted necklace.

About 535-530 B.C.

Sophoules, *Eph. arch.*, 1891, col. 168, pl. 15.
Lechat, in *Mnemeia tes Hellados*, pp. 88 f., pl. XXII.
Dickins, *Cat.*, pp. 220 ff., no. 678.
Payne and Young, *Arch. Marble Sc.*, p. 21, pl. 34, pl. 35, nos. 3, 4.
Langlotz in Schrader, *Marmorbildwerke*, pp. 53 f., no. 10, pls. 20, 21.

113 : Figs. 349-354

ATHENS, AKROPOLIS MUSEUM, 679. 'The Peplos kore.'

Marble statue. Height, with plinth, 1.20 m.; ht. of plinth 2.8 cm.
'Parian' marble.
Found in 1886 west of the Erechtheion.
Put together from several pieces.
Numerous traces of colour (cf. below).
Schrader thought that a piece of a right foot (inv. 483) might belong; cf. Langlotz; loc. cit., fig. 13.

The right arm is lowered and the (angular) hand held some object. The forearm is semi-supinated, that is, it has an inward twist. The left forearm was brought forward, and must have held some offering; it was worked separately, and its tenon fitted into the preserved mortice, where it was fastened with a dowel, for which the holes remain.

She wears a chiton, of which the crinkly folds are visible at the right elbow and beneath the feet, and over it a

Ornament on No. 113: *lower border of chiton.*

belted peplos, with overfold; the loose ends of the belt fall down in front in two vertical bands. Stacked folds are visible at the left elbow and at the bottom on each side. Decorative borders were added in colour (cf. drawing). On each shoulder is a hole for the insertion of the brooch which fastened the peplos; only the overfold is shown open on the left side.

The hair descends in an undulating mass of tresses at the back, and three similar tresses are brought to the front on each side. Over the forehead and temples it is rendered in three wavy bands. Above them is a series of holes for the insertion of metal ornaments (a wreath?). At the back is a taenia. On top of the head are remains of a meniskos. There are traces of a painted necklace.

The eyeballs are prominent; the lachrymal caruncle is indicated, and so is the curvature of the upper eyelid. The lips are differentiated, but they are still carved deeply into the head, resulting in deep hollows round them. In the ears the tragus is indicated and given its characteristic form; and there is an attempt to show the antitragus. The lobe is pierced for the addition of a metal earring.

About 535-530 B.C. One of the latest examples of the wearing of the peplos in Attica. Soon the Ionic fashion with chiton and over it the short himation became practically universal.

The resemblance of this kore to the Leda on the amphora by Exekias in the Vatican (cf. pl. XV, c) has often been pointed out.

Stais, *Eph. arch.*, 1887, pp. 130 ff., pl. IX.
(Petersen and Wolters), *Ant. Denk.*, I, 1891, p. 8, pl. XIX, 2.
Lechat, in *Mnemeia tes Hellados*, p. 78, pl. XVI, left.
Lermann, *Altgriech. Plastik*, pl. XVIII.
Dickins, *Cat.*, no. 679.
Payne and Young, *Arch. Marble Sc.*, pp. 18 f., pls. 29-33, pl. 38, no. 5.
Langlotz in Schrader, *Marmorbildwerke*, no. 4, pls. 3-8.
Lullies and Hirmer, *Gr. Plastik*, pp. 43 f., figs. 41-43.

114 : Figs. 355-357

ATHENS, AKROPOLIS MUSEUM, 660.

Head of a marble statue. Height 16.5 cm.
Marble said to be Parian.
Put together from two pieces.

She wears a curving stephane and disk earrings.
On the skull, above the stephane, the hair is indicated by a series of horizontal waves, which continue down the back, but are flanked on the sides by wavy tresses. Above the forehead it is arranged in horizontal, wavy ridges, with two rows of spiral curls below, and with zigzag side coils above the temples.

The eyes are sloping with flat balls and prominent upper

lids. The lachrymal caruncle is marked. The lower part of the ear is hidden by the disk earring. The lips are carved deep into the cheeks, with vertical grooves at their corners and a deep hollow between the lower lip and the chin.
About 530 B.C.

Lechat, in *Mnemeia tes Hellados*, pp. 106 f., pl. XXXI, 3, below.
Dickins, *Cat.*, no. 660.
Payne and Young, *Archaic Marble Sc.*, p. 62, pl. 39.
Langlotz, in Schrader, *Marmorbildwerke*, pp. 128 f., no. 87, pl. 95.

115 : Figs. 358-361

ATHENS, AKROPOLIS MUSEUM, 598.

Headless marble statue. Height 57 cm. without the plinth.

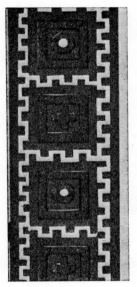

paryphe

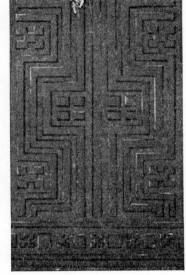

left sleeve

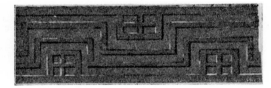

top border of chiton

bottom of chiton

Ornaments on No. 115.

Marble said to be Island.
For the traces of colour see drawings.
The head was worked separately.
The feet are close together, the right forearm was extended, the left arm was lowered to grasp a fold of the drapery.

She wears a chiton, and over it a short Ionic himation, draped from the right shoulder to below the left armpit, and slightly pulled over the top band to form a row of little folds. At its lower end the slack of the chiton sleeve is indicated by stacked folds.
The hair descends in a quadrangular mass of wavy, angular tresses, with four spiral tresses brought to the front on either side.
The sandalled feet protrude in front from the edge of the chiton. At the back the chiton spreads to the ground over the heels.
Last quarter of the sixth century B.C.

Lermann, *Altgriech. Plastik*, pl. VII.
Dickins, *Cat.*, no. 598.
Payne and Young, *Archaic Marble Sc.*, pl. 92, nos. 2, 3.
Langlotz, in Schrader, *Marmorbildwerke*, pp. 85 f., no. 40, pl. 58.

116 : Figs. 362-367

ATHENS, AKROPOLIS MUSEUM, 682.

Marble statue. Height 1.825 m., including plinth which is 2.5 cm. high.
Marble said to be Island.
Found in 1886 north-west of the Erechtheion.
Put together from several pieces. The lower legs and feet, which were found separately, were added by Schrader in 1907. Some missing parts are restored in plaster.
The body was made in two pieces, joining at the knees and secured with dowels and lead runnings.
For the plentiful ornamental bands cf. p. 74.

The right leg is advanced. The right forearm was extended, and worked in a separate piece, inserted with a tenon into a corresponding mortice. The left arm was lowered and grasped a fold of the drapery. The neck is abnormally long.
She wears a belted chiton, and over it a short Ionic himation, draped from the right shoulder to below the left armpit, and pulled a little over the top band, forming little zigzag folds. At its lower end appears the slack of the chiton sleeve, rendered in stacked folds. In the middle of the chiton, in front, is a broad and gaily decorated paryphe, pulled to the side by the left hand, and then descending in stacked folds (partly missing).

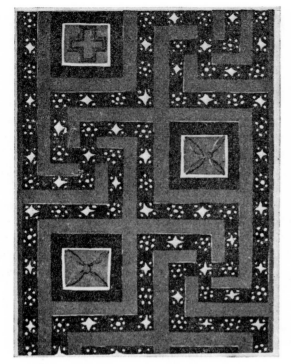

paryphe

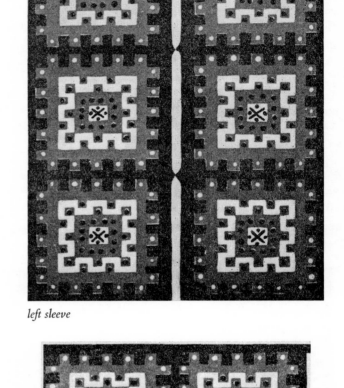

left sleeve

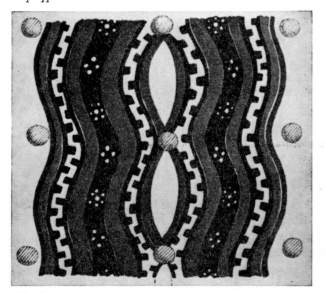

right sleeve

neck of chiton

belt

scattered ornaments

bottom of himation

Ornaments on No. 116.

On the feet are sandals, with the straps carved, and with a hole for the addition of a metal latchet. On the left arm is a bracelet. The toes are of different lengths, with the second toe longer than the first. On the head is a stephane and remains of a meniskos. Along the bottom of the stephane is a row of small holes for the addition of metal ornaments. On the skull, the hair is rendered by radiating ridges, and then falls down the back in a solid mass of zigzag tresses, with four spiral tresses brought to the front on either side; some had bronze pins for the attachment of the hanging ends, for which the holes remain. Above the forehead the hair is rendered in two tiers of vertical locks, the lower terminating in spirals. The eyes slope downward and are obliquely placed. The eyeballs were separately inserted and are missing. The lachrymal caruncle and the curvature of the upper lid are indicated. The lips are differentiated, with hollows surrounding them and vertical depressions at the corners. The ear is deeply carved, with the tragus indicated. A large disk earring hides the lobe.

About 525 B.C. It is one of the best preserved and most highly finished of the extant korai.

Wolters, in *Ant. Denk.*, I, 1891, p. 29, pl. 39.

Lechat, in *Mnemeia tes Hellados*, pp. 83 f., pl. XVIII.

Lermann, *Altgriech. Plastik*, pls. XIV, XV.

Dickins, *Cat.*, no. 682, pp. 232 ff.

Payne and Young, *Arch. Marble Sc.*, pp. 27 ff., pls. 40, 41; pl. 42, no. 1; pl. 43, no. 2.

Langlotz, in Schrader, *Marmorbildwerke*, pp. 86 ff., no. 41, pls. 53-56.

S. Adam, *The Technique of Greek Sculpture*, pp. 86 ff., pls. 36, 37 (with tool marks).

117 : Figs. 368-372

ATHENS, AKROPOLIS MUSEUM, 673.

Marble statue. Height 91 cm.
Marble said to be of Island or Pentelic.
Found in 1886 west of the Erechtheion.
For the traces of coloured ornaments cf. right column.

The left leg is advanced. The right forearm was brought forward, and doubtless held an offering; it was worked separately, with a tenon which fitted into the corresponding mortice. The left arm was lowered and grasped a fold of the drapery.

She wears a chiton, and over it a short Ionic himation, draped over both shoulders, and pulled up a little over the top band, creating a series of little oblique folds—over which the upper edge of the chiton is visible. The mantle hangs down in a series of vertical, stacked folds with zigzag edges. On the lower part of the chiton the paryphe is rendered in colour.

stephane

disk earring

left sleeve

himation

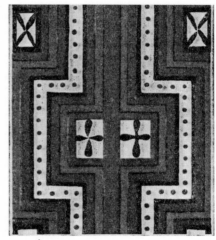

paryphe

Ornaments on No. 117.

The hair hangs down the back in wavy tresses, with four spiral tresses brought to the front on either side; the three inner ones had free-hanging ends, carved in separate pieces, for which the holes that served for their attachment remain. On the head is a stephane, above which the hair is rendered in concentric waves, and above the forehead and temples in vertical, zigzag ridges, ending in spirals. On top of the skull is a meniskos preserved entire (13 cm. long), but bent to one side.

The eyes slant. The lachrymal caruncle and the curvature of the upper lid are marked. The lips are differentiated, and are surrounded by deep hollows. In the ear both tragus and antitragus are indicated. Against the lobe appears a large spiral earring.

Last quarter of the sixth century B.C.

Kavvadias, *Eph. arch.*, 1886, p. 73, pl. 5.
Lechat, in *Mnemeia tes Hellados*, pp. 89 f., pl. XXIII.
Lermann, *Altgriech. Plastik*, pl. XI.
Dickins, *Cat.*, no. 673.
Payne and Young, *Arch. Marble Sc.*, pp. 35 f., pls. 62-64,
Langlotz, in Schrader, *Marmorbildwerke*, pp. 100 f., no. 51, pls. 16, 74, 75.

118 : Figs. 373-376

AKROPOLIS MUSEUM, 672.

Marble statue. Mounted on a plinth. Height 1.03 m.; ht. of plinth 2 cm.
'Island' marble.

stephane

paryphe

himation

bottom of chiton

Ornaments on No. 118.

Found in 1886, west of the Erechtheion.
Put together from two large and several small pieces.
For the traces of coloured ornaments cf. left column.

The feet are close together. The right arm was lowered to grasp a fold of the drapery. The left forearm was brought forward and doubtless held some offering; it was worked in a separate piece, with the tenon fitting into a corresponding mortice and fastened with a dowel, of which the hole remains.
She wears a chiton, and over it a short Ionic himation, draped from the left shoulder to beneath the right armpit; it is pulled a little over the top band, forming a series of zigzag folds. The hanging folds under the right arm were evidently repaired in antiquity (in 'Pentelic' marble), and dowelled.
The hair falls down the back in a mass of wavy tresses, with four similar ones brought to the front on either side. On her head is a high stephane. Above it the hair is carved in concentric, broad ridges; and above the forehead it is rendered in a row of zigzags, with vertical spiral ridges above.
The eyes protrude, with the lachrymal caruncle and the curvature of the upper lid both indicated. The lips are differentiated. In the ears both the tragus and the antitragus are marked; a large disk earring covers the lobe. She wears sandals. The second toe is longer than the first, and the little toe is curved. There are remains of a meniskos.

Last quarter of the sixth century B.C.

E. Gardner, *J.H.S.*, VIII, 1887, p. 167, fig. 3.
Lechat, in *Mnemeia tes Hellados*, cols. 93 f., pl. XXV, right.
Lermann, *Altgriech. Plastik*, pl. V.
Dickins, *Cat.*, no. 672.
Payne and Young, *Archaic Marble Sc.*, p. 37, pls. 68, 69.
Langlotz, in Schrader, *Marmorbildwerke*, pp. 90 f., no. 42, pls. 59, 103.

119 : Figs. 377-380

AKROPOLIS MUSEUM, 670.

Marble statue. Height 1.15 m.
Island marble, according to Lepsius, with right sleeve Pentelic.
Found in 1886, north-west of the Erechtheion.
Put together from several fragments.
For the coloured ornaments see p. 77.

The left leg is advanced. The right forearm (made in a separate piece and dowelled) is brought forward, and the left arm is lowered to grasp a fold of the paryphe. She wears a chiton, which is pulled over the belt to form a pouch (kolpos); also a spiral bracelet on the left forearm, and a painted necklace.

stephane

scattered

disk earring

paryphe

Ornaments on No. 119.

120 : Figs. 381-384

ATHENS, AKROPOLIS MUSEUM, 683.

Marble statue. Height 80.5 cm. (above the plinth).
'Pentelic' marble.
Carved in one piece with the plinth.
Found in 1882, east of the Parthenon.
For the copious colour traces see below.
Put together from several pieces. A piece of the kolpos
of the chiton was found in 1939 in the Athenian Agora
and recognized as belonging by E. Harrison.
The head was made in a separate piece and fitted into a
mortice.

The right foot is a little advanced. The left forearm is
brought forward and holds a bird, of which the upper
part was made in a separate piece and is missing; the hole
for the attachment remains. The right arm is lowered
to hold a fold of the drapery. The hands are angular.
She wears only a chiton, pulled over a belt to form a
deep pouch (kolpos). Down the front of the chiton is a
heavy paryphe of stacked folds. On the feet are (red) shoes.
She wears a curving stephane on her head. Above it,
on the skull, the hair is rendered in zigzag ridges, which
then descend as a mass of tresses down the back. Above

scattered

neck of chiton

right sleeve of chiton

Ornaments on No. 120.

On her head is a strongly curved stephane, decorated
with a painted pattern (cf. above), and supplied with
a series of holes along the top for the insertion of bronze
ornaments. On the skull, above the stephane, the hair
is rendered in concentric, broad ridges, whereupon it
falls down the back in a mass of zigzag tresses, with
four similar tresses brought to the front on each side.
Above the forehead the hair is rendered in a horizontal
row of waves, with a bunch of vertical locks in the
middle.
The eyes are narrow and slanting, with the lachrymal
caruncle and canthus indicated. The lips curve upward
and meet at the corners. In the ear the tragus is indicated,
and a decorated disk earring hides the lobe. There are
remains of a meniskos.
Last quarter of the sixth century B.C.

E. Gardner, *J.H.S.*, VIII, 1887, p. 168, fig. 2.
Lechat, in *Mnemeia tes Hellados*, pp. 92 f., pl. XXV, left.
Lermann, *Altgriech. Plastik*, pl. XIX.
Dickins, *Cat.*, no. 670.
Payne and Young, *Archaic Marble Sc.*, pp. 35 ff., pls. 65-67.
Langlotz, in Schrader, *Marmorbildwerke*, pp. 50 ff., no. 8, pls. 14-16.

the forehead the hair is indicated as a substantial roll of wavy, vertical locks. No traces of a meniskos.

In the eyes both the canthus and the lachrymal caruncle are indicated. The lips are fleshy and differentiated, with a vertical depression at the corners. In the ears both tragus and antitragus are indicated.

Last quarter of the sixth century B.C.

The body has a surprisingly strong corporal quality, and the eager little face has an individuality of its own. The statue was connected by Raubitschek with a base inscribed with a dedication to Athena by Lysias and Euarchis (*I.G.*², no. 620), on which it supposedly stood with a larger figure, now lost.

K. D. Mylonas, *Eph. arch.*, 1883, pp. 42, 182, pl. VIII, 2.
Lechat, in *Mnemeia tes Hellados*, pp. 94 f., pl. XXVI.
Lermann, *Altgriech. Plastik*, pl. XX.
Dickins, *Cat.*, no. 683.
Payne and Young, *Archaic Marble Sc.*, p. 36, pl. 59, nos. 1-3.
Langlotz, in Schrader, *Marmorbildwerke*, pp. 52 f., no. 9, pls. 17-19.
Raubitschek, *B.S.A.*, XL, 1939-40, pp. 24 f., fig. 15 (on p. 57); *Dedications*, pp. 313, f., no. 292.
E. Harrison, *Hesperia*, XXIV, 1955, pp. 169 ff, pl. 65.

121 : Figs. 385-388

ATHENS, AKROPOLIS MUSEUM, 613.

Marble, headless statue. Height 84 cm.
Marble said to be Island.
Found in 1887, east of the Erechtheion.

The right forearm, now missing, was made in a separate piece, and its tenon fitted into a corresponding mortice. It was brought forward and doubtless held an offering. The left arm was lowered and held a fold of the drapery. She wears a chiton, and over it a short Ionic himation, draped from the right shoulder to below the left armpit. The top band—with perhaps some folds of the himation pulled up over it—is missing.

The hair descends in a mass of beaded tresses at the back, with three zigzag tresses brought to the front on either side.

Last quarter of the sixth century B.C.

Dickins, *Cat.*, no. 613.
Payne and Young, *Archaic Marble Sc.*, pl. 93, nos. 7, 8.
Langlotz, in Schrader, *Marmorbildwerke*, no. 31, pp. 73 f., pl. 43.

122 : Figs. 389-393

ATHENS, AKROPOLIS MUSEUM, 680.

Marble statue. Height 1.155 m. A little over life-size.
'Island' marble.
Found in 1886, north-west of the Erechtheion.
Put together from several pieces.
For the painted ornaments, cf. right column.

disk earring

himation

top of chiton

himation

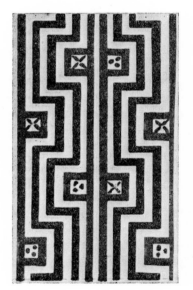

left sleeve

paryphe

himation

Ornaments on No. 122.

The left leg is a little advanced. The right arm is bent, with the hand holding out an apple or pomegranate. The left arm is lowered with the hand grasping a fold of the drapery; the forearm is semi-supinated with an inward twist. The arm is separated from the body most of the way.

She wears a belted chiton, and over it a short Ionic himation, draped from the right shoulder to below the left armpit, and pulled up a little over the top band, forming little wavy folds. At the further end of the band are visible the stacked folds of the slack of the chiton sleeve. The folds of the himation descend in vertical and oblique folds with zigzag edges. At the bottom, on her right side, where the ends of the folds are missing, are two holes with remains of iron nails, due evidently to a later repair.

The hair falls down in a mass of wavy tresses at the back, with four similar tresses brought to the front on either side. On her head is a curved stephane, with a series of holes for the addition of metal ornaments. Above it, on the skull, the hair is rendered in radiating ridges. Above the forehead appear two tiers of wavy ridges, with a parting in the middle, and flanked on each side by side coils of zigzag locks.

The eyes are narrow, with the lachrymal caruncle and the curvature of the upper eyelid indicated. In the mouth the lips are differentiated, carved deep into the face, with a vertical cut at each end and a deep hollow above the chin. In the ears the tragus is given its characteristic shape; the lobe is hidden by a large disk earring, decorated with a painted rosette (cf. p. 78).

On each arm, above the wrist, is a bracelet, carved on the left arm, painted on the right.

About 530-520 B.C.

Lechat, in *Mnemeia tes Hellados*, pp. 85 f., pl. XIX.
(Petersen and Wolters), *Antike Denk.*, I, 1891, p. 8, pl. XIX, 1.
Lermann, *Altgriech. Plastik*, pl. XVII.
Dickins, *Cat.*, no. 680.
Payne and Young, *Arch. Marble Sc.*, pp. 33 f., pls. 54, 55.
Langlotz, in Schrader, *Marmorbildwerke*, no. 45, pp. 95 f., pls. 68, 69.

123 : Figs. 394-397

ATHENS, AKROPOLIS MUSEUM, 675.

Marble statue. Height 55 cm.
Marble said to be Parian.
The body was found in 1888, south of the Parthenon, the head east of the Parthenon in 1886.
Put together from three pieces.
For the copious traces of colour cf. right column.

The left leg is advanced. The left arm was lowered to

stephane

top of chiton

earring

left sleeve

scattered

right sleeve

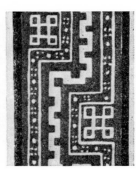
paryphe

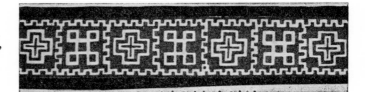
himation

Ornaments on No. 123.

hold the paryphe of the chiton. The right forearm (now missing) was worked in a separate piece and inserted in the corresponding mortice.

She wears a chiton, and over it a short Ionic himation, draped from the right shoulder to below the left armpit, and pulled up a little over the top band where it forms a series of little folds. It hangs down in stacked folds with zigzag edges. The back is left smooth, with no folds indicated, but with the forms of the body clearly marked. On the head is a stephane. Above it the hair is smooth, and then hangs down the back in an undifferentiated mass, with two abbreviated tresses, carved on each side. Three zigzag tresses are brought to the front on each side. Above the forehead is a row of wavy locks, surmounted by vertical spiral ones.

On top of the stephane is a series of holes for the addition of metal ornaments. There is no meniskos. She wears a painted necklace round her neck, and perhaps a second one lower down, as suggested by some extant holes. The eyes are slanting, with prominent eyeballs. The lachrymal caruncle is indicated, and so is the curvature of the upper lid. The lips are differentiated, with hollows surrounding them, and vertical grooves at the corners. In the ear the tragus is indicated. A large disk earring, ornamented with a painted rosette, hides the lobe.

Last quarter of the sixth century B.C.

Kavvadias, *Arch. Deltion*, 1888, pp. 101 f.
Lechat, in *Mnemeia tes Hellados*, pp. 90 f., pl. xxiv, left.
Lermann, *Altgriech. Plastik*, pl. x.
Dickins, *Cat.*, pp. 215 ff., no. 675.
Payne and Young, *Archaic Marble Sc.*, p. 31, pl. 49, nos. 3, 5, pl. 50, nos. 1-3.
Langlotz, in Schrader, *Marmorbildwerke*, pp. 91 ff., no. 43, pls. 60, 61.

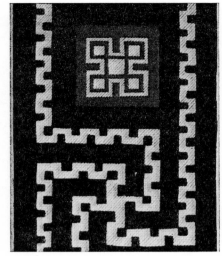
paryphe

scattered

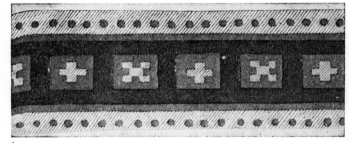
himation

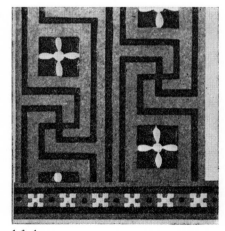
left sleeve

Ornaments on No. 124.

124 : Figs. 398-400

ATHENS, AKROPOLIS MUSEUM, 594.

Headless statue. Height 1.23 m. Over life-size.
Said to be of 'Island' marble.
Found in 1887, east of the Erechtheion.
Numerous colour traces, cf. right column.

The left leg is advanced. The (missing) right forearm was extended (its tenon remains in the corresponding mortice), and the left arm is lowered to grasp the paryphe of the chiton.

She wears a chiton, and over it a short Ionic himation, draped from the right shoulder to below the left armpit; it is pulled a little over the top band, forming a series of stacked pleats. In addition there is a third garment, the epiblema, which hangs from both shoulders down the back and along the sides. The forms of the body, for instance that of the left knee, are carefully marked through the drapery.

The hair fell down the back in a number of wavy tresses (the upper part is missing), and four similar tresses are brought to the front on each side; their missing ends were made in separate pieces and attached, as the extant holes indicate. The clavicles are nicely modelled.

About 510-500 B.C.

The interplay of the three garments with their folds carved in different depths and enlivened by elaborate

painted patterns makes this kore one of the most impressive of the later series.

Petersen, *Ath. Mitt.*, XII, 1887, p. 145, no. 1.
Lermann, *Altgriech. Plastik*, pl. XIII.
Dickins, *Cat.*, no. 594.
Payne and Young, *Archaic Marble Sc.*, p. 30, pls. 46-48.
Langlotz, in Schrader, *Marmorbildwerke*, pp. 102 ff., no. 54, pls. 76, 77.

125 : Figs. 401-404

ATHENS, AKROPOLIS MUSEUM, 615.

Headless marble statue. Height 92 cm.
The marble is said to be Island.
Put together from several pieces. The left lower leg, the left lower arm with the hand, and the end of the folds under the left arm were added by Schrader. The missing head was worked in a separate piece and inserted into a corresponding mortice. The missing right forearm was worked in a separate piece, with a tenon fitting into a mortice.

The left leg is advanced. The right forearm was extended, and so is the left one, with hand held open.
She wears a chiton, and over it a short Ionic himation, draped from the right shoulder to beneath the left armpit (but without the usual stacked folds in front); as a third garment she has an epiblema, which hangs over the left shoulder down to the left knee, across the back, round the right hip, across the body in front, and finally round the left lower arm. A bunch of folds of the himation is laid over it in front.
The hair falls down the back in a mass of tresses, with four wavy tresses (each divided into four strands) brought to the front on each side.
About 500 B.C.
The arrangement of the three garments with their separate folds is logically rendered, creating a varied and interesting composition.

Schrader, *Arch. Marm.*, p. 38, fig. 35.
Dickins, *Cat.*, no. 615.
Payne and Young, *Archaic Marble Sc.*, pl. 92, nos. 5, 6.
Langlotz, in Schrader, *Marmorbildwerke*, pp. 106 f., no. 56, pls. 82, 83.

126 : Figs. 405-410

ATHENS, AKROPOLIS MUSEUM, 696+493, 3518, 342, 4170, 354, 4136, 154.

Front of a marble head of a statue and fragments of the body. Height 27.5 cm.
Thought to be Pentelic marble.

Found in 1888, near the west entrance of the Parthenon. The pieces of the body were connected with the head by Schrader (cf. loc. cit.).

On the head is a polos. Beneath it the hair is rendered in two tiers, the lower consisting of wavy ridges passing from ear to ear, with a central parting, the upper of vertical zigzag bands. At the back it fell down as a smooth mass with horizontal divisions.
In the eyes the lachrymal caruncle, the canthus, and the curvature of the upper lids are expertly rendered. The lips are given different shapes and meet at the corners, with only slight hollows surrounding them.
Enough of the body survives to show that the chiton descended in stacked folds, and was not pulled aside by the hand. So both arms must have been extended. On the feet are sandals, with the soles carved, the straps evidently added in colour. The toes have knobby forms; they are of different lengths, with the little toe curving inward, and the phalanxes indicated.
About 500 B.C.

Kavvadias, *Arch. Deltion*, 1888, p. 201.
Schrader, *Arch. Marmor.*, p. 45, fig. 38, and *Auswahl*, p. 38, figs. 37, 38.
Dickins, *Cat.*, no. 696.
Payne and Young, *Archaic Marble Sc.*, pp. 39 f., pls. 82, 83.
Langlotz, in Schrader, *Marmorbildwerke*, pp. 61 f., no. 20, figs. 22-25, pl. 29.

127 : Figs. 411-416, 434

ATHENS, AKROPOLIS MUSEUM, 674.

Marble statue. Height 92 cm.
Marble said to be Parian.
Found in 1888, south-west of the Parthenon.
Put together from several pieces. The head and neck were made in a separate piece, together with a tenon, for the fastening of which must have served the rectangular holes on the shoulders; they are filled with stone studs, through which lead was presumably poured, in the accustomed manner, to keep the head securely in place (cf. Dickins and Langlotz, locc. cit.).
Also separately carved were the missing right forearm, and the drapery in front of the right leg.
The front part of a left foot (inv. 479), and a piece of the lower thigh (inv. 265), were identified as belonging to this statue by Schrader (cf. fig. 434). A piece of drapery at the right elbow (inv. 347) was added by Lermann.
For the numerous traces of colour cf. p. 82.
The right forearm was brought forward, and the left arm lowered.
She wears a chiton, and over it a short Ionic himation,

I

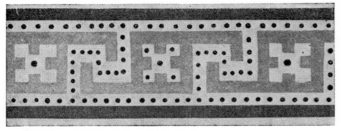

stephane

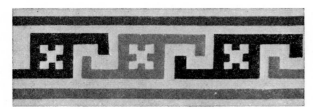

himation

earring

scattered

paryphe

Ornaments on No. 127.

which is draped from the right shoulder to below the left armpit; it is pulled over the top band to form a series of little pleats.

On the head is a stephane, and in the centre of the skull a hole for a meniskos. On the top of the head the hair is rendered in delicate wavy ridges, which then become a mass of wavy tresses falling down the back, with three separate tresses brought to the front on either side. Above the forehead and temples are wavy strands, overlapping one another. The clavicles are delicately modelled.

The eyes are expertly rendered, with both canthus and lachrymal caruncle marked, and the upper lid curving over the eyeball. The lips meet at the corners, and the

transition into the cheeks is rendered with only a slight separating groove.

In the ear both tragus and antitragus are indicated. The lower part of the ear is hidden by the disk earring.

About 500 B.C. One of the latest and most attractive of the korai.

Kavvadias, *Arch. Deltion*, 1888, Oct., p. 181.
Wolters, *Ath. Mitt.*, XIII, 1888, p. 439.
Lechat, in *Mnemeia tes Hellados*, p. 86, pl. xx.
Lermann, *Altgriech. Plastik*, pl. IV.
Dickins, *Cat.*, no. 674.
Payne and Young, *Archaic Marble Sc.*, pp. 34 f., and passim, pls. 76-78.
Langlotz, in Schrader, *Marmorbildwerke*, pp. 93 ff., no. 44, pls. 62-67.

128 : Figs. 417-419

ATHENS, AKROPOLIS MUSEUM, 643 and 307.

Head of a marble statue. Height 14.5 cm.
Marble said to be Parian (no. 643) and Pentelic (307). The upper part of the head was worked in a separate piece, and was refound by Schrader (inv. 307). It was probably a later repair, for it was carved in a different marble, and more cursorily. It includes the stephane and the side coils above the temples. The holes on and below the stephane were evidently for the attachment of metal ornaments.

Above the forehead and temples the hair is rendered by horizontal wavy locks (the middle portion is missing). The eyes are narrow, with the lachrymal caruncle indicated; an incised line marks the upper boundary of the upper eyelid. The mouth has curving, protruding lips, meeting at the corners, with shallow hollows surrounding them. On the crown is a hole for a meniskos. About 510 B.C. (?). Expertly carved with great delicacy.

Lechat, in *Mnemeia tes Hellados*, p. 103, pl. XXXI, left (without top part).
Dickins, *Cat.*, no. 643.
Payne and Young, *Archaic Marble Sc.*, pp. 37 f., pl. 70, no. 1, pl. 71.
Langlotz, in Schrader, *Marmorbildwerke*, pp. 131 f., no. 96, pls. 97, 98.

129 : Figs. 420-422

ATHENS, AKROPOLIS MUSEUM, 616.

Head of a marble statue. Height 20.3 cm.
Marble thought to be Parian.
On the head is a stephane. Above it, on the skull, the hair is carved in broad, concentric ridges, and below it, at the back, in wavy ridges, with three separate zigzag

tresses descending on each side. Above the forehead are horizontal wavy ridges, without a central parting.

The surface of the eyeball is flat, and the lower eyelid not prominent. The lips curve upward, and there is a triangular depression at each corner. In the ears are disk earrings, with central knobs.

Last quarter of the sixth century B.C.

The 'sfumato' surface, which gives the face a personal character, might suggest a date in the early fifth century (so Langlotz), but the renderings of the features—especially of the mouth, with the sharp grooves at the corners—seem to point to an earlier date (so Payne).

Lechat, in *Mnemeia tes Hellados*, col. 110, pl. XXXII, 4.
Dickins, *Cat.*, no. 616.
Payne and Young, *Archaic Marble Sc.*, p. 34, pl. 56 (dated *c.* 520 B.C.).
Langlotz, in Schrader, *Marmorbildwerke*, p. 135, no. 106, pl. 100 (dated *c.* 490 B.C.).

130 : Figs. 423-425

ATHENS, AKROPOLIS MUSEUM, 648.

Head of a marble statue. Height 12 cm.
The marble thought to be Parian.
Features damaged.

She wears a stephane and disk earrings with a central knob, also a taenia confining the hair at the back.

On the skull the hair is kept smooth. It falls down the back in a solid mass with horizontal divisions. On each side descend three globular tresses. Above the forehead the hair is rendered in wavy ridges, with similar side coils over the temples.

The eyes protrude; there are little cuts at the corners of the lips. The ears are summarily worked.

About 510 B.C.

Dickins, *Cat.*, no. 648.
Langlotz, in Schrader, *Marmorbildwerke*, pp. 132 f., no. 99, pl. 103 (there thought to be a head of Athena wearing a helmet).

131 : Figs. 426-428

ATHENS, AKROPOLIS MUSEUM, 661.

Head of a marble statue of Athena. Height 24 cm.
Marble thought to be Pentelic.
A tenon at the bottom shows that the head was separately inserted in the body.
The helmet is much injured, but the neck-piece is clearly visible at the back.

The eyes have prominent upper lids. The lachrymal caruncle is indicated by a little slit. The lips are broad, and

softly modelled, with a gradual transition into the cheeks. Only the left ear is preserved. It is summarily rendered, with a large disk earring obscuring the lower part.

The hair over the forehead and temples is indicated by wavy ridges, with a parting in the middle. At the back and on the sides it descends in wavy ridges. On the skull is a hole for a meniskos.

About 500 B.C., or a little later?

A curiously personal rendering, with the softness of the flesh finely suggested.

Dickins, *Cat.*, no. 661.
Payne and Young, *Archaic Marble Sc.*, p. 34, pl. 58.
Langlotz, in Schrader, *Marmorbildwerke*, p. 132, no. 98, pl. 96.

132 : Figs. 429-430

ATHENS, AKROPOLIS MUSEUM, 136.

Lower part of a marble statue, with the bottom of the chiton and the right foot, mounted on a plinth and set on a base in the form of a capital.
25.5 cm. high.
Marble said to be Parian.
The length of the right foot is 22.05 cm.
The left foot was carved in a separate piece and is missing.
Between the two feet is a large hole, which perhaps was intended to fasten the statue to the base, with the lead poured round the plinth.
On the plinth, near the edge is a hole (1.5 cm. wide and 6 cm. deep), for a spear (?)—in which case the statue will have represented Athena.

The toes are finely modelled, with undulating contours, and differentiated from one another; the second toe is longer than the first, and the little toe is curved markedly inwards. The sole of the sandal is carved; the strap was added in metal, as shown by a surviving hole.

On the abacus of the capital is a painted maeander, and on its echinus a painted palmette design.

About 500 B.C.

The foot is similar in style to that of Akropolis, 674, my no. 127, fig. 434.

Not in Dickins' *Catalogue*.
Payne and Young, *Archaic Marble Sc.*, pl. 44, 1-4.
Langlotz, in Schrader, *Marmorbildwerke*, pp. 176 ff., no. 271, pl. 111.

133 : Fig. 431

ATHENS, AKROPOLIS MUSEUM, 510.

Fragment of a marble statue, consisting of two feet and the bottom of the chiton in front, mounted on a plinth.

Height 34.2 cm. Thickness of plinth 5.4 cm.
Marble said to be Parian.

The folds of the chiton are stacked with a zigzag edge in the middle, more or less vertically and symmetrically, showing that the paryphe must have been held by the hand in the middle of the body, not on the side.
On the feet were sandals, of which only the soles remain, the straps having evidently been indicated in colour.
The toes are finely modelled, each different from the other, with a slight downward curve; the little toe curves inwards, with a marked projection on its outer side.
About 500 B.C.

Not in Dickins' *Catalogue*.
Langlotz, in Schrader, *Marmorbildwerke*, p. 182, no. 290, pl. 110.

134 : Fig. 432

ATHENS, AKROPOLIS MUSEUM, 465.

Pair of feet of a marble statue. Length of feet 9.75 cm. Marble thought to be Chian.
The feet are mounted on a plinth (14.9 by 9.75 cm. and only 2.1 cm. thick).

At the back the bottom of the chiton is preserved.
The toes are well differentiated; the little toe curves strongly inward, with a marked projection on the outer side. The phalanxes are faintly indicated.
Around 500 B.C.

Not in Dickins' *Catalogue*.
Langlotz, in Schrader, *Marmorbildwerke*, p. 183, no. 293, pl. 114.

135 : Fig. 433

ATHENS, AKROPOLIS MUSEUM, 475.

Bottom of a marble statue, with part of the chiton and the feet, mounted on a plinth. Height 52 cm.

The lower end of the chiton is seen at the back, curving on the plinth. The bunch of folds at the left instep must belong to the paryphe.
The toes are nicely modulated, with the second toe longer than the big toe, and the little toe curving inward.
Toward the end of the sixth century B.C.
Schrader thought that this piece might belong to the torso Akr. 611 (Dickins, *Cat.*, no. 611; Langlotz in

Schrader, *Marmorbildwerke*, no. 11). But the feet appear to be of a later style than the torso (cf. Langlotz, loc. cit.); and in Akropolis 611 the paryphe descends vertically down the chiton, so that the end could hardly be shown on the left instep.

Not in Dickins' *Catalogue*.
Langlotz, in Schrader, *Marmorbildwerke*, p. 54, no. 11, fig. 15.

136 : Figs. 435-438

ATHENS, NATIONAL MUSEUM, inv. 6491.

Bronze statuette, mounted on a decorated triangular base, presumably acting as the support of a (missing) mirror. Height 18 cm.
The cylindrical protuberance at the top must have acted as an intervening member.
Found on the Akropolis of Athens, west of the Erechtheion, in 1885, in the Persian debris. It was the first discovery made at the start of the excavations by Kavvadias (cf. p. 5).

She stands with the left leg advanced, the right arm extended, and the left lowered to clasp a fold of the drapery. In the closed right hand she doubtless held some object, now missing. The neck is abnormally long.
She wears a chiton, with a paryphe consisting of stacked folds running vertically down the middle, front and back, and a short Ionic himation, draped from the right shoulder to beneath the left armpit, with a top band decorated with zigzags. On the head is a stephane. The feet are bare, with the toes nicely modulated, and the little one curving inward, and forming a marked projection on the outer side.
The hair falls down the back in a mass of undulating ridges (similar to those used to indicate the crinkly folds of the chiton on the left shoulder and arm). On the skull it is rendered by similar, radiating ridges, and above the forehead by wavy ridges, directed horizontally from ear to ear, with a central parting.
She has a necklace with a pendant.
The eyes are deeply set, with the curvature of the upper eyelid marked, as well as the lachrymal caruncle. The lips are differentiated. The ears are summarily rendered.
About 500 B.C.

Kavvadias, *Eph. arch.*, 1886, p. 73.
Soteriades, in *Mnemeia tes Hellados*, cols. 36 f., pl. XI, left (there thought to be an Athena).
De Ridder, *Bronzes de l'Acropole*, p. 309, no. 793, fig. 298.
S. Karouzou, *Guide*, pp. 198 f., no. 6491.

Group V, 3

Korai from Continental Greece: Attica (outside of the Akropolis), Boeotia, Argos, Elis

Korai 137-146

137 : Figs. 439-440

BERLIN, Staatliche Museen, 1531, and NEW YORK, Metropolitan Museum of Art, 11.185. Hewitt Fund, 1911.

Relief of a girl on a sepulchral stele. Height of upper portion 57 cm.; of whole figure *c.* 1 m.
Said to have been found in the region of Mount Olympos in Attica.
The upper portion, i.e. the head with the right shoulder and left hand, was acquired by Berlin in 1901. The rest of the stele was acquired by New York in 1911 (and the crowning sphinx in 1938).

She stands with the left leg advanced, the right arm lowered, and the left arm raised, holding a flower between thumb and index finger.
She wears a belted and pouched chiton and over it an epiblema, draped over both shoulders and arms, one zigzag edge falling in front of each arm, the other behind it, with the four corners visible at the bottom.
The hair is carved in wavy strands, except on the skull, above a taenia, where it is rendered as a smooth, wavy mass.
The eye is carved with prominent lids and little indication of the curvature of the upper lid or of the lachrymal caruncle. The nose is bulbous at the tip. The lips are fleshy. In the ear both tragus and antitragus are tentatively indicated.
The girl is represented on the stele together with a youth, who is much taller, and so perhaps her brother. On the base of the stele is an inscription, only partly preserved, on which see M. Guarducci, in her appendix to my *Archaic Gravestones of Attica*, pp. 159 ff., no. 37, fig. 204 (with other references). Whether the monument was erected by Megakles of the family of the Alkmeonids, as was once thought, is not certain.
About 540-530 B.C.

Blümel, Staatliche Museen, Berlin, Kat. II, 1, no. A7, pls. 17-18; *Arch. griech. Sk.*, no. 7, figs. 21, 22, 24.
Richter, *M.M.A. Cat. of Sc.*, no. 15; *Archaic Gravestones²*, 1961, no. 37.

138 : Figs. 441-444

NEW YORK, Metropolitan Museum of Art, 07.286.110. Rogers Fund, 1907.

Marble statue. Height 69 cm.
Said to have been found in the neighbourhood of Laurion.
Once in the collection of A. van Branteghem.
The statue was broken at the waist and repaired with a dowel and two horizontal pour holes to secure the dowel with lead.

The head and left arm are evidently due to an ancient repair. The head, with neck, ends below in a large, rounded, tenon, and was inserted in a hollow at the top of the body. The hair is rolled up behind, whereas on the statue the rounded contour of the hair that fell down the back is clearly marked. The head, which is evidently ancient (with closely adhering rootmarks) must have been added after the statue was damaged (in the fifth century B.C.?), and the features recarved to simulate archaic renderings. At the same time a new left forearm was evidently added, extending forward and holding a hare. Originally the arm was lowered and held a fold of the drapery in the usual manner, grasping the paryphe of the chiton in front of the body. At this place the marble was recarved (note its concavity).
With these alien additions removed the statue becomes a typical archaic kore. She stood with the feet close together, the right forearm brought to the front of the chest and holding a pomegranate, the left arm lowered and grasping a fold of the drapery. She wears a chiton, pulled over a belt on either side, forming deep pouches (kolpoi). The back is left smooth. The folds on the front are indicated with delicately carved ridges on the upper part of the chiton, and on the lower part with incised lines, radiating in the direction of the left hand. Descending down the front of the body is a paryphe, rendered in stacked folds.
One may compare the kore Akropolis 670, my no. 119.
About 530-520 B.C.

E. Robinson, *M.M.A. Bull.*, III, 1908, pp. 2 ff., fig. 3.
Chase, *Greek and Roman Sculpture*, pp. 17 ff., fig. 20.
S. Reinach, *Rép.*, v, 1924, p. 105, no. 2.
Richter, *M.M.A. Cat. of Greek Sc.*, 1954, no. 4, pls. VI, VII, with a detailed account of the repairs, and, on pl. VII, illustrations of the various fragments (with their holes) when they were separated in the Museum.

139 : Figs. 446-448

ATHENS, NATIONAL MUSEUM, 25.

Headless marble statue. Height 45 cm.
Found at Eleusis.

The left leg is advanced. The right forearm (missing) was extended, its tenon fitting into the corresponding mortice. The left arm was lowered and grasped a fold of the paryphe.

She wears a chiton, and over it a short Ionic himation, draped from the right shoulder to beneath the left armpit, and descending in vertical and oblique, stacked folds with zigzag edges.

The hair falls down in a mass of zigzag tresses, with three globular tresses brought to the front on either side.

Last quarter of the sixth century B.C.

Philios, *Eph. arch.*, 1884, cols. 183 f., pl. 8, figs. 6 and 6a.
Kavvadias, *Arch. Deltion*, 1888, p. 6, no. 5.
Kastriotes, *Glypta*, no. 25.
S. Karouzou, *Guide*, no. 25, pp. 37 f.
Langlotz, in Schrader, *Marmorbildwerke*, p. 42.

140 : Figs. 449-451

ATHENS, NATIONAL MUSEUM, 26.

Headless marble torso. Height 55 cm.
Found at Eleusis.

The left leg is a little advanced. The right forearm was extended, the surviving tenon fitting into the corresponding mortice. The left arm was lowered and grasped a fold of the paryphe.

She wears a chiton, and over it an epiblema, draped over both shoulders, and descending, front and back, with substantial, stacked folds.

The hair falls down in undulating tresses at the back; three thicker tresses are brought to the front on each side.

Last quarter of the sixth century B.C., probably toward the end.

Philios, *Eph. arch.*, 1884, cols, 185 f., pl. VIII, 7, 7a.
Kastriotes, *Glypta*, no. 26.
S. Karouzou, *Guide*, no. 26, pp. 37 f.

141 : Fig. 445

ATHENS, NATIONAL MUSEUM, 36.

Marble relief with two women. Height 43 cm.
Upper and lower parts missing.
From Athens.

One woman is seated, the other is standing opposite her. The seated woman wears a chiton, and over it the short Ionic himation, draped from the right shoulder to below the left armpit. The right forearm is raised, with the hand holding perhaps a flower; the left is also raised, and held a fold of the himation.

The standing woman wears only the chiton, with ample sleeves. The right forearm is raised, the left extended, with the hand holding a fold of the chiton. The hair descends in wavy tresses over her left shoulder.

Last quarter of the sixth century B.C.

Though the stances are somewhat different, the costume and the action—one hand holding an offering, the other grasping a fold of the drapery—correspond to those of the korai. They testify to the widespread adoption of the current type.

Conze, *Griech. Grabreliefs*, pl. XII.
Svoronos, *Mus. Nat.*, pl. XXI, 2.
Kastriotes, *Glypta*, no. 36.
S. Karouzou, *Guide*, p. 33, no. 36.

142 : Figs. 452-453

ATHENS, NATIONAL MUSEUM, 27.

Head of a marble statue. Height 13 cm.
Found at Eleusis.

She wears a stephane and large disk earrings.
The eyeballs are prominent; the lachrymal caruncle and the curvature of the upper lid are both indicated. The lips meet at the corners with hollows forming the transition into the cheeks. In the ear the tragus is marked. The hair on the skull, above the stephane, is indicated by broad, horizontal ridges, which then continue down the back. On the sides are the beginnings of the tresses that descended over the shoulders.
Above the forehead the hair is rendered by vertical spiral locks, with zigzag side coils.

Last quarter of the sixth century B.C.

Philios, *Eph. arch.*, 1883, col. 95, pl. 5.
Kastriotes, *Glypta*, no. 27.

143 : Figs. 454-455

ATHENS, NATIONAL MUSEUM, 17.

Head of a marble statue. Height 11 cm.
Marble said to be Pentelic.
Found in the Ptoan sanctuary of Apollo, Boeotia, during the French excavations.
The missing piece in the nose must have been worked separately and attached with cement, for the remaining surface is smooth, not a fracture.

She wears a curving stephane and large disk earrings. On the former are traces of a maeander pattern, on the latter of a rosette.
The eyes are obliquely placed; the eyeballs are prominent, the lachrymal caruncle and the curvature of the upper lid are both indicated. The lips curve upward; they meet at the corners, surrounded by rather deep hollows. In the ear the tragus is given its characteristic shape.
The hair is rendered on the skull, above the stephane, by horizontal, broad ridges, which continue down the back, whereas on each side descend four thick, beaded tresses. Above the forehead and temples is a row of spiral locks, directed from the centre to the right and left.
About 520 B.C.

Holleaux, *B.C.H.*, XI, 1887, pl. VII, pp. 1 ff.,
Kastriotes, *Glypta*, no. 17.
Lullies, *J.d.I.*, LI, 1936, p. 147, fig. 9, p. 149.

144 : Figs. 456-459

BOSTON, MUSEUM OF FINE ARTS, 98.658. From the Tyskiewicz Collection.

Bronze statuette of Artemis. Height 19 cm.
Cast in one piece with a three-stepped base.
Said to have been found at Mazi, Elis.

She stands with feet close together, the right arm lowered, the left forearm brought forward and holding a bow.
She wears a belted peplos with overfold, a necklace with pendant, and sandals. The peplos is foldless in front, but down the middle of the back descends a bunch of parallel pleats.
The hair falls down the back in a mass of tresses, with three separate tresses brought to the front on either side.
In the eyes the curvature of the upper lid is nicely indicated, and the lachrymal caruncle is marked. The lips

are differentiated and do not meet at the corners. In the ear the tragus is given its natural shape.
Running down the front of the drapery, below the belt, is incised the inscription: Χιμαρίδας τᾶι Δαιδαλείαι, 'Chimaridas (dedicated it) to the Daidalean goddess'.
The wearing of the peplos at a time when the chiton and Ionic himation were fashionable elsewhere may be due to the fact that the statuette comes from an outlying region.
Last quarter of the sixth century, as indicated by the fairly advanced forms of the features—here combined with a somewhat stiff rendering of the garment.
'The forms of the letters would conform with a date in the last quarter of the sixth century B.C., e.g. in Laconia' (M. Guarducci).

E. Robinson, *Annual Report*, 1898, pp. 26 f., no. 16.
Froehner, *Sale Catalogue of the Tyskiewicz Collection*, Paris, 1898, no. 139, pl. 15.
Neugebauer, *Antike Bronzestatuetten* (1921), p. 43, figs. 18, 19.
Furtwängler, *Kleine Schriften*, II, p. 464, fig. 5.
Langlotz, *Bildhauerschulen*, p. 87, pl. 44, e, pl. 47, a.
Lamb, *Bronzes*, pl. XXXV, d, p. 90.
Chase, *Guide*, 1950, p. 29, fig. 33.
Jeffery, *Local Scripts*, p. 191, no. 67, pl. 39.

145 : Figs. 460-461, 466-467

PARIS, LOUVRE, CA 2941. Acquired in 1932.

Terracotta statuette. Height 20 cm.
From the neighbourhood of Thebes.

She stands with feet almost level, and with both forearms (now mostly missing) extended.
She wears a peplos with overfold, front and back, fastened on the shoulders with large brooches. No folds are indicated. A large chain hangs across her chest.
The hair descends at the back in seven tresses, divided horizontally, and four similar tresses are brought to the front on each side.
Last quarter of the sixth century B.C.
The costume has been explained as a chiton with a 'pélerine'. In view of the related costumes of the contemporary korai, perhaps a peplos with overfold is more likely; though it is true that the 'overfold' of the Theban lady is exceptionally broad. As in no. 144, the wearing of the peplos at a time when the Ionic costume was current may be explained as a 'survival' in an outlying region.

Charbonneaux, *Les terres cuites grecques*, 1936, fig. 9, p. 8.
Besques Mollard, *Cat.*, I, B77, pl. X.

146 : Figs. 462-465

ATHENS, NATIONAL MUSEUM, inv. 5669.

Terracotta statuette, serving as an alabastron, with a cylindrical mouth at the top. Height *c.* 26 cm.
Moulded, front and back.
From near Thebes.

She stands on a quadrangular base, with the left leg advanced, the left arm bent, holding a bird in the hand, and the right arm lowered, to grasp the paryphe of the chiton.
She wears a chiton, from the bottom of which her bare feet protrude, and over it a short Ionic himation, draped from the right shoulder to beneath the left armpit; also **a** veil, or head-band.

The hair falls down the back in globular tresses, with two such tresses brought to the front on either side. The eyes are elongated, with the curvature of the upper lid as well as the lachrymal caruncle indicated. The ears are summarily rendered, but with the tragus given its characteristic form.
Last quarter of the sixth century B.C.
Many examples of this type, with slight variations, have been found all over the Mediterranean, East and West, e.g. in Samos, Rhodes, continental Greece, Sicily, etc. A number of them were evidently made from the same mould; cf. Winter, *Typen*, I, pl. 41; Higgins, *Terracottas in the British Museum*, I, under no. 57; *Greek Terracottas*, pl. 13, D, E.

Not before published?

Group V, 4

Korai from the Islands: Delos, Paros, Andros, Samos, Rhodes, and Cyprus

Korai 147-160

147 : Figs. 468-471

DELOS, MUSEUM, A4064.

Marble statue, from neck to left knee. Height 94 cm.
Found in Delos in 1879.

The left leg is advanced. The right forearm is brought a little forward, the left arm was lowered to grasp a fold of the drapery.
She wears a chiton, and over it a short Ionic himation, draped from the right shoulder to beneath the left armpit.
The hair falls down in a quadrangular mass of wavy tresses at the back, and two similar tresses are brought to the front on either side. The ends of these side tresses were worked separately and are missing; but the holes for their attachment remain.
The buttons for the right chiton sleeve were added in metal, as the remaining holes indicate.
The lower part of the chiton in front has no paryphe, but at the back a bunch of stacked folds descends along the middle.
Last quarter of the sixth century B.C.

Homolle, *B.C.H.*, III, 1879, pp. 108 ff., pls. II, III; *De antiquissimis Dianae simulacris deliacis*, p. 31, pls. 7a, 7b.
Langlotz, *Bildhauerschulen*, p. 132, pl. 83, a.

148 : Figs. 472-475

ATHENS, NATIONAL MUSEUM, 22.

Marble statue.
Head, feet, and both arms are missing.
Found in Delos, in 1884, in the temple of Artemis, during the excavations of the French School.

The left leg is advanced. The left arm was lowered and grasped a fold of the drapery. The right arm was made in a separate piece, from below the shoulder down; from the dowel holes along the side one can deduce that it too was lowered.
She wears a chiton, and over it a short Ionic himation, draped from the right shoulder to beneath the left armpit, and pulled up a little over the top band, forming a series of pleats. As a third garment she has an epiblema, which hangs down from both shoulders over the back and sides.
She also wears a necklace with pendants, and across the chest two chains, which had metal pendants, to judge by the holes that remain—three for each chain. There are also holes between the pleats on the top band of the himation, also doubtless for metal ornaments.
The hair at the back is hidden by the epiblema; but several tresses descend in front on either side; some of

their ends are covered by the epiblema, others were worked in separate pieces and attached, as indicated by the surviving holes.

The folds of the himation have considerable depth. The knee-caps are modelled to show through the drapery. The folds of the chiton held in the left hand, are—exceptionally—preserved, at least in part, descending in stacked formation.

Late sixth century B.C.

For the chains worn across the chest cf. the terracotta statuettes, my nos. 47, 49, and p. 11.

Homolle, *De antiquissimis Dianae simulacris deliacis*, p. 31.
Paris, *B.C.H.*, XIII, 1889, pp. 217 ff., pl. VII.
Kastriotes, *Glypta*, no. 22.
Langlotz, in Schrader, *Marmorbildwerke*, p. 42.

149 : Figs. 476-479

DELOS, MUSEUM, A4067.

Marble statue, from neck to above knees. Height 1.02 m.
Found in Delos in 1879.

The left leg is advanced. The right arm is extended sidewise and bent at the elbow. The left arm is lowered and grasped a fold of the drapery.

She wears a chiton and over it a short Ionic himation, draped from the right shoulder to below the left armpit, with a top band; also a necklace with pendants.

The hair falls down the back in wavy tresses, and five such tresses are brought to the front on either side.

Last quarter of the sixth century B.C.

Homolle, *B.C.H.*, III, 1879, pl. XVII; IV, 1880, pp. 32 ff.; *De antiquissimis Dianae simulacris deliacis*, p. 31, pl. VIII.

150 : Figs. 480-482

DELOS, MUSEUM, A4063.

Marble headless statue. Height 89 cm.
Put together from many pieces.
Found in Delos, near the Propylaia, in 1879.

The left leg is advanced. The right arm is extended a little sidewise, and is bent at the elbow. The left arm was lowered and grasped a fold of the drapery.

She wears a chiton, and over it a short Ionic himation, pulled a little over its decorated top band. The slack of the left chiton sleeve is laid over the band at its further end.

The hair fell down the back in several thick tresses, some of which were worked separately and attached with

dowels, for which the holes remain. In front three tresses descend on each side.

Last quarter of the sixth century B.C.

Homolle, *B.C.H.*, III, 1879, pls. XIV, XV, vol. IV, 1880, pp. 32 ff.; *De antiquissimis Dianae simulacris deliacis* (1885), p. 31, pls. IXa, IXb.
Langlotz, *Bildhauerschulen*, p. 136, pl. 82, b (without the lower part).

151 : Figs. 483-486

NEW YORK, METROPOLITAN MUSEUM OF ART, 07.306. Gift of John Marshall, 1907.

Marble headless statue. Height 1.275 m.
Marble said to be Island.
Evidently found in Paros, for it was seen there by Michaelis in 1864, and by Loewy in 1887.
The surface is much weathered.

The left leg is advanced. The right arm was bent at the elbow and brought forward. The left was lowered and grasped a fold of the paryphe of the chiton.

She wears a chiton, and over it a short Ionic himation, draped from the right shoulder to beneath the left armpit.

The hair falls down the back in wavy tresses, alternating with unworked portions, where the tresses were perhaps indicated in colour. Four long tresses descend on each side in front.

Last third of the sixth century B.C.

Michaelis, *Ann. dell'Inst.*, 1864, p. 267.
Loewy, *Archäol.-epigr. Mitt. aus Oesterreich-Ungarn*, 1887, p. 159, fig. 13, pl. VI, 1.
E. Robinson, *M.M.A. Bull.*, III, 1908, p. 5, fig. 4.
Payne and Young, *Archaic Marble Sc.*, p. 23, note 1, pp. 55 f., note 3.
Langlotz, *Bildhauerschulen*, pp. 132, 135, pl. 82, a, c.
Richter, *M.M.A. Greek Handbook*, 1953, p. 69, pl. 50, f; *Cat.*, no. 5, pl. VIII.

152 : Figs. 487-490

COPENHAGEN, NY CARLSBERG GLYPTOTEK, I.N. 1544. Acquired by Copenhagen in 1896 in Athens.

Marble statue, from neck to knees. Height 73 cm.
Found in the island of Andros.
Surface much weathered.

The left leg is a little advanced. Both forearms are missing; but the remaining traces show that the right was extended, whereas the left was lowered to grasp a fold of the drapery.

She wears a chiton, and over it a short Ionic himation, draped from the right shoulder to beneath the left armpit.

The hair falls down the back in a solid mass of tresses,

and three separate tresses are brought to the front on each side.

Last third of the sixth century B.C.

S. Reinach, *Rép.*, IV, 1913, p. 401, no. 8.
F. Poulsen, in Arndt-Amelung, *Einzelaufnahmen*, nos. 3770-3771; *Cat.* (1951), no. 21. *Billedtavler*, pl. II, no. 21.
Langlotz, *Frühgriech. Bildhauerschulen*, p. 126, no. 11.

153 : Figs. 491-494

BERLIN, STAATLICHE MUSEEN, inv. 1744.

Headless marble statue. Height 52 cm.
Found on the western front of the temple of Hera at Samos.

The left leg is advanced. Both arms are lowered, with hands closed, the left grasping a fold of the paryphe of the chiton, the right holding an edge of the himation. She wears a chiton, pulled up a little over the belt to form two pouches (kolpoi) on either side, and a short, Ionic himation, draped from the right shoulder and covering both breasts. As a third garment she has an epiblema, which hangs asymmetrically over the back, the tops of the shoulders, and down the left upper arm; it probably covered also the back of the head, for no hair is visible.

Early in the last third of the sixth century B.C.

Wiegand, *Ant. Denk.*, III, 1916-17, p. 52, fig. 9.
Langlotz, *Bildhauerschulen*, p. 128, pl. 74, d.
Lippold, *Griech. Plastik*, p. 54, note 1.
Buschor, *Altsam. St.*, V, pp. 93, 96, figs. 373-375.
Blümel, *Arch. griech. Sk.*, no. 37, figs. 106-109.

154 : Figs. 495-498

NICOSIA, CYPRUS, MUSEUM

Limestone statue. Height 74 cm.
The head, lower legs, and much of both arms are missing.
Surface is weathered.
Found among the debris near the gymnasium of Salamis, Cyprus, in 1953.

The left leg is a little advanced. The right forearm was evidently brought forward, and the left was lowered to grasp a fold of the drapery.
She wears a chiton, and over it a short Ionic himation, draped from the right shoulder to below the left armpit, and pulled up a little over the top band, forming a series of long, tongue-shaped pleats.
The hair falls down behind in a square mass of wavy tresses, and three tresses descend in front on either side.

Last quarter of the sixth century B.C.
For the long, tongue-shaped pleats cf. no. 168.

Karageorghis, *Arch. Anz.*, 1963, col. 589, fig. 4; *Sculptures from Salamis*, pp. 7 f., no. 1, pl. VII, 1-4; *Atti del Settimo Congresso*, I, pp. 321 f.,

155 : Figs. 499-500

NEW YORK, METROPOLITAN MUSEUM OF ART, 74.51.2820. From the Cesnola Collection. Acquired in 1874.

Limestone head of a statue. Height 32.5 cm.
From Cyprus.

The eyes are elongated, with the lachrymal caruncle indicated. The lips are differentiated, and their transition into the cheeks is gradual. In the ears are spiral earrings. Round the neck is a necklace of five strings of beads with a clasp in the centre front. Large ornaments cover the ears.
The hair falls down the back in a mass of spiral tresses, and similar spiral locks descend on the shoulders.
A taenia encircles the head. Below it, above the forehead and temples, appear more spiral locks, and above it, on the skull, the hair radiates from the vertex.
Last quarter of the sixth century B.C.

Cesnola, *Cyprus, Its Ancient Cities, Tombs and Temples* (1877), p. 141; *Atlas of the Cesnola Collection of Cypriote Antiquities in the Metropolitan Museum of Art* (1885), I, pl. LXXXII, 534.
Myres, *Handbook of the Cesnola Collection*, no. 1295.
Richter, *Archaic Greek Art*, p. 175, fig. 267.

156 : Figs. 501-503

CAMBRIDGE, FITZWILLIAM MUSEUM, GR 3c 1888.

Terracotta head and neck, broken from a statue. Height 24.5 cm.
'Fashioned hollow by the coil technique, with moulded face' (R. Nicholls).
'Given on August 28th, 1888, by Dr. F. H. H. Guillemard, along with a number of other Cypriot terracottas (especially parts of large figures) and vases, apparently all acquired in Cyprus and of Cypriot provenance' (R. Nicholls).

The eyes are elongated, with the lachrymal caruncle indicated at the inner corners. The lips are differentiated, and at their corners there are deepish hollows. The ears are summarily worked.
She wears a pointed cap with a stephane-like rim, and 'the usual "knobbed" top (now broken away)' (R. Nicholls).

The hair descends at the back in a solid mass, with a single tress brought to the front on either side. Above the forehead and temples it is indicated by a number of superimposed wavy ridges, horizontally placed.
Last quarter of the sixth century B.C.

Not before published. Here included by the kind permission of the Syndics of the Fitzwilliam Museum.

157 : Figs. 504-505

BERLIN, STAATLICHE MUSEEN, inv. 1875.

Marble head. Height 13 cm.
Found at the Heraion, Samos.
Left unfinished.

She wears a veil (epiblema), which covers the entire head with the exception of the face.
The upper eyelid curves over the eyeball, and is made much more prominent than the lower. The lips do not meet at the corners, and have vertical grooves at the transition to the cheeks.
Above the forehead is a series of thick, long locks.
Last quarter of the sixth century B.C.

Buschor, *Altsamische St.*, V, p. 92, fig. 371.
Blümel, *Arch. griech. Sk.*, no. 40, figs. 116, 117.

158 : Figs. 506-507

LONDON, BRITISH MUSEUM, inv. 61.10-24.1.

Terracotta statuette, serving as an alabastron. Height 23 cm.
The cylindrical mouth is missing.
Moulded front and back.
Found at Kameiros, Rhodes.

She stands on a quadrangular base, with the left foot advanced, the right arm bent, and holding a little hare in her hand; the left arm is lowered, with the hand grasping the paryphe of her chiton.
She wears a chiton, and over it a short Ionic himation, draped from the right shoulder to beneath the left armpit; also a head-band and disk earrings. Her hair falls down her back in a mass, with two globular tresses brought to the front on either side.
The eyes are elongated, with the curvature of the upper lid indicated. The lips are differentiated.
Last third of the sixth century B.C.

Winter, *Typen*, I, pl. 42, no. 4.
Walters, *Cat. of Terracottas, Br. Mus.*, B207, pl. XVII.
Higgins, *Terracottas in the British Museum*, I, no. 49, pl. 10.

159 : Figs. 509-511

LONDON, BRITISH MUSEUM, inv. 60.4-4.57.

Terracotta statuette, serving as an alabastron, with a cylindrical mouth at the top. Height 26 cm.
Moulded front and back.
From Kameiros, Rhodes. Found in 1859.

She stands on a quadrangular base, with the left leg advanced. The right arm is lowered, with the hand grasping the paryphe of the chiton. The left arm is bent, with the forearm laid against the chest and the hand holding a bird.
She wears a chiton, and over it a short Ionic himation, draped from the right shoulder to beneath the left armpit; also a veil or head-band.
The hair falls down the back in globular tresses, with two such tresses brought to the front on either side. The eyes are elongated, with the lachrymal caruncle and the curvature of the upper lid both nicely rendered. The lips are differentiated, and there are grooves between their corners and the cheeks.
Last quarter of the sixth century B.C.
Similar to my no. 160, and perhaps made from the same mould? That one was found in Rhodes, the other near Thebes shows a wide export, presumably from the East.

Winter, *Typen*, I, pl. 41, no. 1.
Walters, *Cat. of Terracottas, Br. Mus.*, B205, pl. XVII.
Higgins, *Terracottas in the British Museum*, I, no. 57, pl. 13.

160 : Fig. 508

PARIS, LOUVRE, MC681.

Terracotta statuette serving as an alabastron, with a cylindrical mouth at the top. Height 26 cm.
Moulded front and back.
From Rhodes.

Similar to the preceding. Apparently made from the same mould, the only difference being in the shapes of the mouth and base, which were of course made separately.

Winter, *Typen*, I, pl. 41, no. 1, b.

Group V, 5

Korai from the East: Miletos, Didyma, Klazomenai, Sardes, Kyzikos, Theangela, Cyrene, and Memphis

Korai 161-170

161 : Figs. 512-515

BERLIN, STAATLICHE MUSEEN, inv. 1577.

Headless marble statue. Height 1.06 m.
Found in Miletos in 1900, in a wall of Hellenistic date, together with several seated statues.

She stands with the right leg a little advanced. The right arm is lowered, with the hand grasping a fold of the chiton. The left arm is bent, with the forearm brought to the front of the body and holding a bird in the hand. She wears a chiton, which is pulled over a belt, forming small pouches (kolpoi) on the sides, and over it, a short Ionic himation, draped over both shoulders, and hanging down in stacked pleats, front and back.
The hair descends in a quadrangular mass of beaded tresses at the back, and four wavy tresses are brought to the front on either side. She wears a bracelet on each arm.
The missing head and neck were worked in a separate piece, as indicated by a large dowel hole. Behind the right hand a dowel, of which a piece remains, served for the attachment of a separately worked piece of drapery.
Last quarter of the sixth century B.C.

Wiegand, *Arch. Anz.*, 1901, p. 198; *Ant. Denk.*, III, p. 52.
Langlotz, *Bildhauerschulen*, p. 173.
Buschor, *Altsamische St.*, II, p. 36, fig. 125, and v, p. 89, fig. 352.
Alscher, *Griech. Plastik*, II, p. 161, fig. 47a.
Blümel, *Arch. griech. Sk.*, no. 49, figs. 135-138.
Himmelmann-Wildschütz, *Istanbuler Mitteilungen*, XV, 1965, p. 27, pl. 9.

162 : Figs. 516-519

BERLIN, STAATLICHE MUSEEN, inv. 1793.

Lower part of a marble statue. Height 58 cm.
Found at Didyma, nor far from the temple.

The left leg is advanced. Both arms are lowered; the right hand holds a fold of the himation, the left grasps the paryphe of the chiton.
She wears a belted chiton, and over it a short Ionic himation.

The forms of the legs are shown beneath the drapery. Probably early in the last third of the sixth century B.C.

Darsow, *J.d.I.*, LXIX, 1954, p. 109.
Blümel, *Arch. Griech. Sk.*, no. 48, figs. 133, 134.

163 : Figs. 520-523

PARIS, LOUVRE, 3380. Acquired in 1898, as a gift of P. Gaudin.

Torso of a marble statue, from neck to above knees. Height 80 cm.
Found near Klazomenai.

The right arm is bent, with the forearm brought to the front of the body and holding a bird in the hand. The left arm is lowered, with the hand grasping a fold of the paryphe of the chiton.
She wears a chiton and a short Ionic himation, which has a plain top band, and is draped from the right shoulder to below the left armpit.
The hair falls down at the back in a series of tresses, divided horizontally, with two similar tresses brought to the front on either side.
Probably early in the last third of the sixth century B.C.
The bottom of a statue, with two feet and part of the chiton (Ma 3303), which was once thought to belong to the upper part (cf. illustrations in Langlotz and Lippold, locc. cit.) has been recognized as not belonging and has been removed. The rendering of the feet seems indeed later than that of the drapery.

Collignon, *Rev. arch.*, 1900, 2, pp. 374 f., pl. XV.
Michon, *B.C.H.*, XXXII, 1908, pp. 259 ff., pl. III.
Catalogue sommaire (1922), p. 41, no. 3380.
Langlotz, *Bildhauerschulen*, p. 104, pl. 60, c.
Lippold, *Griech. Plastik*, p. 61, pl. 16, no. 2.

164 : Figs. 524-527

MANISA, MUSEUM.

Marble monument in the form of a shrine, decorated with figures in relief. Height 62 cm.
Found at Sardes in 1963.

The top of the monument is missing.
The surface is weathered and parts have flaked off.

In front, in high relief, is shown the figure of a woman standing with the feet close together, the right arm lowered to grasp a fold of the paryphe of the chiton, the left arm bent, with the forearm brought to the front of the body and the hand holding some offering.
She wears a chiton pulled over a belt to form a pouch (kolpos) on each side. An epiblema descends shawl-like from both shoulders. Round her neck is a heavy necklace.
On each side of the monument is carved a woman in low relief, one in profile to the right, the other in profile to the left. The right hand of each is lowered and grasps a fold of the paryphe of the chiton, the left arm is bent and the forearm raised. Each wears a chiton and a short Ionic mantle, descending in stacked folds.
Last third of the sixth century B.C.

Mitten, *Bull. of the American Schools of Oriental Research*, no. 174, April 1964, pp. 39 ff., figs. 25, 26.

165 : Figs. 528-530

BERLIN, Staatliche Museen, inv. 1851.

Head of a marble statue. Height 25 cm.
Said to be from the neighbourhood of Kyzikos. Acquired by Wiegand in the antiquity market, and presented by him to the Museum.

The eyeballs protrude, with the upper lid curving over it; the lachrymal caruncle is indicated. The lips curve slightly upward and are differentiated. At their corners are grooves. In the ear both tragus and antitragus are given their characteristic shapes.
The hair descends in wavy ridges from the front of the skull down the back, with three wavy tresses brought to the front on each side. Above the forehead and temples it is rendered in large waves, with a central parting. There is no stephane, and there are no earrings.
The head has been dated both around 500 B.C., and considerably earlier. According to its anatomical renderings, it should belong in the last quarter of the sixth century, later than the Siphnian karyatid.

Blümel, *Berl. Mus.*, LIV, 1933, pp. 53 f. (ill.); *Arch. griech. Sk.*, p. 40, no. 31, figs. 85, 86 ('beginning of 5th century B.C.').
Lippold, *Griech. Plastik*, p. 65 ('gegen 500 v. Chr.').
Fink, *Die Haartrachten der Griechen*, p. 70.
Himmelmann-Wildschütz, *Istanbuler Mitteilungen*, XV, 1965, pp. 35 ff., pls. 21, 22 (dated around 525 B.C.).

166 : Fig. 531

BERLIN, Staatliche Museen, inv. 1900.

Fragmentary marble votive relief. Height 41 cm.
Probably found in Miletos.
Put together from two pieces.
Surface has suffered.

A woman is shown in front view, standing with the right arm lowered and the hand holding the paryphe of the chiton, the left arm bent, with the forearm placed against the body and holding what looks like a bird.
She wears a chiton, pulled over a belt on either side to form pouches (kolpoi), and an epiblema, which covered the head and fell down her back from the shoulders.
Last third of the sixth century B.C.
Blümel, loc. cit., compares the recently found base from Kyzikos in Istanbul, Akurgal, *Die Kunst Anatoliens*, p. 234, figs. 200, 220.

Blümel, *Arch. griech. Sk.*, no. 46, fig. 128.

167 : Figs. 532-535

LONDON, British Museum, B319. Acquired in 1889; inv. no. 89.5-22.2.

Marble headless statue. Height 39 cm. About half life-size.
Found at Theangela, Caria.
Surface corroded in parts.

She stands with the right leg a little advanced. The right arm is lowered, with the hand grasping the paryphe of the chiton; the left arm is bent, with the forearm brought to the front of the body and holding a bird in the hand. She wears a chiton, pulled a little over the belt, an Ionic short himation, draped from the right shoulder to below the left armpit; also, as a third garment, an epiblema, hanging down the back from both shoulders, with a pleated overfold.
The forms of the body are shown modelled beneath the drapery.
Last third of the sixth century B.C.

Pryce, *Br. Mus. Cat.*, I, 1, pp. 149 f., B319, fig. 188.

168 : Figs. 536-537

CYRENE, Museum, 14.008.

Headless marble statue. Height 98 cm.
Marble said to be Island.
From the Sanctuary of Cyrene.

The left leg is a little advanced. The right arm is lowered to grasp a fold of the chiton. The left forearm (now missing) was extended and doubtless held an offering (there is a hole in the fracture).

She wears a chiton, and over it a short Ionic himation, draped from the left shoulder to below the right armpit, and pulled up a little over the top band to form a series of long, stacked folds. Along the right sleeve of the chiton is a row of holes for the attachment of buttons. The hair falls down at the back in a mass of wavy tresses, divided horizontally and arranged in two registers. On either side in front are three thin, globular tresses, widely spaced.

Last quarter of the sixth century B.C.

S. Reinach, *Gazette des Beaux-Arts*, 1914, pp. 277 f.
Ghislanzoni, *Notiziario archeologico*, I, 1915, p. 184, fig. 59, a, b.
S. N. Deane, *A.J.A.*, XXVI, 1922, pp. 113 f.
Picard, *Manuel*, I, p. 581.
Pfuhl, *Ath. Mitt.*, XLVIII, 1923, p. 139, fig. 5.
Knoblauch, *Studien zur archaisch-griechisch. Tonbildnerei*, 1937, p. 111.
Lippold, *Griech. Plastik*, p. 90.
E. Paribeni, *Catalogo*, no. 8, pls. 12, 14, 15.

169 : Figs. 538-539

CYRENE, MUSEUM, 14.009.

Headless marble statue. Height 1.20 m.
Marble said to be Island.
From the Sanctuary of Cyrene.

The pose is antithetic to that of no. 168, that is, the right leg is advanced, the left arm is lowered to hold a fold of the chiton, and the right forearm (now missing) extended to hold an offering (there is a dowel hole in the fracture).

She wears a chiton and a short Ionic mantle, draped from the right shoulder to beneath the left armpit, and pulled up over the top band to form a series of stacked folds (also long but more widely spaced than in no. 168). Along the left chiton sleeve is a row of holes, for the attachment of presumably metal buttons.

In both figures (nos. 168 and 169) the folds of the himation which descend front and back are about equal in length, not, as is usual, longer on the side of the shoulder on which the mantle is draped (cf. p. 8).

Last quarter of the sixth century B.C.

Ghislanzoni, *Notiziario archeologico*, I, 1915, p. 184, fig. 60, a, b.
E. Paribeni, *Catalogo*, no. 9, pls. 13, 14, 15.
See also the other references given under no. 168.

170 : Fig. 540

CAIRO, ARCHAEOLOGICAL MUSEUM.

Small limestone statue, mounted on a rectangular plinth. Height 72 cm.
Found at Mit Radineh (Memphis) in 1898.
Slight traces of red on shoes, plinth, and mantle.

She stands with the left leg slightly advanced, the right arm bent and laid against the chest, the left arm lowered to grasp a fold of the drapery (though both forearms are missing, their action can be made out from the remaining traces).

She wears a chiton, and over it a short Ionic himation, draped from the right shoulder to below the left armpit; also shoes.

The hair hung down at the back in a mass of tresses, and three such tresses were brought to the front on either side; they were made in separate pieces and are now missing, but the holes that served for insertion remain.

The eyes and eyebrows were also inlaid separately and are missing. The ears were pierced for the insertion of earrings. On the head was a polos, made in a separate piece, and now missing.

There is little detail on the back.

Last quarter of the sixth century B.C.

Journal d'entrée du Musée, no. 33006.
C. C. Edgar, *Catalogue général des antiquités égyptiennes du Musée du Caire*, Greek Sculpture, p. 3, no. 27431, pl. I.

Group V, 6

Korai from the West: South Italy, Sicily, Albania, Spain

The series begins with two interesting korai found near Taranto, both left unfinished. Then comes one of the metopes from Foce del Sele with running 'Nereids', who, being in motion, are not, strictly speaking, korai. But they are important witnesses for the competence of local sculptors, since they were worked in local sandstone (cf. under no. 173).

I have also included an interesting Etruscan bronze statuette, with an inscription, of this period (no. 178).

Korai 171-179

171 : Figs. 541-544

TARANTO, Museum.

Headless marble statue. Height 1.29 m.
Left unfinished; the back only roughly blocked out.
Found in 1923 at Punta del Tono, near Taranto.
Surface weathered.

The head was worked separately and fastened to the body with a large dowel.
The left leg is advanced. The right forearm was extended; it was worked separately and inserted in a corresponding mortice. The left arm was perhaps lowered with the hand grasping the paryphe of the chiton (now all broken away).
She wears a chiton and a short Ionic himation, draped from the right shoulder to below the left armpit.
The hair is shown hanging down the back.
Last quarter of the sixth century B.C.
Various theories have been held as to whether this statue and others from Sicily and South Italy were made in Italy or imported from the East. That South Italian sculptors were able to carve the archaic kore type is now conclusively shown by the sandstone metopes of c. 500 B.C. found in Foce del Sele (cf. fig. 548). The marble of the kore from Tarentum is presumably Greek (Parian?), and must therefore have been imported. Whether the blocking out was done before or after transit remains uncertain, but on the present evidence local archaic workshops must be envisaged (cf. no. 173).
Last quarter of the sixth century B.C.

Wuilleumier, *Tarente*, pp. 268 f.
Rumpf, *Röm. Mitt.*, 38/39, 1923/24, p. 477.
M. Santangelo, *Boll. d'Arte*, XXXVIII, 1953, pp. 1 ff., figs. 1-10.
Dunbabin, *The Western Greeks*, p. 291.
Langlotz and Hirmer, *Die Kunst der Westgriechen*, pl. 42, pp. 66 f.
Von Matt and Zanotti-Bianco, *Grossgriechenland*, pl. 88.

172 : Figs. 545-547

BERLIN, Staatliche Museen. Acquired in 1882.

Small headless marble statue.
Left unfinished.
Found in Satiro, near Taranto.

The left leg is advanced. Both forearms were extended. They are now missing, except for parts of their tenons which fitted into the corresponding mortices.
She wears a sleeved chiton and a short Ionic himation, draped from the right shoulder to beneath the left armpit. The chiton has a paryphe of folds running down the middle of the back, and the slack of the wide sleeves is indicated by hanging folds below the tenons of the forearms.
No hair is indicated falling, as usually, down the back—a curious omission, perhaps due to the unfinished state of the statue.
Last quarter of the sixth century B.C.

Studniczka, *J.d.I.*, XLIII, 1928, p. 154, fig. 9.
Neugebauer, *Arch. Anz.*, 1935, col. 718.
Wuilleumier, *Tarente*, p. 268, pl. IV, 4.
Blümel, *Staatl. Mus., Berlin, Kat.* II, 1, no. A16, pls. 30-32; *Arch. griech. Sk.*, no. 20, figs. 52-54.

173 : Fig. 548

PAESTUM, Museo Nazionale.

Sandstone metope, with two running female figures in relief. Height c. 85 cm.
Found at Foce del Sele in 1936. Belonged to the chief temple of the Heraion. One of several similar representations.

Both women extend their arms in the usual attitude for rapid motion.

Each wears a chiton, and an Ionic short himation, draped from the right shoulder to beneath the left armpit, as well as a stephane on the head.

The hair descends in a series of wavy tresses down the back, and is arranged in vertical spiral locks above the forehead.

The features are in the style current at the end of the sixth century B.C., but the material being sandstone and somewhat corroded, the details are not always sharp. In the ears, for instance, the antitragus is not indicated. The expert carving in a local material, with the details of the complicated Ionic costume perfectly understood, shows the proficiency of the native sculptors of the time.

Zancani Montuoro and Zannotti-Bianco, *Heraion alla Foce del Sele*, I, pp. 141 ff., pls. XLI-LXVI.
Langlotz and Hirmer, *Die Kunst der Westgriechen*, pl. 30, p. 164.
Von Matt and Zanotti-Bianco, *Grossgriechenland*, pl. 41.

174 : Fig. 556

REGGIO DI CALABRIA, MUSEO NAZIONALE.

Terracotta head of a woman. Height 23 cm.
Found at Medma (Rosarno).

She wears a stephane and earrings. The hair descends down the back, and is arranged in two tiers of spiral locks above the forehead and temples.

The eyeballs protrude. The lips pass gently into the cheeks with only a slight hollow at the corners.
Toward the end of sixth century B.C.

Von Matt and Zanotti-Bianco, *Grossgriechenland*, p. 100, pl. 96.

175 : Figs. 549-551

GELA, ANTIQUARIO.

Terracotta statuette, mounted on a rectangular base, and supporting a basin. Total height 35 cm.; ht. of kore 29 cm.
Found on the akropolis of Gela in 1953, 'inside a pithos, with other, evidently votive objects, datable *c.* 570-530 B.C.' (Orlandini).
'Made of local clay' (Orlandini). Put together from several pieces.

She stands with the left leg advanced. The (missing) right arm was extended, the left lowered, with the hand holding the paryphe of the chiton.
She wears a belted chiton, from which her feet protrude in front, but which covers her heels at the back; also a short Ionic himation, draped from the right shoulder

to beneath the left armpit, where the slack of the chiton sleeve is indicated by a few stacked folds.

The hair hangs down the back in a series of wavy tresses, with two similar tresses brought to the front on either side. Over the forehead and temples it is rendered by wavy ridges passing from ear to ear, with a parting in the middle.

In the eyes the curvature of the upper lid is indicated. The lips are differentiated, but do not meet at the corners, and there are hollows surrounding them. The ears are summarily rendered.

The basin at the top is hemispherical in form, with spool-shaped handles surrounding the rim, placed alternately horizontally and vertically.
Early in the last third of the sixth century.

Female figures acting as supports of utensils are of course well known, from early archaic times on. They appear both in bronze and terracotta. The present example was apparently votive, but the type undoubtedly reproduces a functional object—'perhaps an incense-burner', as Orlandini suggests (cf., e.g., Pernice, *Oest. Jahr.*, II, 1899, p. 65, fig. 6; M. Besnier, in Daremberg and Saglio, *Dictionnaire*, s.v. turibulum, thymiaterion, p. 544, fig. 7183); or a container of water for lustral purposes? (cf. under perirrhanteria, my p. 27).

Orlandini, *Archeologia classica*, VI, 1954, pp. 1 ff., pl. I.
Neutsch, *Arch. Anz.*, 1954, col. 656, fig. 103.
Langlotz and Hirmer, *Die Kunst der Westgriechen*, p. 60, pl. 21, right.

176 : Figs. 552-555

LONDON, BRITISH MUSEUM, no. 548. From the Payne Knight Collection.

Bronze statuette serving as the support of a mirror. Height 23.6 cm.
Found in a garden near Rome in 1790.

She stands with her left leg advanced, the right forearm extended and holding a sphinx in her hand, the left arm lowered, with the hand grasping a fold of the chiton, together with one of the himation.
She wears a chiton and a short Ionic himation, draped from the right shoulder to beneath the left armpit. On the feet are pointed shoes.
The hair falls down the back in a mass of horizontal tiers. Two wavy tresses descend in front on either side. Above the forehead the hair is rendered in vertical wavy ridges. On top of the head is the attachment connecting the statuette with the mirror, consisting of a central palmette, a horizontal member ending in spirals, and a sphinx on either side.
Late sixth century B.C., perhaps around 500 B.C.

Jantzen, *Bronzewerkstätten in Grossgriechenland u. Sizilien, J.d.I.*, Ergänzungsheft, XIII, 1937, p. 27, no. 21, pl. 13, figs. 53, 54.
Walters, *Cat. of Bronzes*, no. 548.
Langlotz and Hirmer, *Die Kunst der Westgriechen*, pl. 27, p. 63.

177 : Figs. 557-560

PARIS, LOUVRE.

Bronze statuette serving as the support of a utensil.
Height 28 cm.
Said to be from Albania.

She stands with the left foot only slightly advanced, holding a jug (olpe) in her right hand and a stemmed cup in her left, evidently in the act of making a libation.
She wears a sleeved peplos with a broad belt and decorated with incised designs. On her head is a polos, on the feet are laced shoes, and round her neck is a necklace with pendants.
The hair falls down the back in a solid mass of tresses, and above the forehead it is rendered in three tiers of vertical ridges, with a parting in the middle.
The ear is stylized with the tragus indicated, but not the antitragus. The lids of the eye are rendered by ridges, with little indication of the curvature of the upper lid. The lips are differentiated, but sunk fairly deep into the face.
Last third of the sixth century B.C. Another example of the survival of the peplos in an outlying region; cf. nos. 144, 145.

Langlotz, *Bildhauerschulen*, p. 30, pl. 18, a.
De Ridder, *Cat. des bronzes du Louvre*, I, no. 140, pl. 16.
Charbonneaux, *Les bronzes grecs*, L'Œil du connoisseur, pp. 77, 143, pl. xx, 1 (end of 6th century).

178 : Figs. 561-562

BERLIN, STAATLICHE MUSEEN, Fr. 2155.

Bronze statuette. Height 16.4 cm.
Found at Perugia.

She stands with her feet close together, the right forearm brought forward (apparently once holding a flower between thumb and forefinger), the left arm lowered to grasp a fold of the drapery.
She wears a chiton, and over it an epiblema, draped over both shoulders; also a pointed cap (tutulus), a taenia, a necklace, large disk earrings, and pointed shoes. The garments are decorated with incised ornaments.
At the back is an Etruscan inscription.
An interesting Etruscan version of the Greek kore type, perhaps of *c.* 500 B.C. Cf. no. 203.

Martha, *L'art étrusque* (1889), p. 505, fig. 339.
Nogara and Pinza, *Materiali per la etnologia antica toscano-laziale*, p. 322, fig. 266.
Führer, Berlin, Bronzen, p. 28, pl. 13.

179 : Figs. 563-564

GRANADA, MUSEUM.

Bronze statuette. Height 11 cm.
Found at Atarfe, in the province of Granada.
Surface much corroded, so that details are difficult to make out.

She stands with the left leg slightly advanced and both forearms extended, probably holding offerings in the missing hands.
She wears a chiton and apparently an epiblema, draped over both shoulders; also a substantial necklace.
Probably about 500 B.C. I include it here in spite of its bad condition, because, coming from Spain, it is an interesting witness of the kore type of this period penetrating to the far west.

García y Bellido, *Los hallazgos griegos de España*, 1936, no. 18.
Richter, *Archaic Greek Art*, p. 189, figs. 280, 281.

GROUP VI: THE EUTHYDIKOS KORE GROUP
(about 500–480 B.C.)

WITH the korai assigned to our sixth group we come to the last phase of the archaic period. It is noteworthy that there are fewer statues of korai assignable to this epoch than to the preceding. Comparatively few have been found on the Athenian Akropolis. One must remember that the two decades in question represent the time of the Persian wars. The relative scarcity of full-size dedicatory statues, at least in Athens, can be easily explained by the threat of Persia, before and after Marathon. In war private enterprise tends to be limited—then as now.

General Survey and External Chronological Evidence

External evidence for dating our sixth group of korai is supplied from various sources.

The pediments of the temple of Aphaia at Aigina contain a statue, and part of a statue, of Athena, one datable around 490 B.C., the other about 480. Since in one the chiton and the short Ionic himation are preserved (cf. plate XIX, a), and the features in both are well preserved (cf. plate XX, a), they supply useful comparisons; cf. Furtwängler, *Beschreibung der Glyptothek* (1910), pp. 95 ff., no. 74, and pp. 123 f., no. 89.

Comparable—for the renderings of the features—are also such late members of the Ptoon 20 group of kouroi as the Blond Boy, the Kritios Boy (plate XX, e, f), and a head in New York. Cf. *Kouroi²*, figs. 568–571, 505, 506.

Another useful comparison, at least for the features, is with the Tyrannicides, Harmodios and Aristogeiton, definitely dated 477/476 (in the archonship of Adeimantos, the fourth year of the 75th Olympiad), of which several Roman copies exist, all displaying sub-archaic modelling.

One may also mention the metopes of Temple E at Selinus, erected just after 480 B.C. (cf. Dinsmoor, *Architecture of Ancient Greece*, p. 109), where the Hera standing before Zeus, clothed in chiton and Ionic himation, has acquired a new grandeur and a new freedom (plates XIX, b; XX, b). She belongs, in fact, to the beginning of the early classical period. Instructive also is the well preserved head found in the pronaos of the temple (cf. Benndorf, *Die Metopen von Selinunt*, pl. XI, no. 1, p. 60, and my plate XX, c, d).

The vase-paintings of the first two decades of the fifth century furnish interesting parallels in the rendering of folds; and it is also noteworthy that the regular costume of the women consists, as in our sculptured korai, of the chiton and the short Ionic himation. As examples among many I may cite the Demeter by Makron on a kylix in the British Museum, E.140 (plate XIX, c; cf. Beazley, *A.R.V².*, p. 459, no. 3); a Trojan woman attacking a Greek with the leg of a couch, on a hydria in Naples by the Kleophrades Painter (plate XIX, d; cf. Beazley, *A.R.V.².*, p. 189, no. 74); and the graceful Artemis by the Pan Painter on a psykter in Munich (plate XIX, e; cf. Beazley, *A.R.V².*, p. 556, no. 101).

In all these varied works the women appear not only in similar attitudes and with similar costumes, but, in contrast to the preceding period, with serious expressions and with a tendency toward simplification in the rendering of the folds.

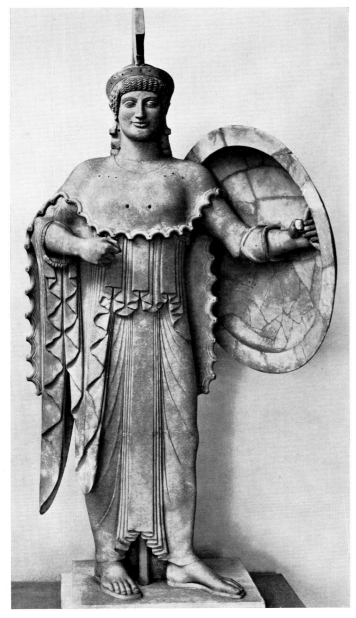

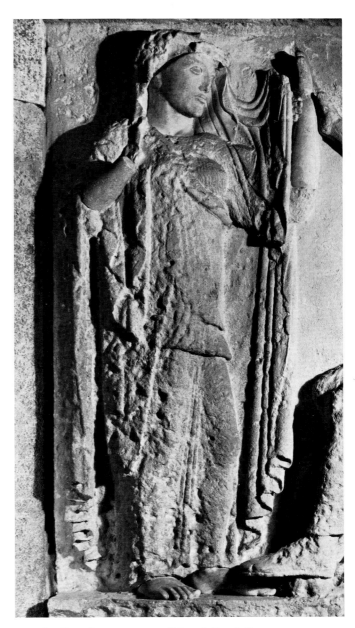

XIX–a. Athena, from the West pediment of the Temple of Aphaia at Aigina, about 490 B.C. Munich

XIX–b. Hera, from a metope of Temple E at Selinus. Palermo, Museum

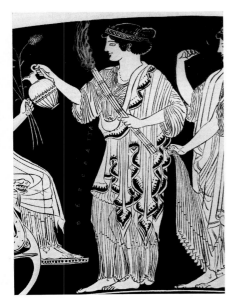

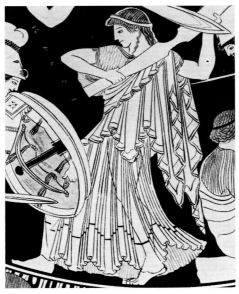

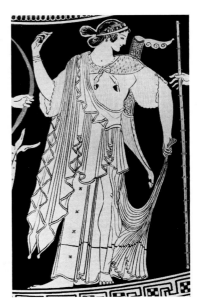

XIX–c. Demeter, on a kylix by Makron, c. 485 B.C. British Museum

XIX–d. Trojan women, on a kylix by the Kleophrades Painter, c. 485 B.C. Naples

XIX–e. Artemis, on a psykter by the Pan Painter, c. 480 B.C. Munich

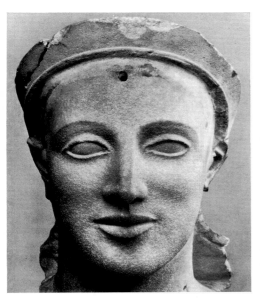

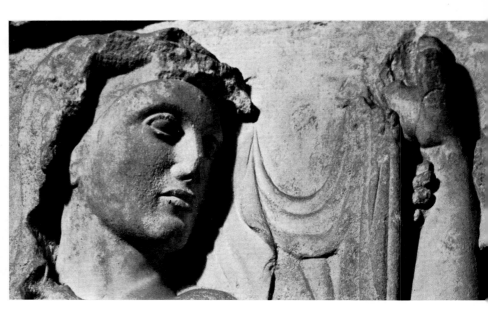

XX–a. Head of Athena from the East pediment of the
Temple of Aphaia at Aigina, about 480 B.C. Munich

XX–b. Head of Hera. Detail of Plate XIX–b.

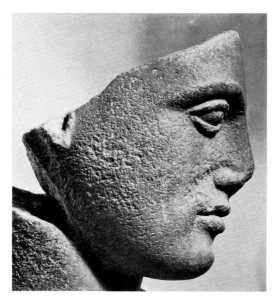

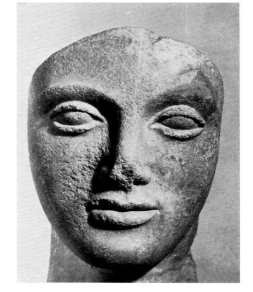

XX–c, d. Head found in the pronaos of Temple E at Selinus, about 480–470 B.C. Palermo

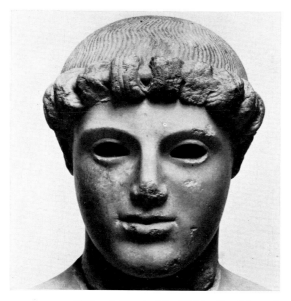

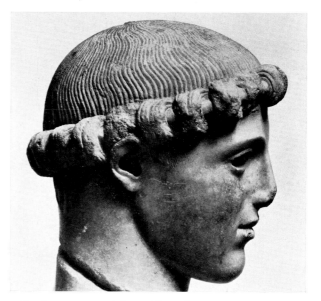

XX–e, f. Head of the 'Kritios Boy' from the Akropolis, about 480 B.C. Athens, Akropolis Museum

The marble and limestone statues, heads, and reliefs included in this sixth group come from the Akropolis of Athens (nos. 180-184, 187, 188), from Eleusis (nos. 185, 186), from Delos (no. 189), Xanthos (no. 192), Thasos (no. 193), Cyprus (nos. 190, 191), and from the Esquiline hill of Rome (no. 194). They are supplemented by bronze and terracotta statuettes from various localities, principally from Southern Italy and Sicily (cf. nos. 195-206). Of special interest are two Etruscan statuettes, with the same costume and conventions as their Greek prototypes (cf. nos. 202, 203). Throughout we note again, as in the preceding period, that the stances and renderings of details are the same as in contemporary other sculptures and vase-paintings. The expressions tend to become more serious, the archaic smile disappears, the transition between the lips and cheeks becomes gradual, without transverse cuts or hollows, and there is in some examples a simplification of the former elaboration in the folds of the garments. Above all, a statuesque element has entered into the appearance of some of these korai, heralding the approach of the classical age. Throughout, however—and this is of no little interest—the Ionic costume, with the short, elaborately pleated himation, continues to be worn, making in fact its final appearance, before the introduction of a new fashion (cf. p. 109)— which already appears in one or two late examples of this group (cf. nos. 194, 199).

In trying to assign specific dates to the korai of this group, one must bear in mind that the transition between it and the korai of the preceding group was of course gradual. The date 'about 500 B.C.' could sometimes be raised or lowered. Artists did not proceed by the clock. And so some of the early members of this group could be late members of group V, and vice versa.

Korai 180-206

180 : Figs. 565-572

ATHENS, AKROPOLIS MUSEUM, 686+609. 'The Euthydikos Kore.'

Marble statue, consisting of an upper and a lower part, with the middle portion missing. Height of (a), from top of head to bottom of left hand, 58 cm.; of (b), above base, 41.5 cm.; ht. of base, in the form of an inscribed capital, c. 21 cm.
The upper part was found in 1882, east of the Parthenon, the lower part in 1886 or 1887 near the Erechtheion.
The marble has been thought to be Parian.
Both parts have been put together from a number of pieces, with a few restorations in plaster. The connection of the pieces was made by Winter, loc. cit.

The figure stands with the left leg advanced. The right forearm, now missing, was extended; it was made in a separate piece, with a tenon, of which part survives, fitting into a corresponding mortice. The left arm is lowered and grasped a fold of the chiton.

She wears a chiton and a short Ionic himation, draped from the right shoulder to below the left armpit, with a top band, over which the slack of the left chiton sleeve is laid at the further end. On the left shoulder the surface, instead of being diversified by crinkly folds, is left smooth and was once decorated with figured bands, of which Winter made out two four-horse chariots (cf. drawing on p. 100).
She also wears a taenia, wound twice round the head, and then knotted and descending down the back. The hair at the back is rendered in a quadrangular mass with horizontal divisions, and on the skull by concentric bands. Three long wavy tresses are brought to the front on either side. Above the forehead and temples are wavy strands with a parting in the middle.
The eyes have prominent lids, and the lachrymal caruncle and canthus are both indicated. The lips are full, and descend a little at the corners, which gives the head a pouting expression. The transition between lips and cheeks is gradual, with no separating grooves and hollows. In the ear both tragus and antitragus are given their characteristic shapes.

Traces of painted decorations on No. 180

Throat and collar-bones are lightly indicated.

In the bottom part only a few folds of the chiton are indicated, but the few radiating ones show that the material was pulled to one side by the left hand.

The feet are bare, with the toes of different lengths and the little one curving inward. The phalanxes are marked. The plinth is embedded in the base, with lead. On the round abacus of the capital is the inscription: Εὐθύδικος hο Θαλιάρχο ἀνέθεκεν, 'Euthydikos, the son of Thaliarchos, dedicated (it)'. Thaliarchos appears as a kalos name on two little pyxides of the time of Epiktetos (*c.* 520-510 B.C.); cf. Beazley, *A.R.V.*², p. 81. But of course this Thaliarchos need not have been the same person as Euthydikos' father.

Early fifth century B.C.

K. D. Mylonas, *Eph. arch.*, 1883, p. 44, no. 25.
Winter, *J.d.I.*, II, 1887, p. 216, pl. XIV.
Lechat, in *Mnemeia tes Hellados*, cols. 81 ff., pl. XVII, 2.
Dickins, *Cat.*, nos. 686, 609, pp. 241 ff.
Payne and Young, *Archaic Marble Sc.*, pp. 39 ff., pls. 84-88.
Langlotz, in Schrader, *Marmorbildwerke*, pp. 77 ff., no. 37, pls. 45-49.
Raubitschek, *Dedications*, no. 56.

181 : Figs. 573-577

ATHENS, AKROPOLIS MUSEUM, 685.

Marble statue. Height 1.225 m.
Marble thought to be Parian.
Found in 1888, south-west of the Parthenon.
For the traces of colour, cf. right column.
The left forearm was added by Schrader.

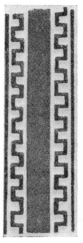
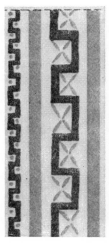
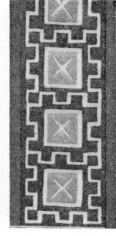

belt *himation* *paryphe*

earring *scattered*

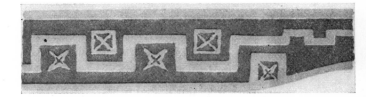

stephane

Ornaments on No. 181.

The left leg is advanced. Both forearms were extended. They were worked in separate pieces and dowelled. On the left forearm is the tail of a bird which she must have held in her hand. Beneath it appears a circular bracelet.

She wears a chiton and a short Ionic himation, draped from the right shoulder to beneath the left armpit, and pulled a little over the top band to form a few pleats. The hair falls down the back in a mass of wavy strands, and four tresses are brought to the front on each side. On her head is a stephane. Above it the hair is rendered in horizontal ridges across the skull; and above the forehead are horizontal zigzag ridges, with a parting in the middle, and with a hole on either side, perhaps for the attachment of a wreath. The eyes are long and narrow, with the lachrymal caruncle and the canthus both indicated. The lips are full, without deep hollows round them. In the ear the tragus is prominently marked; the antitragus is hidden by a large disk earring.

On the skull is a hole for a meniskos.

Early fifth century B.C.

Kavvadias, *Arch. Deltion*, 1888, p. 181.
Lechat, in *Mnemeia tes Hellados*, cols. 78 f., pl. XVI, right.
Lermann, *Altgriech. Plastik*, pl. VI.
Schrader, *Arch. Marm.*, p. 37, figs. 33, 34; *Auswahl*, p. 12, fig. 26, pls. 7, 8.
Dickins, *Cat.*, no. 685.
Payne and Young, *Archaic Marble Sc.*, p. 35, pls. 72, 74.
Langlotz, in Schrader, *Marmorbildwerke*, pp. 97 f., no. 47, pls. 70, 71.

182 : Figs. 578–582

ATHENS, AKROPOLIS MUSEUM, 684.

Marble statue. Height 1.19 m.
Marble said to be Island, except the piece of the right arm, which is supposedly Pentelic.
The greater part was found in 1882–1883, east of the Parthenon. Further fragments were added later by Brückner and Schrader.
For the colour traces, cf. right column.

The left leg is advanced. The right forearm was extended, the left arm lowered to grasp a fold of the chiton. She wears a chiton and a short Ionic himation, draped from the right shoulder to below the left armpit, and pulled up a little over the top band to form a series of pleats. In addition she has an epiblema, which hangs shawl-like over the upper part of the back (beneath the hair), and over both shoulders, with one end wound round the right elbow.

She also wears a taenia on her head, a necklace, a bracelet on her right arm, and disk earrings. The buttons on the right sleeve were added in metal.

The hair falls down her back in a mass of fine, rippling strands, and three wavy tresses are brought to the front on each side. Over the forehead it is rendered in wavy strands, with similar side coils at each end. There is a hole on the skull for a meniskos.

In the eyes the lachrymal caruncle and the canthus are both marked. The lips are differentiated, with an easy transition between their corners and the cheeks. In the ear the tragus is prominently marked. The lower part of the ear is hidden by the disk earring.

About 500–490 B.C.

Philios, *Eph. arch.*, 1883, col. 97, pl. VI.
Lechat, in *Mnemeia tes Hellados*, cols. 79 ff., pl. XVII, left.
Lermann, *Altgriech. Plastik*, pl. XX.
Schrader, *Arch. Marm.*, p. 33, figs. 29–31.
Dickins, *Cat.*, no. 684.
Payne and Young, *Archaic Marble Sc.*, p. 35, pls. 79–80.
Langlotz, in Schrader, *Marmorbildwerke*, pp. 104 ff., no. 55, pls. 78–81.

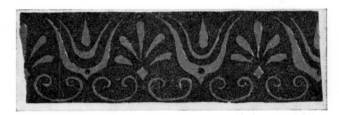

stephane

chiton

himation

earring

scattered

Ornaments on No. 182.

183 : Figs. 583-586

ATHENS, AKROPOLIS MUSEUM, 676.

Marble statue. Height 68 cm.
The marble is said to be Pentelic by Lepsius, Parian by Kaludis.
Found in 1882, east of the Parthenon.
For the traces of colour, cf. below.
The lower right leg was connected by Schrader.

The left leg was advanced. The right forearm (missing) was extended and worked in a separate piece with a tenon which fitted into the corresponding mortice. The left arm was lowered to grasp the paryphe of the chiton. She wears a belted chiton, and over it a short Ionic himation, draped from the right shoulder to beneath the left armpit, and pulled up a little over the top band, to form a series of wavy pleats.

On her head is a stephane. The hair on the skull is rendered by wavy ridges going in a downward direction, which below the stephane become a mass of zigzag tresses descending down the back, with three wavy tresses (each divided into four strands) brought to the front on either side. Over the forehead the hair is carved in two horizontal wavy ridges, surmounted by a row of vertical curls ending in spirals.
Eyes, lips, and ears are rendered in the developed manner of the early fifth century. Disk earrings, decorated with rosettes, hide the lower parts of the ears. There is an arched groove at the corners of the lips.
About 500-490 B.C.

K. D. Mylonas, *Eph. arch.*, 1883, col. 43, no. 22, and col. 182, pl. VIII, 1.
Lechat, in *Mnemeia tes Hellados*, col. 92, pl. XXIV, right.
Lermann, *Altgriech. Plastik*, pl. XVI.
Dickins, *Cat.*, no. 676.
Payne and Young, *Archaic Marble Sc.*, pl. 59, nos. 4-6.
Langlotz, in Schrader, *Marmorbildwerke*, pp. 99 f., no. 49, pl. 73.

184 : Figs. 587-590

ATHENS, AKROPOLIS MUSEUM, 688.

Marble statue. Height 51 cm.
Marble said to be Pentelic.
Put together from two pieces: head and body.
The body was found in 1889 in the Propylaia; the head was known before 1885; it was probably found in 1882 during excavations by Stamatakis in the Propylaia.

Both forearms were extended; they were worked in separate pieces, with tenons inserted in corresponding

paryphe

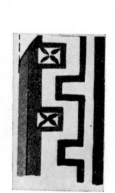

himation

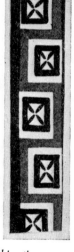

himation

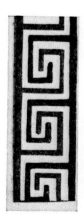

chiton

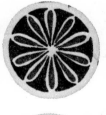

earrings

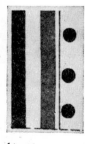

himation

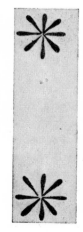

scattered

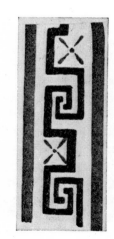

stephane

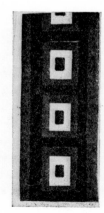

left sleeve

Ornaments on No. 183.

mortices. In the right tenon two dowel holes are preserved.

She wears a chiton, with a central stacked fold, and an epiblema, worn over both shoulders and with the outer sides turned over to form stacked folds with zigzag edges, front and back. At the top of the back the epiblema is pulled up to form bunched folds which cover the hair.

On the head is a stephane, reaching only to the ears. Above it the hair is rendered in wavy ridges radiating from the vertex of the skull, and continuing down the back of the neck. Several tresses are brought to the front on each side, but are presently also covered by the epiblema. Over the forehead the hair is indicated by wavy ridges with a parting in the middle, and with side coils above the temples.

The eyeballs are level with the prominent lids. The lips are differentiated, and have undulating contours, with slight depressions at their corners. The ears are given their characteristic shape, with both tragus and antitragus marked.

The forms of the throat and of the clavicles are indicated.

About 480 B.C. Beginning of the early classical style.

Kavvadias, *Arch. Deltion*, 1889, pp. 85, 106.
Dickins, *Cat.*, no. 688.
Payne and Young, *Archaic Marble Sc.*, pp. 30, 40, note 2, pl. 89.
Langlotz, in Schrader, *Marmorbildwerke*, p. 62, no. 21, pls. 30, 32.

185 : Figs. 591-594

ATHENS, NATIONAL MUSEUM, 24.

Small marble statue. Height 69 cm.
Found at Eleusis in 1887.
Put together from three pieces. Both arms are mostly missing.

The left leg was advanced. The right forearm must have been extended. The left arm descended along the side and grasped a fold of the chiton.

She wears a chiton, with a central paryphe of stacked folds at the back, and over it a short Ionic himation, draped from the right shoulder to beneath the left armpit, and pulled up a little over the top band to form a series of little pleats.

The hair falls down the back in a mass of wavy tresses, with no tresses brought to the front. Over the forehead the hair is rendered by vertical wavy strands ending in spirals, and with wavy side coils above the temples. The features show advanced renderings, delicately carved. In each ear are two little holes, evidently for the addition of metal earrings. Behind the ears, at the bottom

of the stephane, are deepish holes, perhaps for the attachment of the ends of the stephane, made in separate pieces, and now missing.

About 490-480 B.C.

Philios, *Arch. Eph.*, 1884, col. 182.
Kastriotes, *Glypta*, no. 24.
S. Karouzou, *Guide*, p. 37, no. 24.
Langlotz, in Schrader, *Marmorbildwerke*, p. 42 (= 480 B.C.).

186 : Figs. 595-596

ATHENS, NATIONAL MUSEUM, 60.

Marble head of a small statue. Height 16.5 cm.; about half life-size.
Marble thought to be Island.
Found at Eleusis.

A taenia encircles the head. Above it the hair is rendered in wavy ridges, radiating from the vertex of the head, and continuing down the back. There are no side tresses. Above the forehead and temples it is carved in horizontal zigzag waves, with similar side coils.

The mouth, eyes, and ears are delicately carved with advanced renderings. The corners of the lips pass into the cheeks without a separating groove or hollow.

First quarter of the fifth century B.C.

Philios, *Eph. arch.*, 1889, col. 130.
Kastriotes, *Glypta*, no. 60.
S. Karouzou, *Guide*, p. 38, no. 60.

187 : Figs. 597-598

ATHENS, AKROPOLIS MUSEUM, 641.

Head of a small marble statue. Height 6.7 cm.
Marble thought to be Pentelic.

She wears a stephane and disk earrings with central knobs.

In the eyes both the lachrymal caruncle and the canthus are indicated. The lips are delicately modelled. The ears are set obliquely.

The hair is rendered in wavy tresses, descending from the skull down the back and shoulders. Above the forehead it is carved in horizontal, zigzag waves, with similar side coils.

First two decades of the fifth century B.C.

Schrader, *Arch. Marm.*, p. 37.
Dickins, *Cat.*, no. 641.
Payne and Young, *Archaic Marble Sc.*, pl. 81.
Langlotz, *Bildhauerschulen*, pp. 154, 160, pl. 95, f.; in Schrader, *Marmorbildwerke*, p. 134, no. 104, pl. 99.

188 : Figs. 599-600

ATHENS, AKROPOLIS MUSEUM, no. 634.

Small fragmentary marble head. Height 7.3 cm.
Marble said to be Island.
Found north-west of the Erechtheion in 1887.
Flat at the back, so perhaps from a relief. Dickins, however, thought that the missing parts belonged to the helmet of an Athena.

The eyeball somewhat protrudes.
The curving lips pass gently into the cheeks.
The modelling is throughout in developed style, with soft transitions from plane to plane.
Comparable to the Blond Boy and, like it, probably carved just before the catastrophe of 480-479. So also Langlotz, loc. cit., whereas Dickins dates the head in the second half of the fifth century B.C. Langlotz compares the head in Strassburg, Michaelis, *Strassburger Antiken*, p. 10, figs. 3, 4.

Sybel, *Katalog der Marmorskulpturen*, no. 5058.
Petersen, *Ath. Mitt.*, XII, 1887, p. 145.
Graef, *Ath. Mitt.*, XV, 1890, p. 20, no. 5.
Dickins, *Cat.*, no. 634.
Langlotz, in Schrader, *Marmorbildwerke*, pp. 136 f., no. 110, fig, 94, pl. 32.

189 : Figs. 601-604

DELOS, MUSEUM, A4945 (13).

Head of a marble statue. Height 25 cm.
Found in Delos, near the Propylaia, in 1879.
Surface much weathered. Put together from several pieces.

She wears a stephane, and the ears are pierced for the addition of metal earrings. The hair is rendered on the skull by broad concentric ridges, on which are carved narrow, wavy, radiating ones. At the back and sides it is carved in similar ridges over an undulating surface. Above the forehead are rows of zigzags, with narrow side coils.
The rendering of the features is advanced—as far as one can judge in their present damaged state.
First quarter of the fifth century B.C.

Homolle, *Monuments grecs*, 1878, p. 61; *B.C.H.*, III, 1879, pl. VIII, left, and IV, 1880, pp. 36 f.; *De antiquissimis Dianae simulacris deliacis*, p. 26, pl. V, 1.

190 : Figs. 605-607

LONDON, BRITISH MUSEUM, 1917.7-1.85. Acquired in 1873 from Castellani.

Small limestone statue, mounted on a quadrangular plinth. Height 39 cm.
From Cyprus.
Put together from a number of pieces. 'The head rejoined, but seems to belong' (Pryce).
Remains of red and yellow colour.

The left foot is slightly advanced. The right arm is brought to the front of the body, and held an object in the hand (now missing). The left arm is lowered and grasps a fold of the drapery.
She wears a chiton, and over it a short Ionic himation, draped from the right shoulder to the left armpit; also bracelets and earrings with central bosses. On her feet are shoes.
Her hair falls down the back in a series of tresses, but with no tresses brought to the front. On her head is a stephane, and beneath it, above the forehead, the hair is rendered in globular bands, with side coils below the temples.
The back is left plain.
Early fifth century B.C.

Pryce, *British Museum, Catalogue*, I, 2, C280, p. 106, fig. 176, right.

191 : Figs. 608-610

LONDON, BRITISH MUSEUM, 1917.7-1.115. Acquired in 1773 from Castellani.

Small limestone statue, mounted on a quadrangular base. Height 39.5 cm.
From Cyprus.
Put together from a number of pieces, but more or less complete, with the right hand preserved.
Remains of red and yellow colour.

Similar to the preceding, with some variations: the head is slightly raised and the expression is more alert; above the forehead the hair is rendered in globular bands without side coils.
The back, here too, is left plain.
Early fifth century B.C.

Pryce, *Br. Mus. Cat.*, I, 2, p. 106, C281, fig. 176, left.

192 : Fig. 612

LONDON, BRITISH MUSEUM, inv. 13287.

Marble relief, from the Harpy Tomb, with three female figures. Height of slab 1.02 m.; ht. of figures about 90 cm.
Traces of colour.
Found in 1838, among the ruins of Xanthos, adjoining the theatre (cf. Fellows, *Lycia*, p. 170).

The surface is considerably weathered. Was once mounted on a Lycian sepulchral tower.

The female figures are in the attitude of the korai, bringing offerings to a seated personage.
Each wears a chiton and the Ionic mantle, draped over both shoulders; also a stephane in the hair.
The hair hangs down the back in a mass of wavy tresses, with separate ones brought to the sides.
The attitudes are slightly different in the three figures. The one at the back grasps her chiton with the left hand, and holds up an egg(?), or fruit(?) in her right. The middle one has a flower in her left hand, and a pomegranate in her right. The one in front grasps her chiton with the right hand, and a fold of her himation with the left. The two front women have shoes; the feet of the back woman are missing.
About 500 B.C.

A. H. Smith, *Br. Mus. Cat.* (1892), p. 55, no. 94.
Pryce, *Br. Mus. Cat.*, I, 1, pp. 126 f., B287, pl. XXIV.
Lippold, *Griech. Plastik*, p. 67, pl. XVII, 3.

193 : Fig. 613

PARIS, LOUVRE, 696.

Three nymphs, in procession, holding offerings; carved in relief. Height *c.* 92 cm.
One of the three reliefs found in the prytaneion of Thasos.

Each of the three figures is different from the other in attitude, in the offerings held, and in the garments worn. The middle one wears a chiton and over it a short Ionic himation, draped from the left shoulder to beneath the right armpit. In the right hand she holds the paryphe of her chiton, in the left a circlet. The woman at the back wears a chiton and an epiblema, which hangs down from the back of her head, over both shoulders; in one hand she holds a circlet, in the other a pomegranate. The woman in front wears a chiton with a deep kolpos, and an epiblema, which hangs down her back and both shoulders; she too holds an offering in each hand.
First quarter of the fifth century B.C.
It is interesting to compare these korai with those on the Harpy Tomb (no. 192). In attitude, action, and apparel they are strikingly similar, but the style of the Xanthos women is still wholly archaic, that of the Thasos women heralds the classical period.

Miller, *Rev. arch.*, 1865, 2, p. 438, pls. 24, 25.
Michaelis, *Arch. Ztg.*, XXV, 1867, cols. 1 ff., pl. 217; *A.J.A.*, V, 1889, pp. 417 ff., fig. 41.
Catalogue sommaire (1922), p. 41, no. 696, pl. XXVI.
Lippold, *Griech. Plastik*, p. 116.

194 : Fig. 611

ROME, CONSERVATORI MUSEUM, 987.

Marble funerary relief. Height 1.735 m.
The marble is said to be 'greyish Parian'.
Found on the Esquiline, in the Villa Palombara.

She stands in profile to the right, the left foot advanced, the right forearm extended, with a dove in the hand, the left also extended and daintily holding a fold of her mantle with two fingers.
She wears a peplos with overfold, and a mantle (epiblema), draped over her back and both shoulders; also a kerchief (sakkos) on her head. The folds of the peplos are rendered by vertical ridges of different widths, with a zigzag edge at the bottom, and with stacked folds in the overfold. The folds of the mantle go in different directions, with occasional zigzags as well as rounded 'eyes'. At the back the mantle is pulled up to form a loop. The eye is carved in more or less front view, but with the lachrymal caruncle marked at the inner corner. In the ear both tragus and antitragus are nicely indicated. The lips are differentiated and pass softly into the cheeks. The profile views of the figure and of the drapery are not rendered consistently; for instance, both breasts are indicated, and the central pleat of the overfold is shown frontal.
On the feet are sandals, with the soles plastically rendered, whereas the straps were doubtless once painted. The feet are finely modelled with the toes differentiated.
About 480–470 B.C. The combination of archaic and more advanced renderings, as well as the wearing of the peplos instead of the Ionic mantle, suggest a date a little after 480 B.C.

Bull. Com., X, 1882, p. 244, no. 1.
Ghirardini, *Bull. Com.*, XI, 1883, pp. 144 ff., pls. XIII, XIV.
Stuart Jones, *Cat. Cons. Mus.*, pp. 212 f., no. 5, pl. 80.
Helbig, *Führer*[3], no. 974; Helbig-Speier, *Führer*[4], II, no. 1506.
Schrader, *Oest. Jahr.*, XVI, 1913, pp. 11 f., fig. 5.
Richter, *Archaic Greek Art*, p. 187, fig. 285.

195 : Figs. 614–617

PARIS, LOUVRE, 1688.

Bronze statuette, serving as a mirror support; mounted on a stool. Height of statuette 18 cm.
Found in Thebes.

The left leg is advanced and both arms are extended. She wears a belted and sleeved chiton, fastened with a brooch on each shoulder and decorated at the top, back, and along the sleeves with a zigzag border.

Running down the front of the lower part of the chiton is a pleated paryphe.

Encircling her head is a beaded chaplet, over which the hair is gathered up behind.

First quarter of the fifth century B.C.

Pottier, in Dumont and Chaplain, *Céramiques de la Grèce*, II, p. 251, no. 17.
De Ridder, *Cat. des bronzes du Louvre*, II, no. 1688, pl. 77.
Langlotz, *Bildhauerschulen*, p. 37, pl. 18c, pl. 22, d.
Charbonneaux, *Les bronzes grecs*, pp. 77, 142, pl. XV (in colour).
Richter, *Furniture²*, p. 43, fig. 252 (for the stool).

196 : Figs. 618-621

BERLIN, STAATLICHE MUSEEN, MJ 7429.

Bronze statuette, mounted on an Ionic capital. Total height 13.4 cm.; ht. of statuette 11 cm.
From Paestum.
The column on which the capital was mounted is missing.

She stands with the left leg advanced, the right arm raised (evidently to support something that was on her head), and the left arm lowered with the hand grasping a fold of her chiton.

She wears a chiton and a short Ionic himation, draped from her right shoulder to beneath the left armpit.

On the head is a taenia and her hair falls down her back in a mass.

The rendering of the features is advanced, and the expression is serious.

The object on her head has been thought to have been a basket.

On the four sides of the abacus of the capital is a dedicatory inscription in Doric dialect: Τἀθάναι Φιλλὸ Χαρμυλίδα δεκάταν. 'Phillo, the daughter of Charmylidas, to Athena, as a tithe.'

First quarter of the fifth century B.C.

E. Curtius, *Arch. Zeitung*, XXXVIII, 1880, pp. 27 ff., pl. 6.
Neugebauer, *Antike Bronzestatuetten*, p. 64 f., fig. 34; *Arch. Anz.*, 1922, col. 84.
Berlin, *St. Mus., Führer, Bronzen*, 1924, p. 24, no. 7429, pl. 17.
Lamb, *Bronzes*, p. 143, pl. 51, b.
Zancani Montuoro and Zanotti-Bianco, *Heraion*, I, p. 133, fig. 37.
Jeffery, *Local Scripts*, p. 260, no. 7, pl. 50.

197 : Figs. 622-623

LONDON, BRITISH MUSEUM, 198. Acquired from the Payne Knight Collection.

Bronze statuette. Height 7.5 cm.
From Rome.
Probably served as the support of a mirror. Mounted on a two-stepped base.

She stands with the left leg slightly advanced. The right forearm is extended with the hand holding a pomegranate; the left arm is lowered, to grasp a fold of the chiton.

She wears a chiton, and over it a short Ionic himation, draped from the right shoulder to beneath the left armpit.

The hair is short. The feet are bare.

First quarter of the fifth century B.C.

Walters, *Cat. of bronzes*, no. 198.
Jantzen, *Bronzewerkstätten in Grossgriechenland und Sizilien*, 13.
Ergänzungsheft, *Arch. Inst.*, p. 7, note 1, no. 10, pl. 28, fig. 119.

198 : Figs. 624-627

LONDON, BRITISH MUSEUM, 550. From the Payne Knight Collection.

Bronze statuette. Acted as the support of a mirror. Height 20 cm.
Actual finding place not known.
The disk-mirror and the base on which the figure stood are both missing.

She stands with the right leg advanced and both arms extended, holding a fruit in her right hand. The breasts are prominent.

She wears a belted chiton, pulled up to form a kolpos; also a taenia, over which the hair is rolled up at the back.

The slight bending of the legs at the knees gives the figure a curiously unsteady pose, especially in profile view.

The expression is serious, with large, staring eyes.

About 480 B.C. or a little later?

Walters, *Cat. Br. Mus. Bronzes*, no. 550.
Jantzen, *Bronzewerkstätten in Grossgriechenland und Sizilien* (1937), p. 4, no. 28, pl. 4, fig. 17 (attributed to a Locrian school).
Langlotz and Hirmer, *Die Kunst der Westgriechen*, p. 71, pl. 64.

199 : Figs. 628-631

LONDON, BRITISH MUSEUM, no. 188. From the Towneley Collection.

Bronze statuette. Height 12.5 cm.
On the head is the bottom of the utensil which the figure supported.

She stands with the feet close together, the right forearm extended and the hand holding a flower, the left arm lowered and the hand grasping a fold of her garment.

She wears a belted peplos with overfold, pinned with a brooch on each shoulder, and pulled over the belt to form pouches (kolpoi); it has decorative, incised borders. The hair is rolled over a taenia at the back and parted above the forehead.

On the lower part of the figure, in front, is a dedicatory inscription in Doric dialect: Ἀριστομάχα ἀν|έθεκε τᾷ Ἐλευθίᾳ, 'Aristomacha dedicated (it) to Eleuthia' (i.e. 'Eileithyia').

First quarter of the fifth century B.C.

'The omission of the iota subscript, the addition of the oblique stroke in the rho, the almost horizontal stroke in the alpha, the horizontal strokes in the epsilon, all point to a period posterior to the sixth century B.C.' (M. Guarducci). And this is what the advanced rendering of the features indicates—here combined with a stiff rendering of the body.

'There was an important and popular sanctuary of Eileithyia in Hermione (cf. Paus., II, 35, 11), which is one of the few Doric localities which the forms of the letters would fit' (M. Guarducci).

Gerhard, *Ges. Abh.*, p. 265, pl. XXXI, 6.
Walters, *Cat. of Bronzes*, no. 188, pl. II.
Farnell, *Cults of Greek States*, II, pl. 59, p. 614.
Langlotz, *Bildhauerschulen*, pp. 68, 71, pl. 33, b.
Jessen, in *R.E.*, s.v. Eileithyia, in vol. V, 2 (1905), col. 2102 (on inscription).

200 : Figs. 632–636

VIENNA, KUNSTHISTORISCHES MUSEUM, inv. VI, 350.

Bronze statuette. Height 7.6 cm.
From the de France Collection. Since 1808 in the Vienna Museum.
The finding place is not known.
The surface is corroded in a few places.

She stands with the left foot advanced, the right forearm raised and holding a flower in the hand, the left arm lowered and grasping a fold of the drapery—not of the chiton, but apparently a hanging fold of the himation.

She wears a chiton and a short Ionic himation, draped over both shoulders; also a chaplet on her head. Her hair hangs down her back in a mass of delicate ridges, and similar ridges radiate from the vertex of the skull. On her feet are shoes.

First quarter of the fifth century B.C.

Sacken and Kenner, *Die Sammlungen des k. k. Münz- und Antiken Cabinetes* (1866), p. 299, no. 1143.

Von Sacken, *Die antiken Bronzen in Wien* (1871), p. 46, pl. XVIII, 2, 2a.
Von Schneider, *Album auserlesener Gegenstände der Antiken-Sammlung* (1895), p. 10, pl. XXV, 3.
Reinach, *Rép. stat.*, II, p. 640, 5.
Bernoulli, *Aphrodite*, p. 79, no. 13.

201 : Figs. 637–639

ATHENS, NATIONAL MUSEUM, 12110.

Terracotta statuette of Artemis. Height 15 cm.
Found at Praeneste. Acquired through the gift of Prince Odescalchi at the beginning of the century.
The back is flat.

She stands with the left leg a little advanced, holding a hind in her lowered right hand, and a bow in her left. She wears a chiton and a short Ionic himation, draped from the left shoulder to below the right armpit; it is pulled a little over the top band to form a series of elongated pleats.

On her head is a polos. The hair above the forehead is rendered by wavy ridges, with a parting in the middle. Three tresses are brought to the front on either side.

The toes protrude from beneath the chiton; they are more or less parallel to one another, but the little toe curves inward.

First quarter of the fifth century B.C.

Not before published (?).

202 : Figs. 642–643

LONDON, BRITISH MUSEUM, no. 493.

Bronze statuette, on a base supported by two seated lions, and with rams' heads at the back. Height 21.6 cm. The right hand is missing.

She stands with the left leg a little advanced, the right forearm extended, and the left arm lowered to grasp a fold of her chiton.

She wears a sleeved chiton and a short Ionic himation, draped from the right shoulder to beneath the left armpit; also a necklace with pendant, and a decorated stephane. The feet are bare.

The hair falls down the back, with three undulating tresses brought in front on either side.

The features are in the developed style of the first half of the fifth century.

Etruscan, first quarter of the fifth century B.C.

De Ridder, *B.C.H.*, XXII, 1898, p. 20 ff., pl. III.
Walters, *Br. Mus. Cat. of Bronzes*, no. 493.
Jantzen, *Bronzewerkstätten in Grossgriechenland und Sizilien*, p. 67, C, 8, pl. 28, fig. 118.

203 : Fig. 644

LONDON, BRITISH MUSEUM, no. 551.

Bronze statuette; served as the support of a mirror. Height 23 cm.
From the Towneley Collection.
On top of the head, acting as the support of the mirror, are two foreparts of swans, back to back.

She stands with the feet close together, the right arm extended with the palm of the hand open, and the left arm lowered to a fold of the chiton.
She wears a chiton and a short Ionic himation, draped from the right shoulder to beneath the left armpit. The top band of the himation and the ends of the chiton sleeves are decorated with zigzag patterns.
The hair falls down the back in a quadrangular mass, and is rendered above the forehead by straight, vertical incisions.
Etruscan, first quarter of the fifth century B.C.
An interesting Etruscan version of the familiar Greek theme.

Walters, *Cat. of Bronzes*, no. 551.

204 : Figs. 645-646

LONDON, BRITISH MUSEUM, B427. Acquired in 1875.

Large terracotta statuette. Height 39 cm.
From Sicily.
Mounted on a two-stepped low base.
The back is modelled.
Bottom repaired.

She stands with the left leg advanced. In her right hand she holds a flower to her breast, with her left she grasps the paryphe of her chiton.
She wears a chiton, and over it a short Ionic himation, draped from the right shoulder to beneath the left armpit. As a third garment she has an epiblema, which descends from the back of her head down the back and sides.
Her hair falls down her back in a quadrangular mass, with two tresses brought in front on either side. Two rows of globular curls are shown across the forehead.
On her head is a stephane.
About 500 B.C., or a little later.

Winter, *Typen*, I, p. 106, no. 5, a.
Walters, *Cat. of Terracottas*, B427.
Higgins, *Terracottas in the Br. Mus.*, I, pl. 149, no. 1089.

205 : Figs. 640-641

ATHENS, NATIONAL MUSEUM, 1078.

Terracotta statuette, mounted on a plinth. Height 13 cm.
Provenance not known.
The back is flat, the surface weathered.

She stands with the left leg slightly advanced. In her right hand she holds a bird; the left arm is lowered, with the hand grasping a fold of her drapery.
She wears a chiton and a short Ionic himation, draped from the right shoulder to below the left armpit; as a third garment she has an epiblema, which covers her head and hangs down her back and shoulders.
On her feet are shoes.
Of her hair there is visible only the wavy band above her forehead, with coils at the sides.

Not before published (?).

206 : Figs. 647-648

NEW YORK, METROPOLITAN MUSEUM OF ART, 35.11.4 Fletcher Fund, 1935.

Terracotta statuette, serving as an alabastron, mounted on a rectangular plinth. Height 26.7 cm.
From Sicily.
Portions of the front edge of the mantle and of the left shin are restored.

She stands with the left leg a little advanced and both arms lowered along the sides; the hands are closed.
She wears a chiton, and over it an epiblema, worn like a short Ionic himation, draped from the left shoulder to below the right armpit with the side edges turned over to form stacked folds, front and back. Running down the front of the chiton is a paryphe with another set of stacked folds.
The feet are bare, with toes differentiated, the second being longer than the first and the little one curving inward.
The hair falls down the back in a solid mass, divided horizontally into broad ridges, with two separate tresses brought to the front on either side. Above the forehead and temples it is rendered by delicate wavy ridges, passing from ear to ear, and with a parting in the middle.
The eyes are elongated, with the gaze directed downward.
First quarter of the fifth century B.C.

C. Alexander, *M.M.A. Bull.*, XXX, 1935, pp. 178 f., figs. 2, 3.
Richter, *M.M.A. Handbook of the Greek Coll.*, 1953, p. 69, pl. 51, d.

EPILOGUE: SUCCESSORS

THE story of the archaic kore ends about 480 B.C. But the phenomenal progression from conventionalized to more naturalistic renderings which was attained during the almost 200 years that we have contemplated was to have a long future. For the first time, not only in Greek art, but in all other arts, the representation of the human figure had been freed from age-old conventions. The evolution which ensued in all branches of Greek art is well known. Here we will only, by way of an epilogue, recall a few characteristic examples of the standing, draped female figure in the succeeding periods, and watch the increasing freedom in the renderings of the stance and in the drapery—for they were made possible by the achievements of the sculptors of our korai. And most of these later Maidens in one way or another testify to their heritage.

For the second quarter of the fifth century, that is, the period immediately succeeding the archaic korai, we may select first two figures from the temple of Zeus at Olympia,[1] datable c. 470-460 B.C. (cf. figs. 649-650). They too stand erect, but now with head and limbs no longer in the prescribed stiff attitudes, but with a new freedom of movement, and with the folds of the peplos—which now regains ascendancy (cf. p. 10)—rendered with more truth to nature, and yet in a strictly formalized composition. Concurrently comes one of the statues found in 1838 at Xanthos in Lycia and now in the British Museum[2] (cf. figs. 652-654). It has the same architectural quality as the statues from Olympia, but retains the old motif of holding a fold of the drapery in one hand, with a resultant variety in the composition of the lower part of the figure.

Fig. 651 shows a comparable, less well known statue once in Lord Elgin's collection at Broom Hall, Scotland, and now in the J. Paul Getty Museum in Malibu, California.[3]

Here too belong several graceful bronze statuettes, mostly supports of mirrors, shown wearing a peplos with overfold, and standing with one foot advanced, and with the arms in various attitudes, either old or new. Figs. 655-662 illustrate examples in the Louvre,[4] in the British Museum,[5] and in the National Museum of Athens,[6] culminating in two great works of art—a statuette from Pinde from the Karapanos Collection[7] (figs. 664-666), now in the Athenian National Museum, and the so-called 'Spinnerin' in Berlin[8] (fig. 663). They are still linked by many bonds with the past, but at the same time evince the new combination of sobriety and spontaneity characteristic of the post-Persian epoch.

After 450 B.C. come the great epochs of the Parthenon, of the Erechtheion, and of the Nike Balustrade, in which the drapery becomes progressively richer, more variegated, and more naturalistic, without, however, losing the quality of a conscious artistic design. Plain and variegated surfaces, lights and shadows, grooves and ridges are combined in harmonious compositions. Figs. 668, 667 show Maidens from the Parthenon frieze[9] (c. 442-438 B.C.) and a superb detail of drapery from the

[1] Treu, *Olympia*, III, 1894, Die Bildwerke in Stein und Thon, pl. X, 1 and 2, pp. 50 ff. (Hippodameia and Sterope).

[2] Pryce, *Cat., British Museum*, I, 1, B318.

[3] *Guidebook, The J. Paul Getty Museum, Los Angeles* (1956), p. 15, no. 14; H. Stothart, *A Handbook of Sculpture in the J. Paul Getty Museum*, p. 8, pl. 13.

[4] De Ridder, *Bronzes du Louvre*, II, no. 1689, pl. 77; Langlotz, *Bildhauerschulen*, p. 170, pl. 73, a.

[5] Walters, *Cat. of Bronzes*, no. 242; Langlotz, *Bildhauerschulen*, p. 30, pl. 16, b.

[6] Inv. 6197, 6198.

[7] Lechat, *B.C.H.*, XV, 1891, pp. 461 ff., pls. IX, X; S. Papaspyridi (Karouzou), *Guide*, pp. 211 f., no. 540.

[8] Wiegand, 73. *Berliner Winckelmannsprogramm*, 1913; Neugebauer, *Antike Bronzestatuetten*, pp. 72 f., pl. 36; *Führer, Berlin, Bronzen*, p. 66, no. 30082, pl. 33. Now interpreted as an adorans in the act of sacrificing; cf. Blümel, *Arch. Anz.*, 1955, col. 313.

[9] In the Louvre. From the East frieze. Lullies and Hirmer, *Greek Sculpture*, pls. 156, 157.

East pediment of the Parthenon[10] (438-432 B.C.), figs. 669-670 two karyatids of the Erechtheion[11] (421-413 B.C.).

These three stages of development are reflected in vase-painting first in the regal Artemis on the Argonaut krater by the Niobid Painter in the Louvre, G34 (plate XXI, a; cf. Beazley, *A.R.V.*[2], p. 601, no. 22), of the second quarter of the fifth century B.C.; then by the stately Melousa by the Peleus Painter on a neck-amphora in the British Museum, E271 (plate XXI, b; cf. Beazley, *A.R.V.*[2], p. 1039, no. 13) of the third quarter of the century; and lastly by the graceful Aphrodite and Helen on an oinochoe in the Vatican (plate XXI, c; cf. Beazley, *A.R.V.*[2], p. 1173, bottom) of the last quarter of the century.

The compositional scheme weakens somewhat in the succeeding epoch of the fourth and early third century B.C., but the general effect gains in graciousness. Figs. 672, 671, 673 show the 'Nereid' from the Athenian Agora,[12] of the early fourth century; the 'Herculaneum matron' in the National Museum of Athens,[13] a Roman copy of a Greek original of *c.* 340 B.C.; and the Themis by Chairestratos from Rhamnous in Athens,[14] datable shortly after the end of the century.

These still self-contained compositions are then followed by the turbulent, somewhat restless, and yet magnificent creations of the Hellenistic age, such as the Nike of Samothrace[15] (fig. 674), and the grandiose Nyx of the Pergamon Altar.[16]

To show how far we have travelled from the Nikandre of Delos (no. 1), the Auxerre figure (no. 18, pl. XXII, a), and the Samian and Akropolis korai (nos. 55, 67, 110 ff.), and yet how much was preserved of their majesty and charm, let us glance at the terracotta statuette of a lady from Tanagra, now in the Museum of Hamburg[17] (pl. XXII, b). She too wears a chiton and a mantle as did her archaic sisters, she has the same wavy hair, she stands with one foot advanced, one arm raised, the other lowered, and she has the same femininity, but all is changed to conform to the new conception of delicacy and grace.

In conclusion it may be interesting to recall what happened to our korai in the Roman age. Though straight Roman copies of archaic sculptures are comparatively rare, the rich complication of the draperies of the korai exercised some appeal. As witnesses we have first a torso from Castelporziano in the Terme Museum[18] (cf. figs. 675-678), and a torso in the Conservatori Museum[19] (cf. figs. 679-681), both of which may be termed more or less faithful reproductions of archaic Greek korai. What, however, became more popular were adaptations of the Greek type, in which the multitudinous folds of the Greek draperies were dramatized into more restless creations. As

[10] A. H. Smith, *Cat. of Sculpture, Br. Mus.*, I, pp. 113 f., no. 303, M.

[11] *In situ*, on the Athenian Akropolis. For bibl. cf. Smith, *Cat. of Sculpture, British Museum*, I, no. 407.

[12] In the Agora Museum, inv. 1311-S182. T. L. Shear, *Hesperia*, II, 1933, pp. 527 ff., figs. 10-12, pl. XVI.

[13] Kastriotes, *Glypta*, no. 242; S. Papaspyridi, *Guide*, p. 91, no. 242. Found at Aigion, in the Peloponnese.

[14] Statue of Themis, in the National Museum, Athens. Found at Rhamnous, in the temple of Themis, and signed by the sculptor Chairestratos. Cf. Kastriotes, *Glypta*, no. 231; S. Papaspyridi (Karouzou), *Guide*, p. 79, no. 231, pl. V.

[15] In the Louvre, no. 2369. *Catalogue sommaire* (1922), p. 129; Lullies and Hirmer, *Greek Sculpture*, pl. 248.

[16] In the Pergamon Museum, Berlin. Lullies and Hirmer, *Greek Sculpture*, pl. 245.

[17] Hoffmann and Hewicker, *Kunst des Altertums, Museum für Kunst und Gewerbe, Hamburg*, no. 33.

[18] E. Paribeni, *Sculture greche del v secolo, Museo Nazionale Romano*, no. 76. Cf. also the similar torso once thought to be archaic Greek, but recognized as later by Bianchi Bandinelli in an article 'Kore Guicciardini', *Critica d'Arte*, 1941, pp. 91 ff, pls. L-LIV. On the much discussed subject of archaistic copies and creations cf. also especially Bulle, 'Archaisierende griechische Rundplastik', *Abh. Bayr. Akad.*, XXX, 2, 1918; Schmidt, *Archaistische Kunst in Griechenland und Rom*, 1922; Becatti, 'Lo stile arcaistico', *Critica d'Arte*, 1941, 6, pp. 33 ff., and *Rendic. Pont. Acc. di Archeol.*, XVII, 1940-41, pp. 85 ff.

[19] Stuart Jones, *Catalogue of the Palazzo dei Conservatori*, no. 1.; Helbig-Speier, *Führer*[4], vol. II, no. 1511.

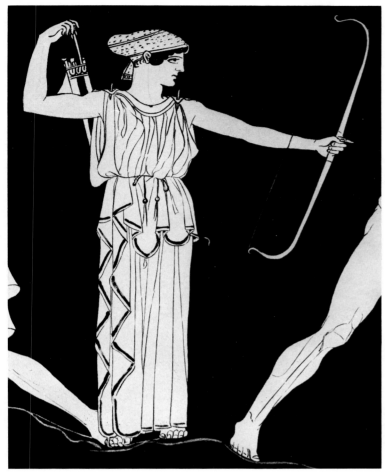

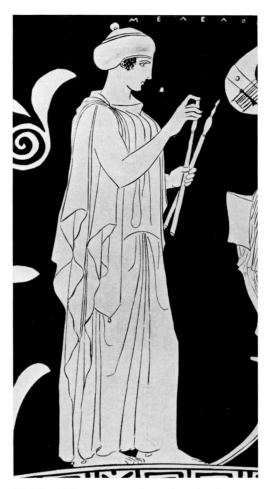

XXI–a. Artemis, on a krater by the Niobid Painter, about 460–450 B.C. Louvre

XXI–b. Melousa, on a neck-amphora by the Peleus Painter, about 440 B.C. British Museum

XXI–c. Aphrodite and Helen, on an oinochoe by the Heimarmene Painter, about 420 B.C. Vatican

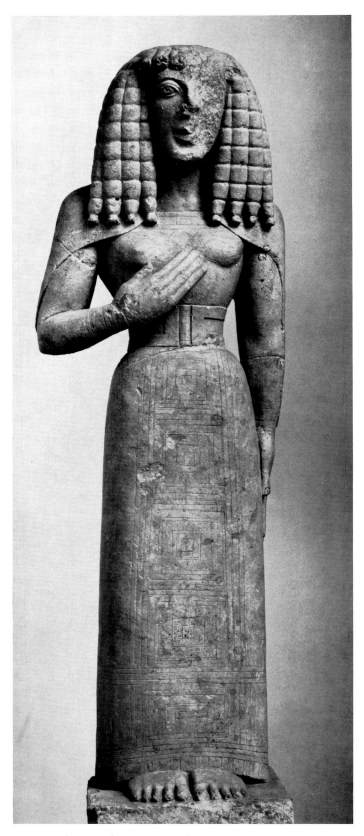

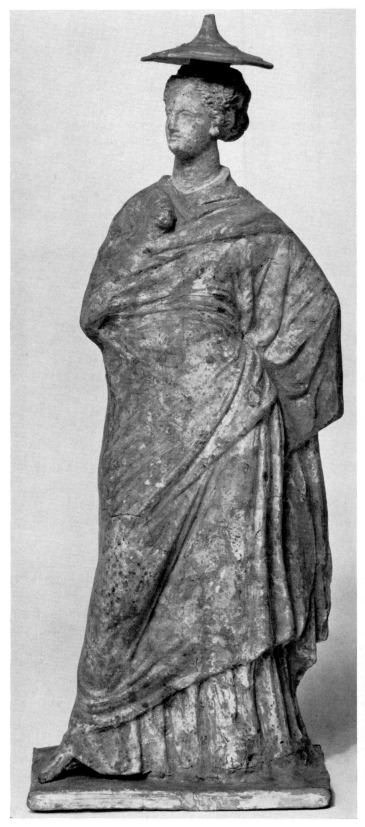

XXII–a. The statue from Auxerre, about 625–600 B.C. Louvre. Cf. figs. 76–79

XXII–b. Terracotta statuette of a lady, from Tanagra, late fourth century B.C. Hamburg, Museum für Kunst und Gewerbe

examples will serve a figure in the Conservatori Museum[20] (fig. 682), and a torso at Eleusis[21] (figs. 683-685), in both of which tell-tale innovations are introduced in the top band of the Ionic himation. Since both are headless, we do not know whether the features simulated the archaic, or were in developed style. But in the almost complete bronze statuette in the British Museum[22] (figs. 686-689), one can observe the retention of archaic daintiness in stance and rendering of folds, combined with a head in a more developed style, creating a somewhat incongruous and yet undeniably attractive effect. With it we may close the long history of the Greek kore.

[20] Stuart Jones, op.cit., no. 7; Helbig-Speier, *Führer*⁴, vol. II, no. 1510.
[21] Kourouniotes, *Guide*, 1934 (in Greek), pp. 70 f.; English translation by O. Broneer, p. 92 f.
[22] Walters, *Catalogue of Bronzes*, no. 192.

ILLUSTRATIONS

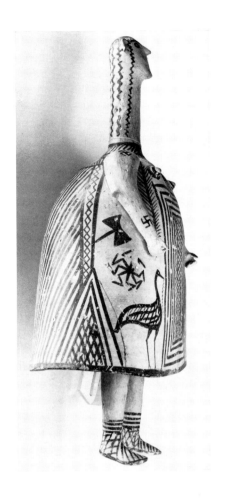
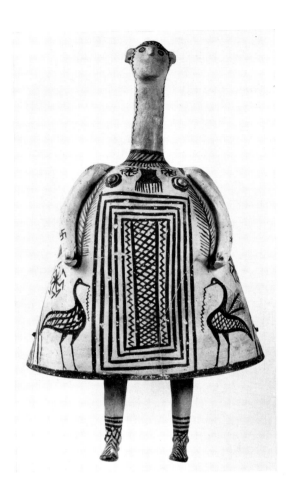
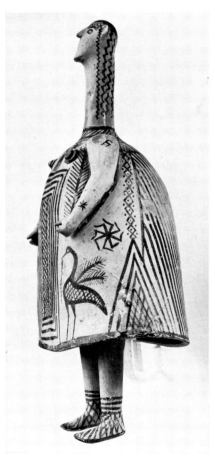
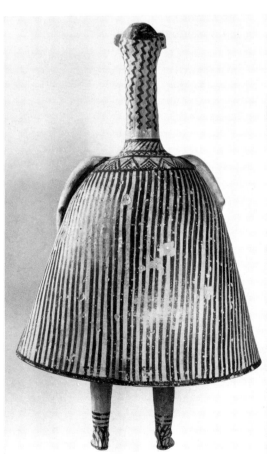

Figs. 1–4 (Louvre B 52)

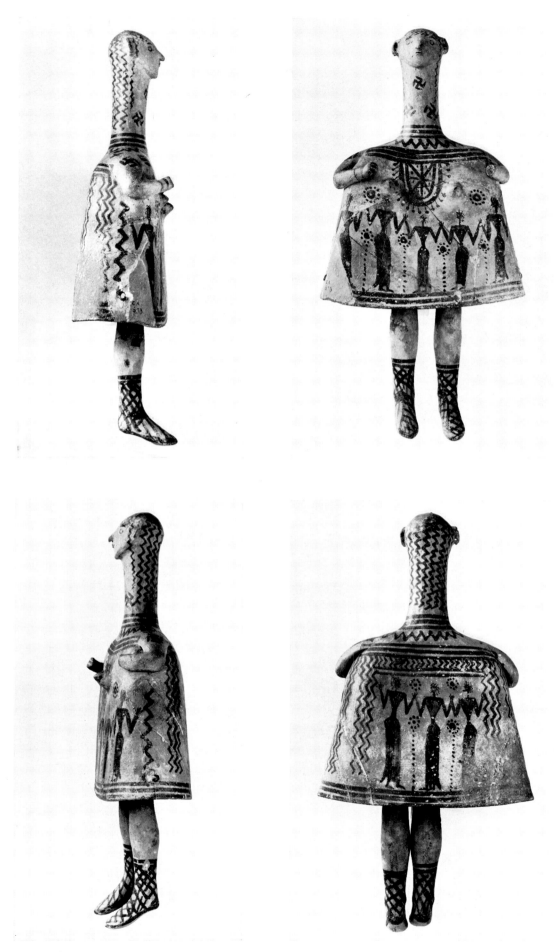

Figs. 5–8 (Louvre B 53)

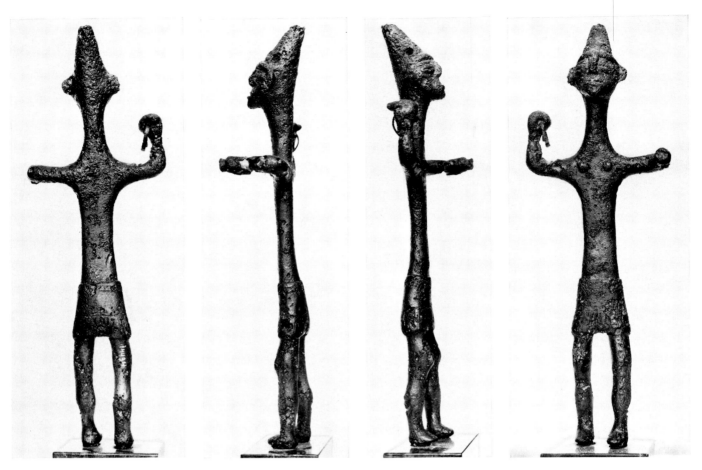

Figs. 9–12 (Athens, National Museum)

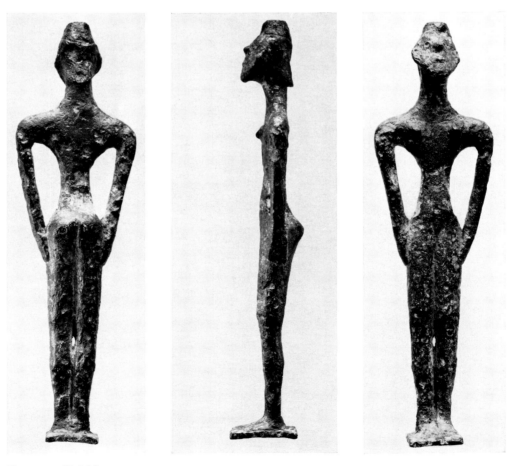

Figs. 13–15 (Delphi)

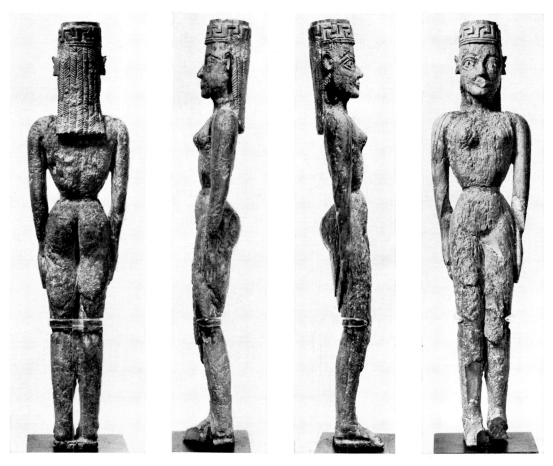

Figs. 16–19 (Athens, National Museum)

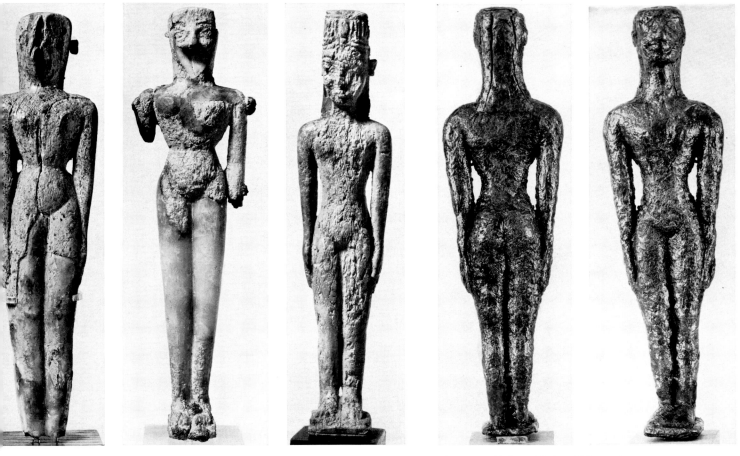

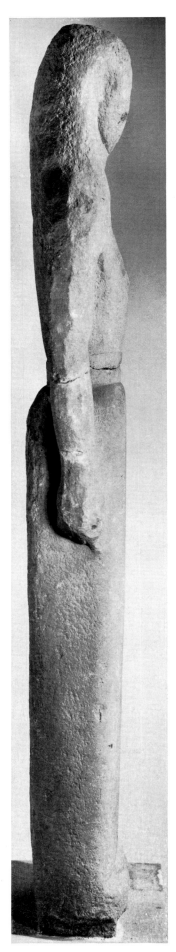

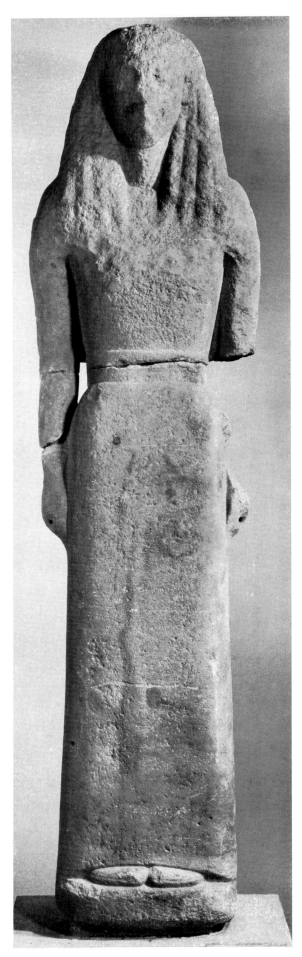

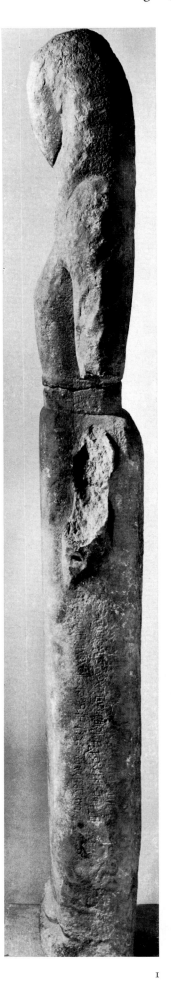

Figs. 25–27 (Athens, National Museum)

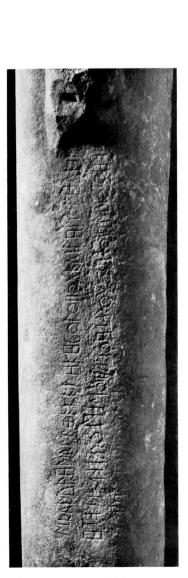

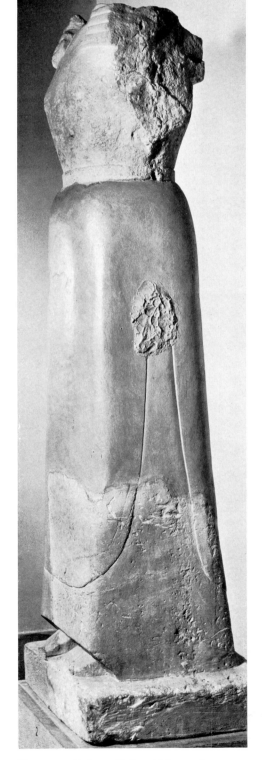

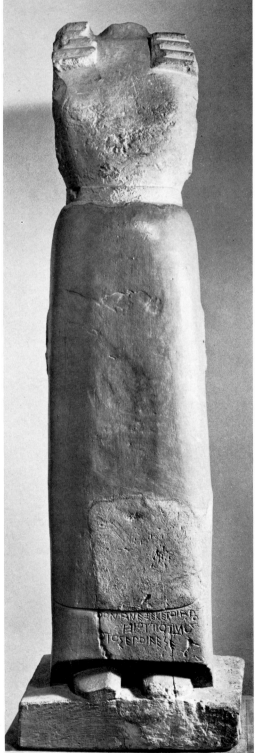

Fig. 28 (Athens, National Museum) I Figs. 29–30 (Athens, National Museum) 2

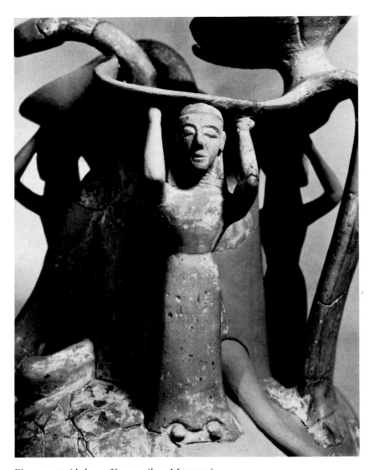

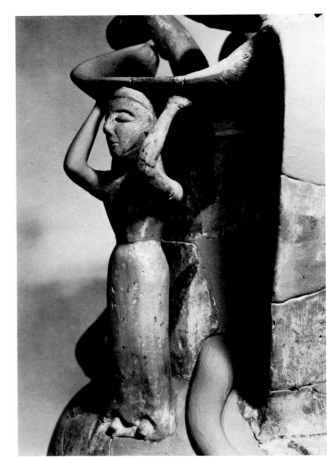

Figs. 31–32 (Athens, Kerameikos Museum) 3

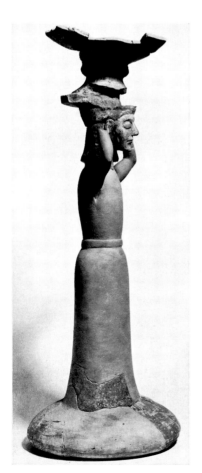

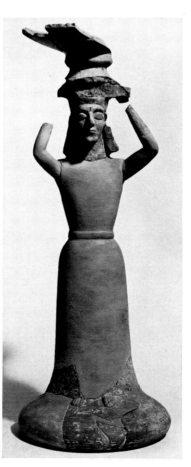

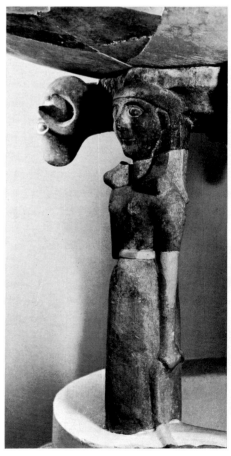

Figs. 33–34 (Athens, Kerameikos Museum) 4 Fig. 35 (Corinth) 5

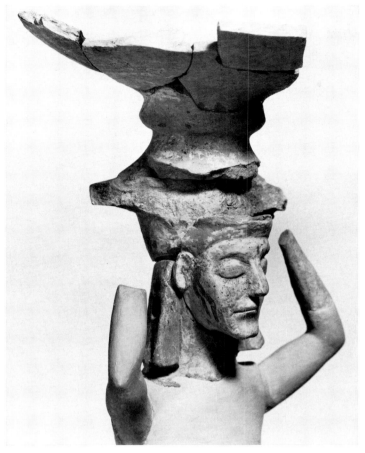

Fig. 36 (Athens, Kerameikos Museum) 4

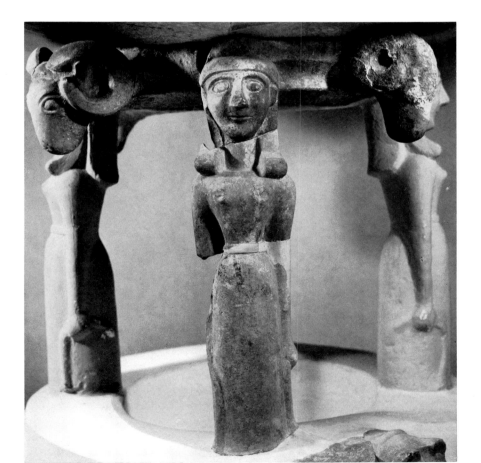

Fig. 37 (Corinth) 5

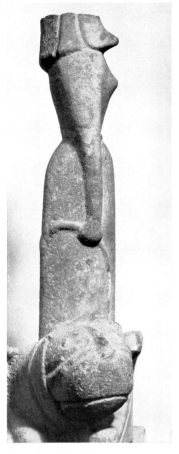
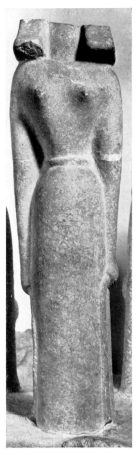
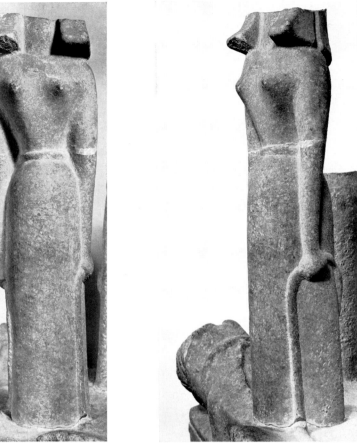

Figs. 38–40 (Berlin)

6

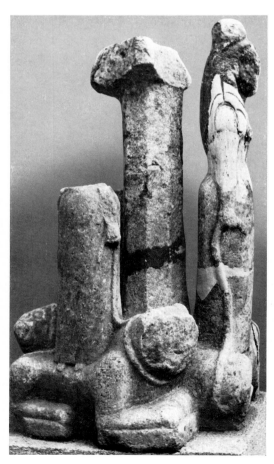
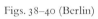
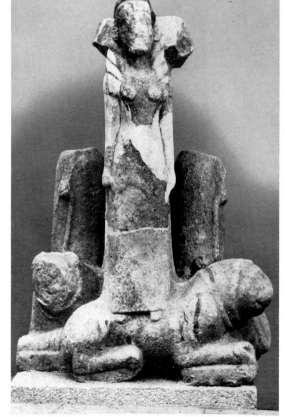
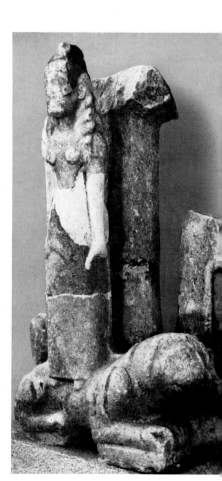

Figs. 41–43 (Rhodes)

Fig. 44

I. THE NIKANDRE—AUXERRE GROUP

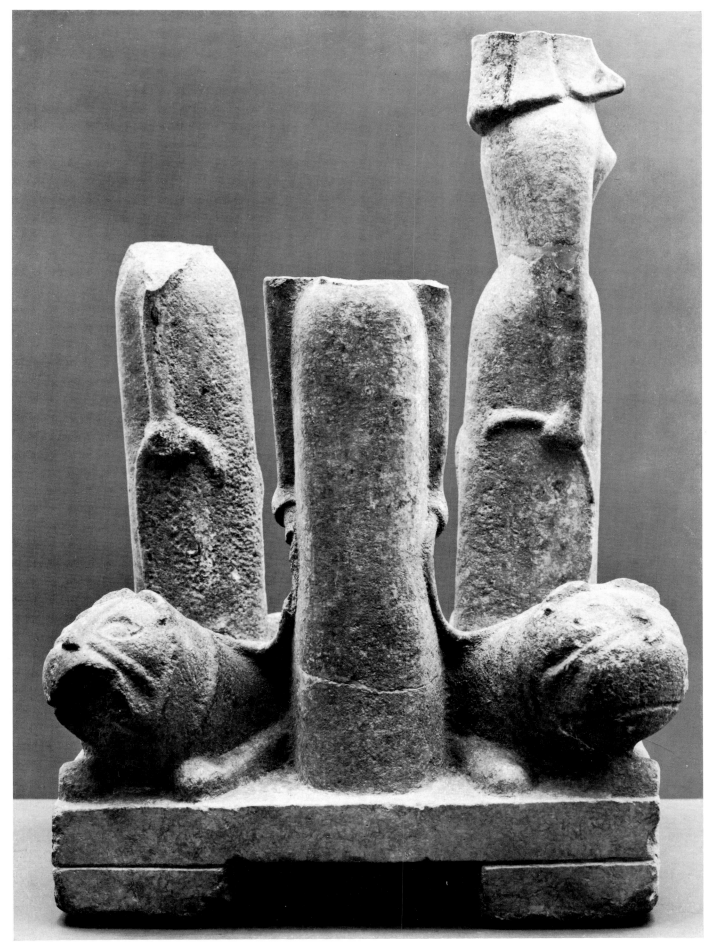

Fig. 44 (Berlin)

6

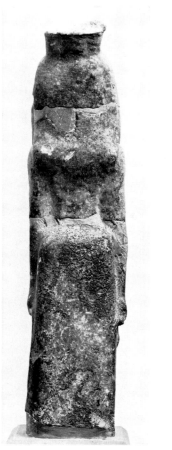
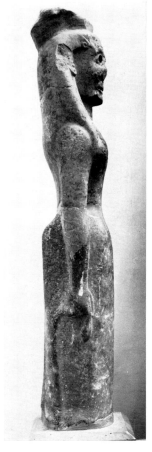
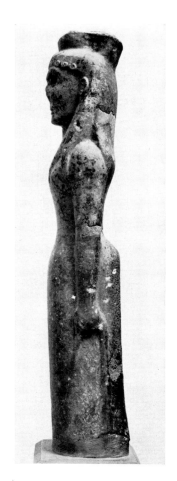
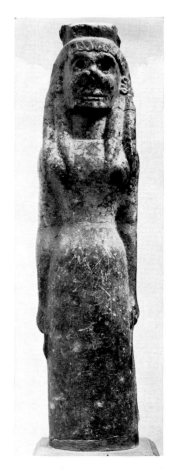

Figs. 45–48 (Olympia)

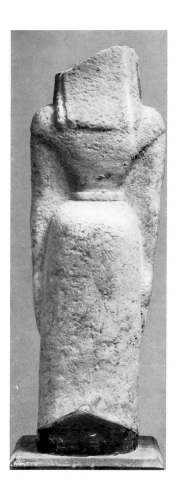
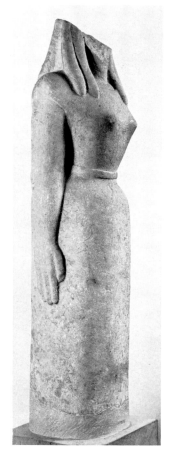
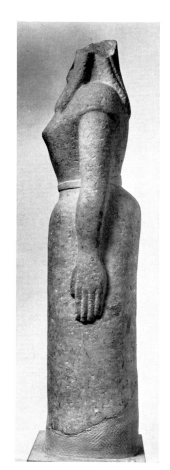
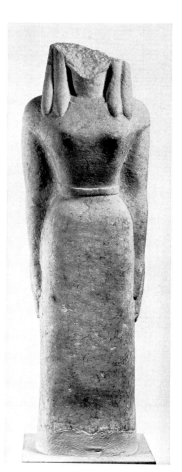

Figs. 49–52 (Athens, National Museum)

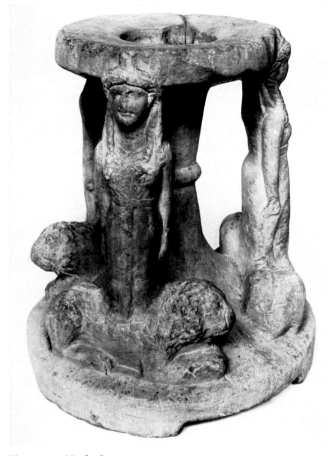

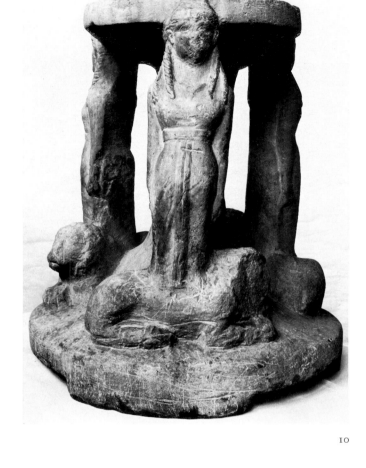

Figs. 53–54 (Oxford) 10

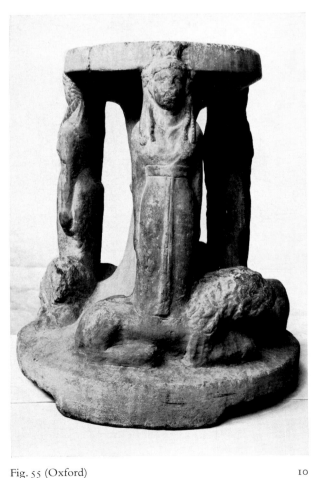

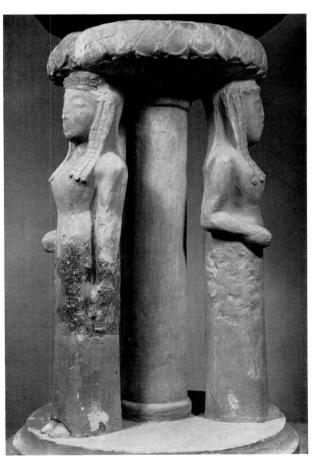

Fig. 55 (Oxford) 10 Fig. 56 (Delphi) 11

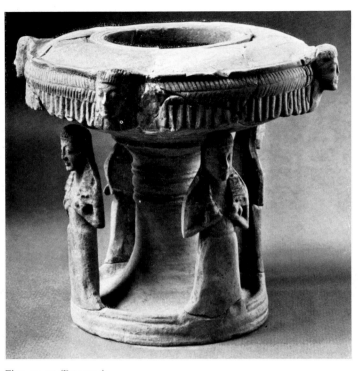

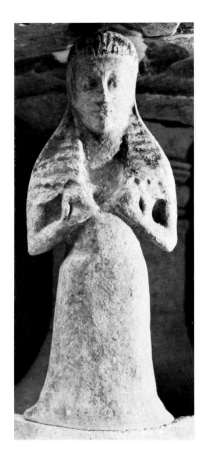

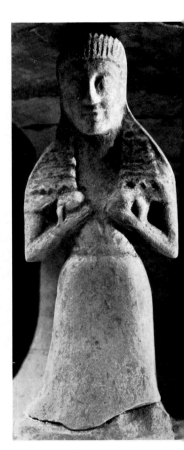

Figs. 57–59 (Paestum)

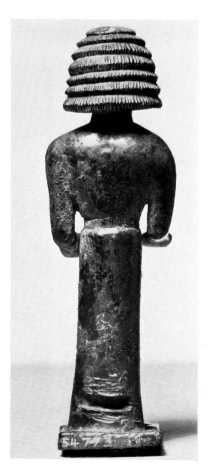

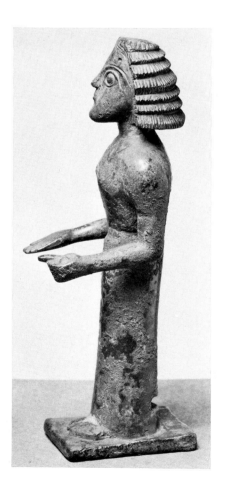

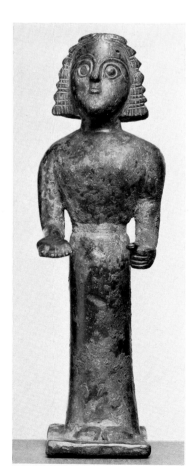

Figs. 60–62 (Baltimore)

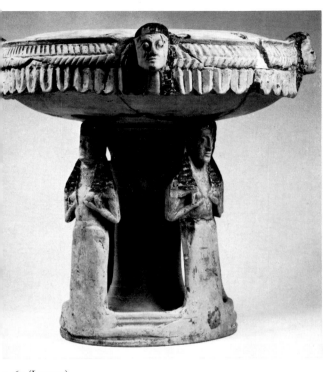

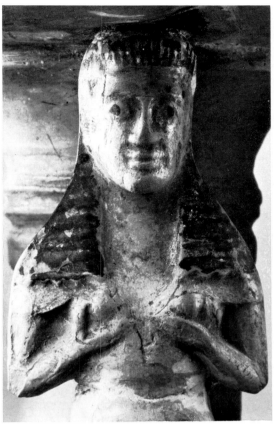

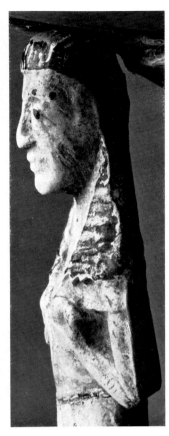

63–65 (Louvre)

13

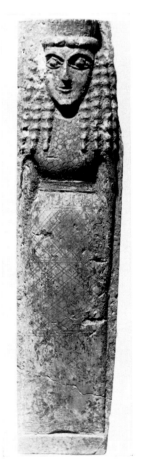

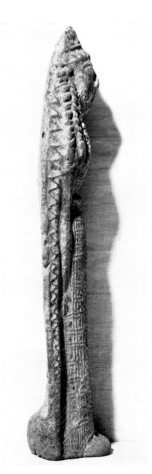

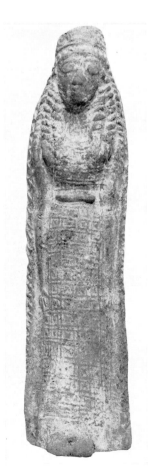

Figs. 66–67 (Megara Hyblaia) 15 Figs. 68–69 (Palermo) 15a

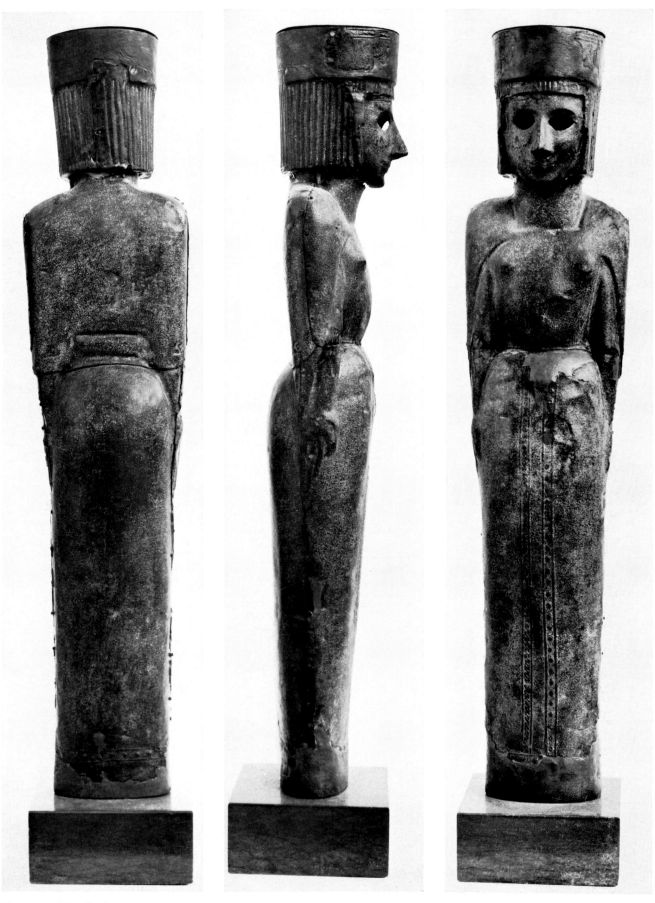

Figs. 70–72 (Heraclion)

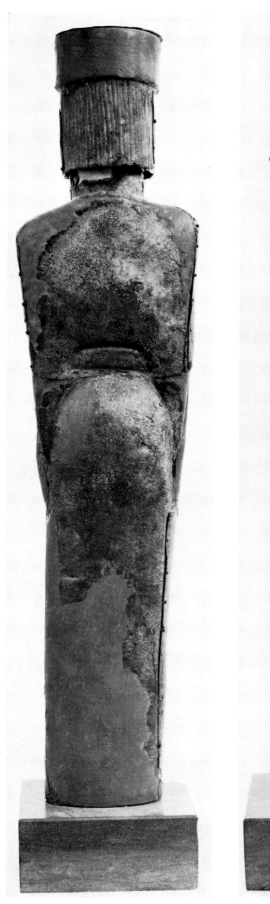
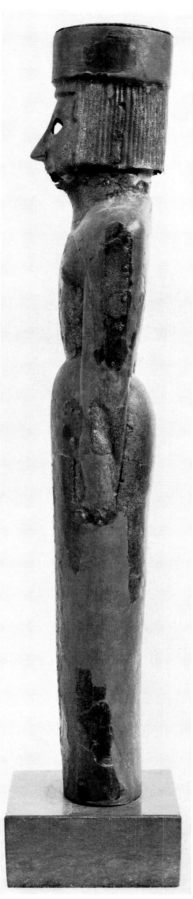
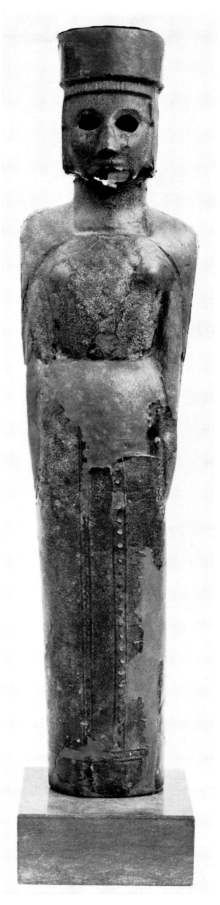

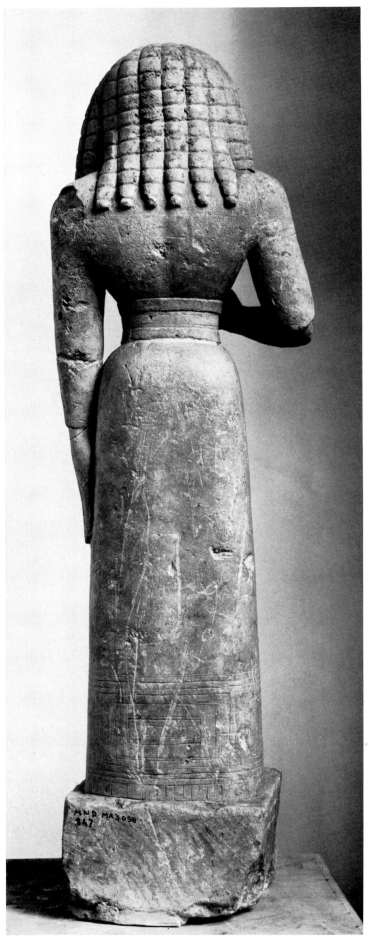
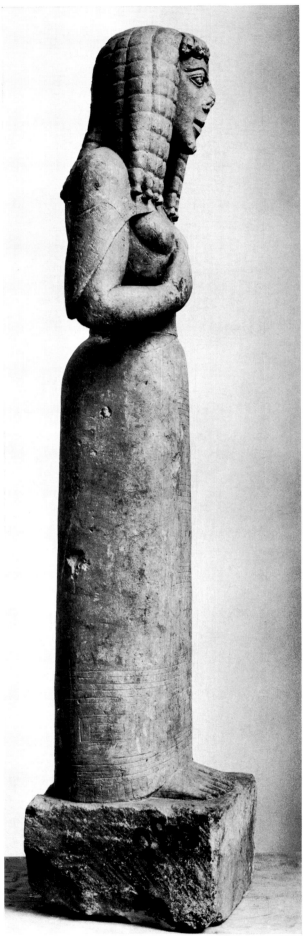

Figs. 76–77 (Louvre)

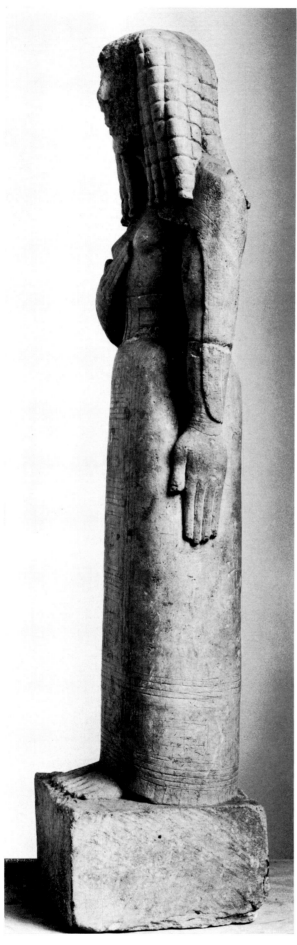

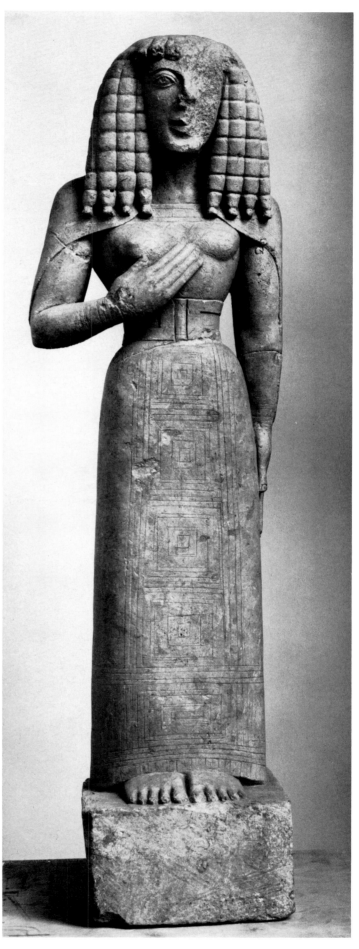

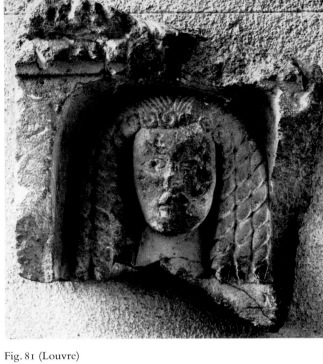

Fig 80 (Samos) 21 Fig. 81 (Louvre) 2

Figs. 82–83 (Samos)

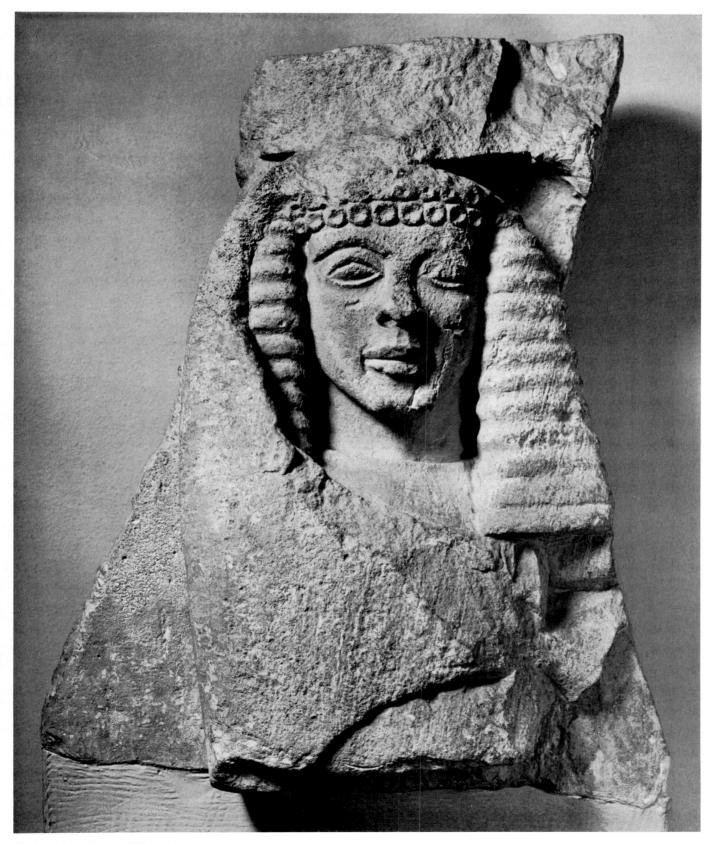

Fig. 84 (Athens, National Museum)

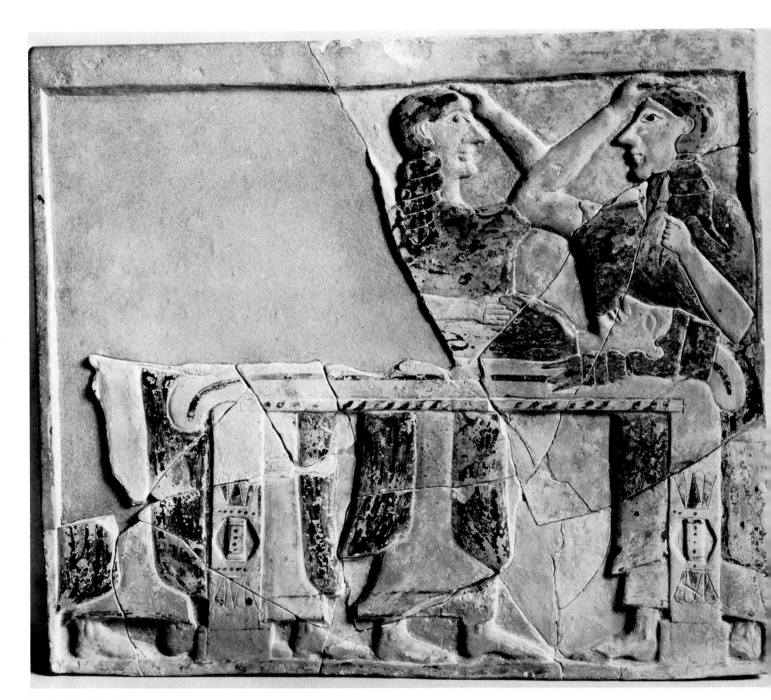

Fig. 85 (New York)

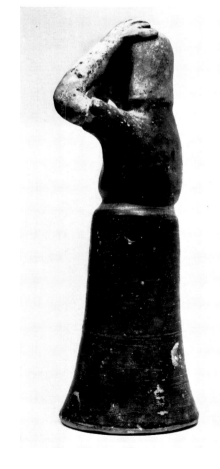

Figs. 86–89 (Athens, National Museum)

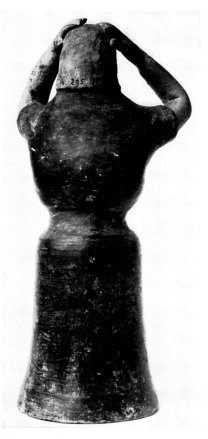
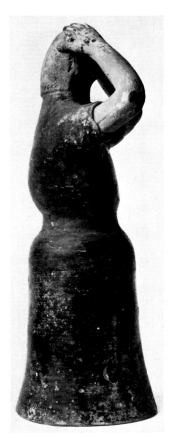
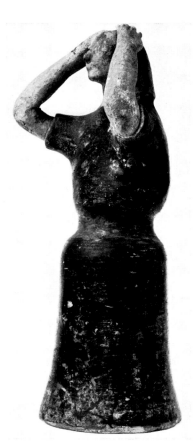
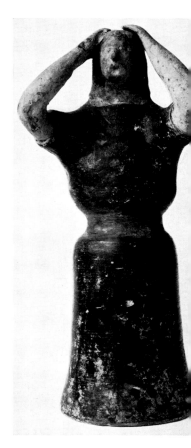

Figs. 90–93 (Louvre)

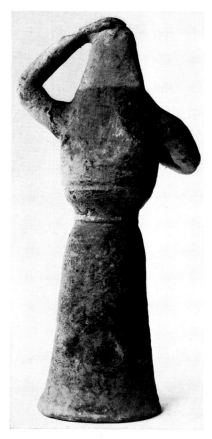

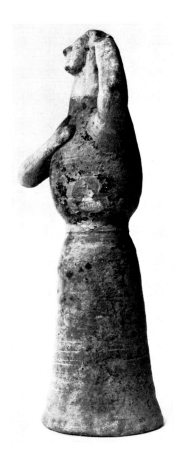
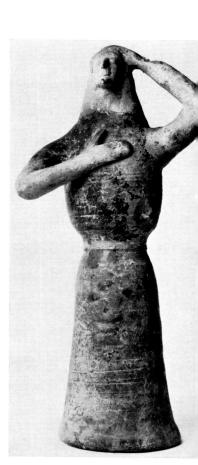

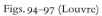

Figs. 94–97 (Louvre)

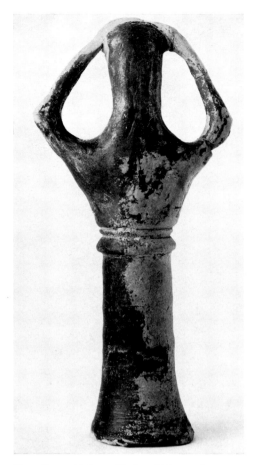
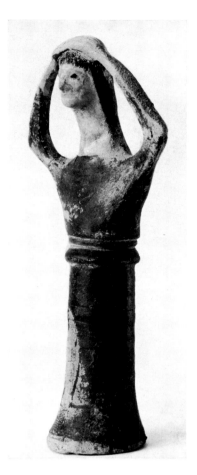
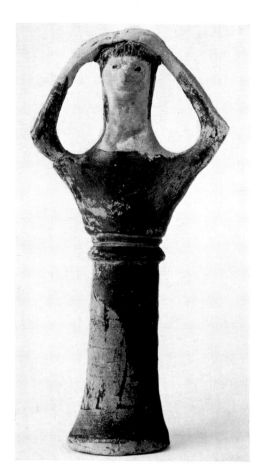

Figs. 98–100 (Athens, National Museum)

26

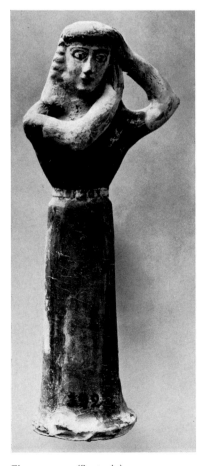
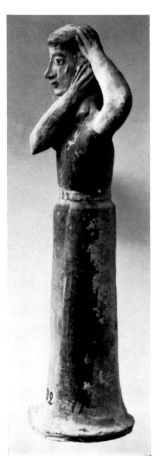
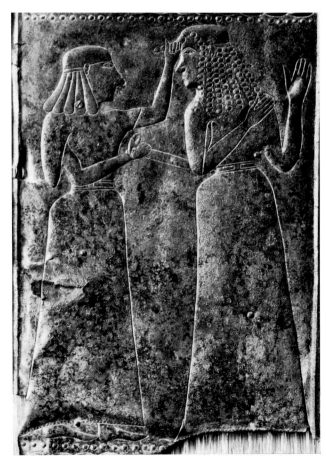

Figs. 101–102 (Santorin)

27

Fig. 103 (Athens, National Museum)

30

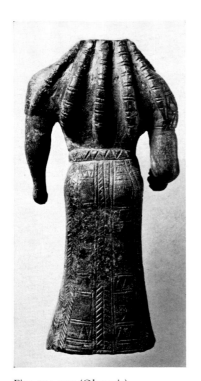
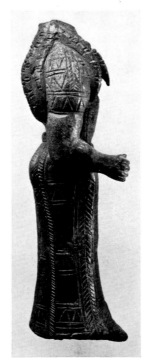
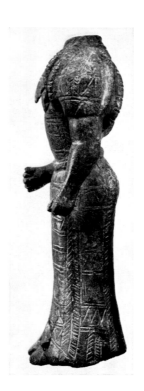
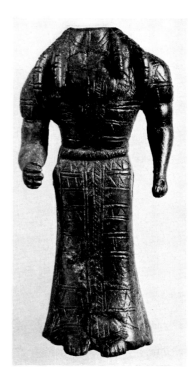

Figs. 104–107 (Olympia) 28

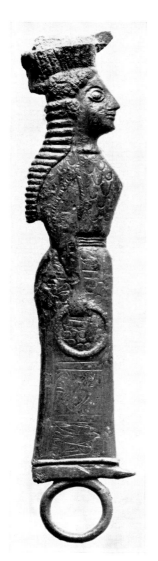

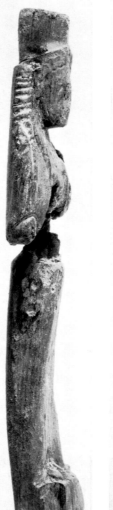

Fig. 108 (Louvre) 29 Figs. 109–112 (Syracuse) 31

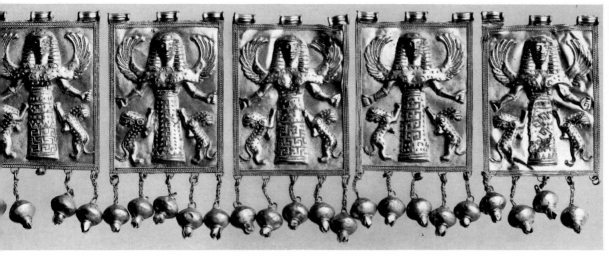

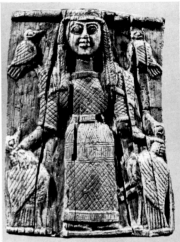

13 (British Museum) 32 Fig. 114 (Athens, National Museum) 34

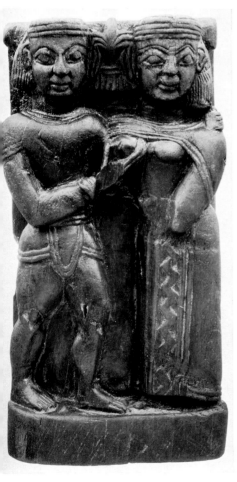

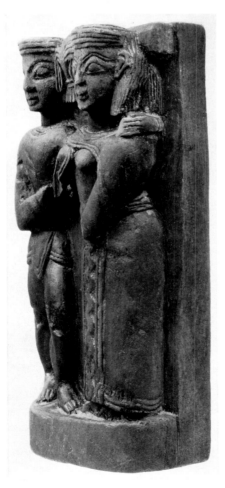

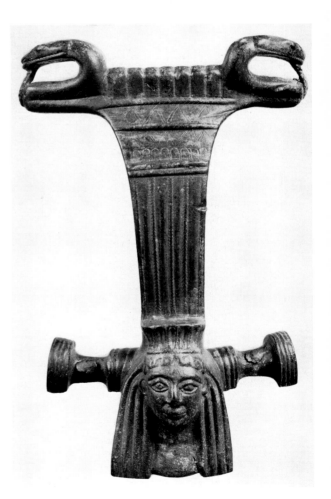

s. 115–116 (formerly Samos) 33 Fig. 117 (Louvre) 35

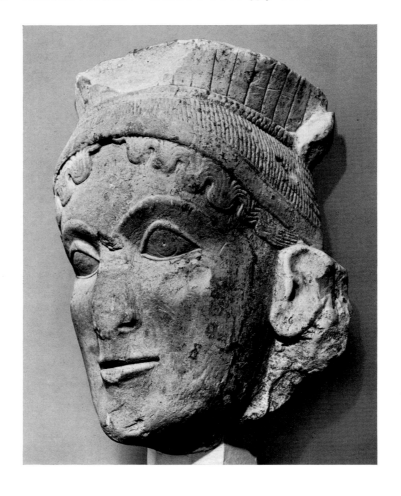

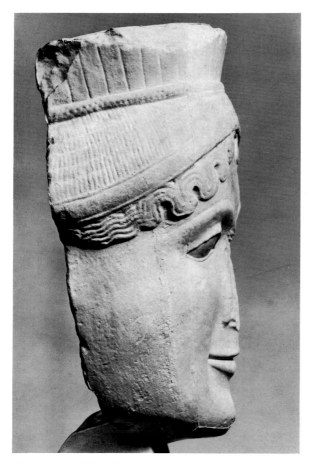

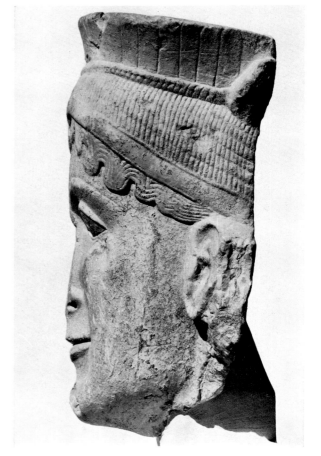

Figs. 118–120 (Olympia)

Fig. 121 II. THE OLYMPIA HERA—BERLIN KORE—AKROPOLIS 593 GROUP

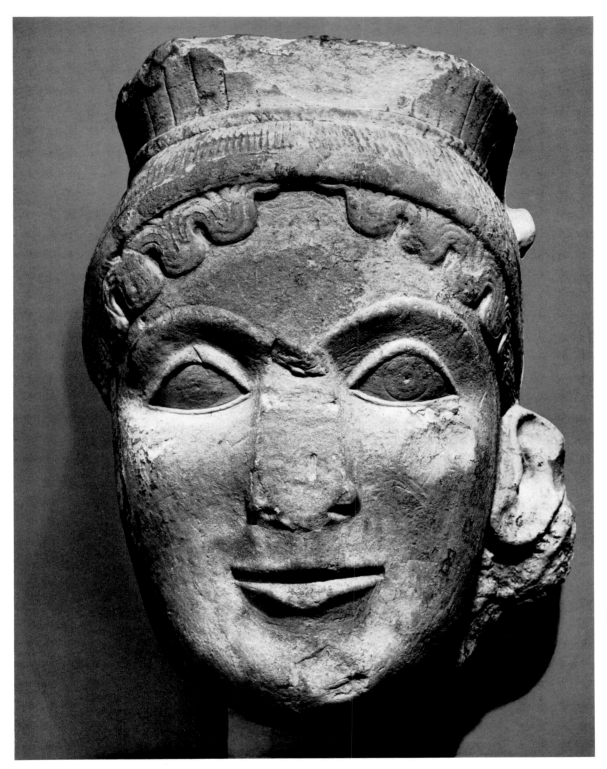

Fig. 121 (Olympia)

Figs. 122–125 (Chios)

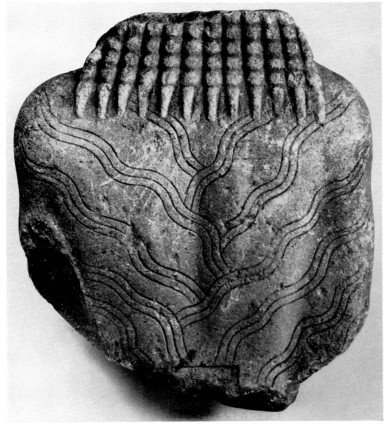

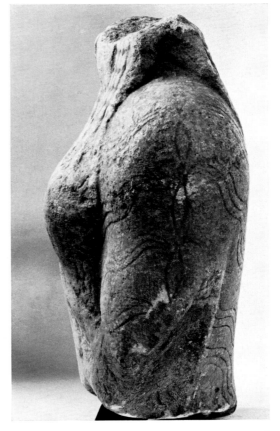

Figs. 126–128 (Chios)

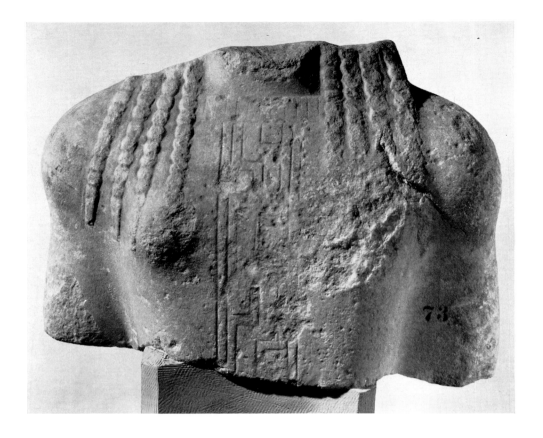

Figs. 129–131 (Athens, National Museum)

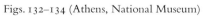

Figs. 132–134 (Athens, National Museum) 40

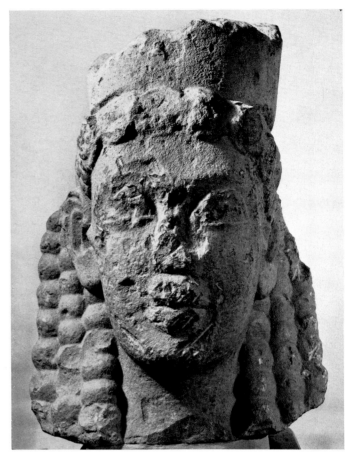

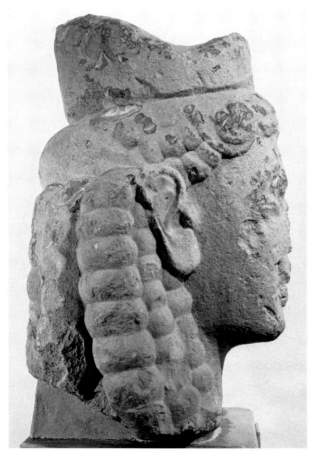

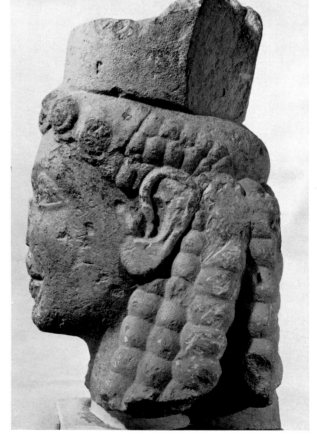

Figs. 135–138 (Syracuse)

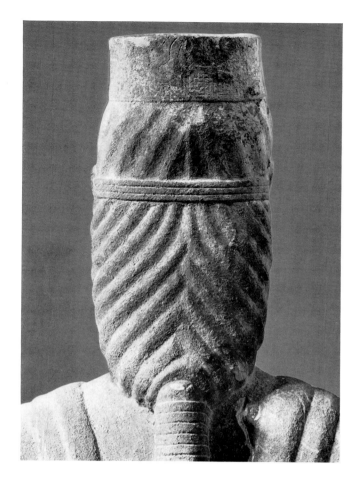

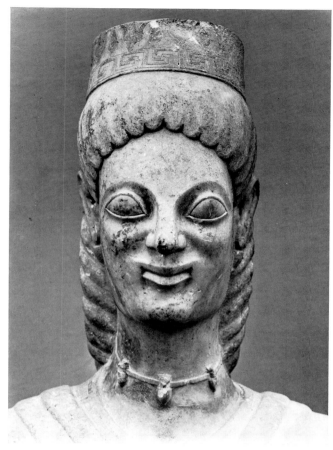

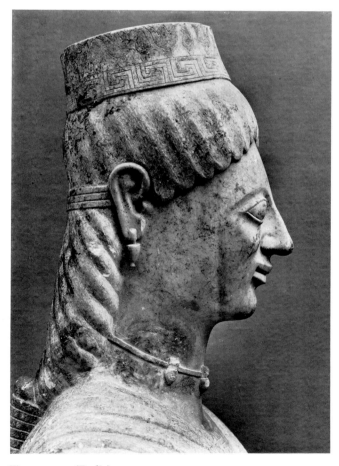

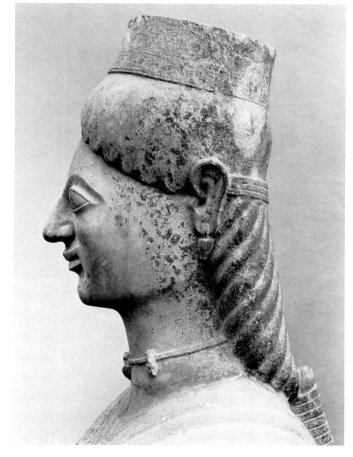

Figs. 139–142 (Berlin)

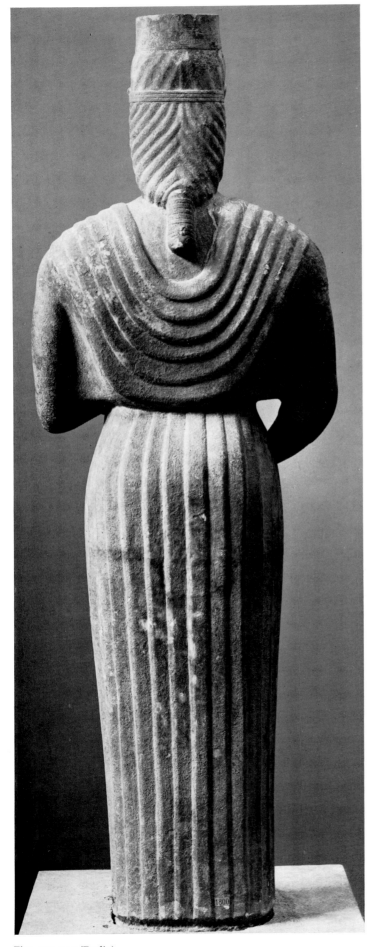

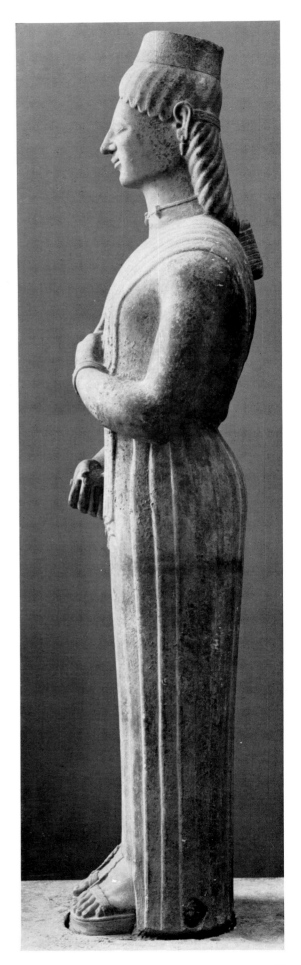

Figs. 143–144 (Berlin)

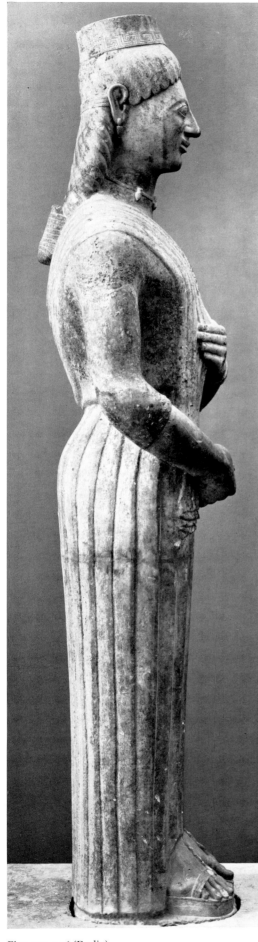
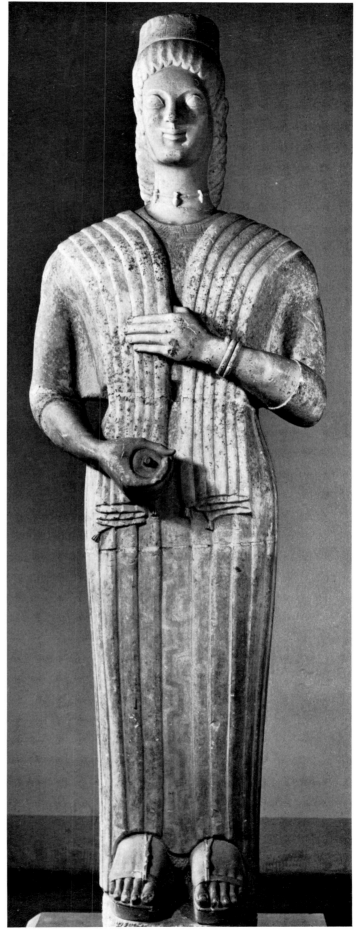

Figs. 145–146 (Berlin) 42

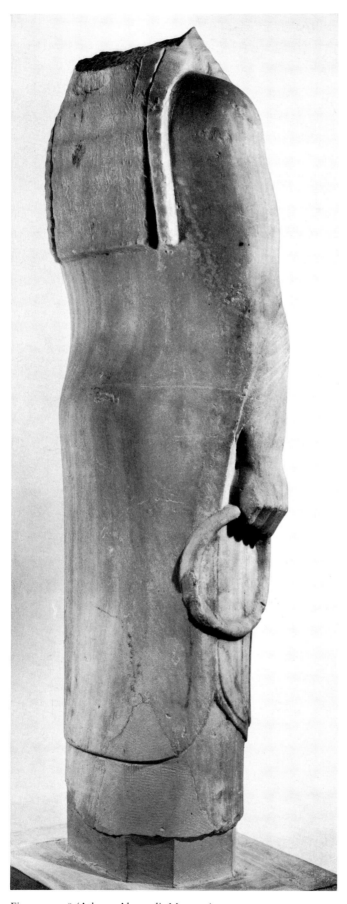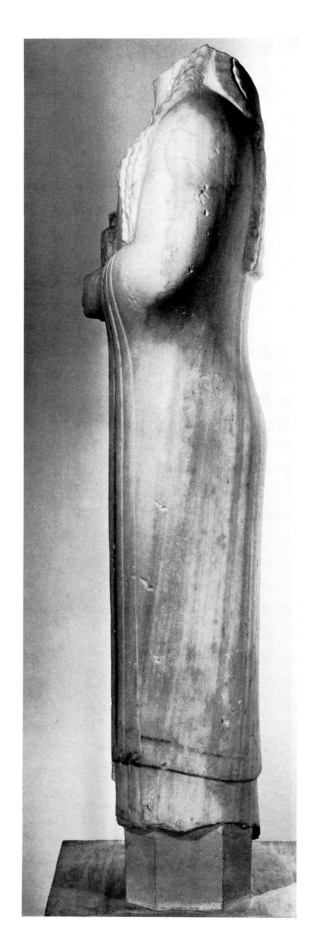

Figs. 147–148 (Athens, Akropolis Museum)

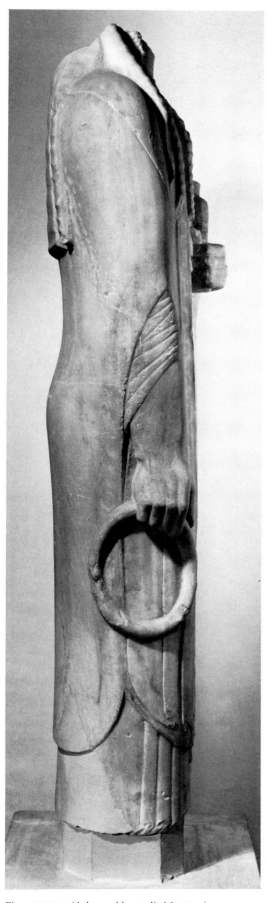

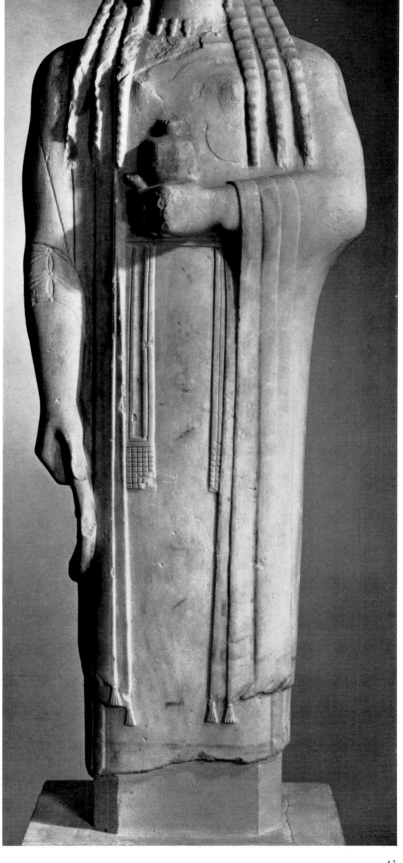

Figs. 149–150 (Athens, Akropolis Museum)

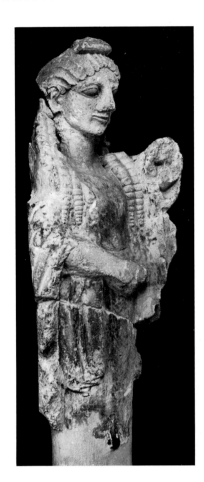

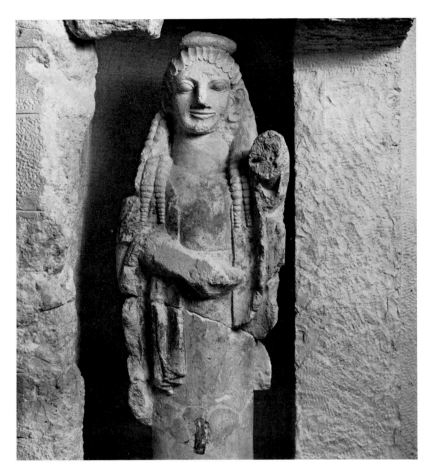

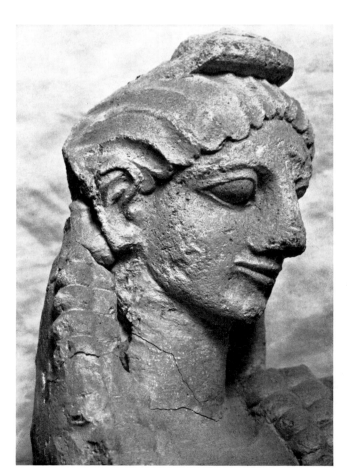

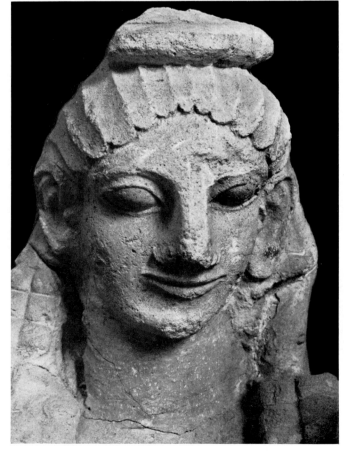

Figs. 151–154 (Athens, Akropolis Museum)

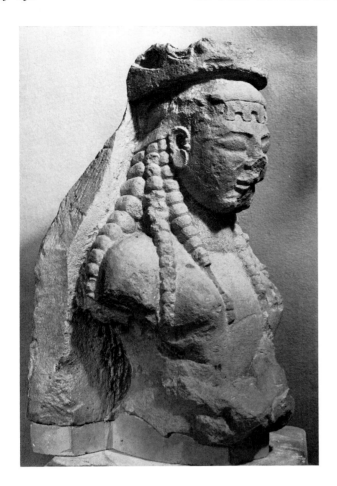
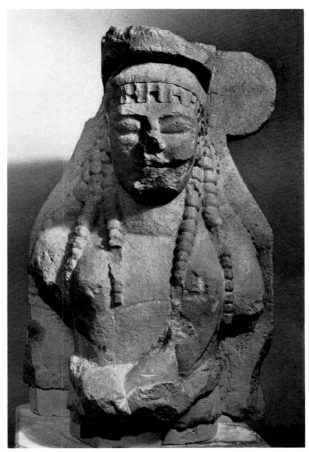
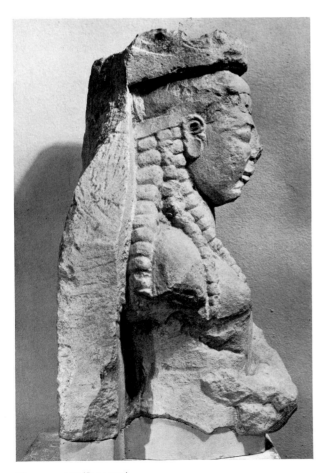
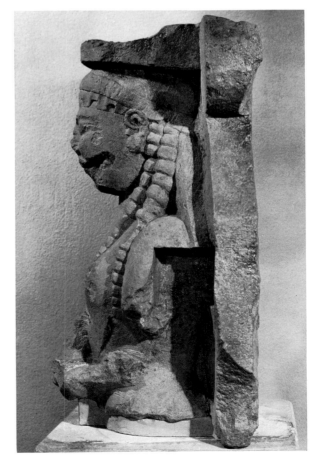

Figs. 155-158 (Syracuse)

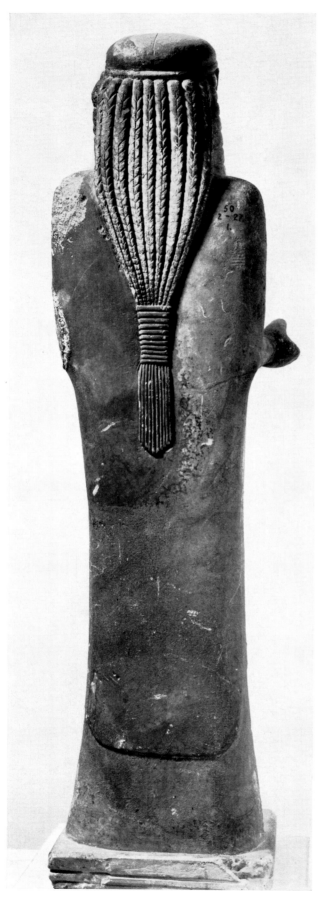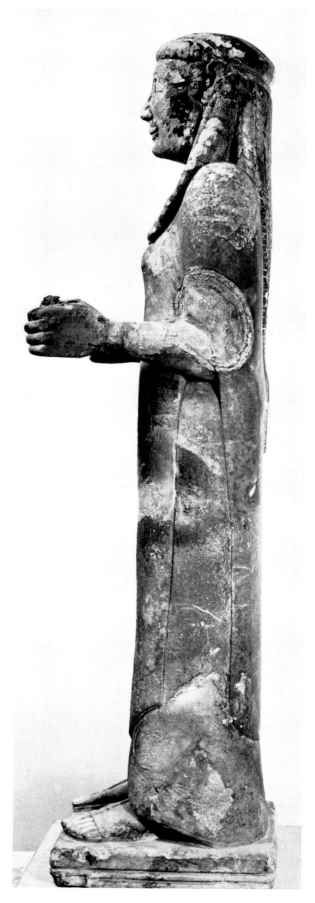

Figs. 159–160 (British Museum)

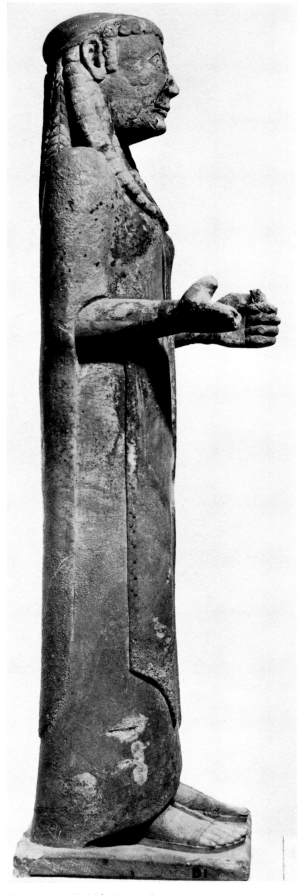 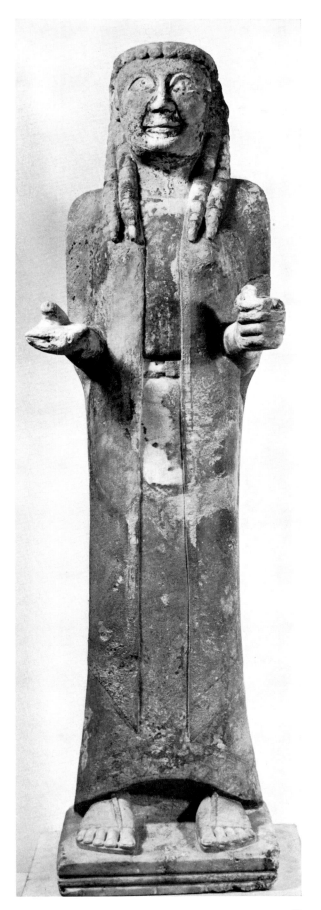

Figs. 161–162 (British Museum)

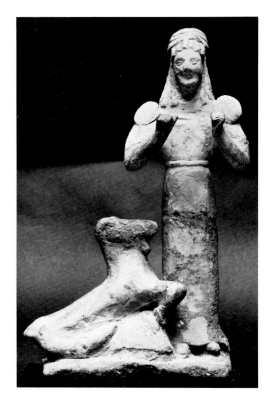

Figs. 163–165 (Louvre)

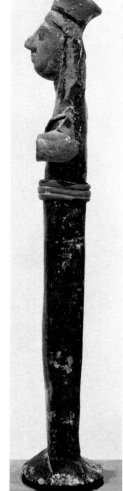

Figs. 166–167 (Athens, National Museum)

Figs. 168–169 (British Museum)

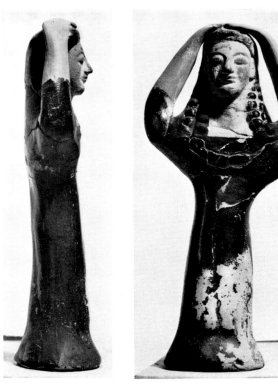

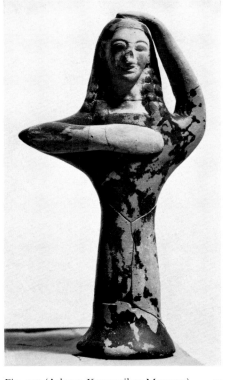

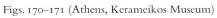

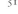

Figs. 170–171 (Athens, Kerameikos Museum) 50 Fig. 172 (Athens, Kerameikos Museum) 51

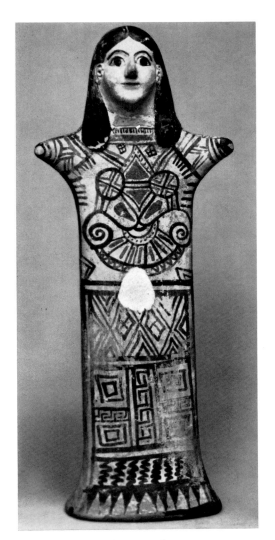

Figs. 173–174 (British Museum) 52

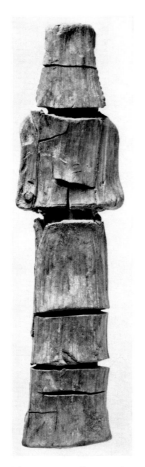 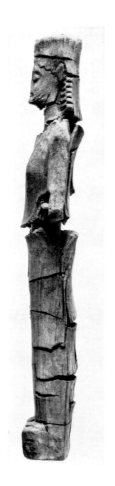 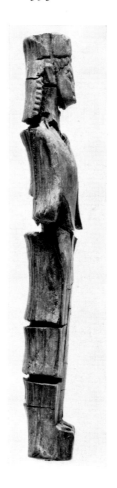 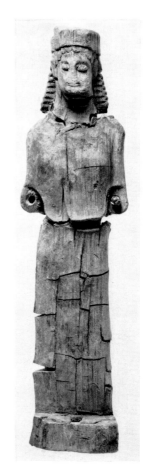

Figs. 175–178 (Syracuse)

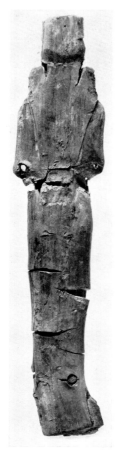 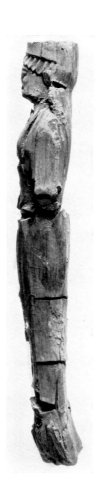 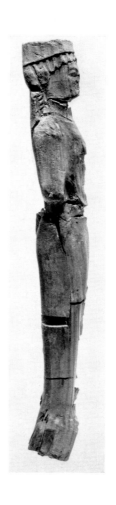 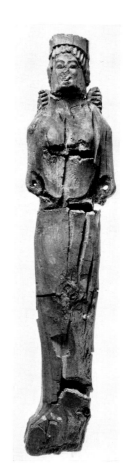

Figs. 179–182 (Syracuse)

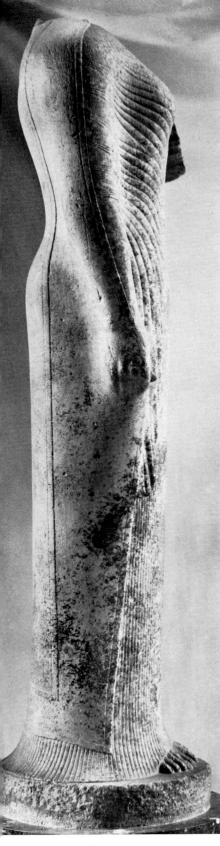
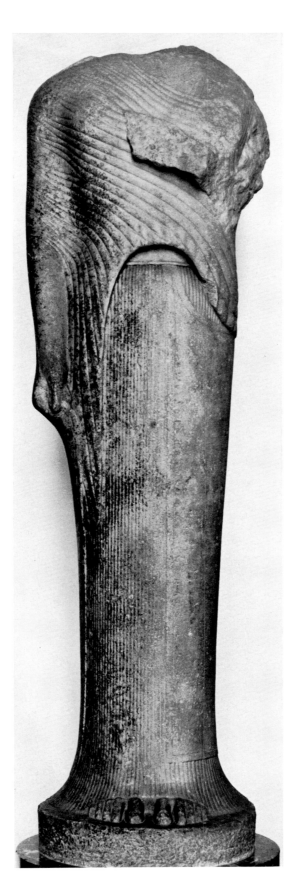
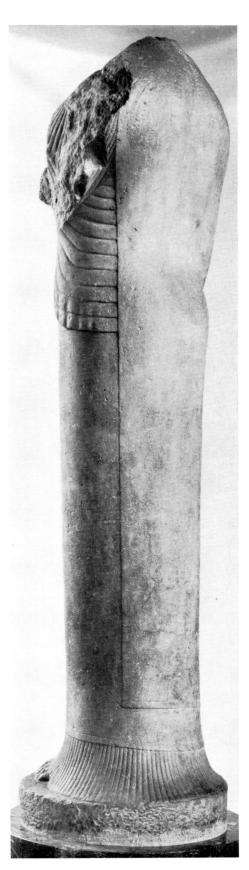

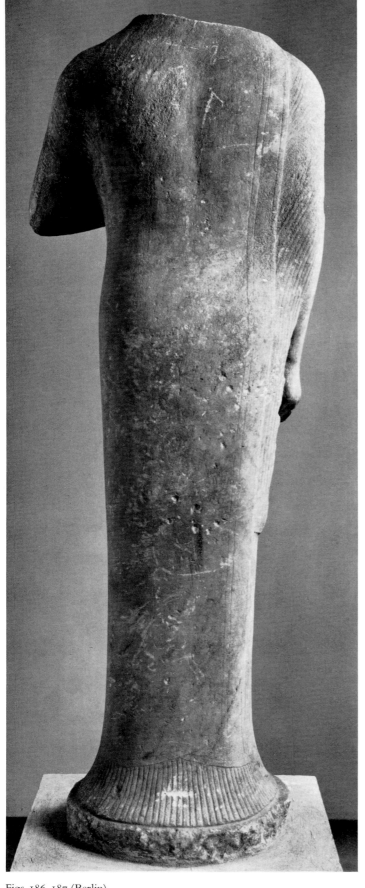

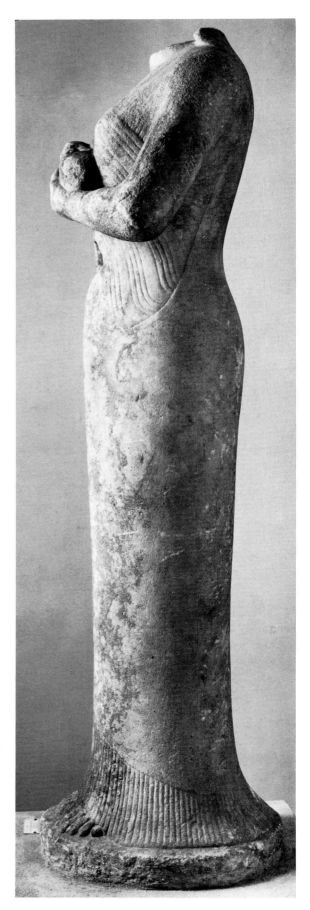

Figs. 186–187 (Berlin)

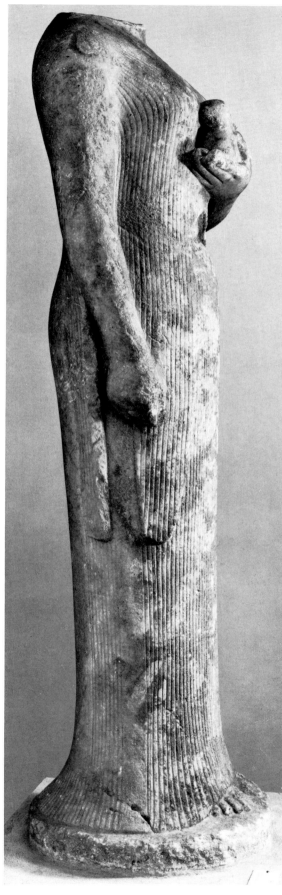
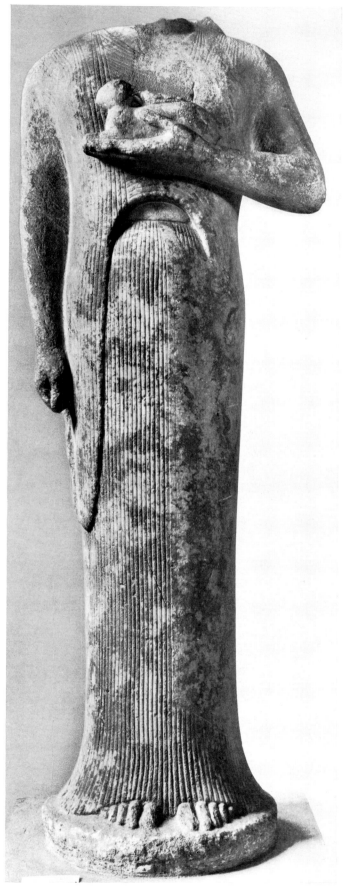

Figs. 188–189 (Berlin)

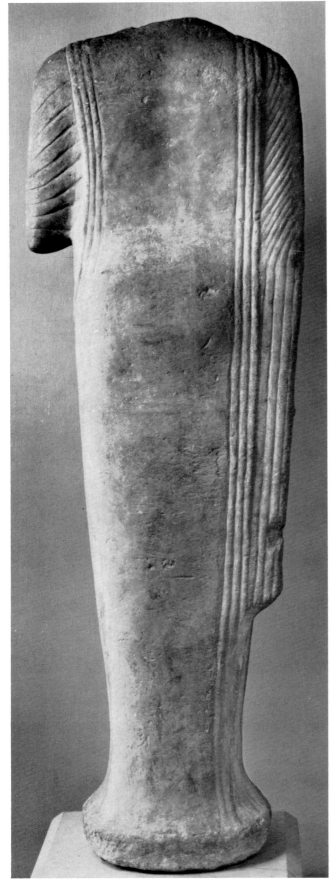
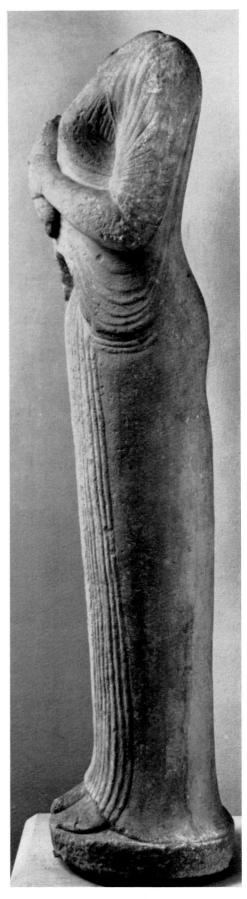

Figs. 190–191 (Berlin)

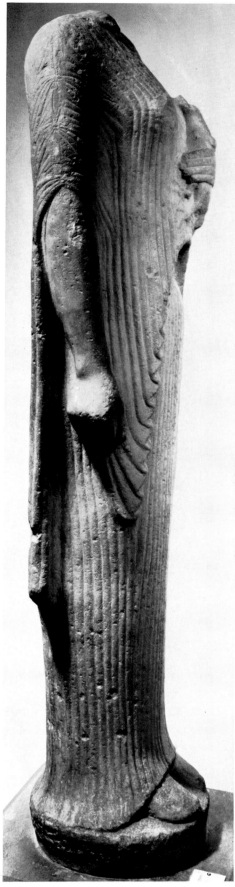
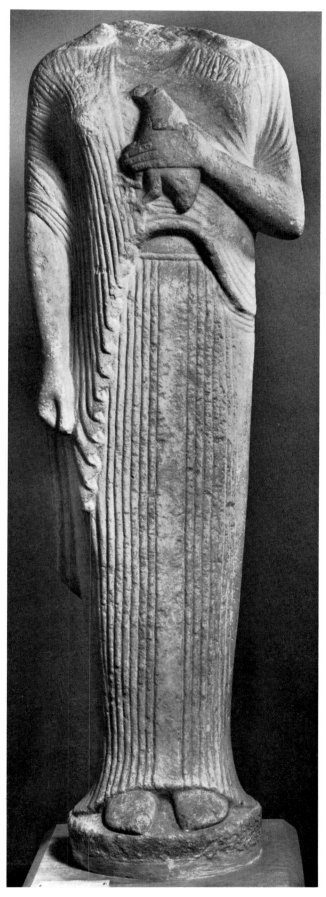

Figs. 192–193 (Berlin)

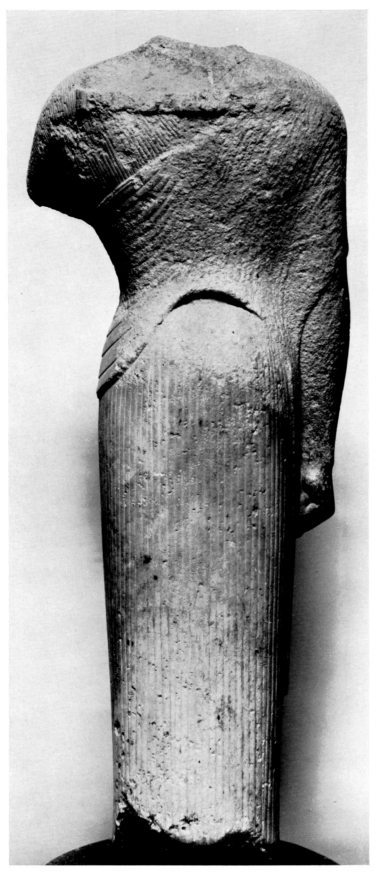
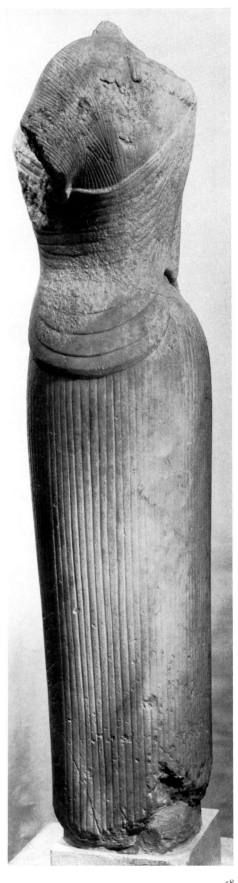

Figs. 194–195 (Athens, Akropolis Museum, no. 619)

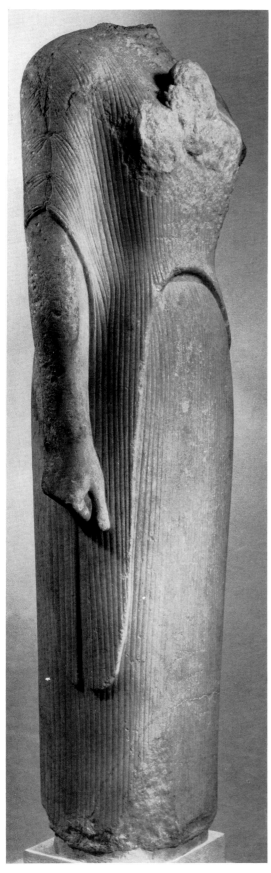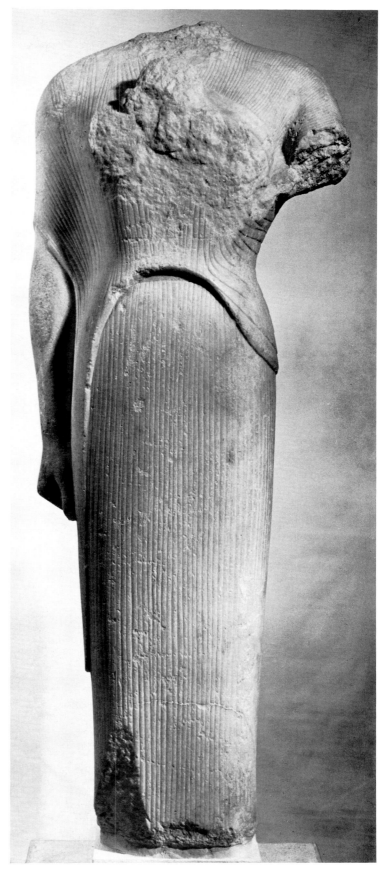

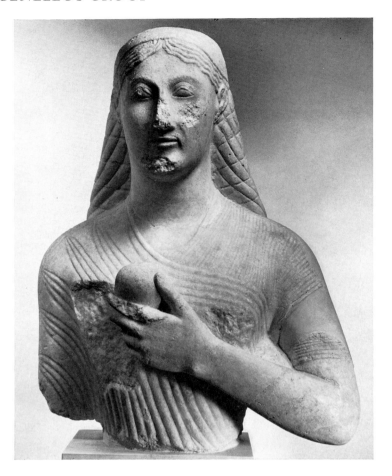

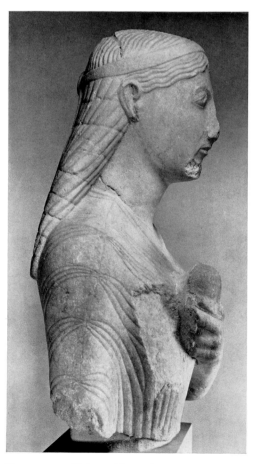

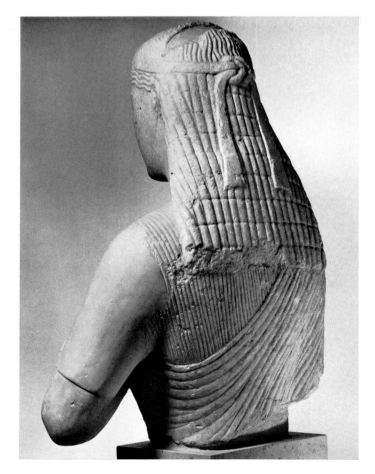

Figs. 198–200 (Athens, Akropolis Museum, no. 677)

Fig. 201 (Berlin) 60

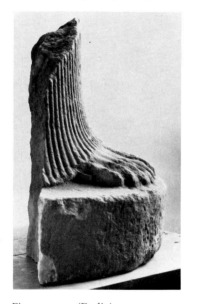

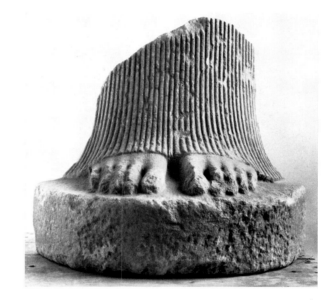

Figs. 202–203 (Berlin) 60

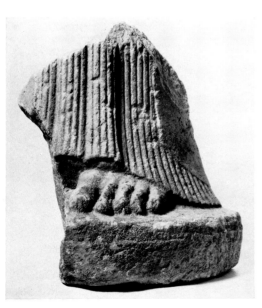

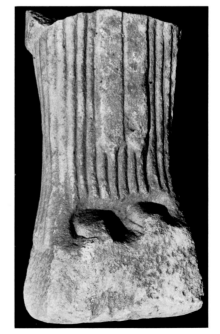

Figs. 204–205 (Samos) 61 Fig. 206 (Manisa) 62

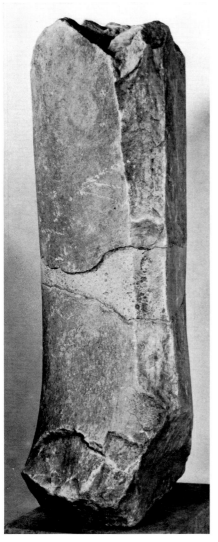

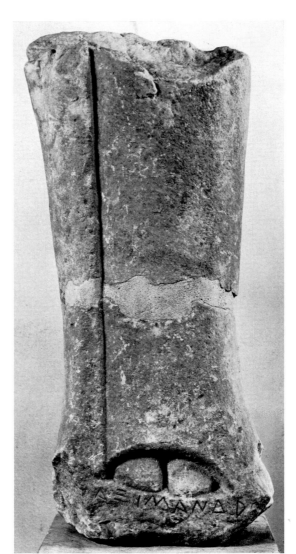

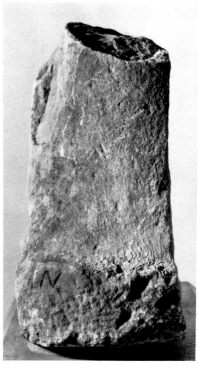

Figs. 207–208 (Berlin) 63 Fig. 209 (Berlin) 64

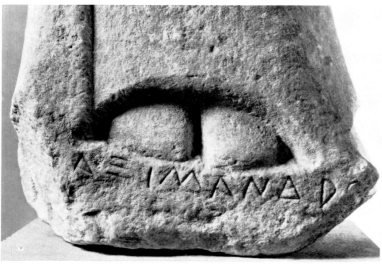

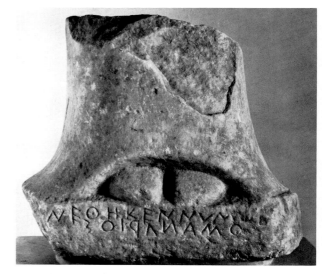

Fig. 210 (Berlin) 63 Fig. 211 (Berlin) 64

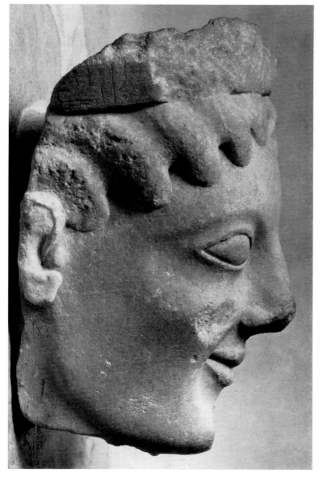
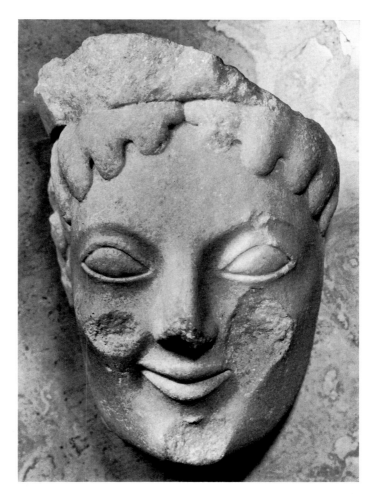

Figs. 212–213 (Athens, Akropolis Museum, no. 654) 65

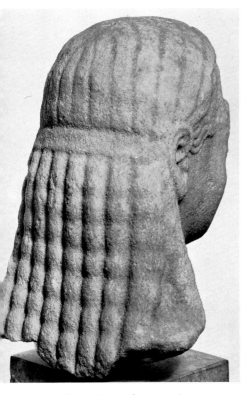
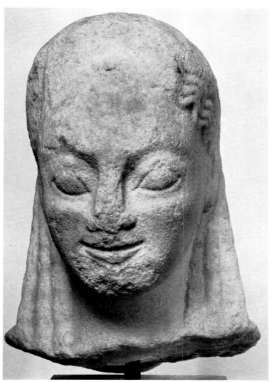
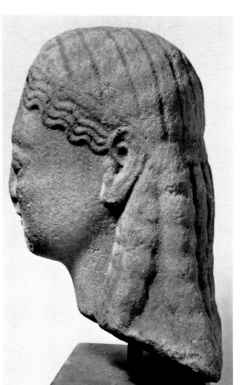

s. 214–216 (Athens, National Museum) 66

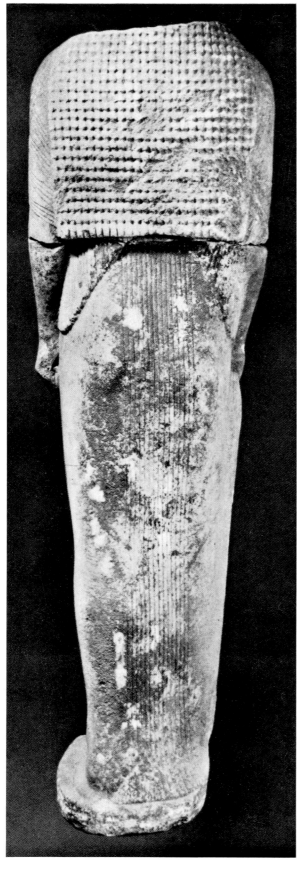

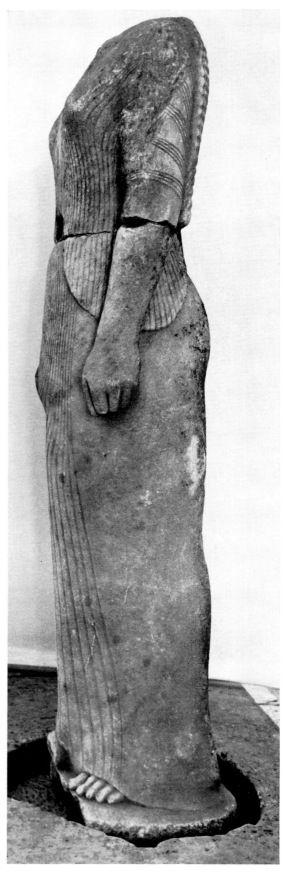

Figs. 217–218 (Samos): Philippe

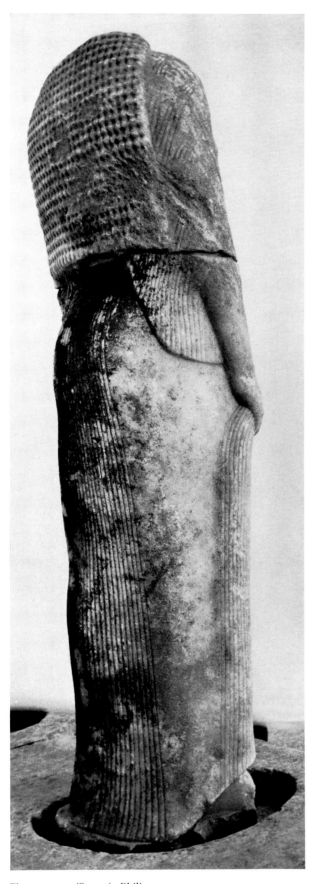
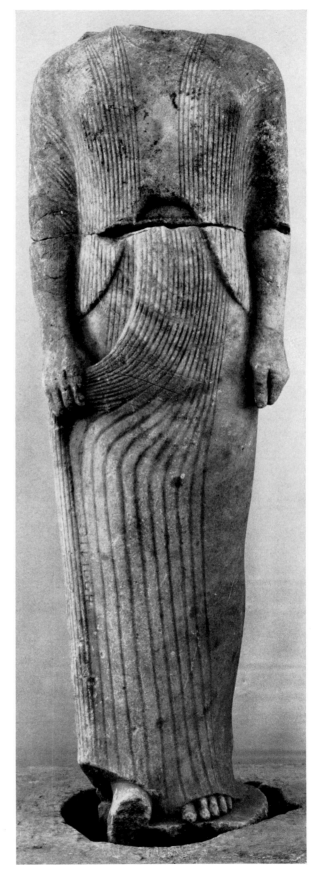

Figs. 219–220 (Samos): Philippe

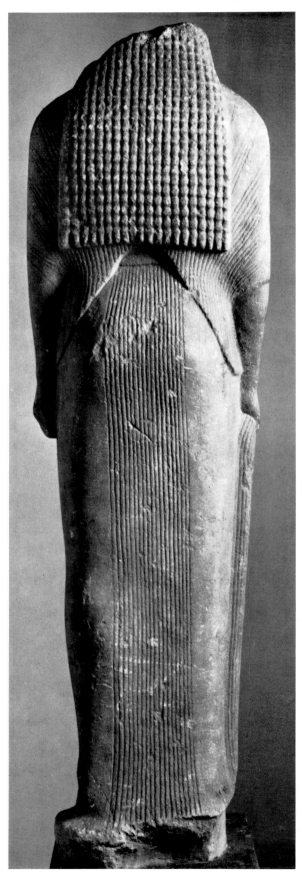
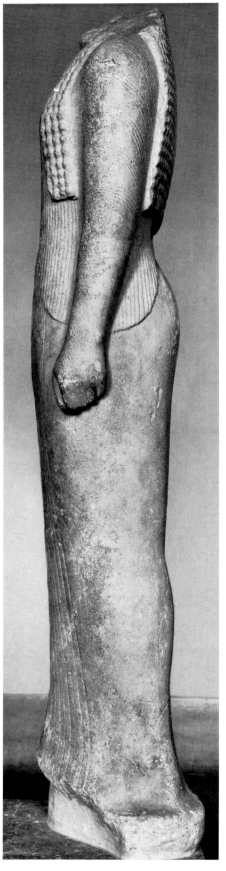

Figs. 221–222 (Berlin): Ornithe

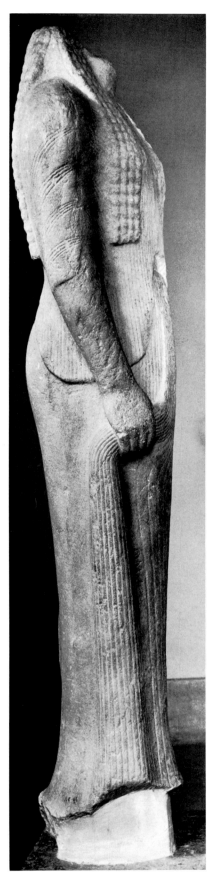 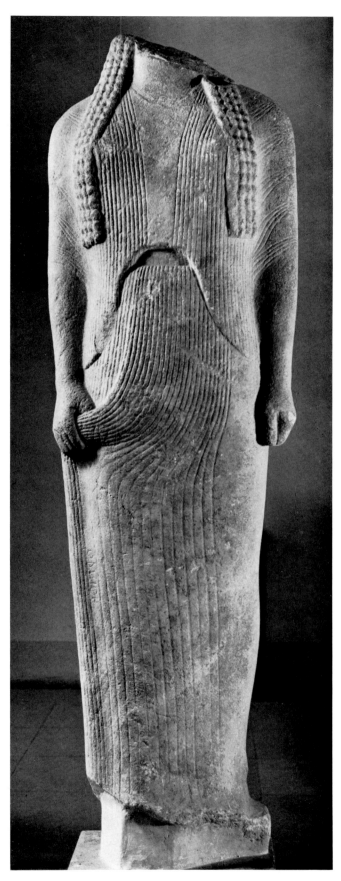

Figs. 223–224 (Berlin): Ornithe 68

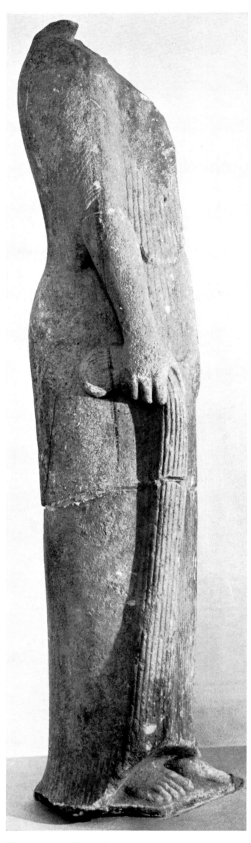

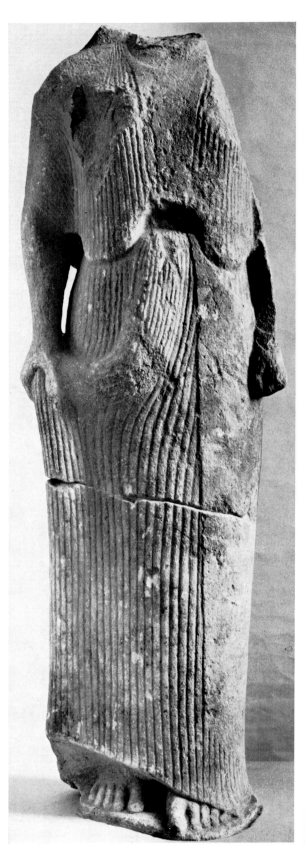

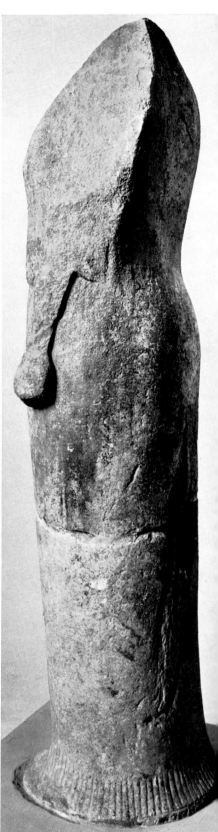

Figs. 225–227 (Samos)

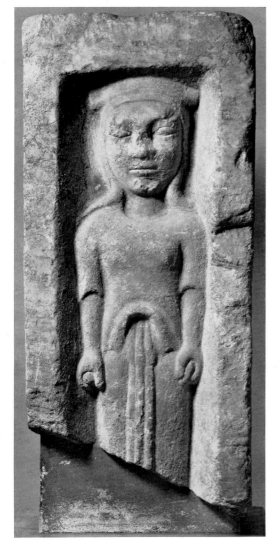

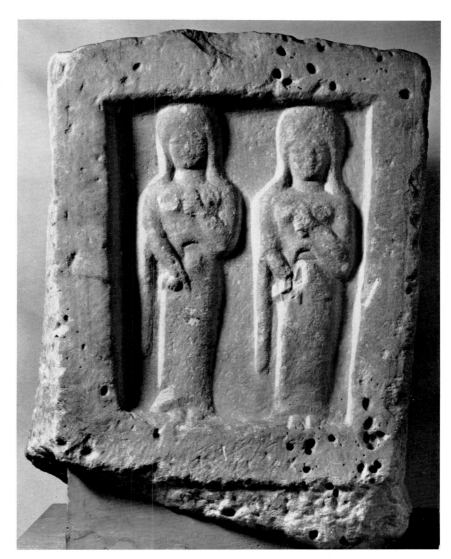

Fig. 228 (Berlin) 70 Fig. 229 (Berlin) 71

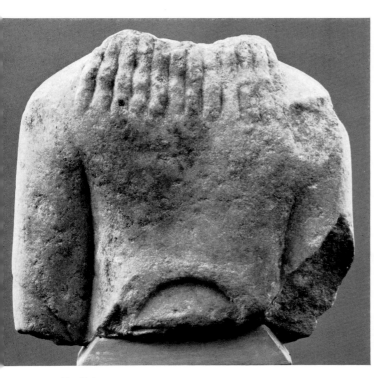

Figs. 230–231 (Berlin) 72

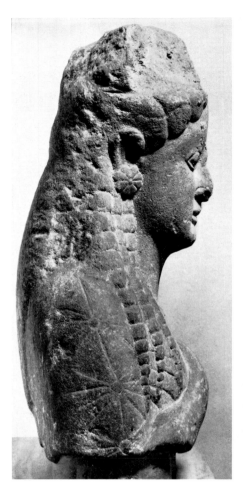
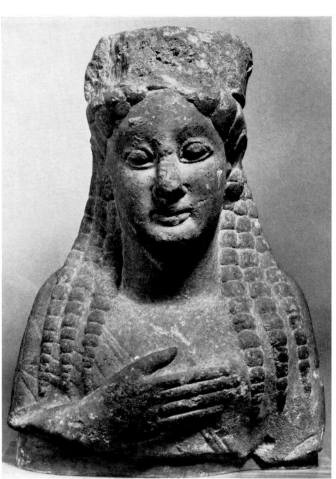
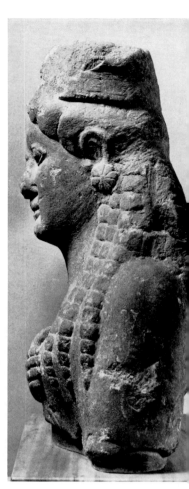

Figs. 232–234 (Berlin)

Fig. 235 (Athens, Akropolis Museum, no. 592)

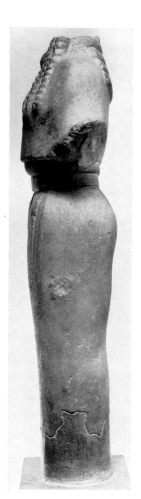
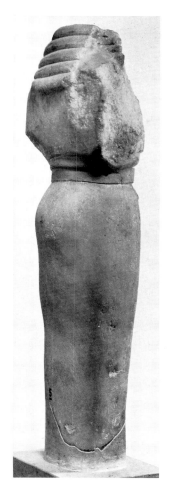
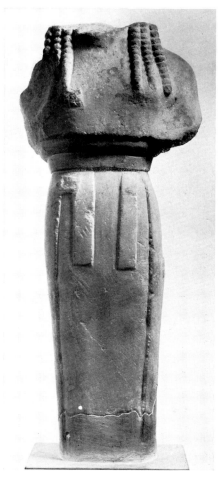

Figs. 236–239 (Athens, National Museum)

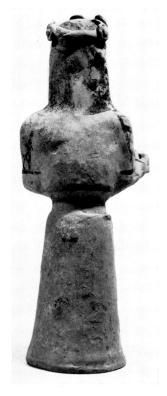
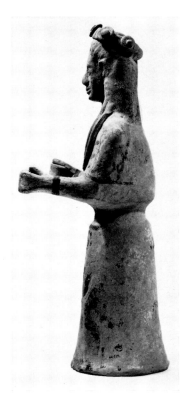
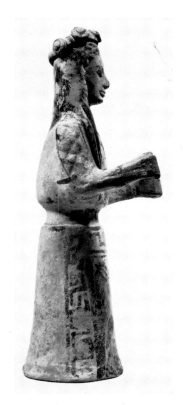
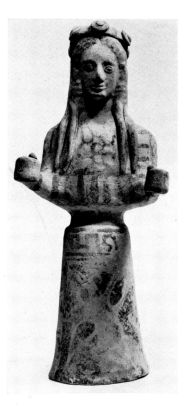

Figs. 240–243 (Athens, National Museum)

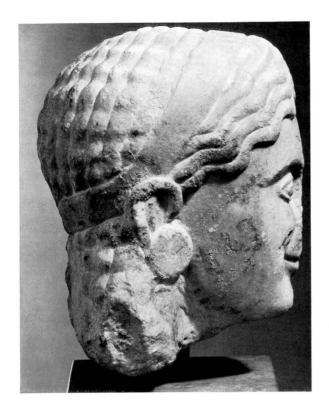

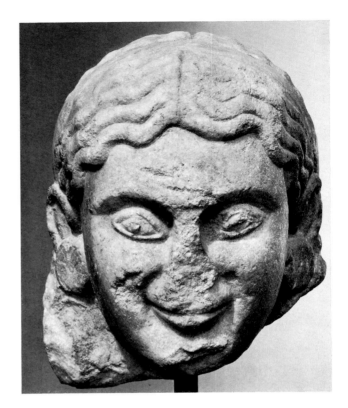

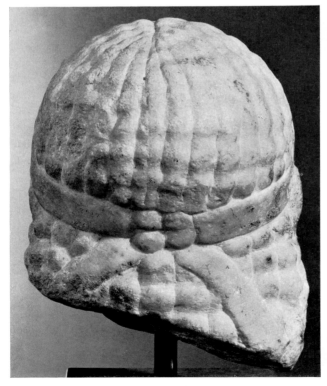

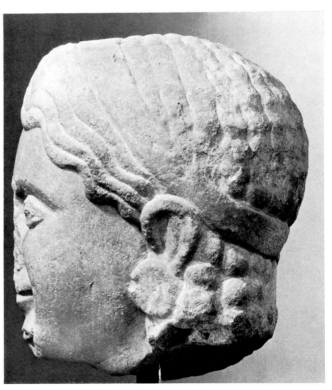

Figs. 244–247 (Copenhagen)

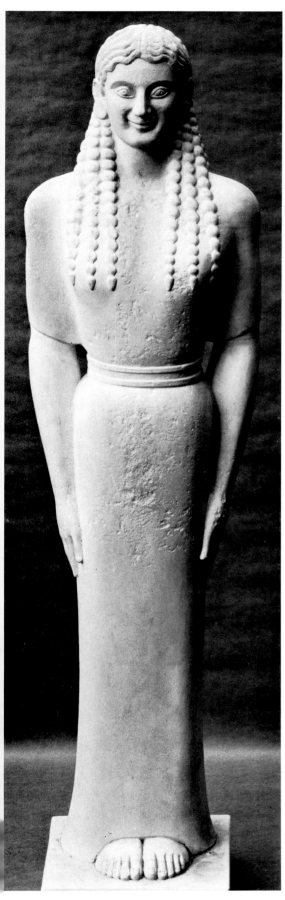

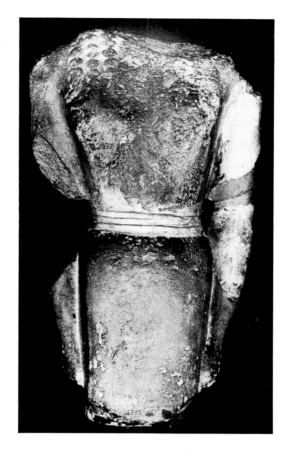

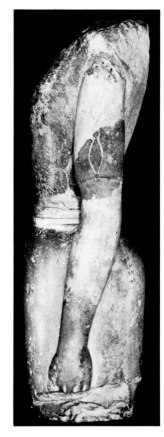

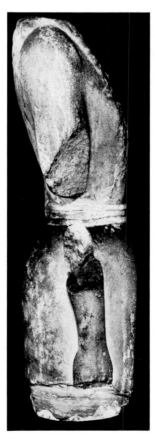

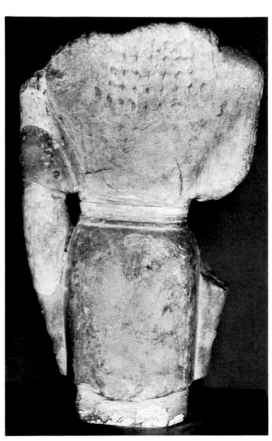

Fig. 248 (cast) 76, 77 Figs. 249–252 (Istanbul) 76

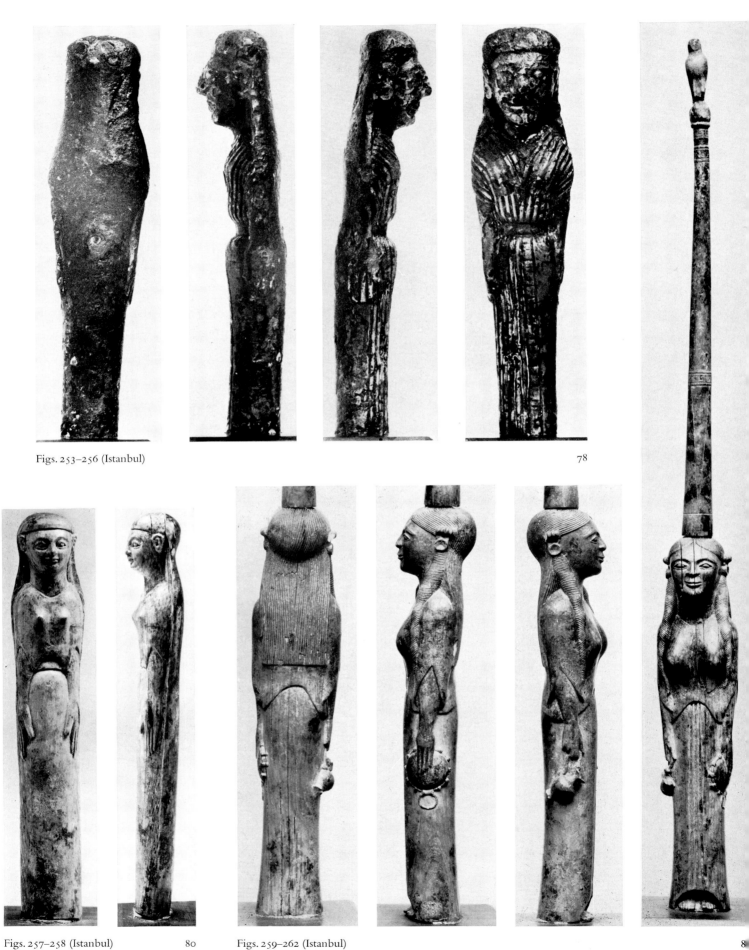

Figs. 253–256 (Istanbul) 78

Figs. 257–258 (Istanbul) 80 Figs. 259–262 (Istanbul) 8

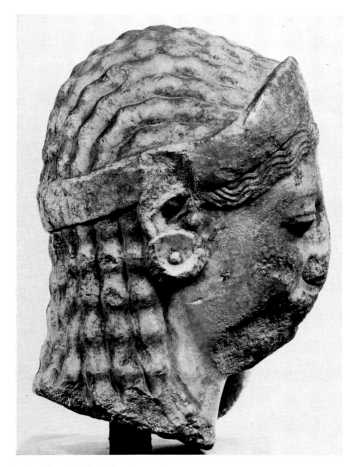

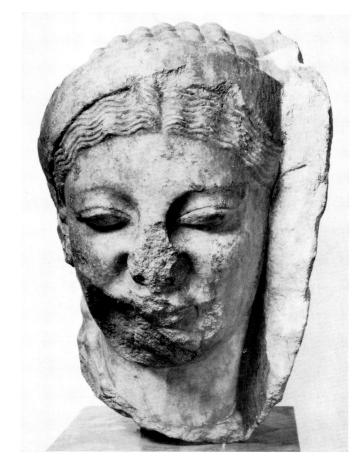

Figs. 263–264 (British Museum) 82

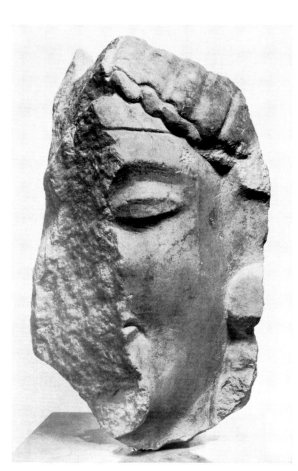

Fig. 265 (British Museum) 82

Fig. 266 (British Museum) 83

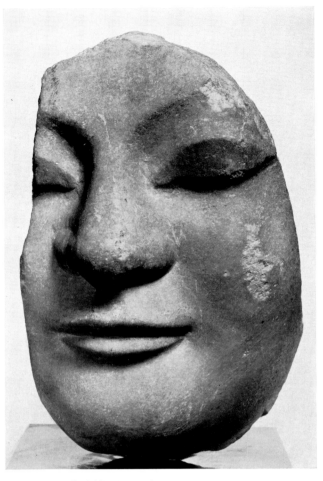

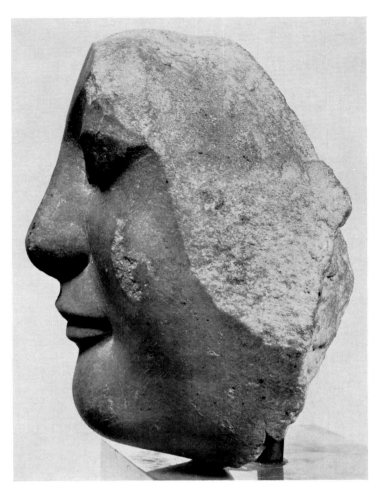

Figs. 267–268 (British Museum) 84

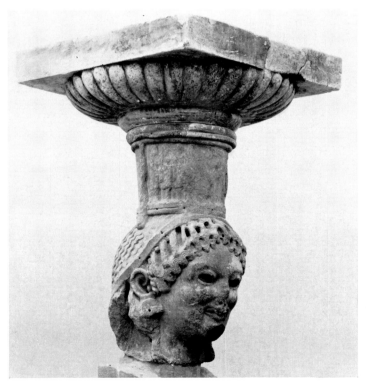

Fig. 269 (British Museum) 85 Fig. 270 (Delphi) 86

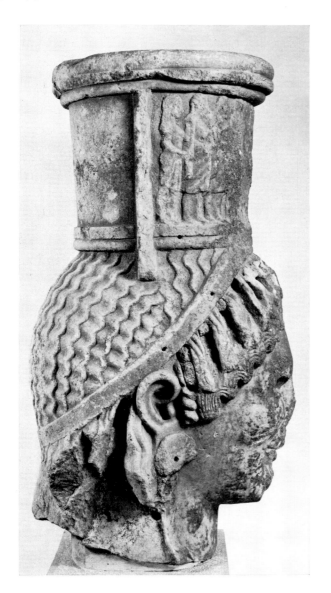

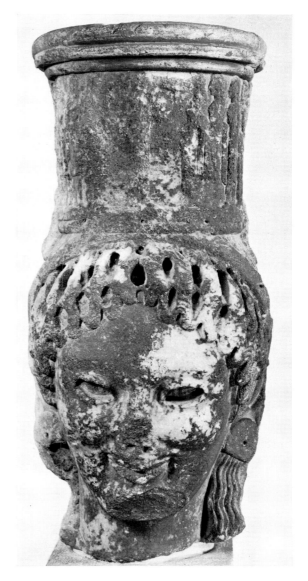

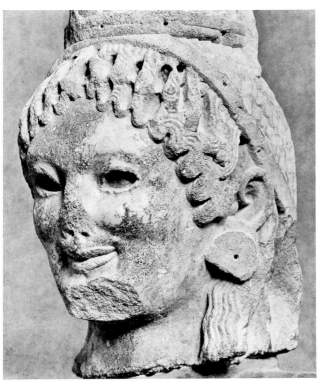

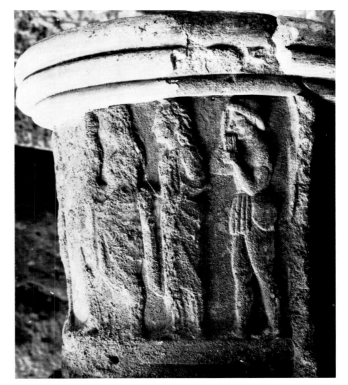

Fig. 271–274 (Delphi)

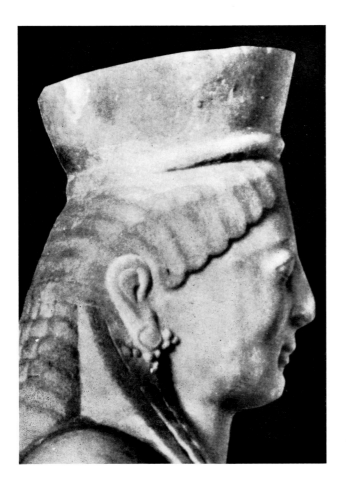
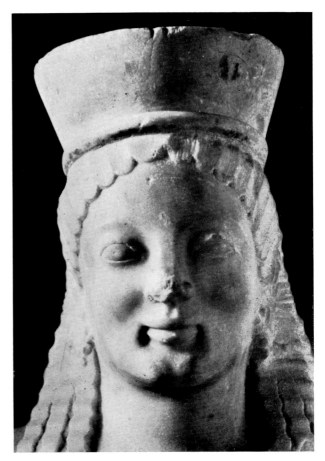

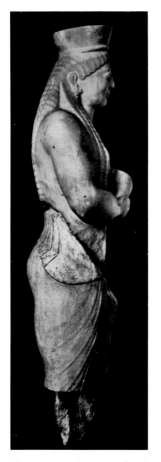
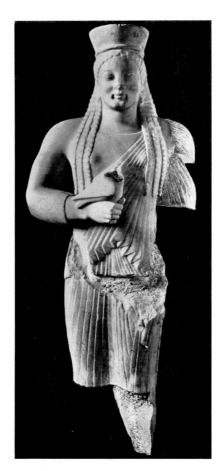
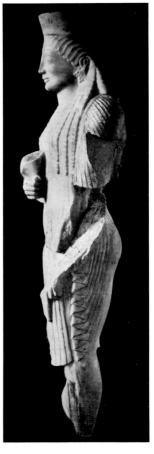

Figs. 275–279 (Lyons and Athens, Akropolis Museum)

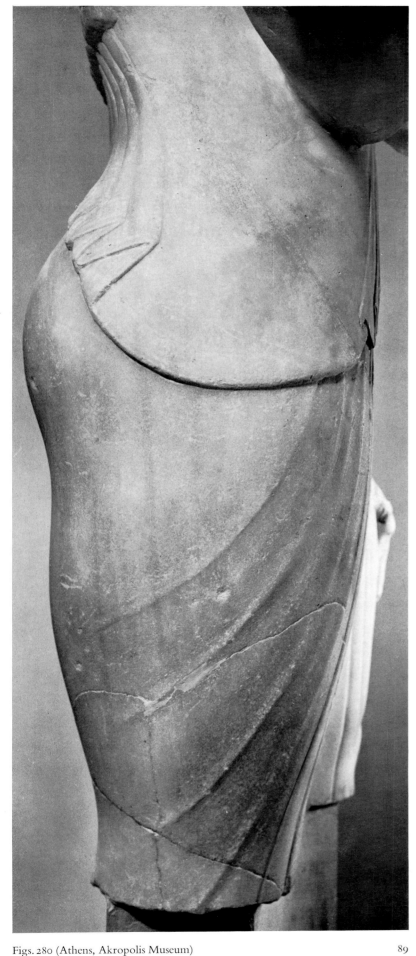

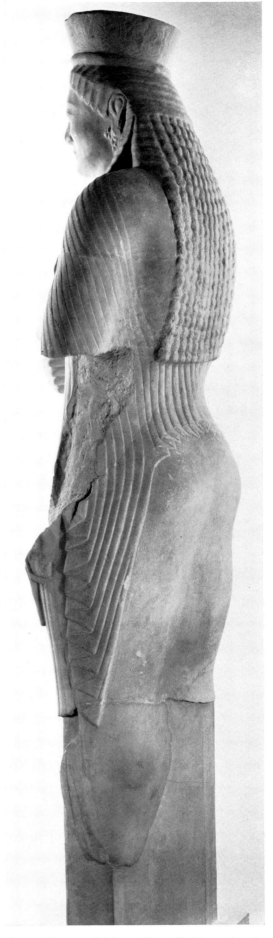

Figs. 280 (Athens, Akropolis Museum) 89 Fig. 281 (Lyons and Athens, Akropolis Museum) 89

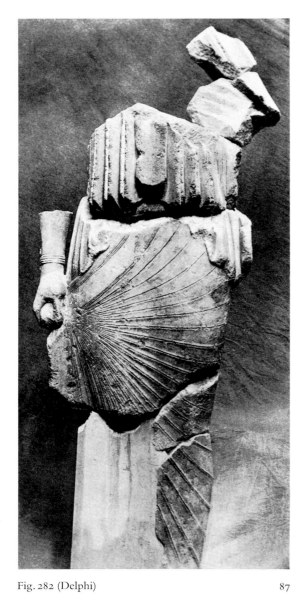

Fig. 282 (Delphi) 87

Fig. 283 (Delphi) 88

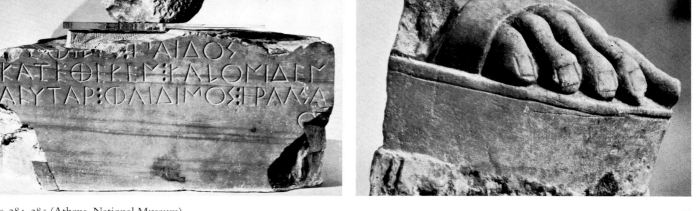

Figs. 284–285 (Athens, National Museum) 91

Fig. 286 (Palermo) 90

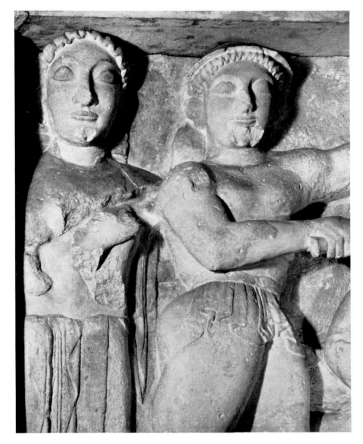

Fig. 287 (Palermo) 90

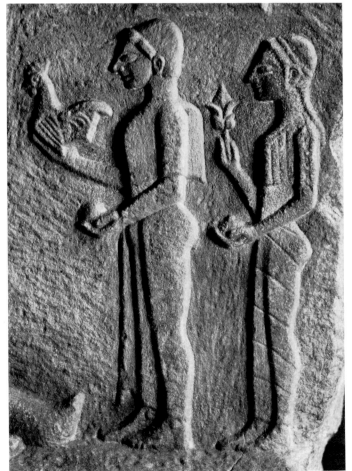

Fig. 288 (Berlin) 92

Figs. 289–290 (Berlin)

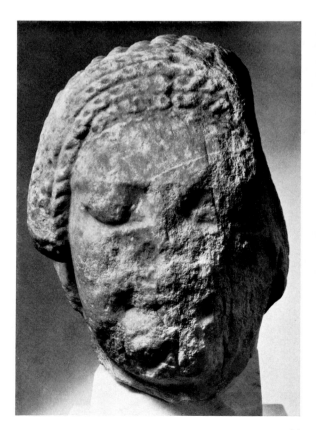

Figs. 291–292 (Berlin)

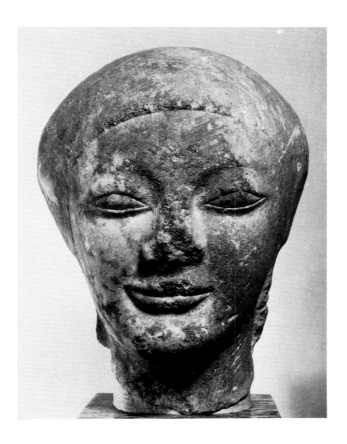

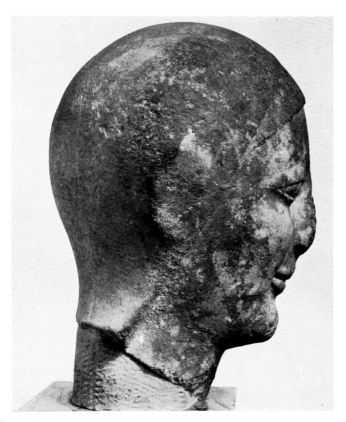

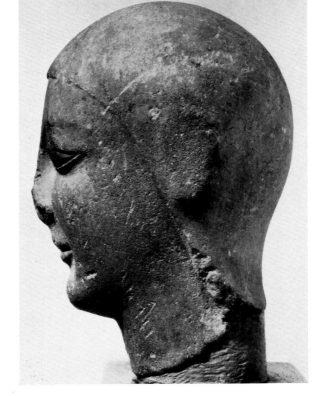

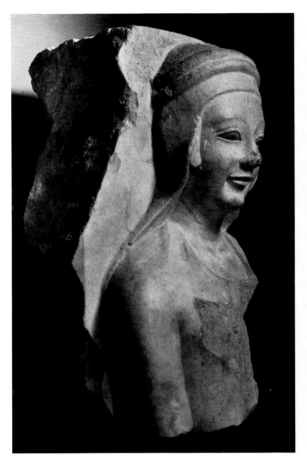
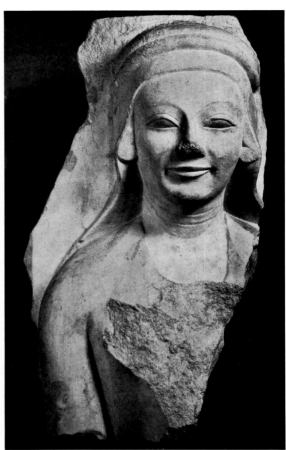

Figs. 296–297 (Berlin)

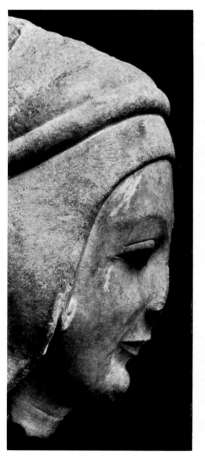
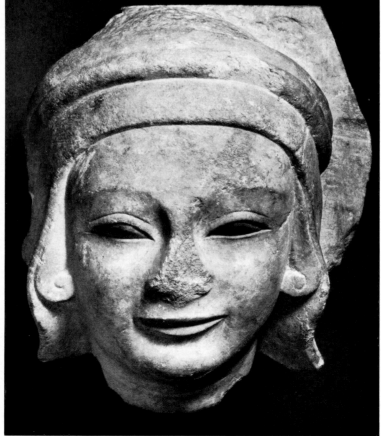
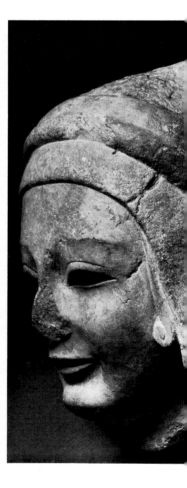

Figs. 298–300 (Berlin)

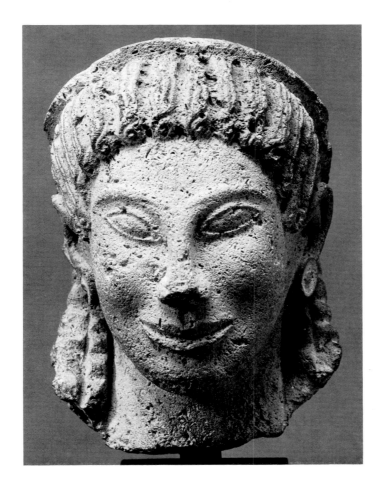

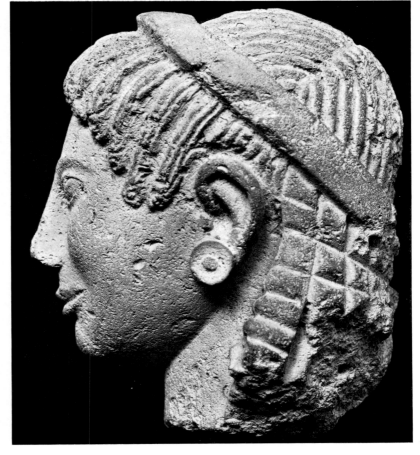

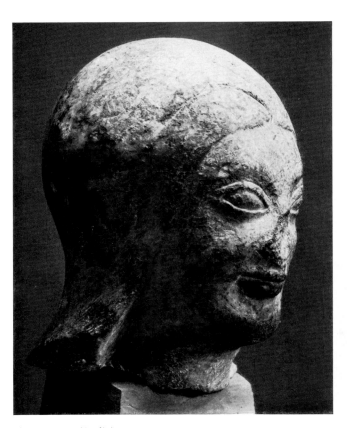
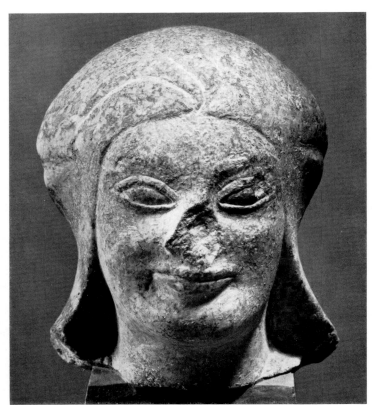

Figs. 304–305 (Berlin)

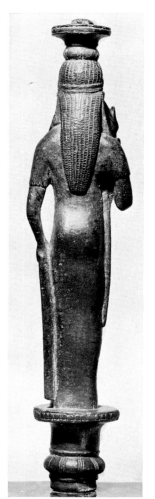
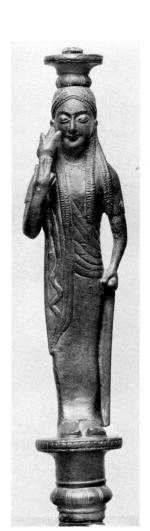
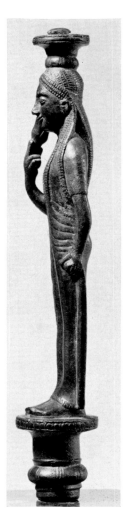

Figs. 306–308 (Berlin)

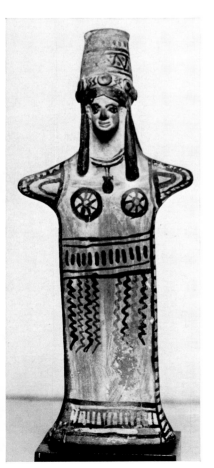
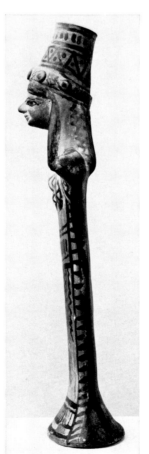
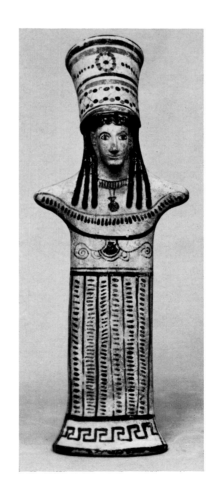
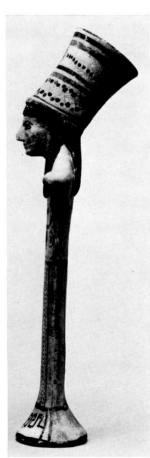

Figs. 309–312 (Berlin) 101

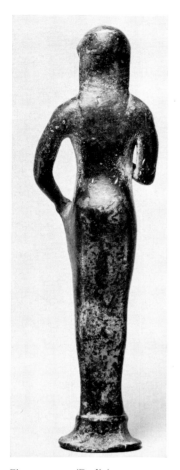
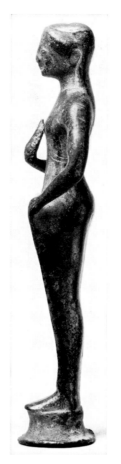
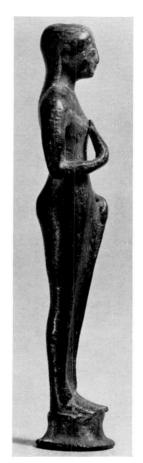
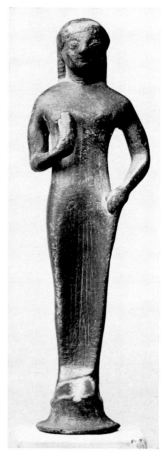

Figs. 313–314 (British Museum) 102 Figs. 315–316 (Louvre) 103

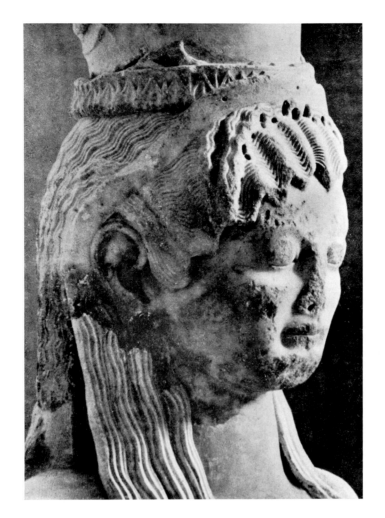

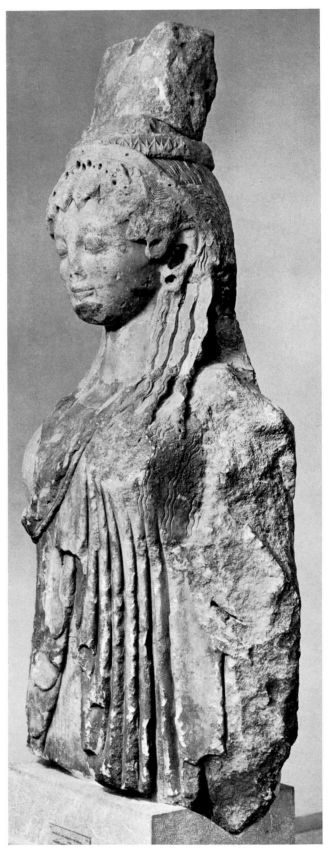

Figs. 317–318 (Delphi)

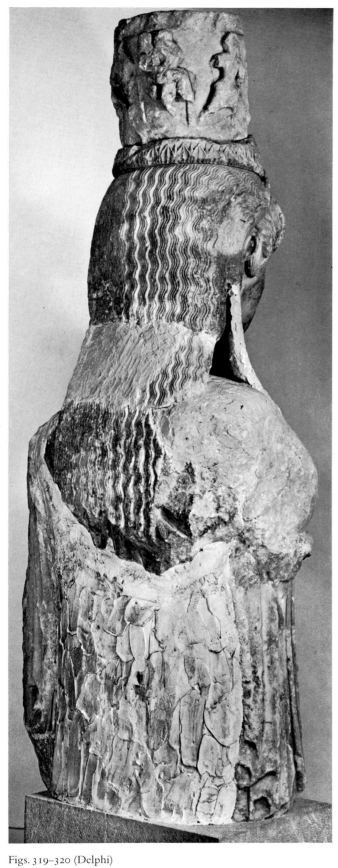
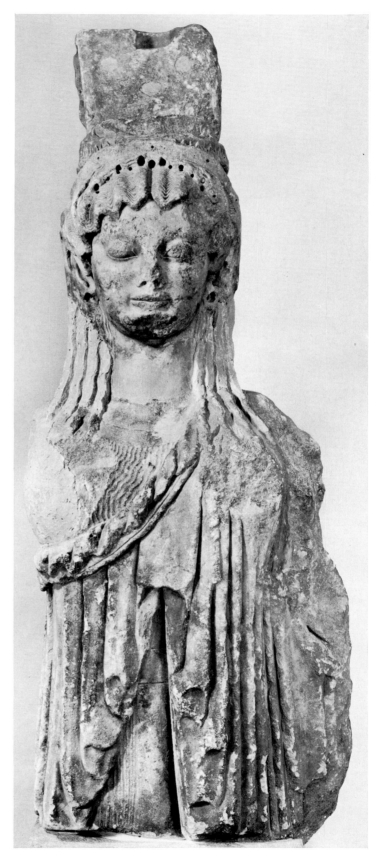

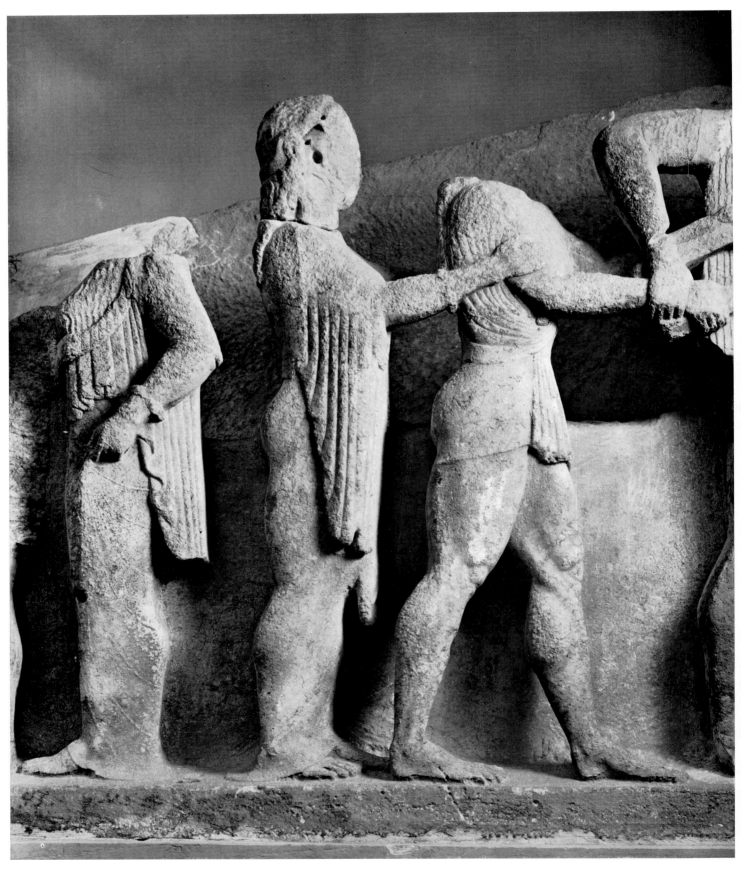

Fig. 321 (Delphi)

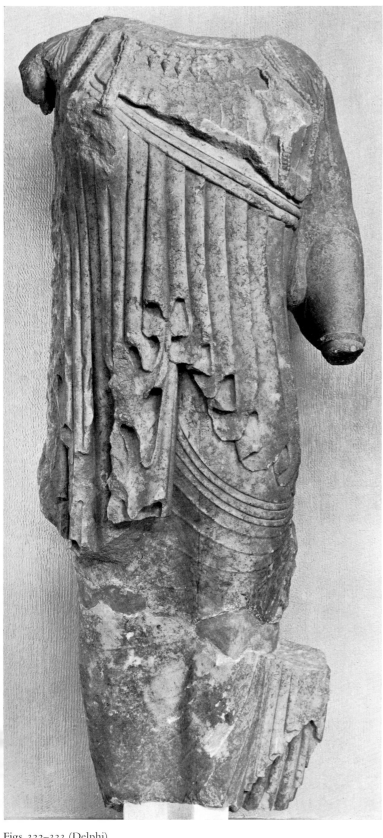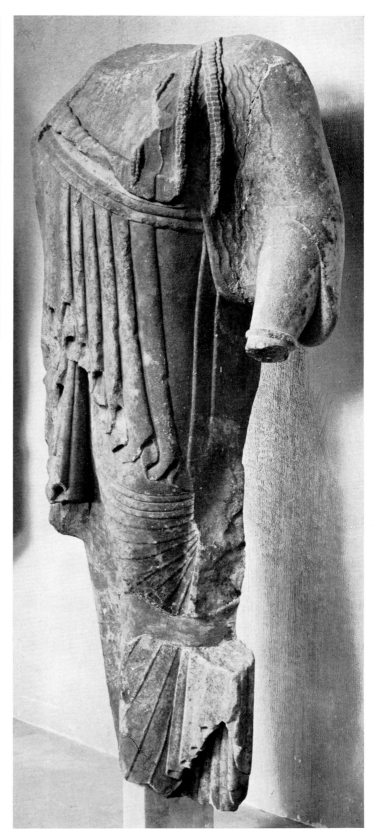

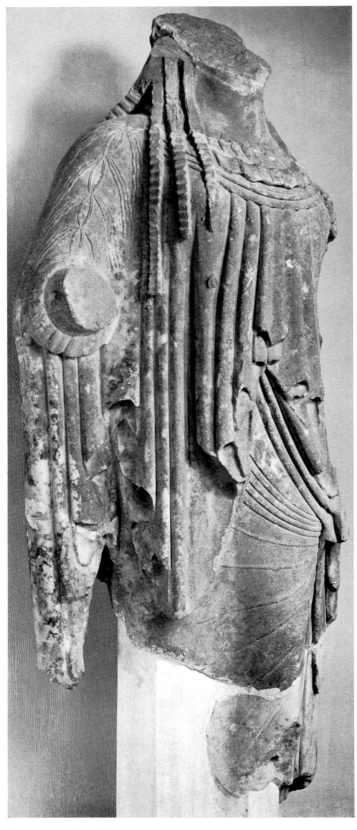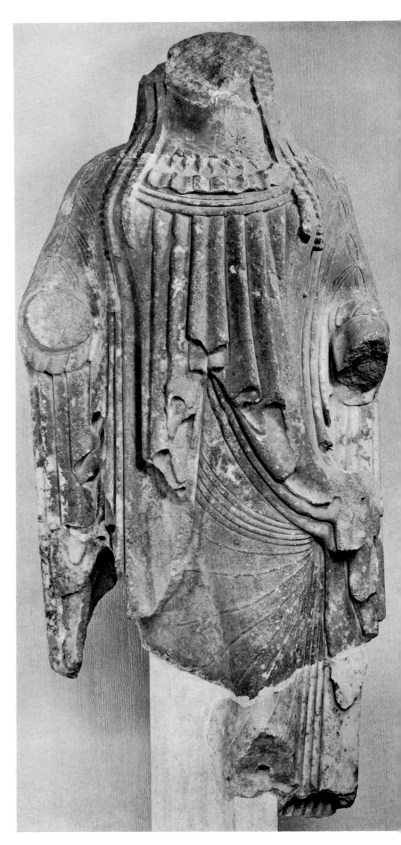

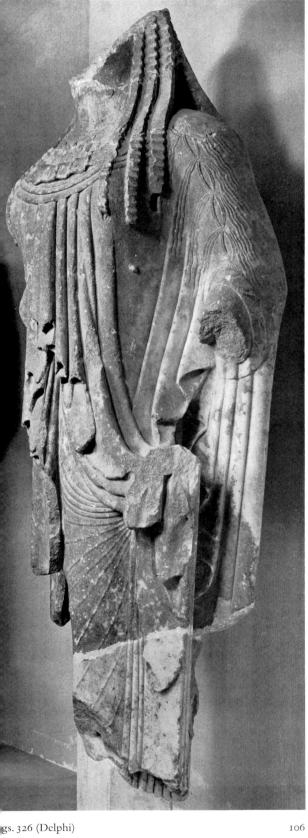

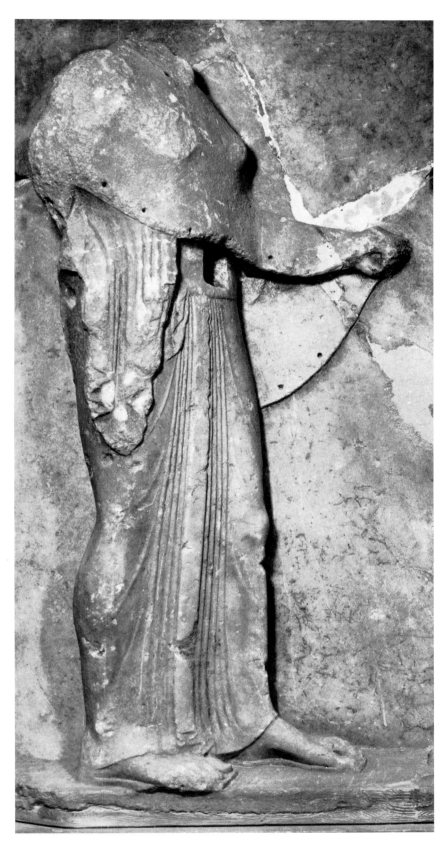

Figs. 326 (Delphi) 106 Fig. 327 (Delphi) 108

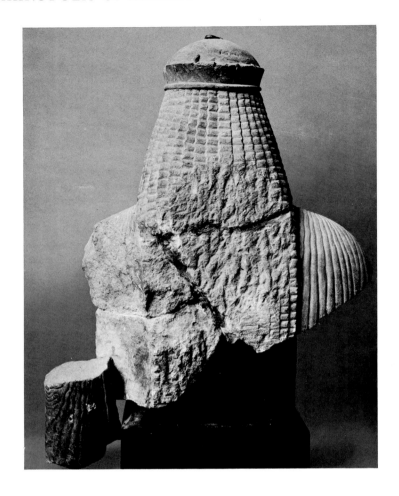

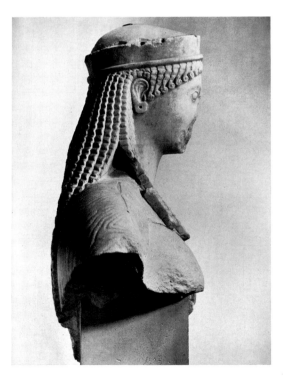

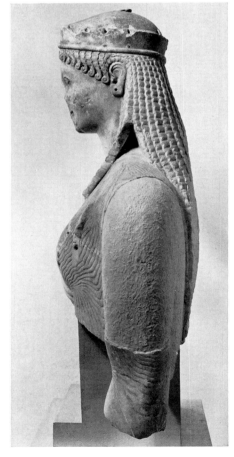

Figs. 328–330 (Athens, Akropolis Museum, no. 669)

Fig. 331 V.2 KORAI FROM THE AKROPOLIS OF ATHENS

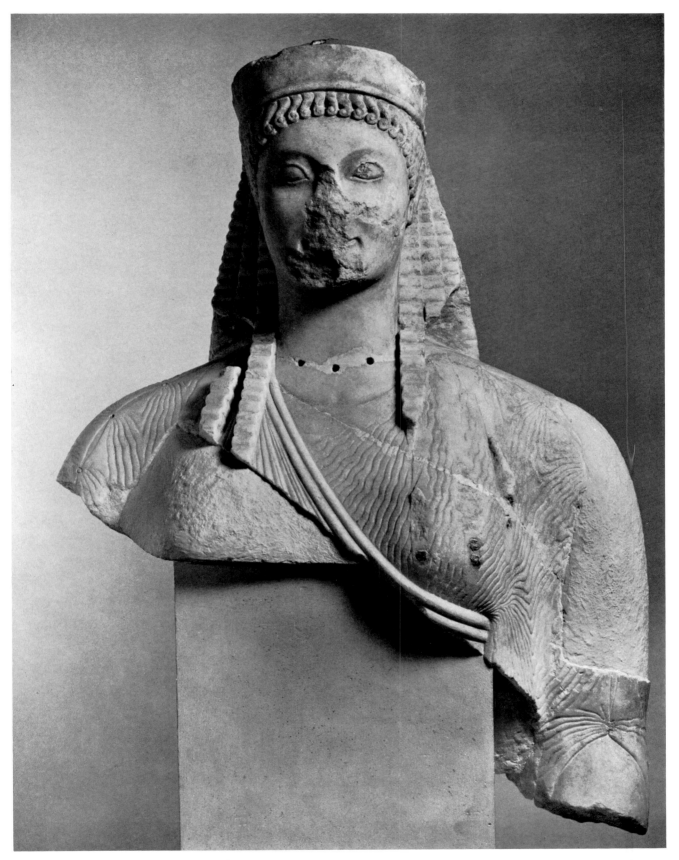

Fig. 331 (Athens, Akropolis Museum, no. 669)

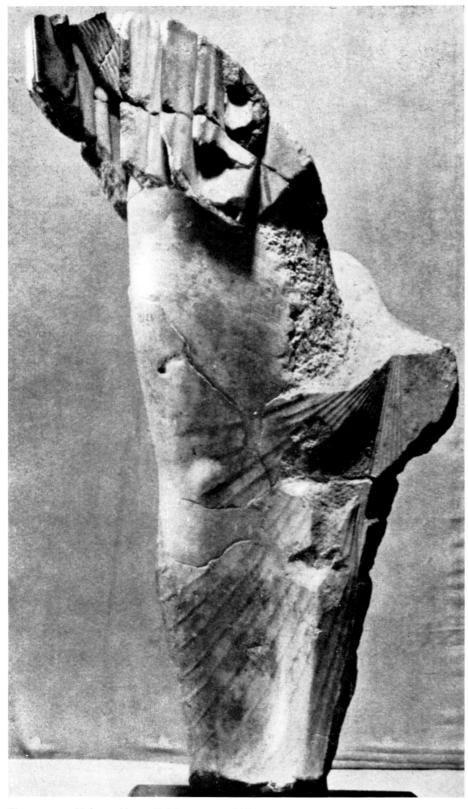
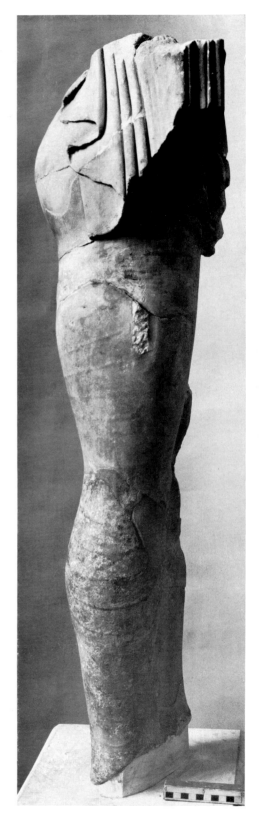

Figs. 332–333 (Athens, Akropolis Museum, no. 669)

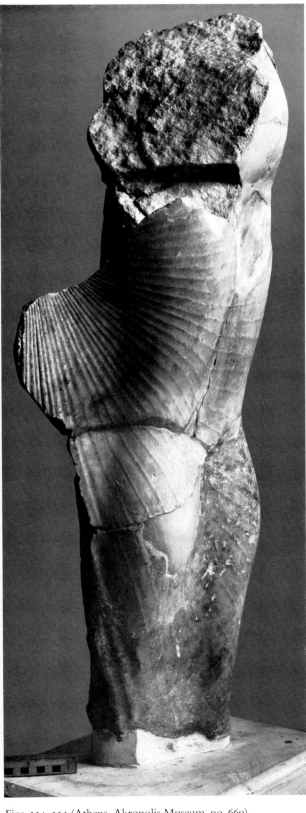

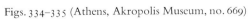

Figs. 334–335 (Athens, Akropolis Museum, no. 669)

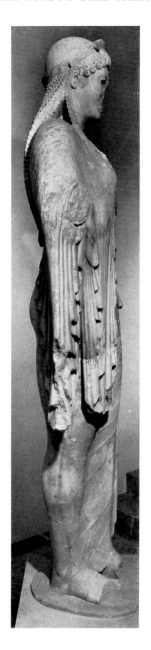
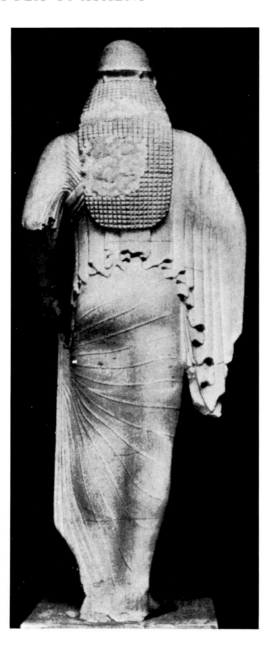
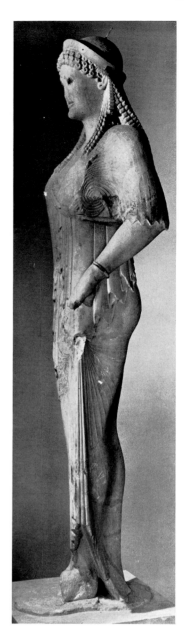

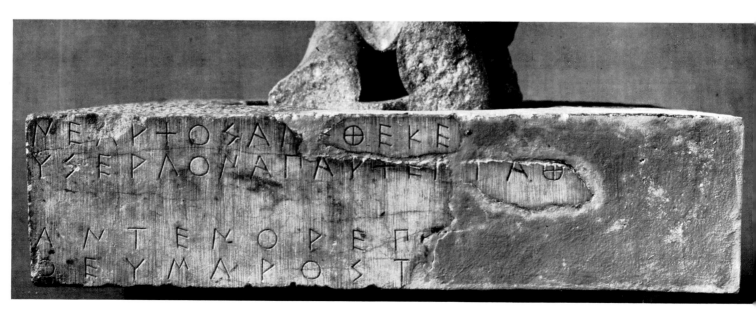

Figs. 336–339 (Athens, Akropolis Museum, no. 681): The Antenor Kore

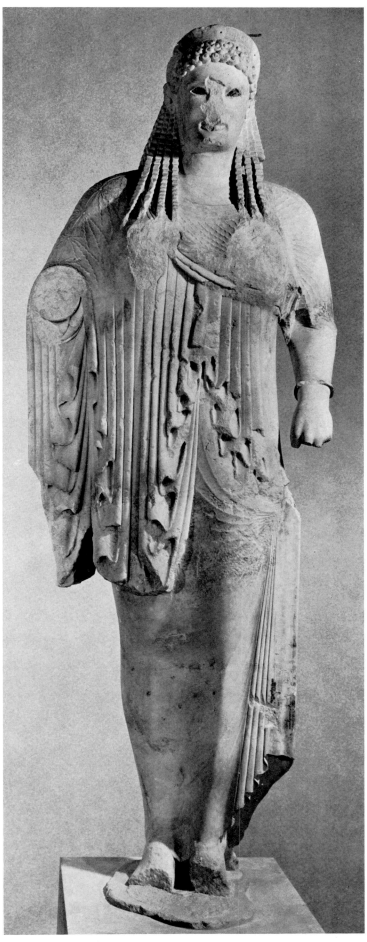

Fig. 340 (Athens, Akropolis Museum, no. 678) 110

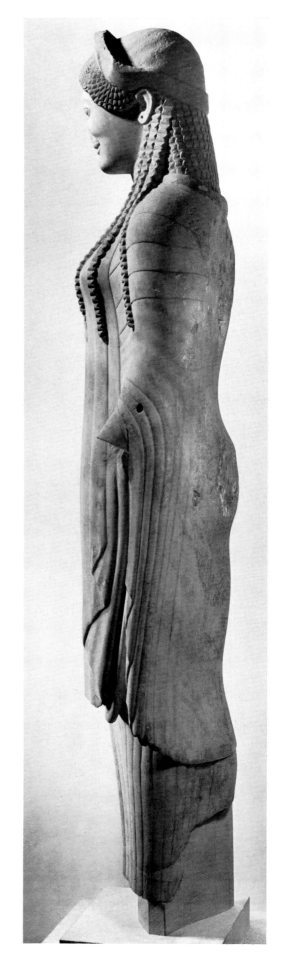

Figs. 341–342 (Athens, Akropolis Museum, no. 671)

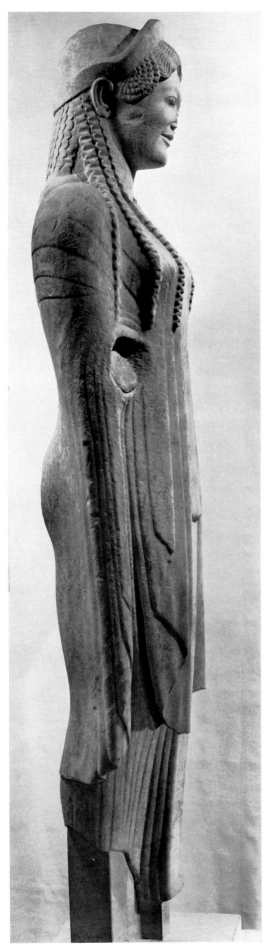
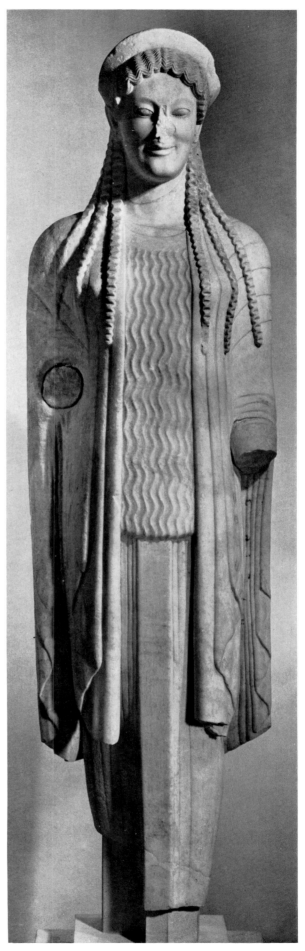

Figs. 343–344 (Athens, Akropolis Museum, no. 671)

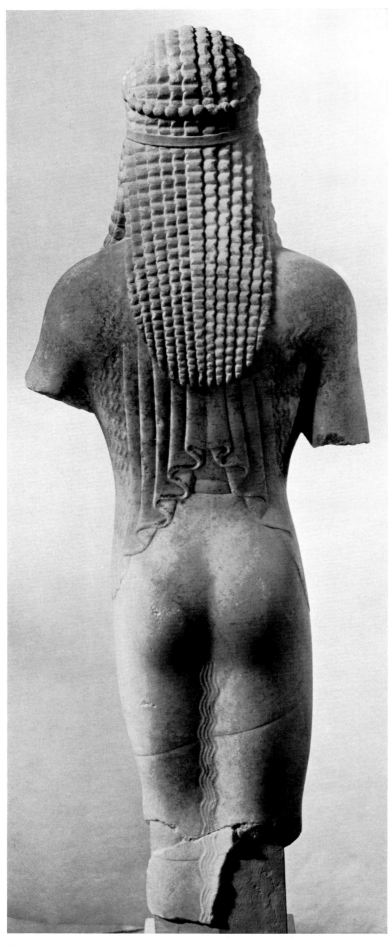

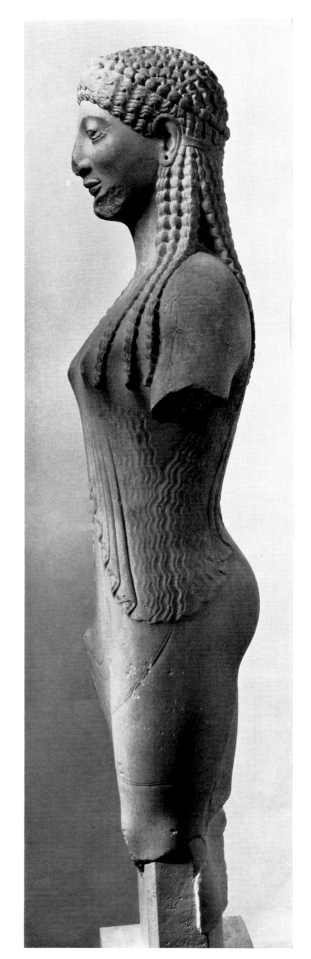

Figs. 345–346 (Athens, Akropolis Museum, no. 678)

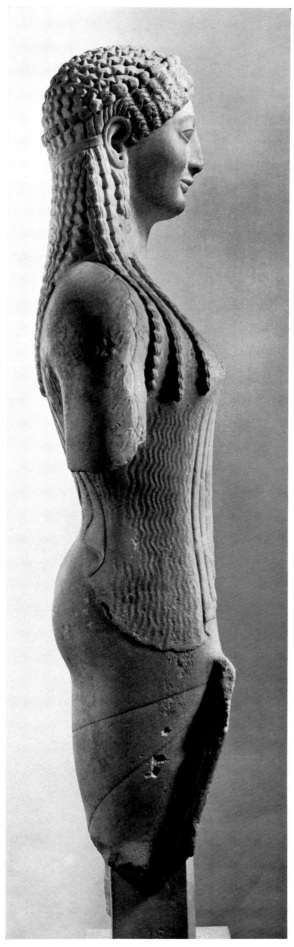
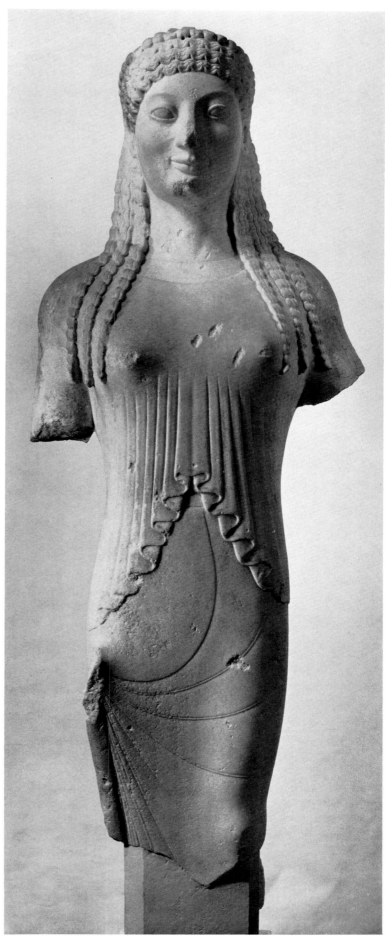

Figs. 347-348 (Athens, Akropolis Museum, no. 678)

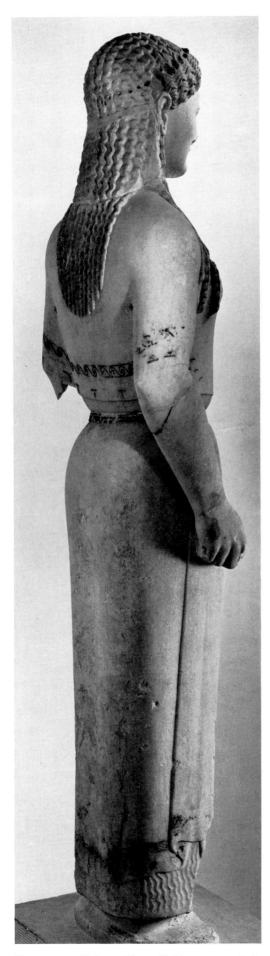
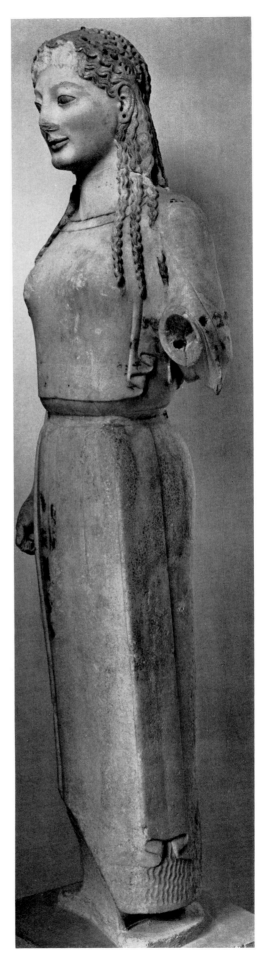

Figs. 349–350 (Athens, Akropolis Museum, no. 679)

Fig. 351 V.2 KORAI FROM THE AKROPOLIS OF ATHENS

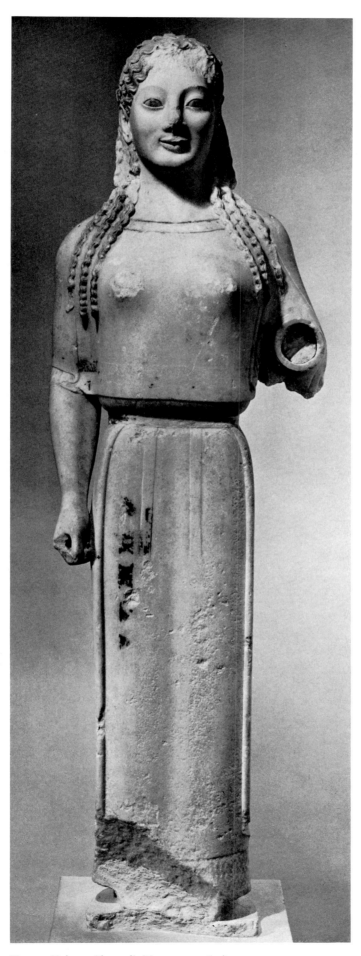

Fig. 351 (Athens, Akropolis Museum, no. 679) 113

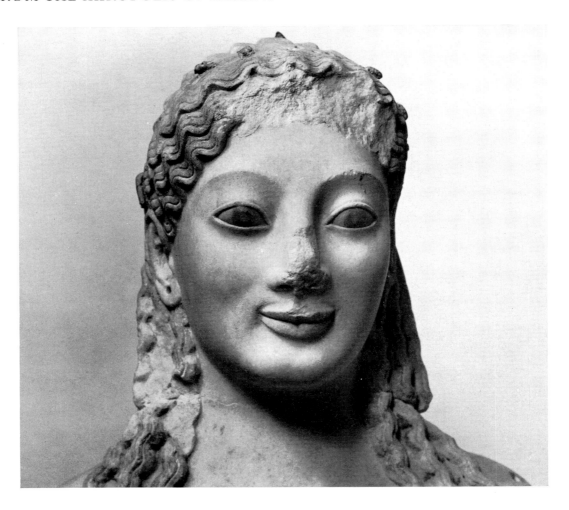

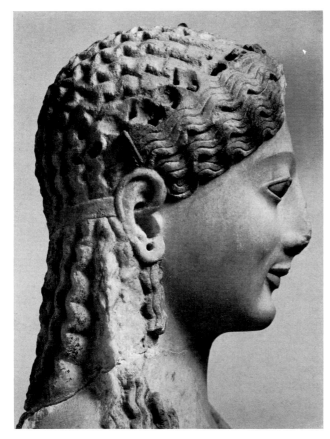

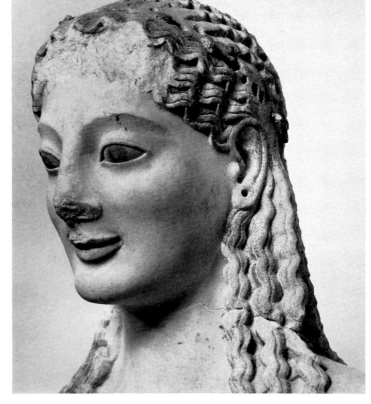

Figs. 352–354 (Athens, Akropolis Museum, no. 679)

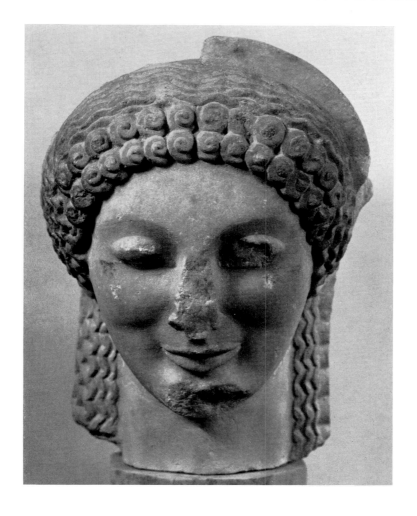

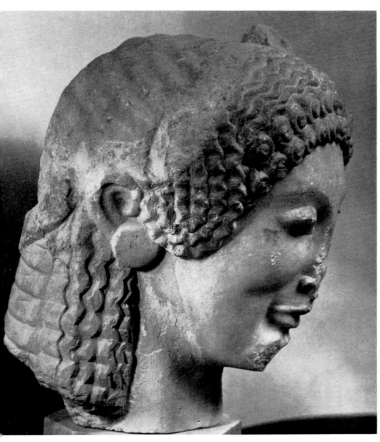

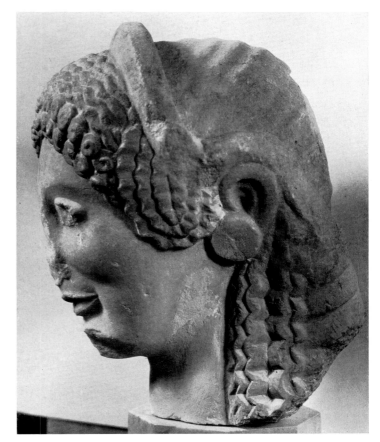

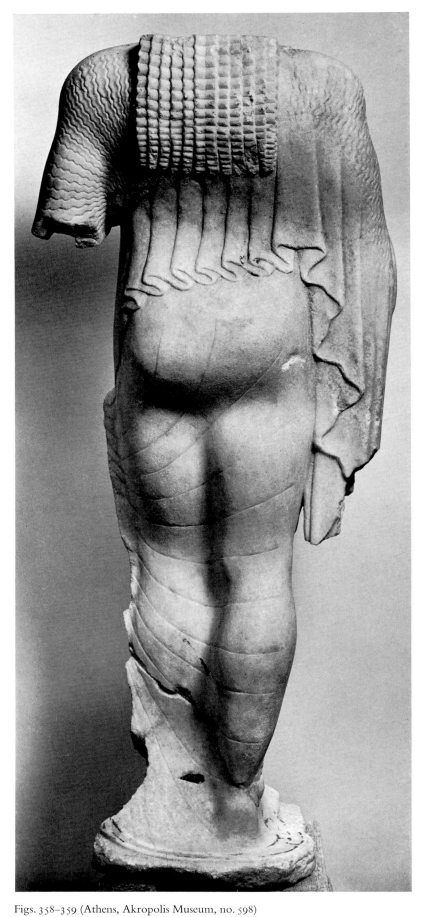
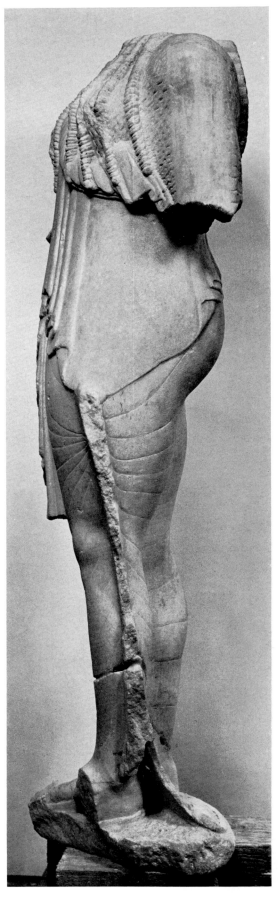

Figs. 358–359 (Athens, Akropolis Museum, no. 598)

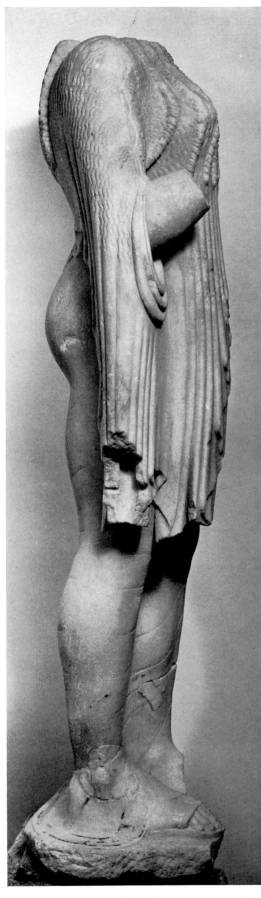
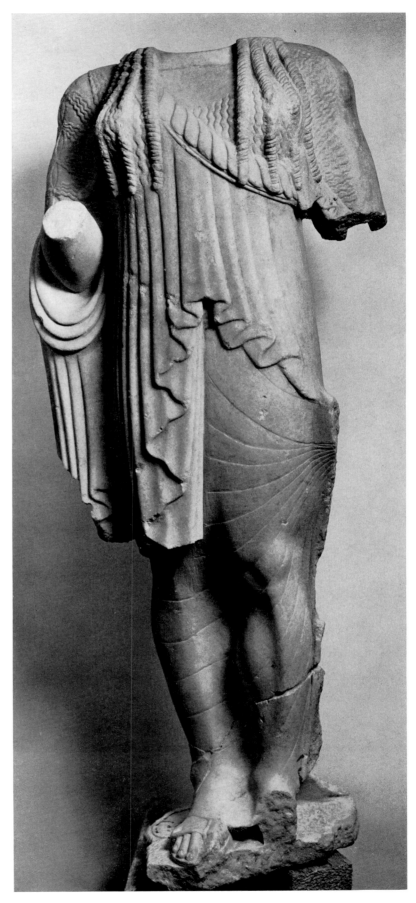

Figs. 360–361 (Athens, Akropolis Museum, no. 598)

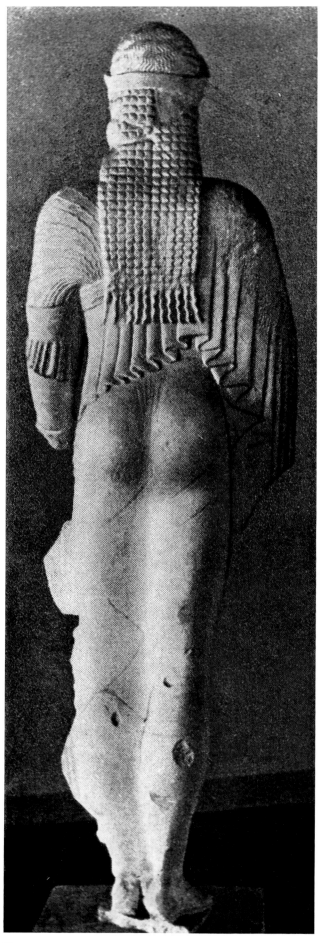

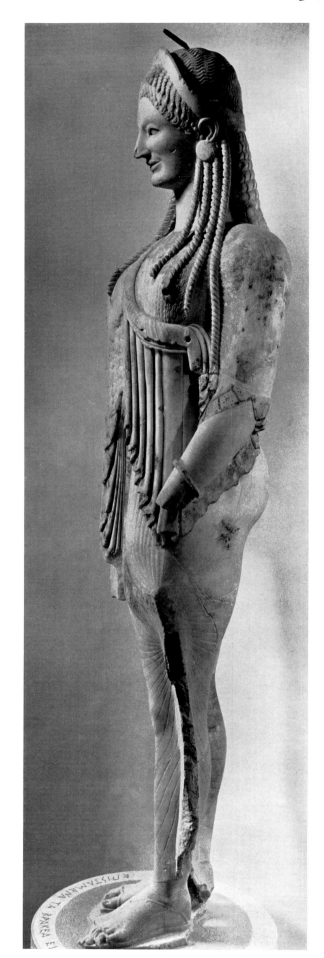

Figs. 362–363 (Athens, Akropolis Museum, no. 682)

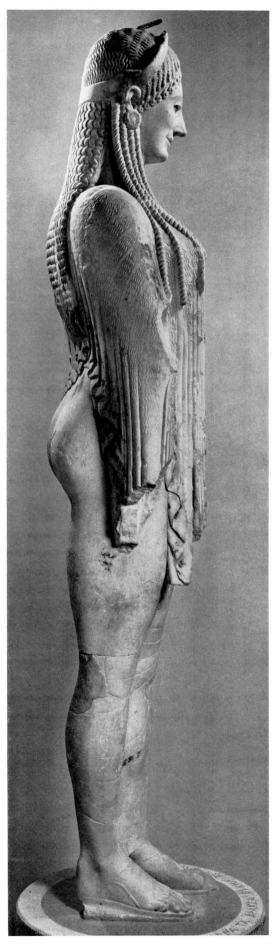
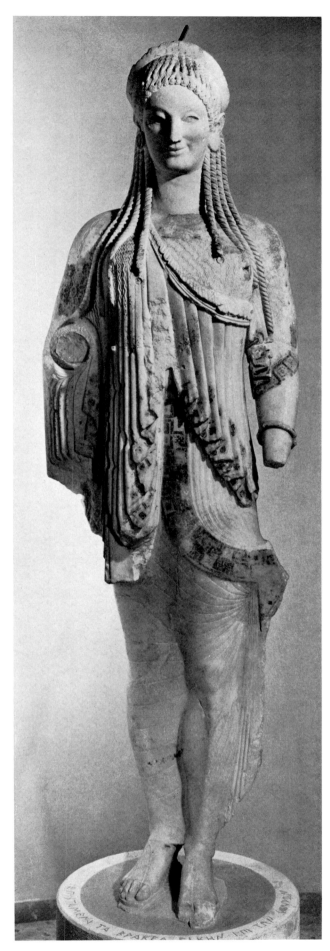

Figs. 364–365 (Athens, Akropolis Museum, no. 682) 116

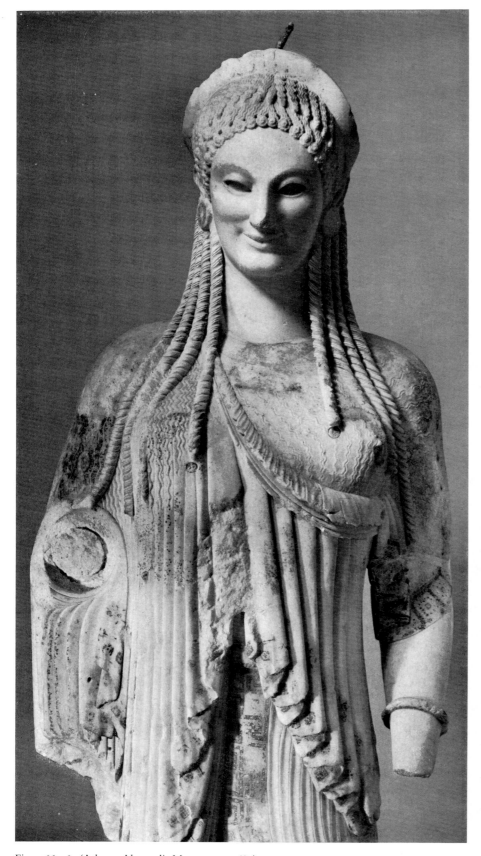
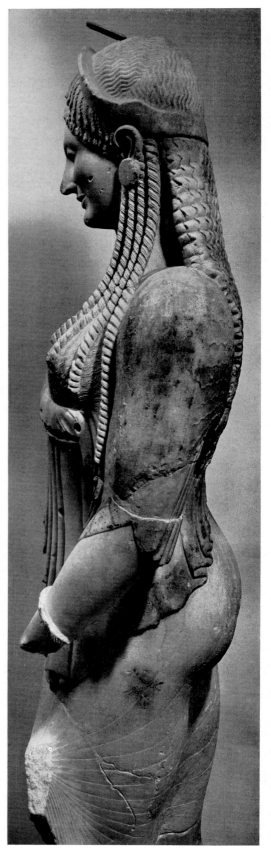

Figs. 366–367 (Athens, Akropolis Museum, no. 682)

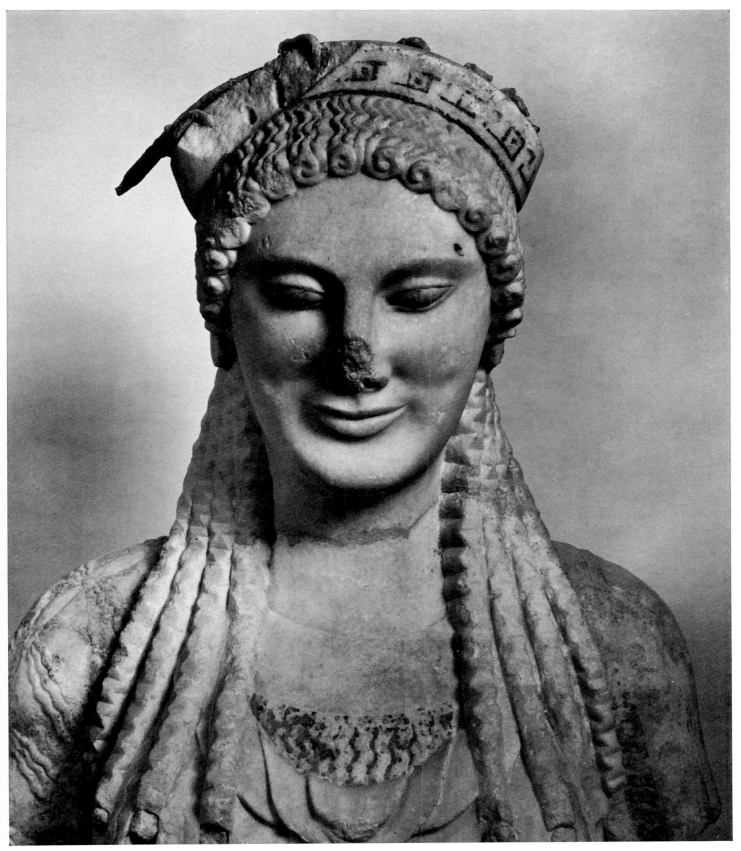

Fig. 368 (Athens, Akropolis Museum, no. 673) 117

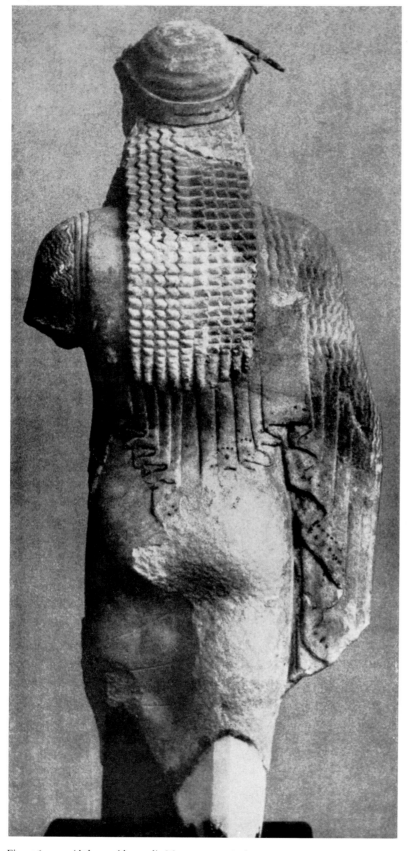
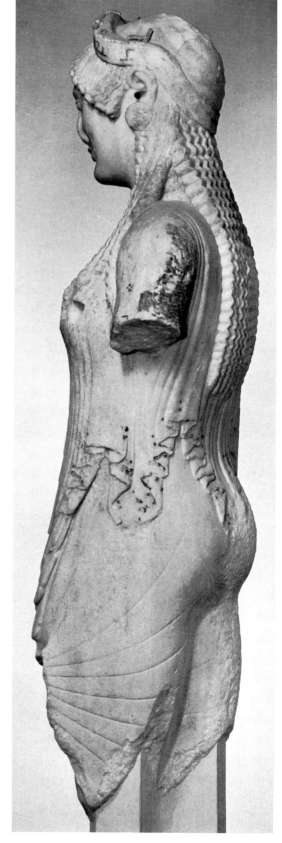

Figs. 369–370 (Athens, Akropolis Museum, no. 673)

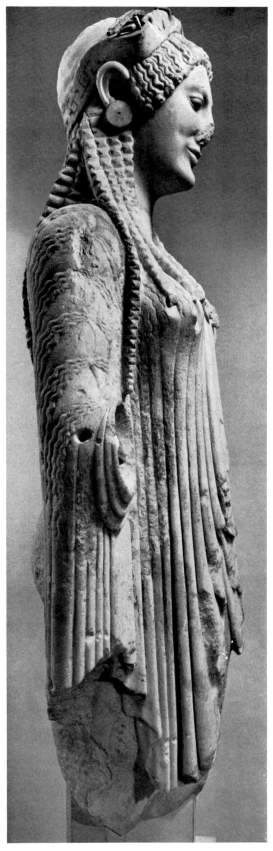

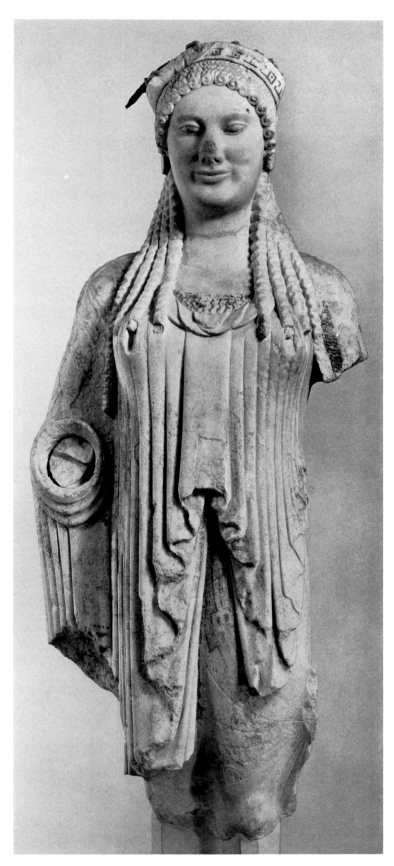

Figs. 371–372 (Athens, Akropolis Museum, no. 673)

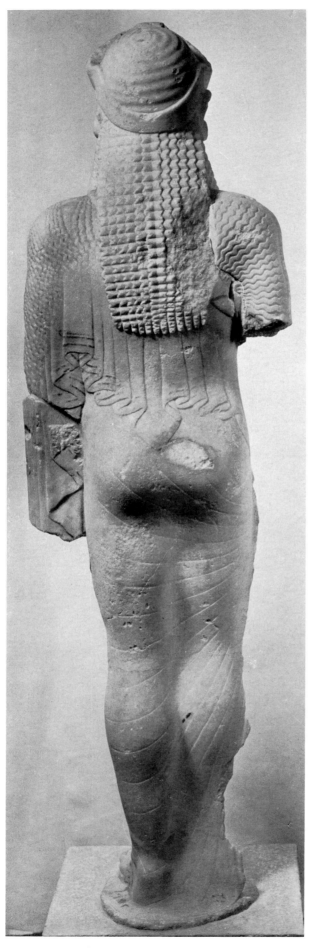

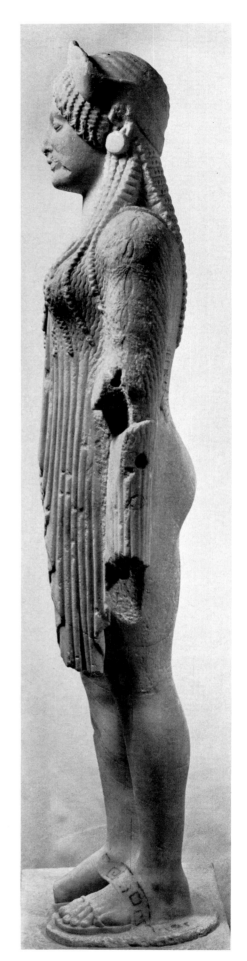

Figs. 373–374 (Athens, Akropolis Museum, no. 672)

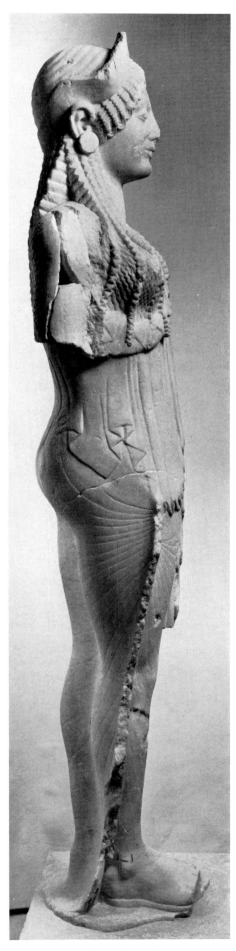
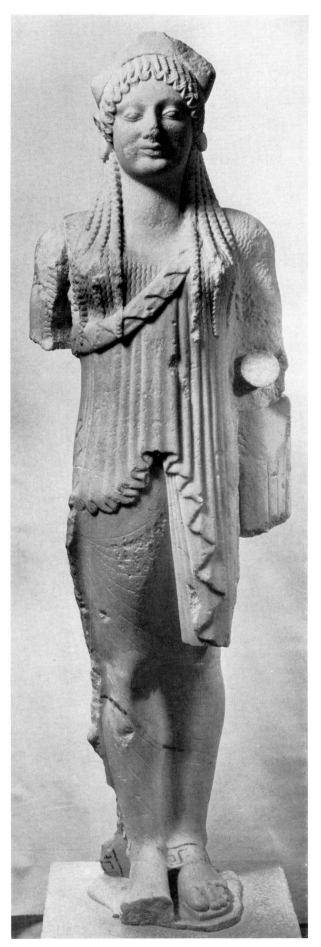

Figs. 375–376 (Athens, Akropolis Museum, no. 672)

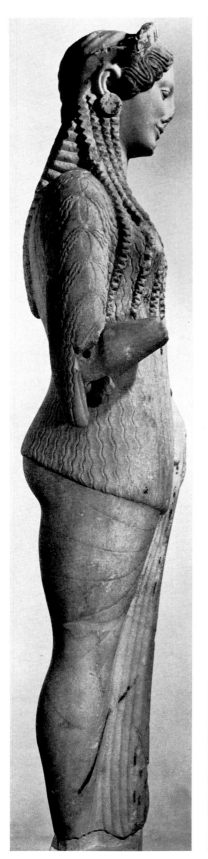
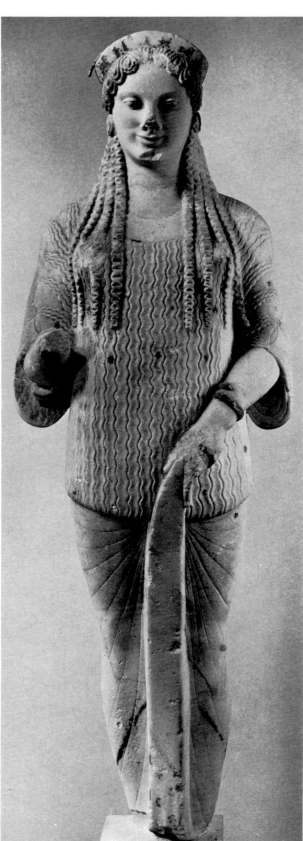
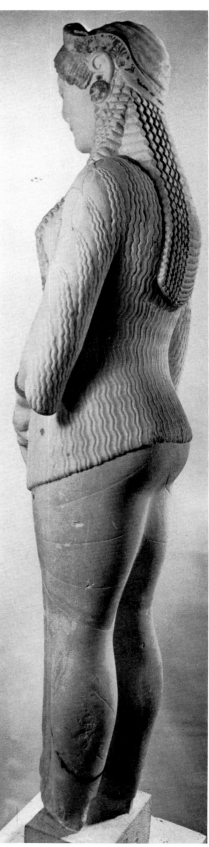

Figs. 377–379 (Athens, Akropolis Museum, no. 670)

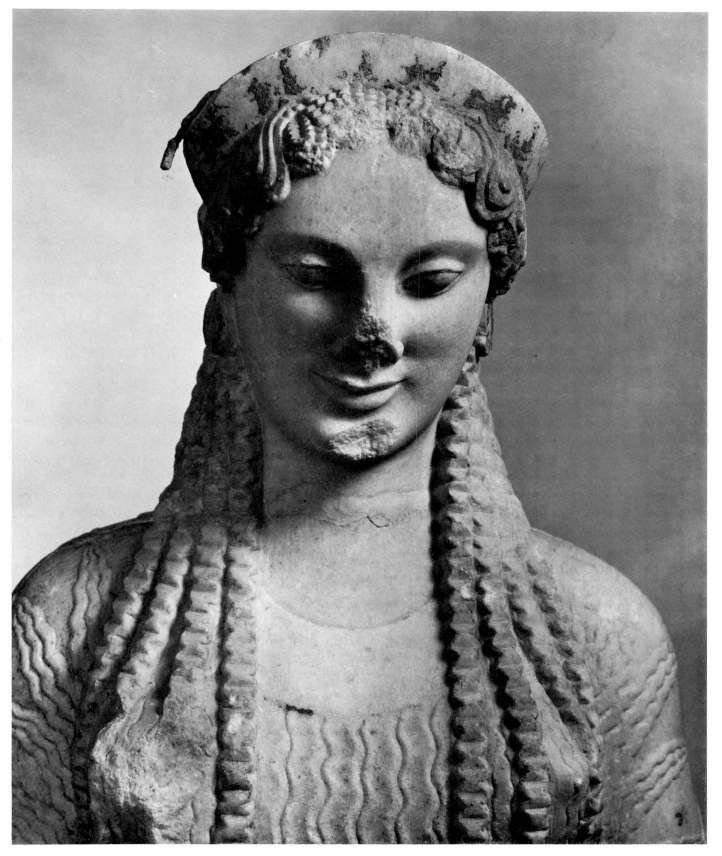

Fig. 380 (Athens, Akropolis Museum, no. 670)

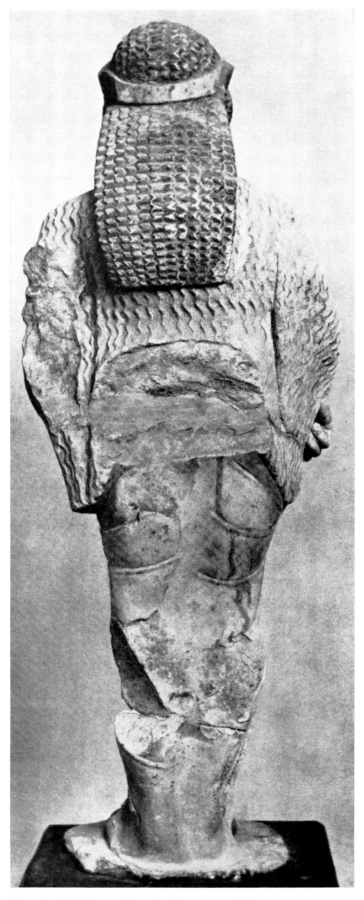

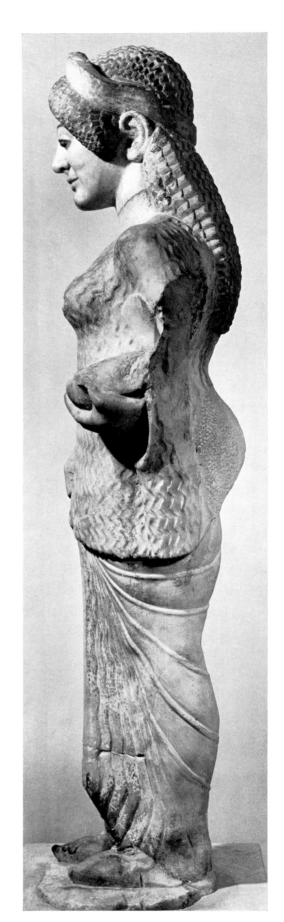

Figs. 381–382 (Athens, Akropolis Museum, no. 683)

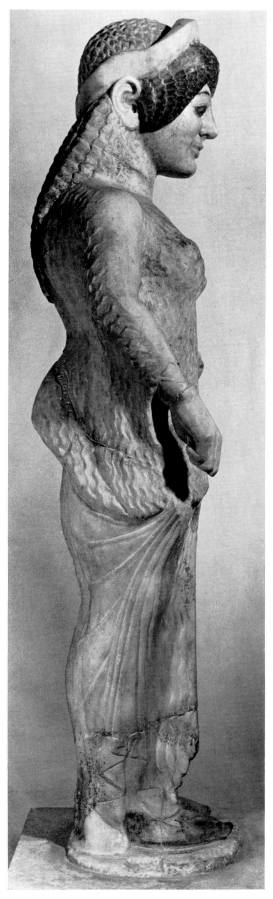
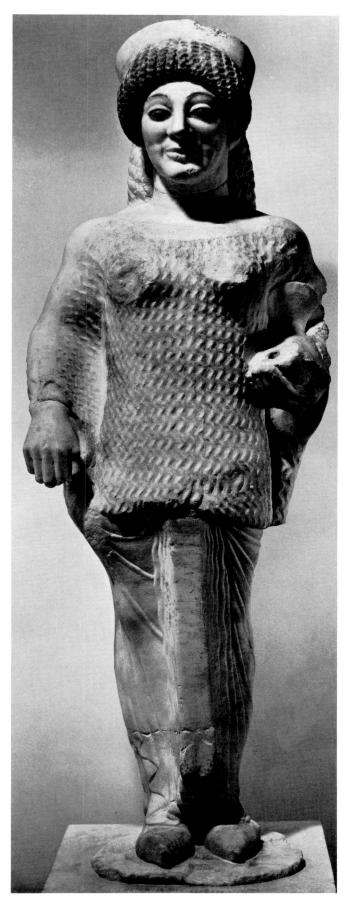

Figs. 383–384 (Athens, Akropolis Museum, no. 683)

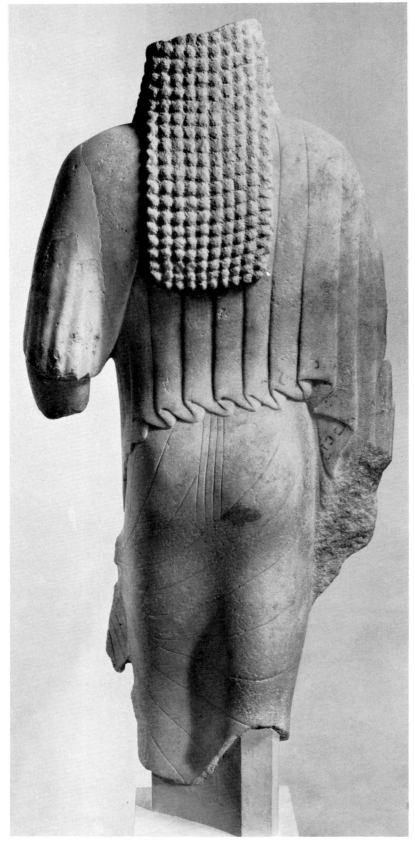

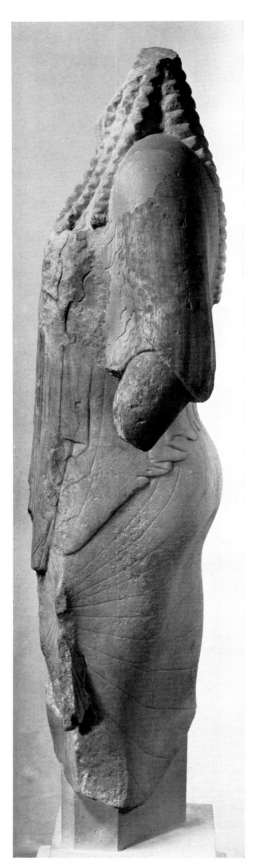

Figs. 385–386 (Athens, Akropolis Museum, no. 613)

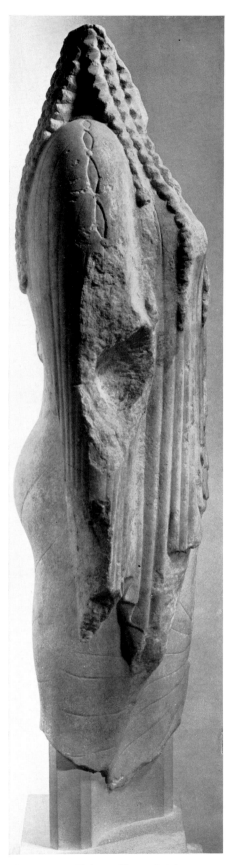
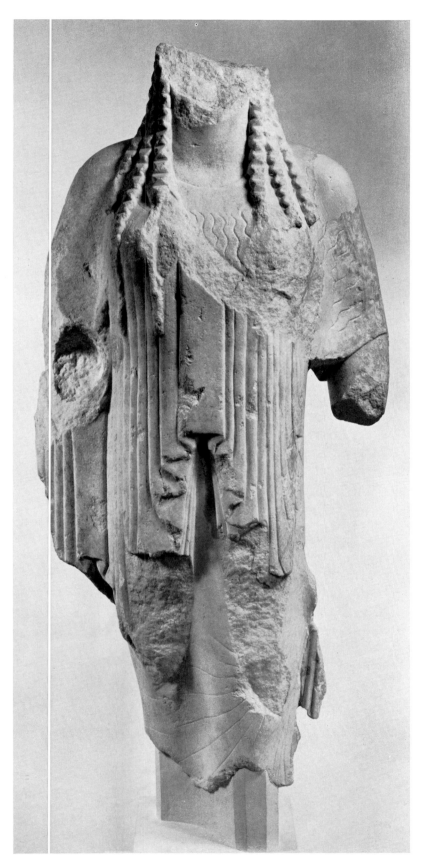

Figs. 387–388 (Athens, Akropolis Museum, no. 613)

Fig. 389

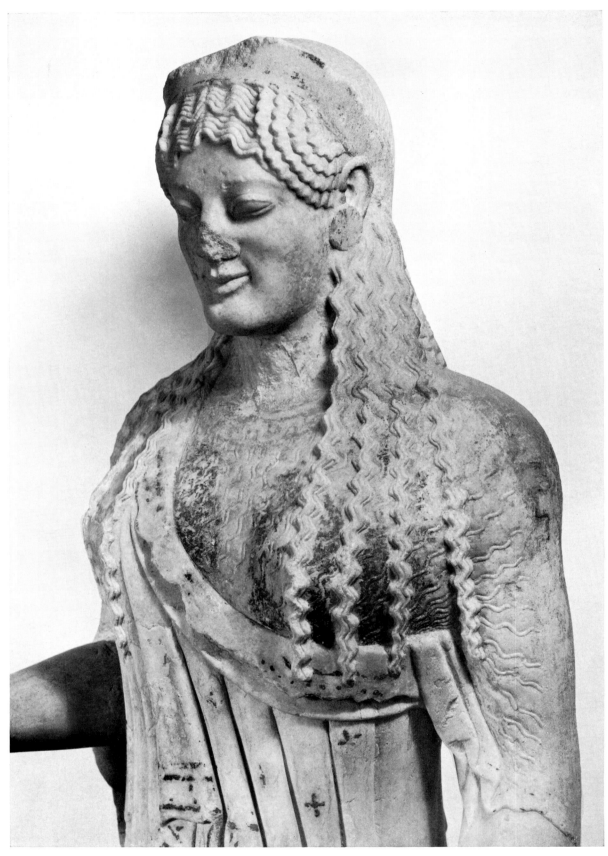

Fig. 389 (Athens, Akropolis Museum, no. 680)

Fig. 390　　　　　　　　　　　　　　　　　　　　　　　V.2 KORAI FROM THE AKROPOLIS OF ATHENS

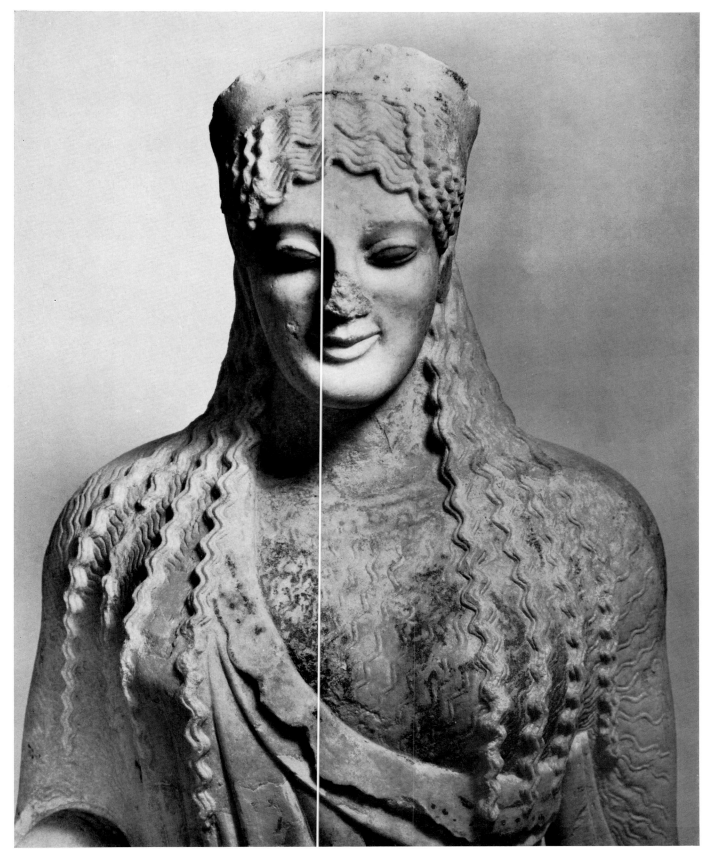

Fig. 390 (Athens, Akropolis Museum, no. 680)

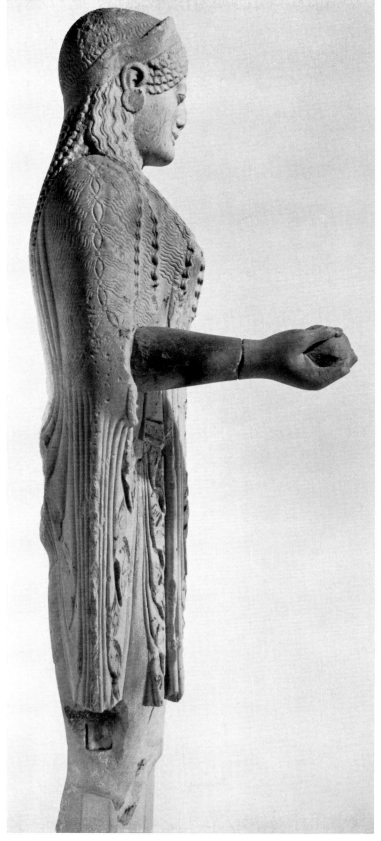
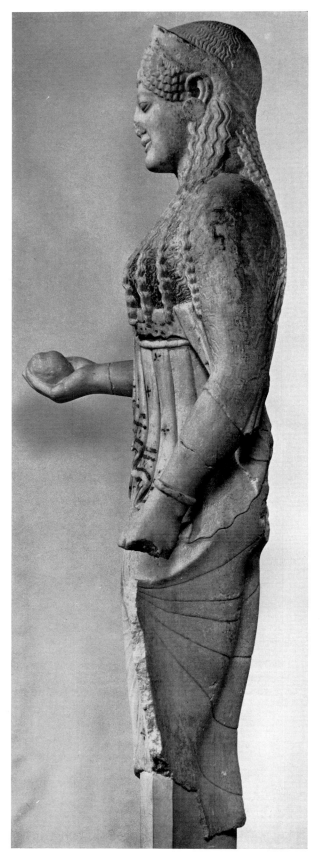

Figs. 391–392 (Athens, Akropolis Museum, no. 680)

Fig. 393 V.2 KORAI FROM THE AKROPOLIS OF ATHENS

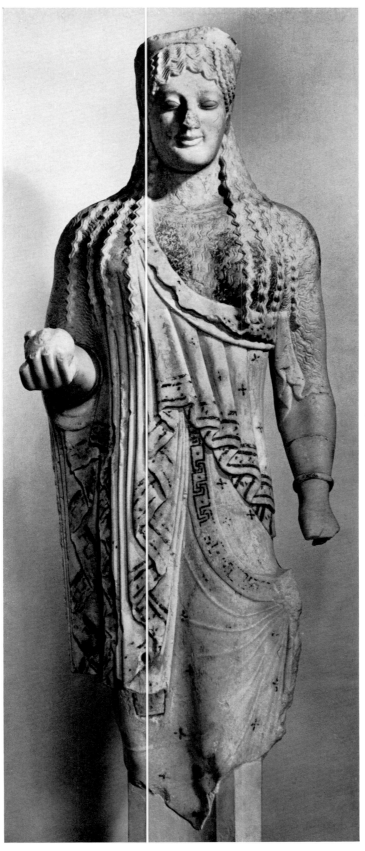

Fig. 393 (Athens, Akropolis Museum, no. 680)

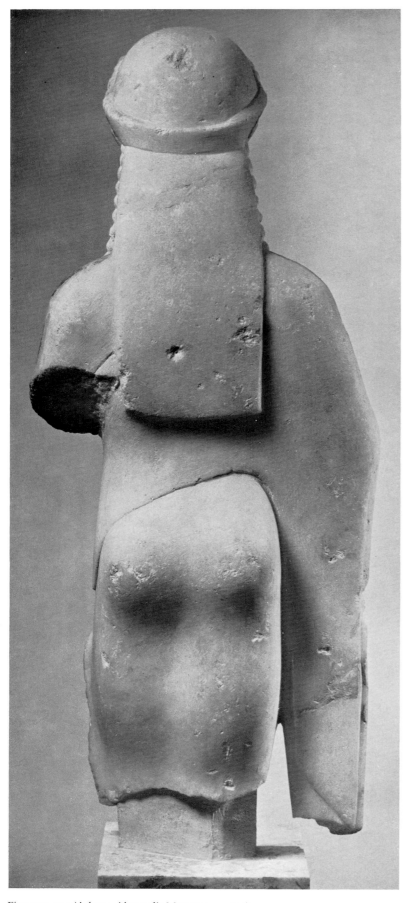

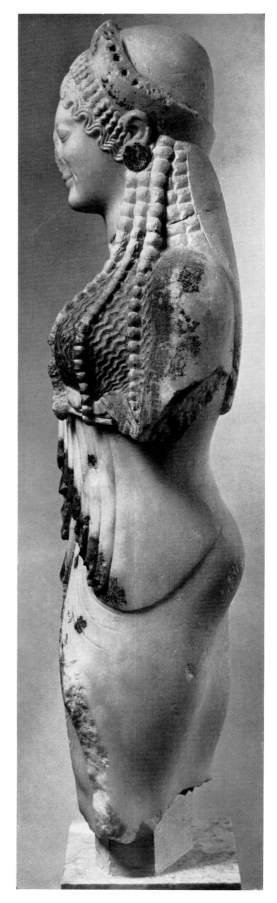

Figs. 394–395 (Athens, Akropolis Museum, no. 675)

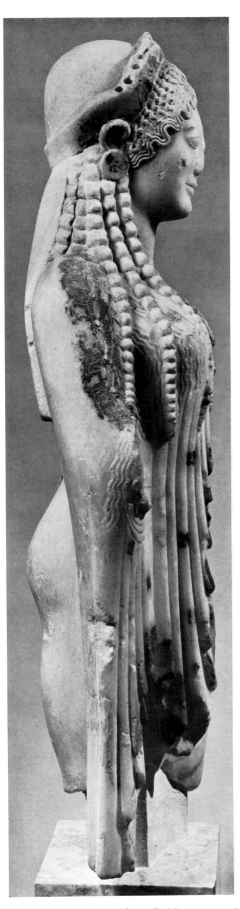

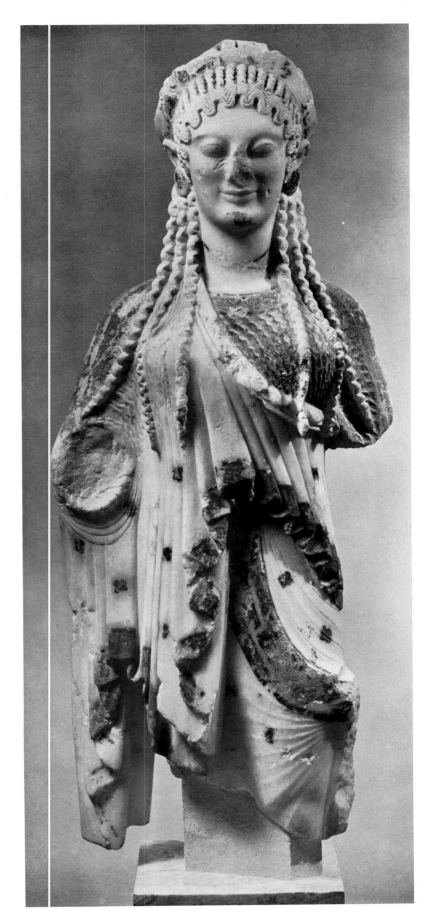

Figs. 396–397 (Athens, Akropolis Museum, no. 675)

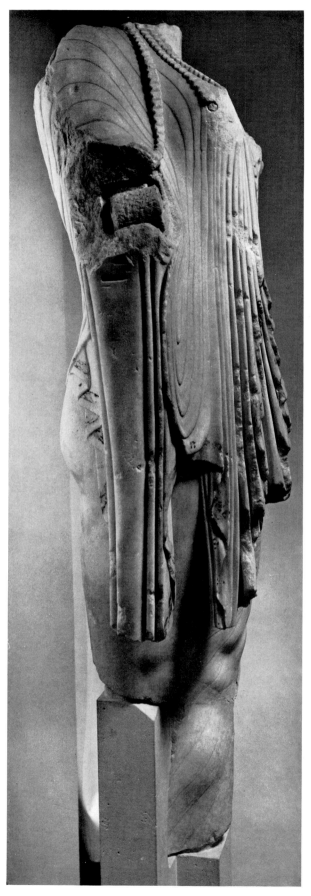
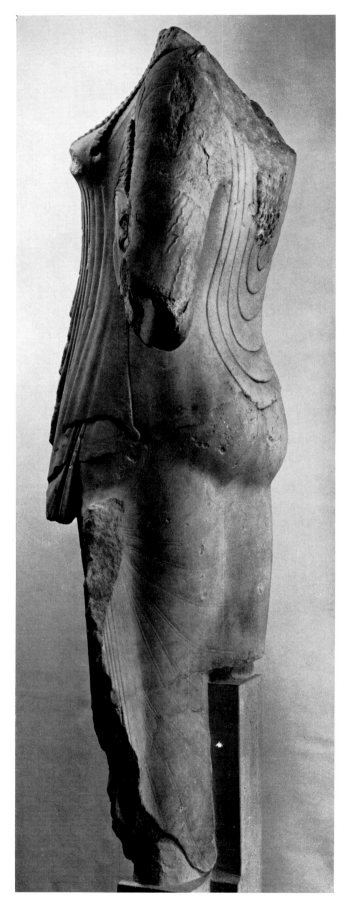

Figs. 398–399 (Athens, Akropolis Museum, no. 594)

Fig. 400 V.2 KORAI FROM THE AKROPOLIS OF ATHENS

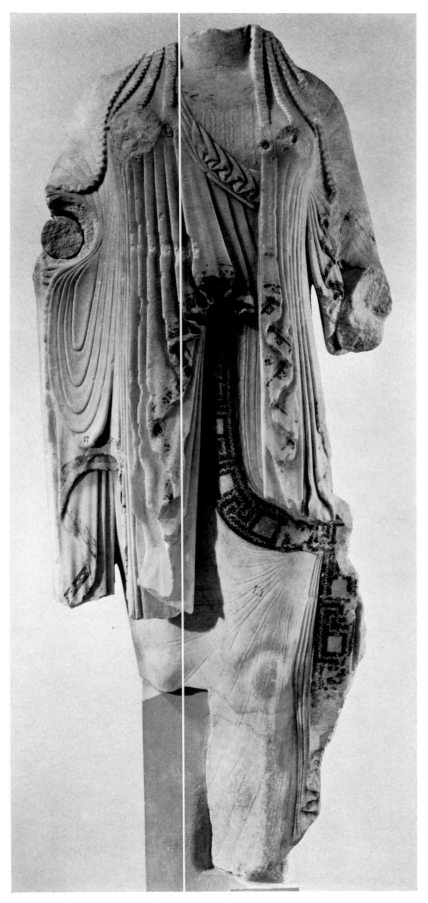

Fig. 400 (Athens, Akropolis Museum, no. 594)

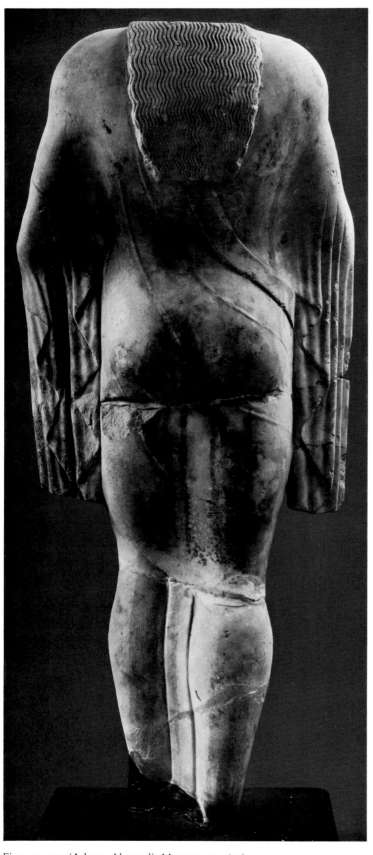

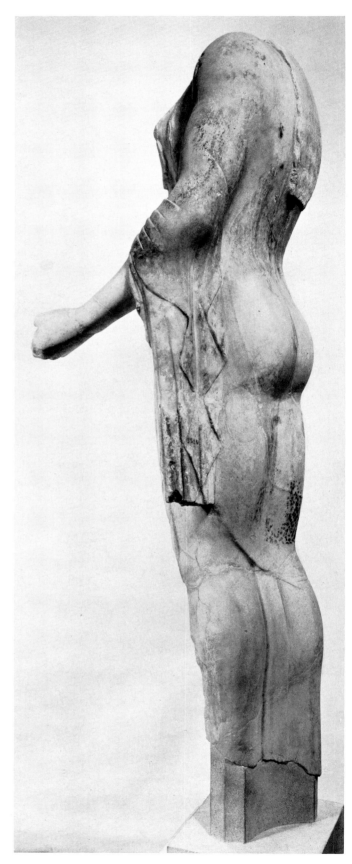

Figs. 401–402 (Athens, Akropolis Museum, no. 615)

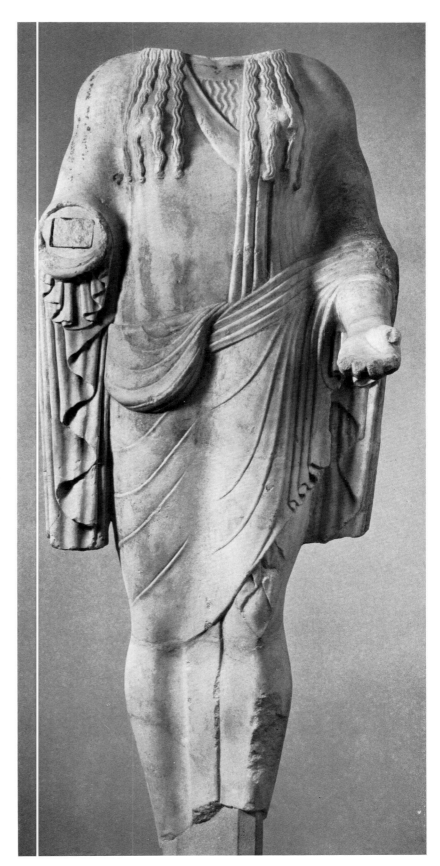

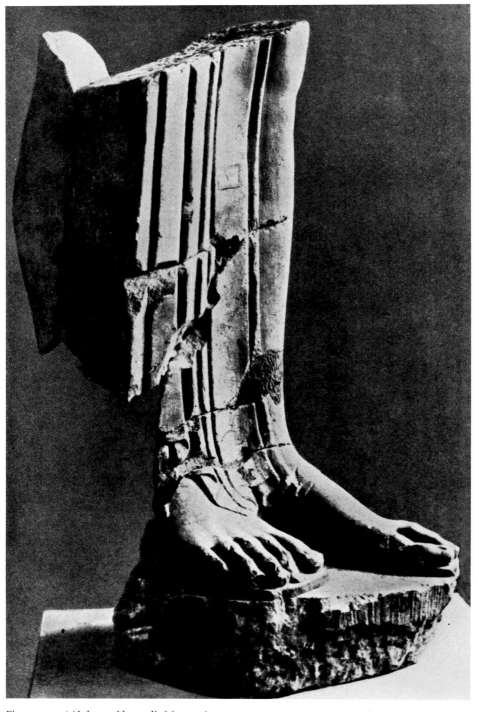
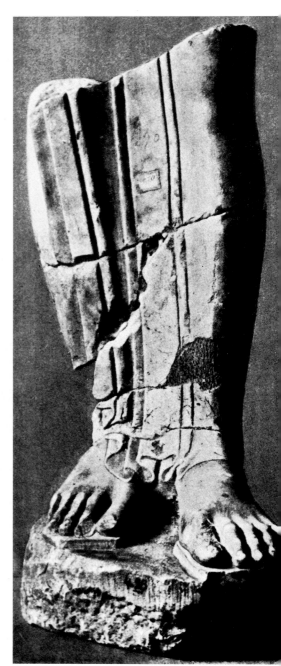

Figs. 405–406 (Athens, Akropolis Museum)

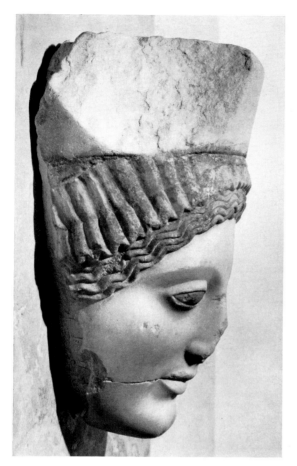

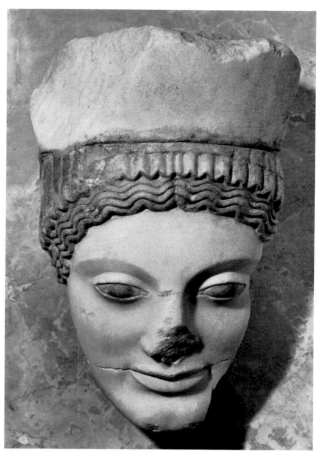

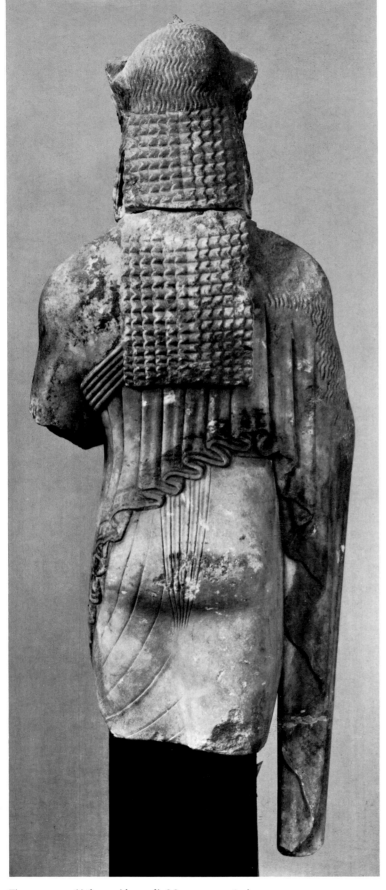

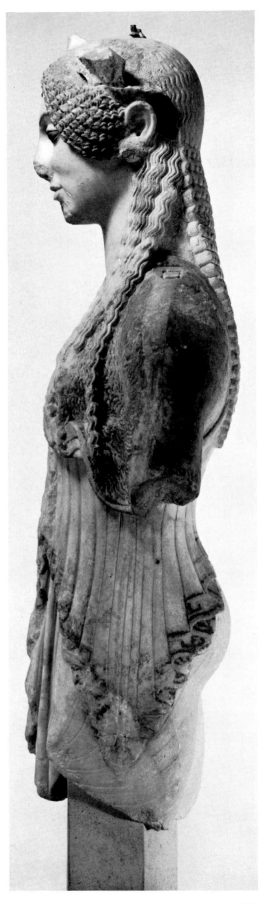

Figs. 411–412 (Athens, Akropolis Museum, no. 674)

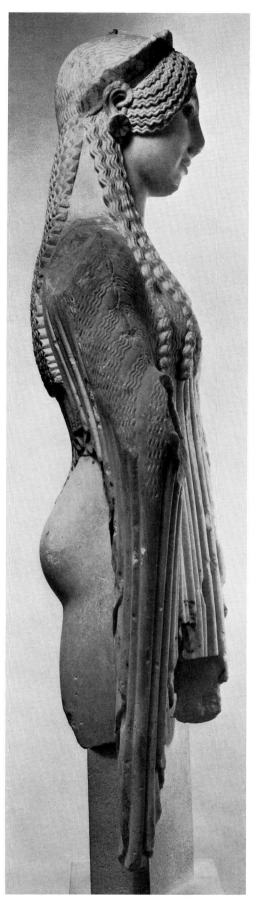
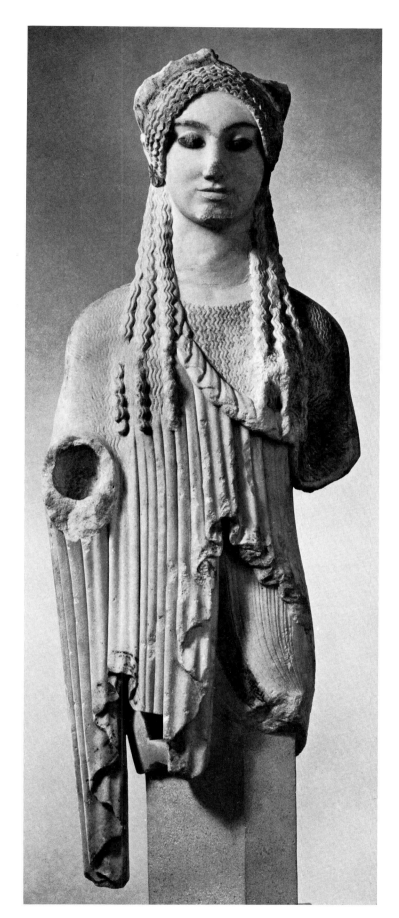

Figs. 413–414 (Athens, Akropolis Museum, no. 674)

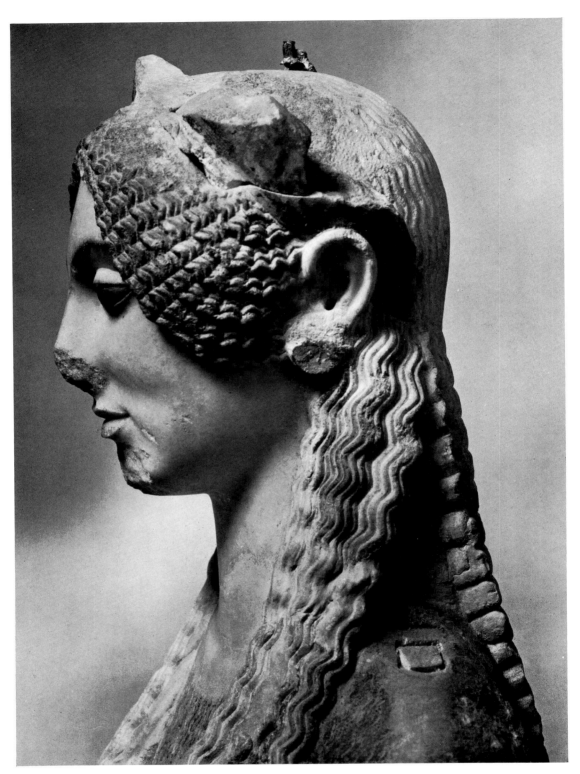

Fig. 415 (Athens, Akropolis Museum, no. 674)

Fig. 416 V.2 KORAI FROM THE AKROPOLIS OF ATHENS

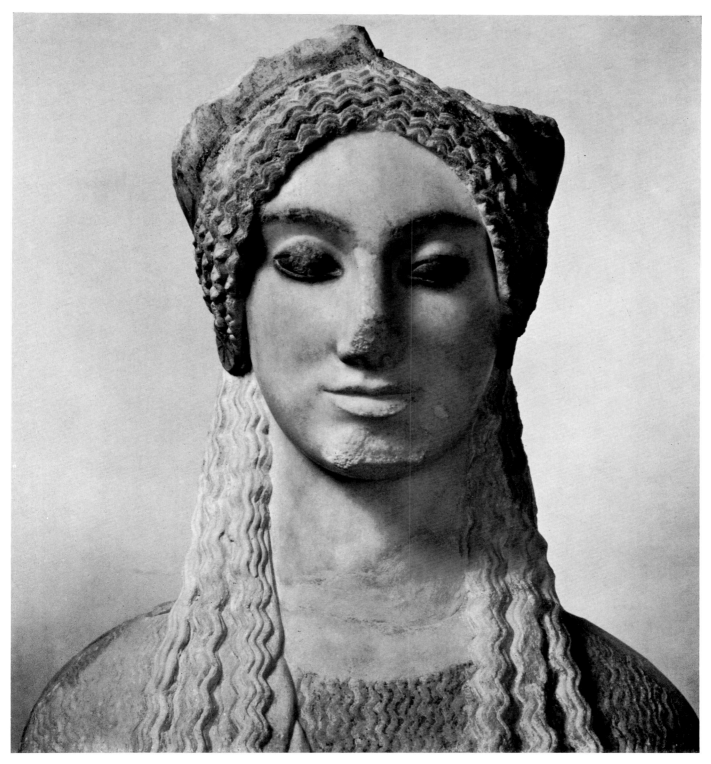

Fig. 416 (Athens, Akropolis Museum, no. 674)

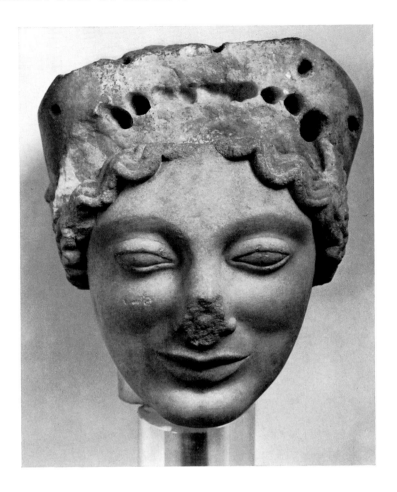

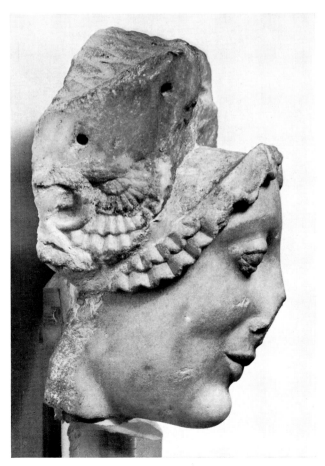

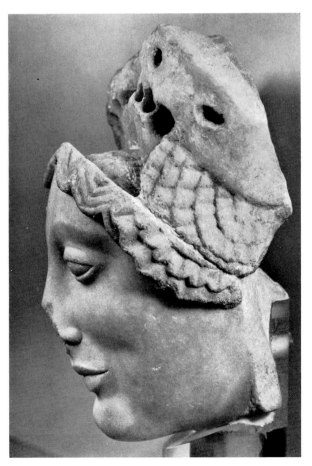

Figs. 417–419 (Athens, Akropolis Museum, no. 643, 307)

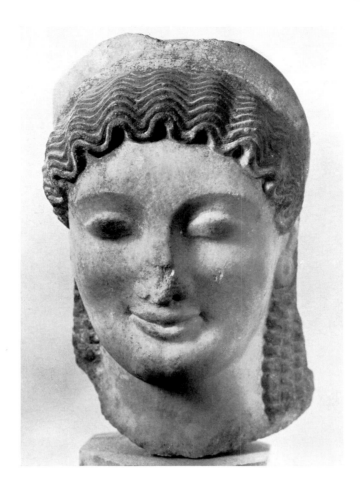

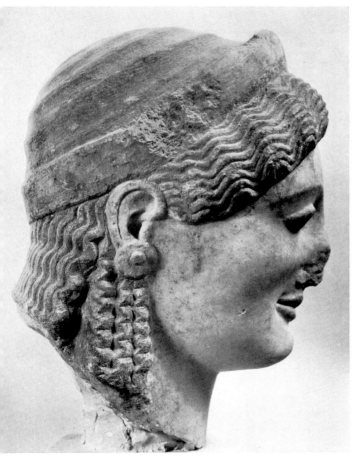

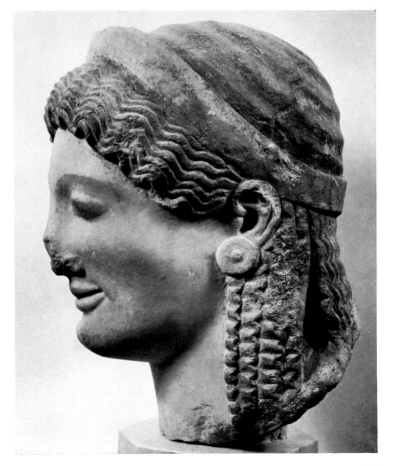

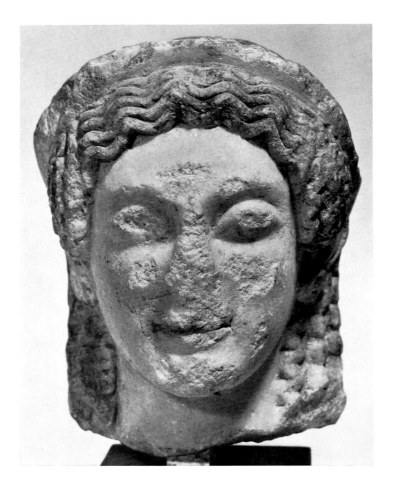

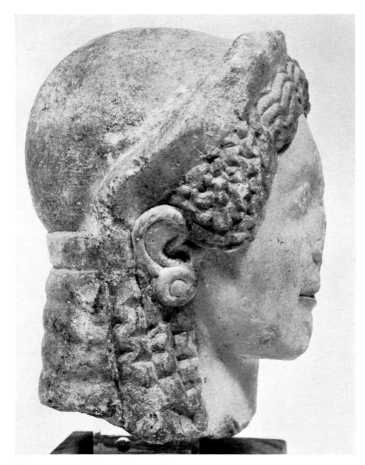

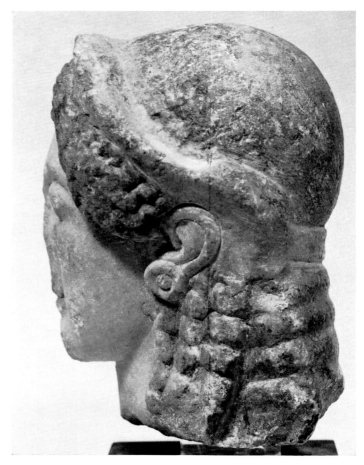

Figs. 423–425 (Athens, Akropolis Museum, no. 648)

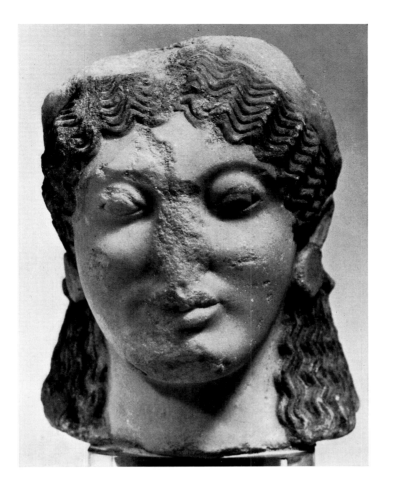

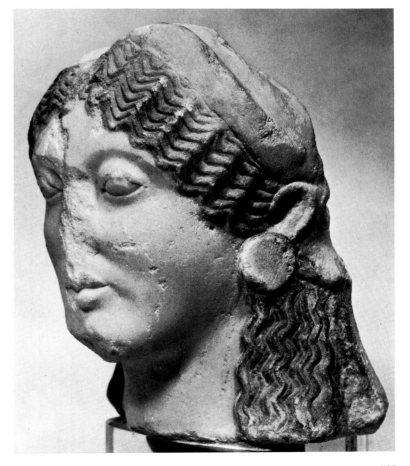

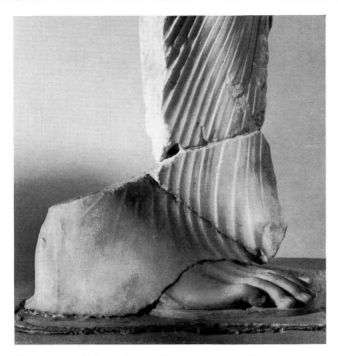

Figs. 429–430 (Athens, Akropolis Museum, no. 136)

132

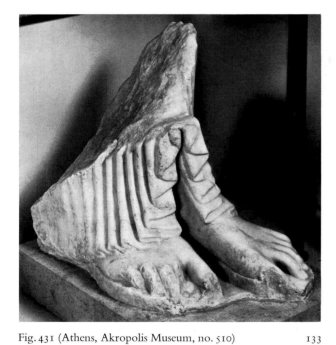

Fig. 431 (Athens, Akropolis Museum, no. 510)

133

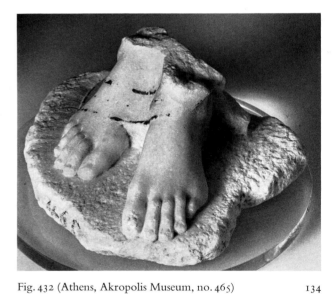

Fig. 432 (Athens, Akropolis Museum, no. 465)

134

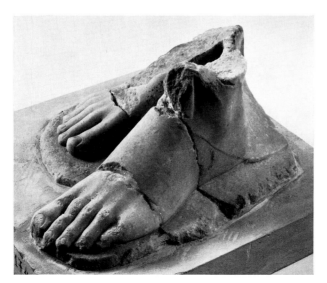

Fig. 433 (Athens, Akropolis Museum, no. 475)

135

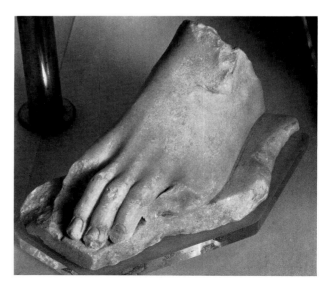

Fig. 434 (Athens, Akropolis Museum, no. 674)

127

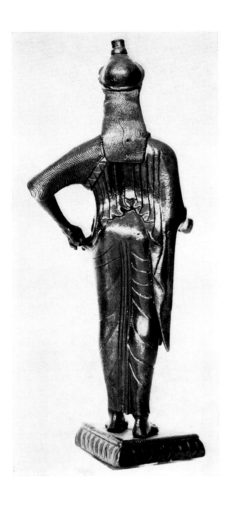
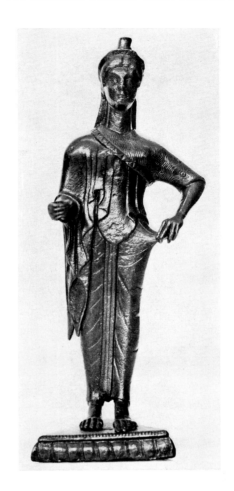

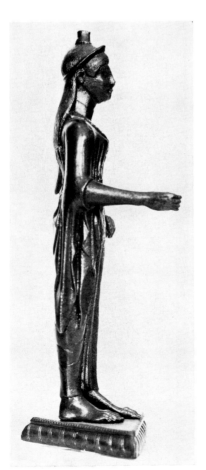
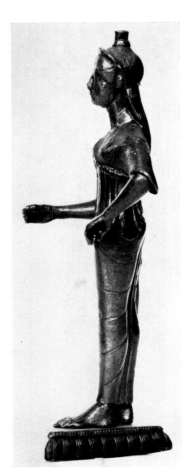

Figs. 435–438 (Athens, National Museum)

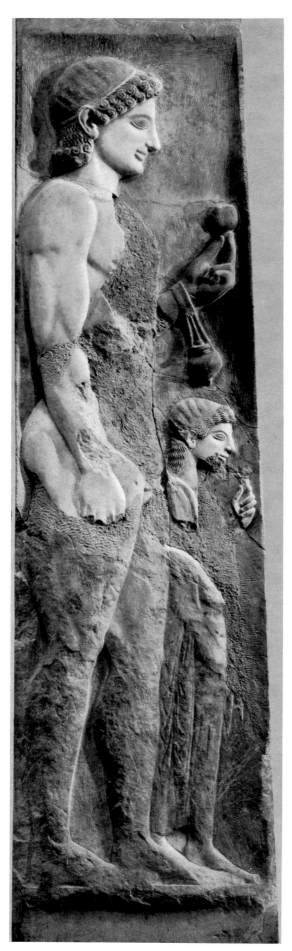

Fig. 439 (New York and Berlin)

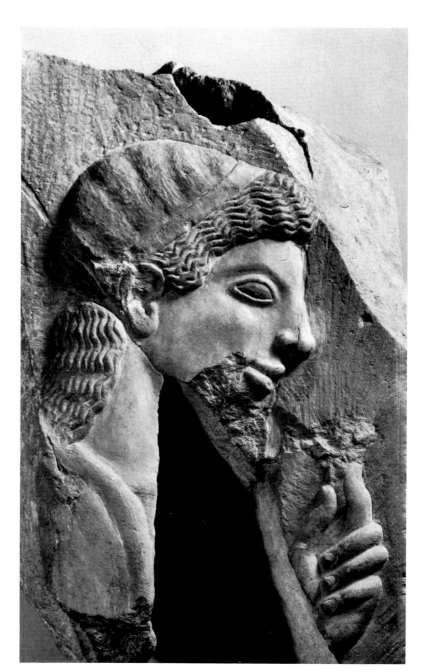

Fig. 440 (Berlin)

137

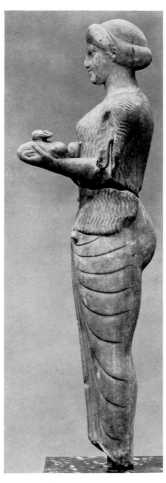
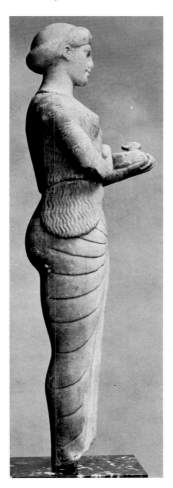
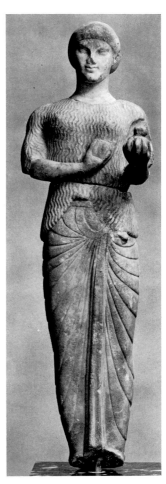

Figs. 441–444 (New York, Metropolitan Museum) 138

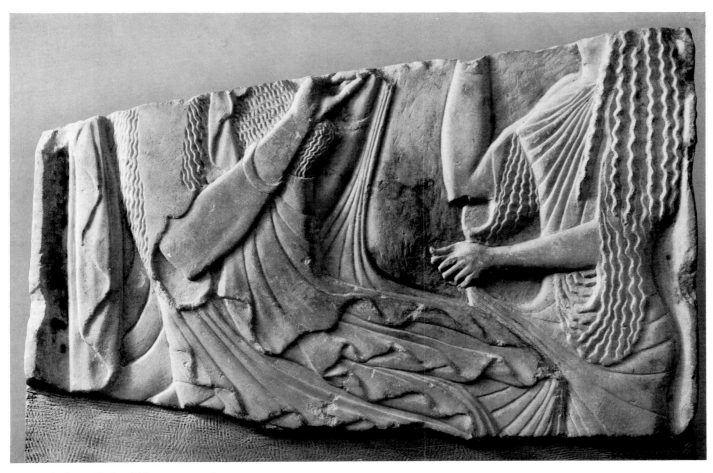

Fig. 445 (Athens, National Museum, no. 36) 141

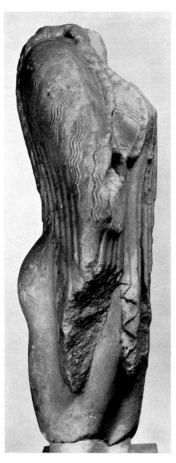
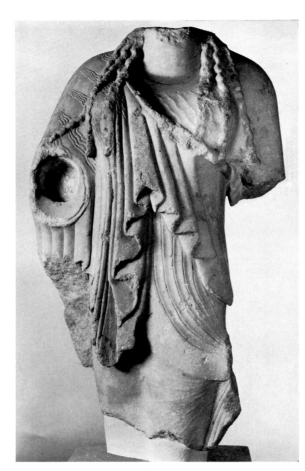
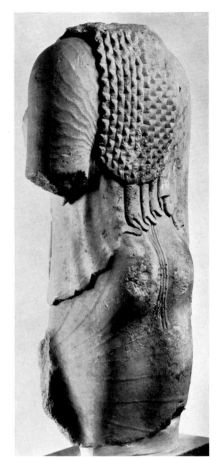

Figs. 446–448 (Athens, National Museum, no. 25)

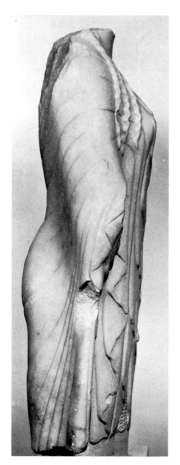
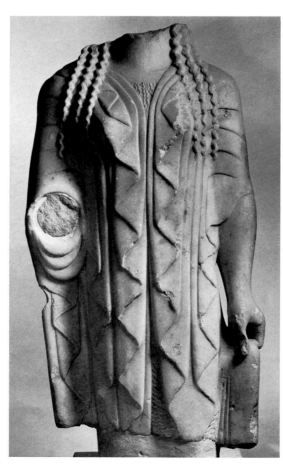
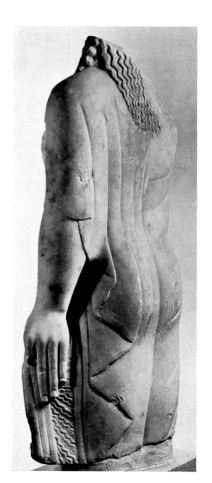

Figs. 449–451 (Athens, National Museum, no. 26)

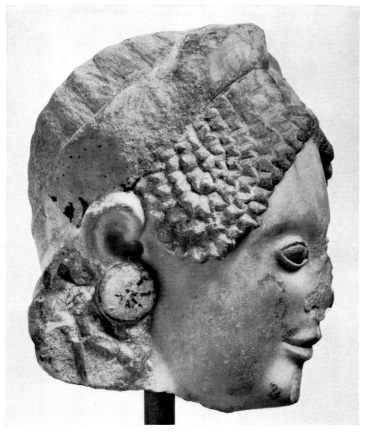

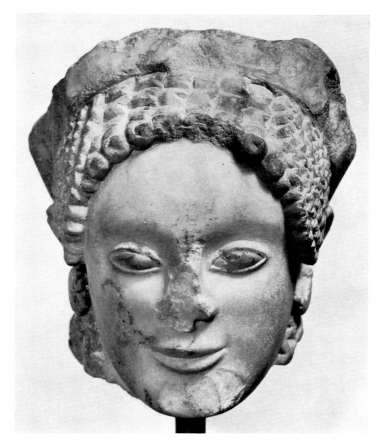

Figs. 452–453 (Athens, National Museum, no. 27)

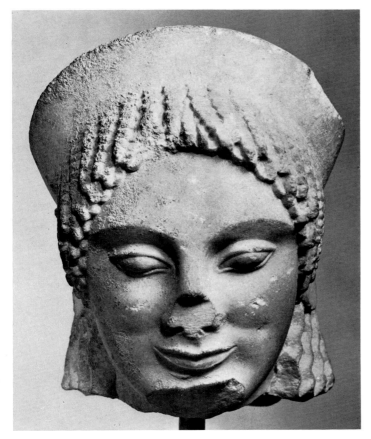

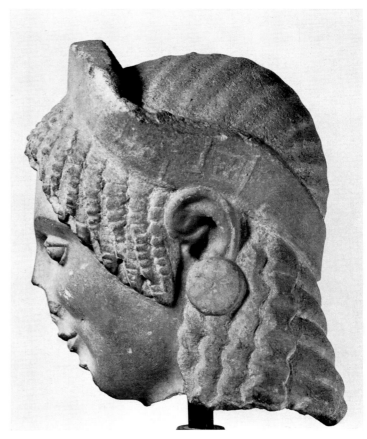

Figs. 454–455 (Athens, National Museum, no. 17)

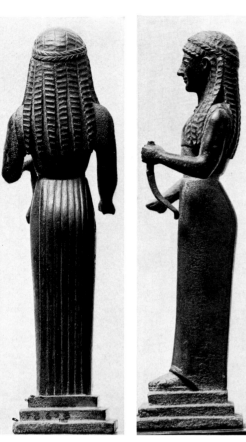
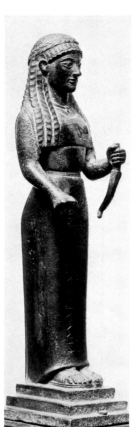
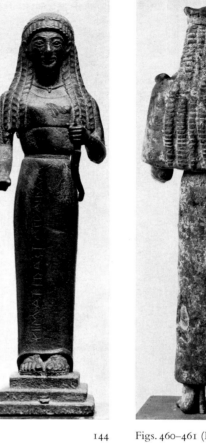
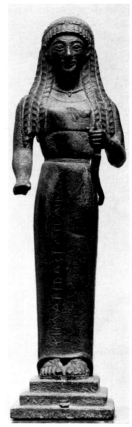

Figs. 456–459 (Boston, Museum of Fine Arts) 144 Figs. 460–461 (Louvre)

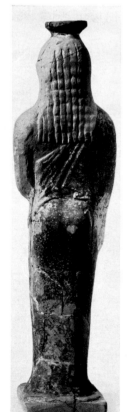
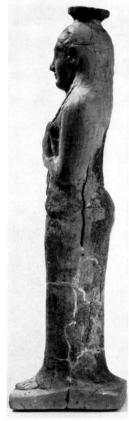
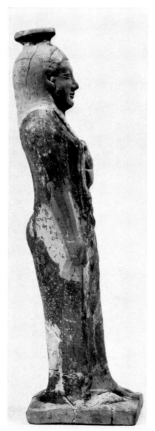
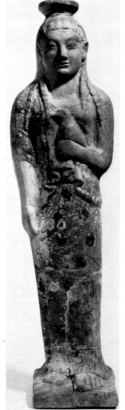
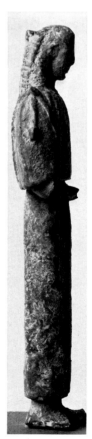
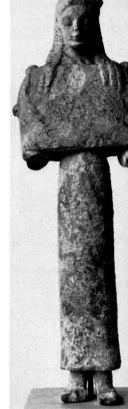

Figs. 462–465 (Athens, National Museum) 146 Figs. 466–467 (Louvre)

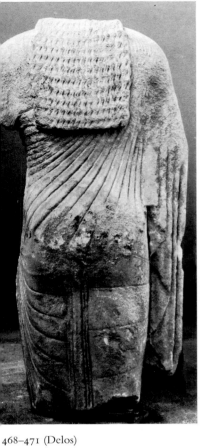
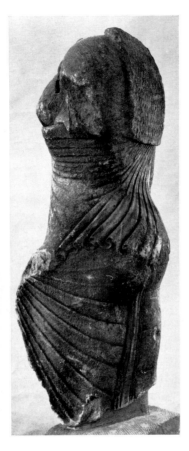
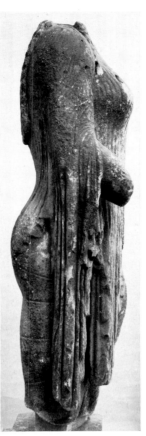
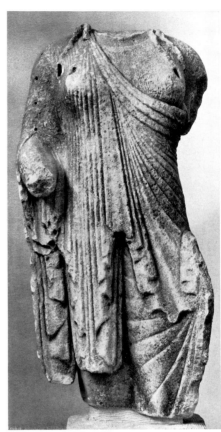

468–471 (Delos)

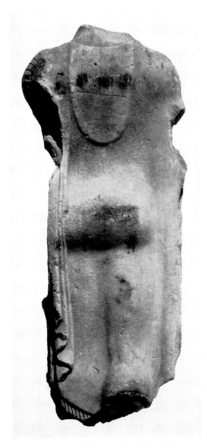
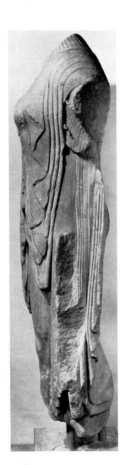
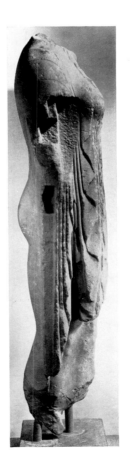
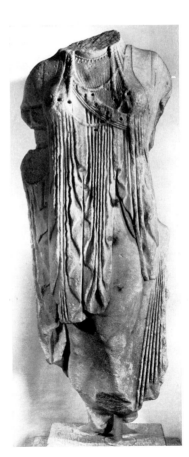

Figs. 472–475 (Athens, National Museum, no. 22)

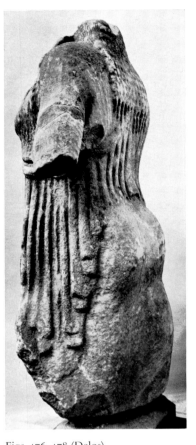
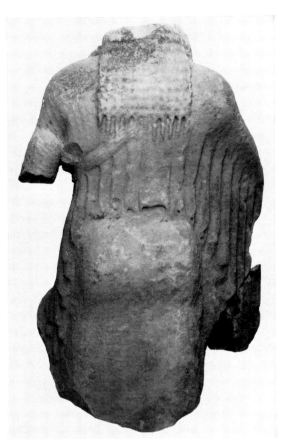
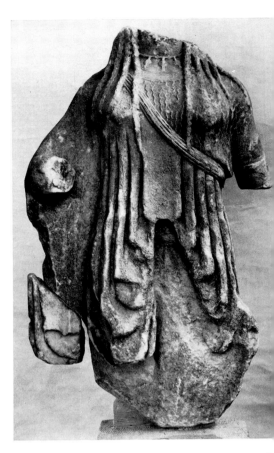

Figs. 476–478 (Delos)

1

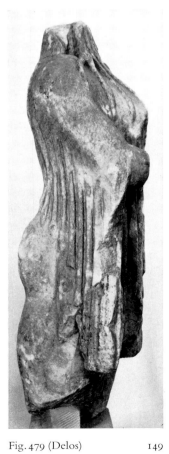
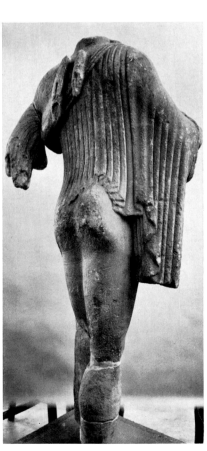
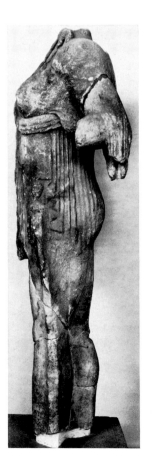
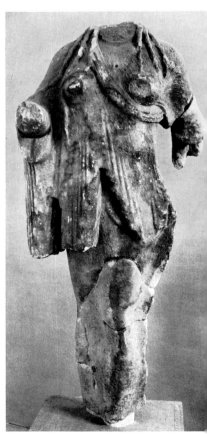

Fig. 479 (Delos) Figs. 480–482 (Delos)

1

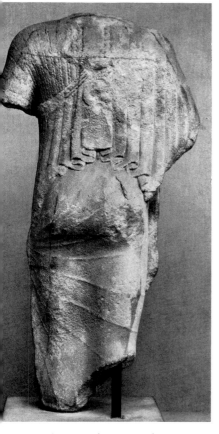
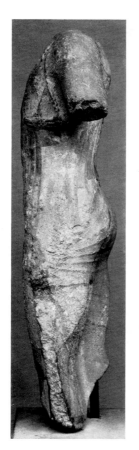
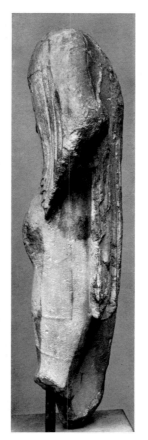
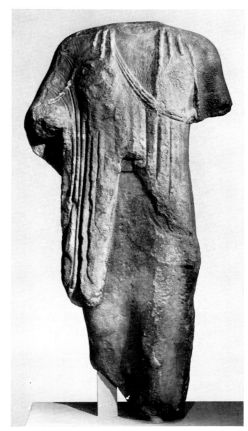

.483–486 (New York, Metropolitan Museum) 151

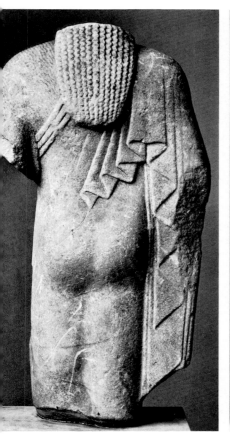
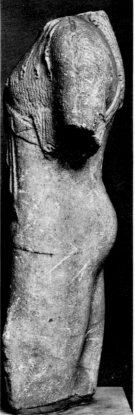
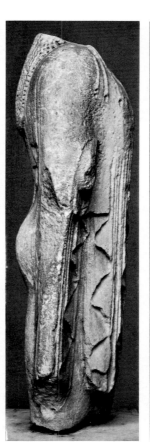
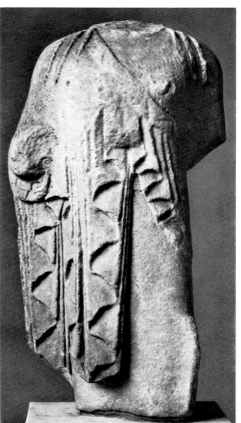

.487–490 (Copenhagen) 152

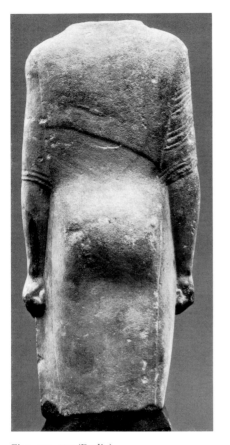
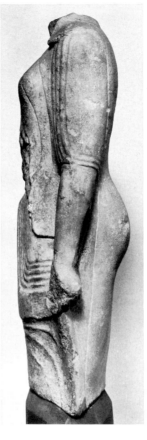
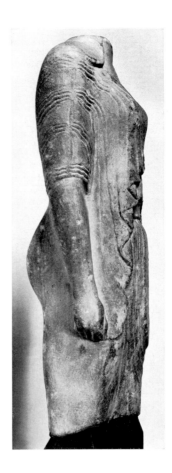
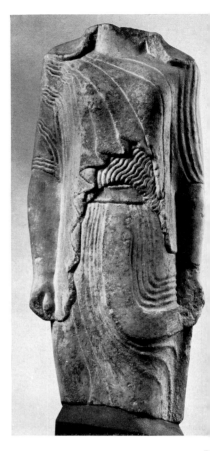

Figs. 491–494 (Berlin)

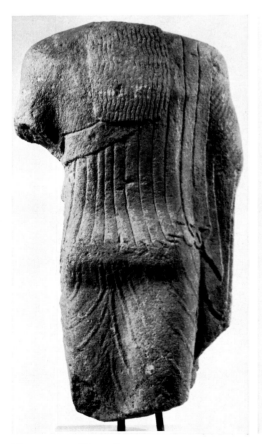
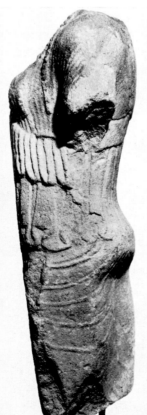
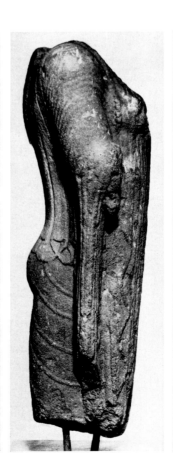
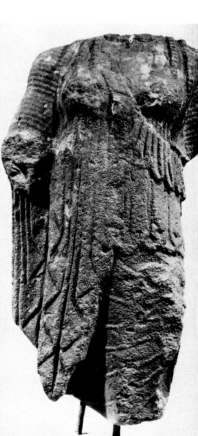

Figs. 495–498 (Cyprus)

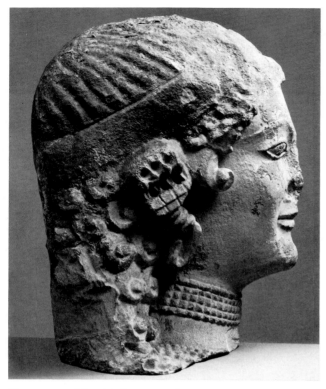

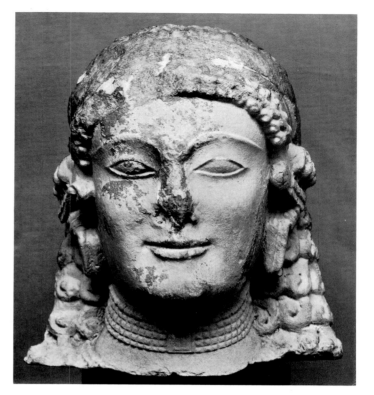

Figs. 499–500 (New York, Metropolitan Museum)

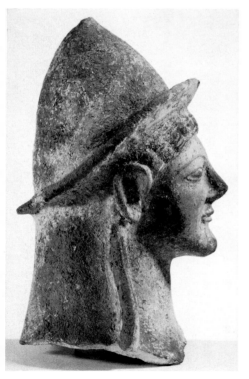

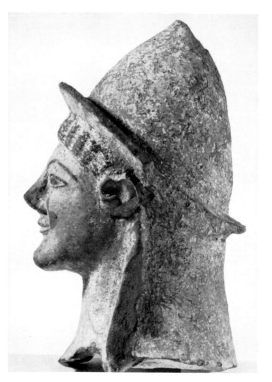

Figs. 501–503 (Cambridge, Fitzwilliam Museum)

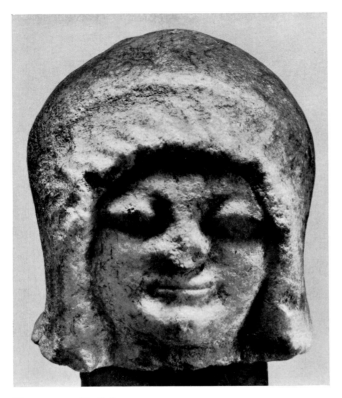

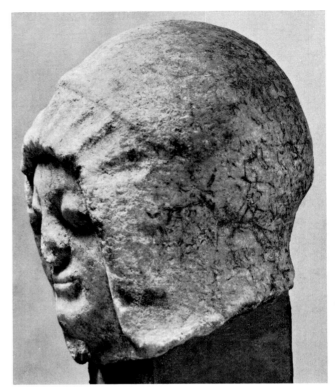

Figs. 504–505 (Berlin) 157

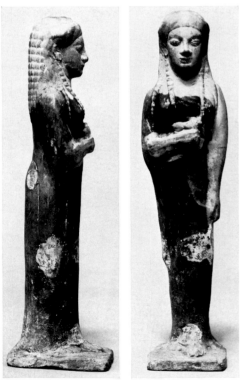

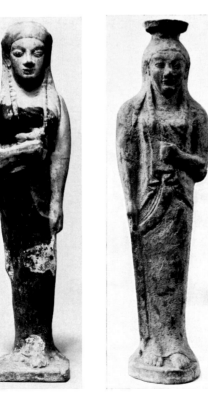

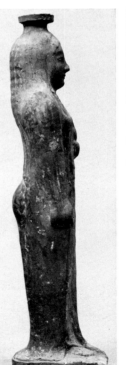

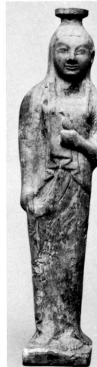

Figs. 506–507 (British Museum) 158 Fig. 508 (Louvre) 160 Figs. 509–511 (British Museum)

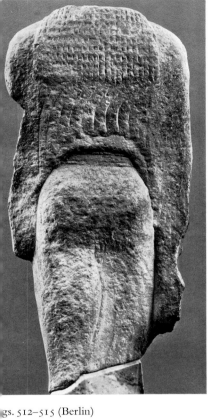
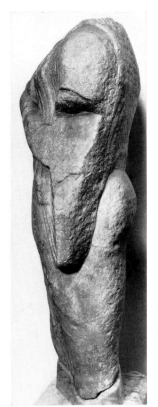
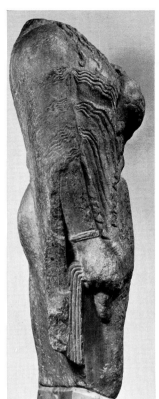
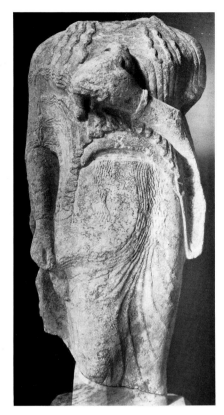

gs. 512–515 (Berlin) 161

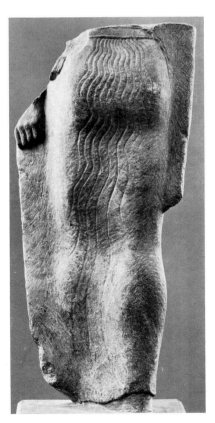
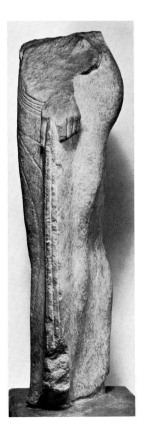
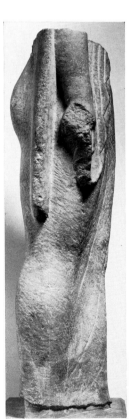
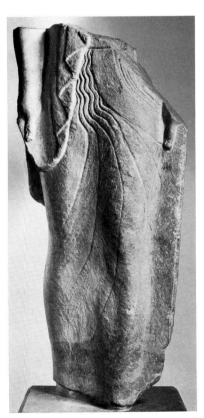

Figs. 516–519 (Berlin) 162

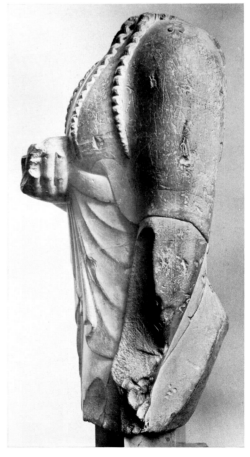

Figs. 520–522 (Louvre) 163

Fig. 523

V.5 KORAI FROM THE EAST

Fig. 523 (Louvre)

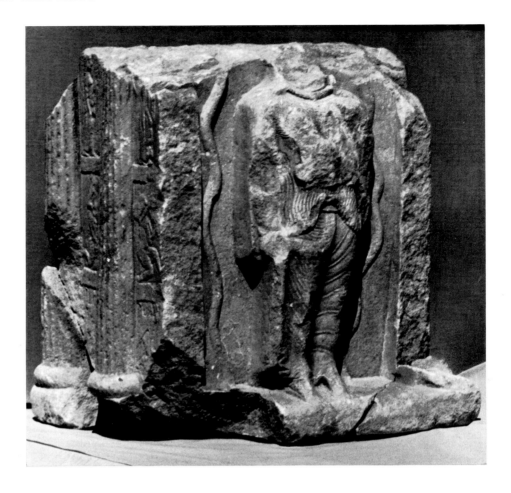

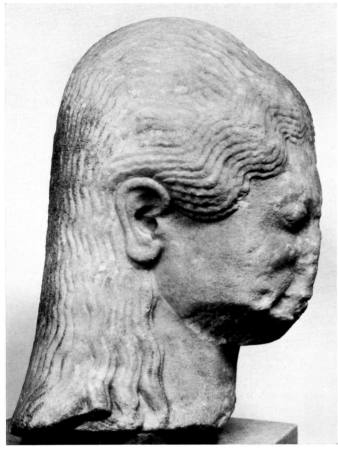

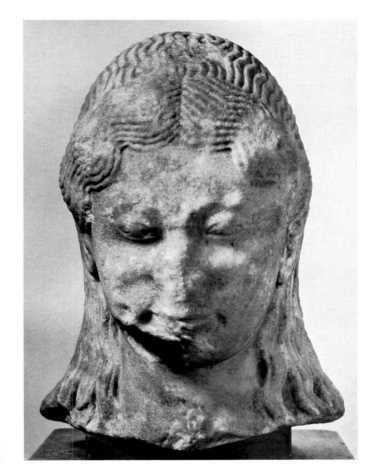

Figs. 528–529 (Berlin)

165

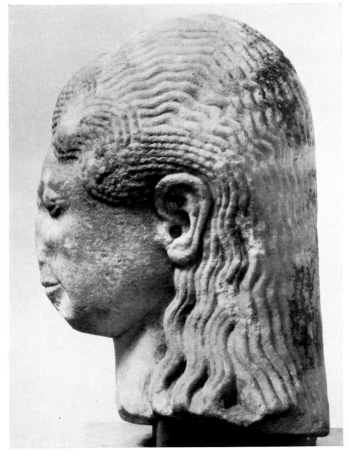

Fig. 530 (Berlin)

165

Fig. 531 (Berlin)

166

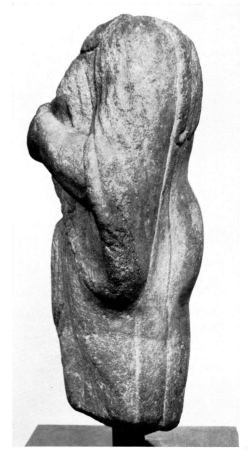

Figs. 532–535 (British Museum)

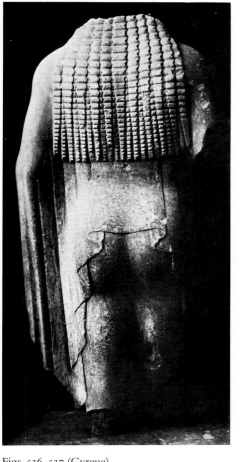

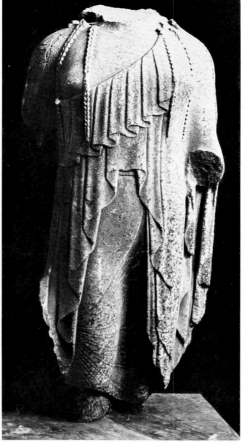

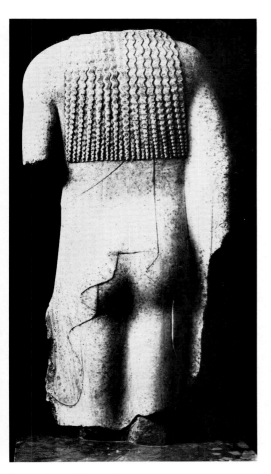

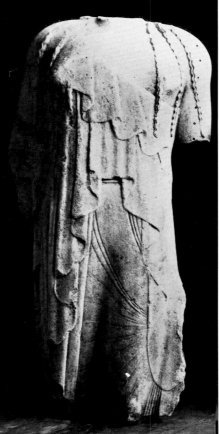

Fig. 540 (Cairo)

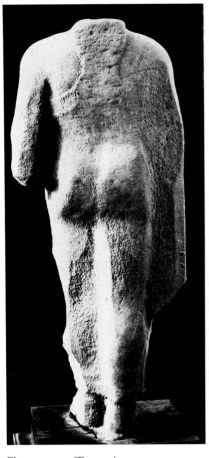
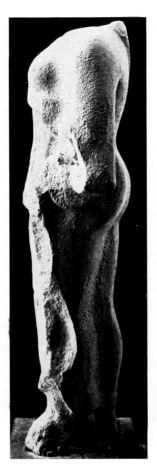
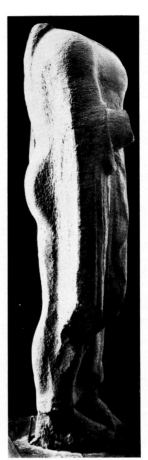
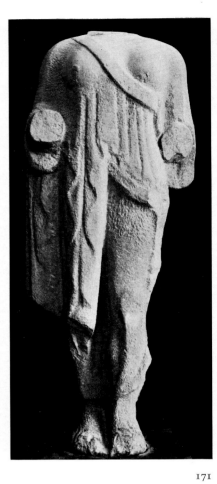

Figs. 541–544 (Taranto)

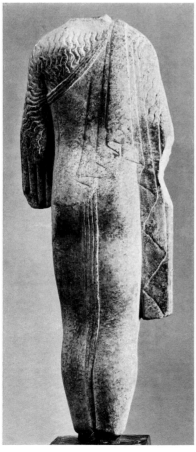
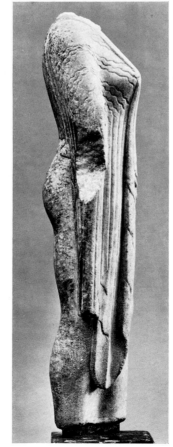
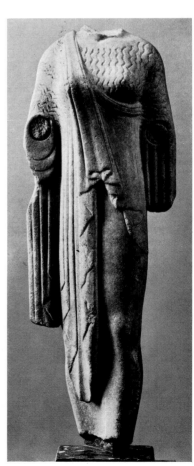

Figs. 545–547 (Berlin

Fig. 548

V.6 KORAI FROM THE WEST

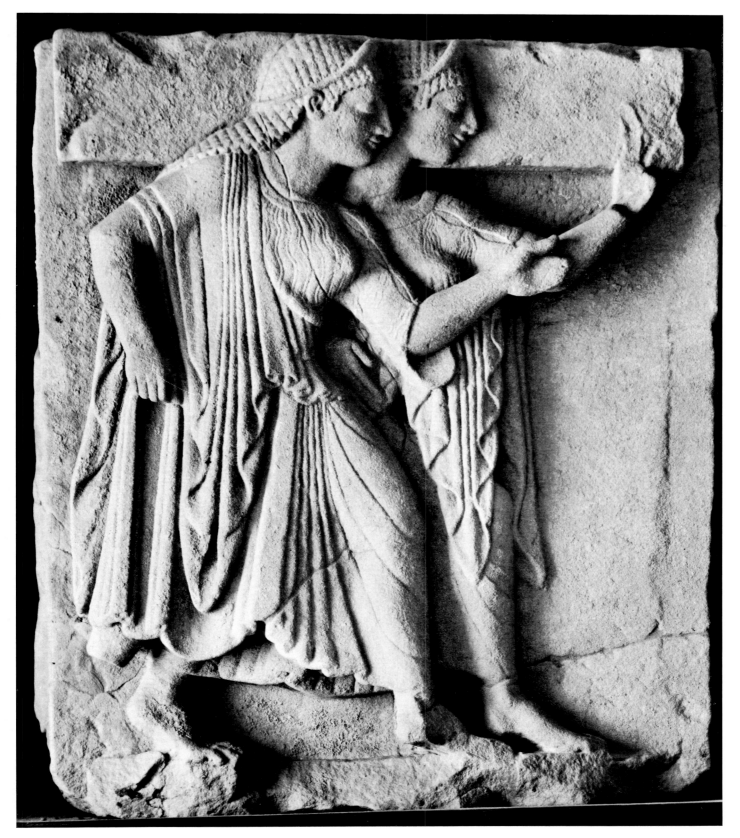

Fig. 548 (Paestum)

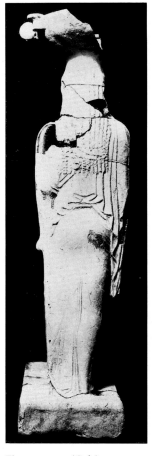
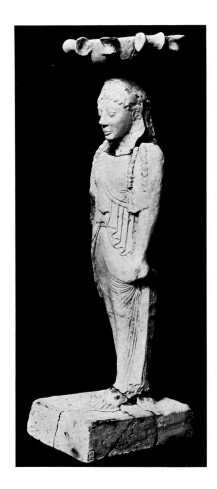
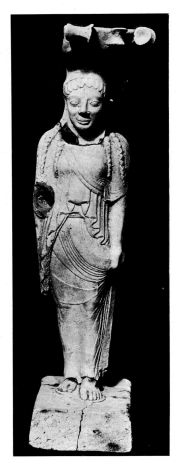

Figs. 549–551 (Gela)

175

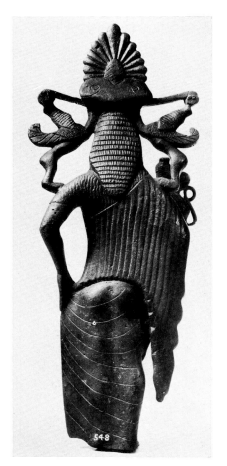
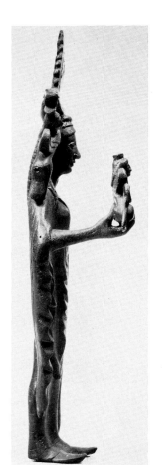
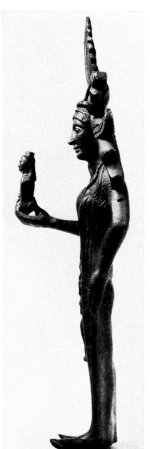
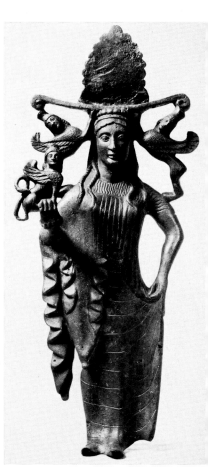

Figs. 552–555 (British Museum)

176

Fig. 556　　　　　　　　　　　　　　　　　　　　　　　　　　　　V.6 KORAI FROM THE WEST

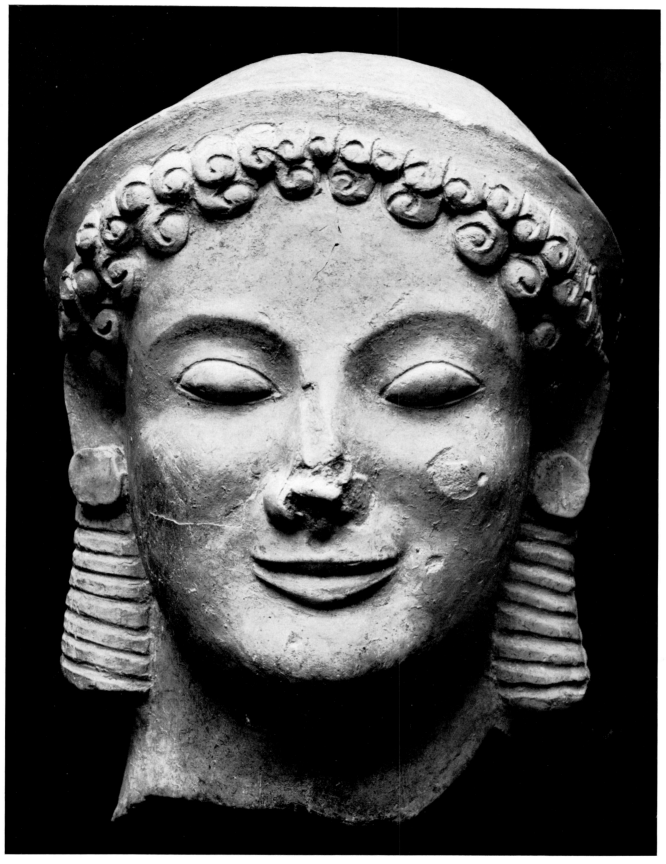

Fig. 556 (Reggio di Calabria)

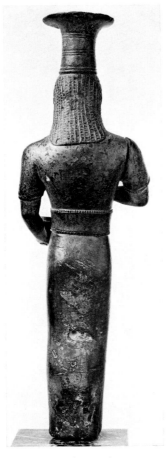
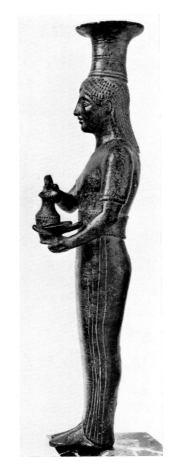
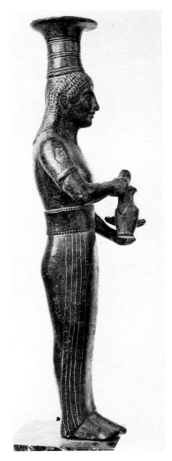
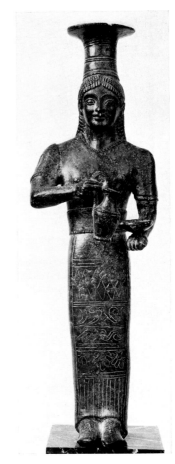

Figs. 557–560 (Louvre)

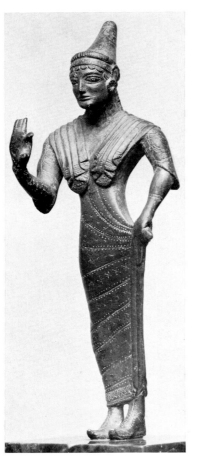
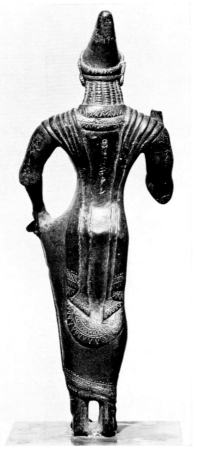
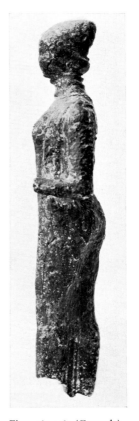

Figs. 563–564 (Granada)

Figs. 561–562 (Berlin)

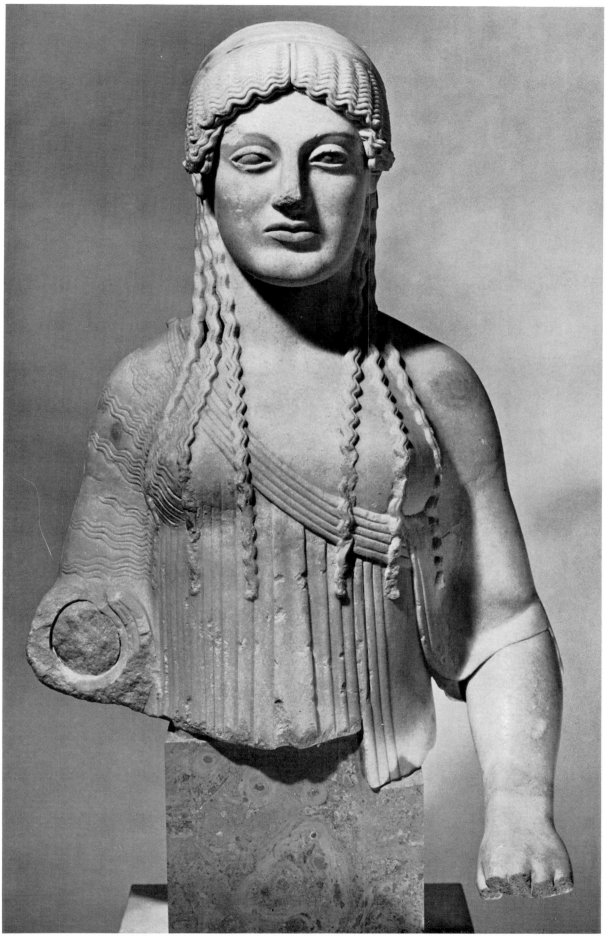

Fig. 565 (Athens, Akropolis Museum, nos. 686, 609)

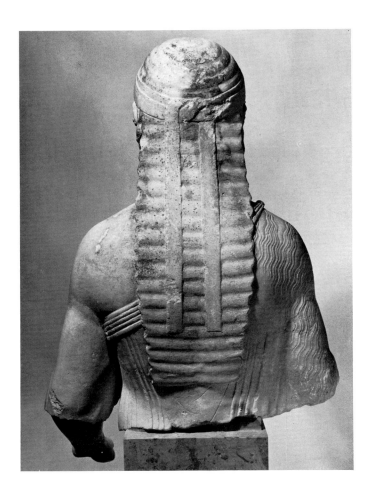

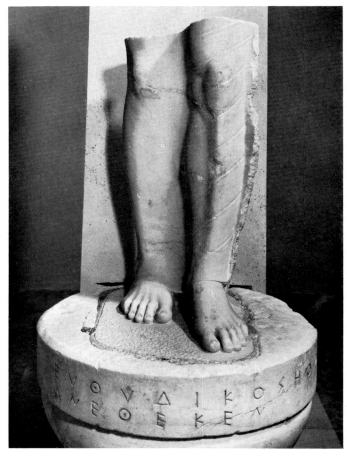

Figs. 566–568 (Athens, Akropolis Museum, nos. 686, 608)

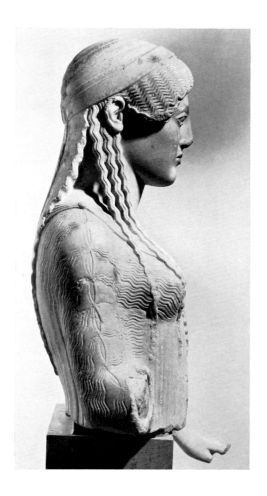

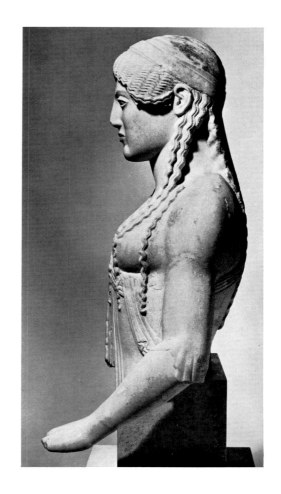

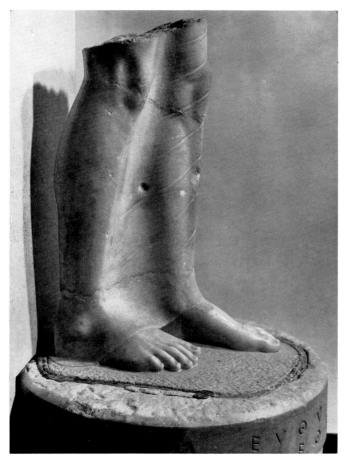

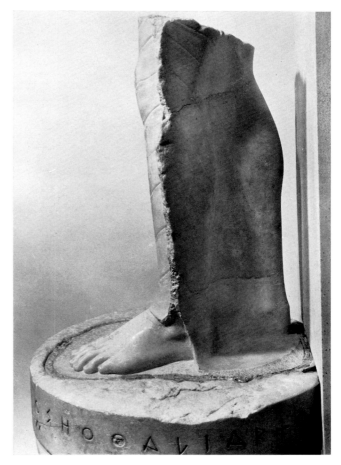

Figs. 569–572 (Athens, Akropolis Museum, nos. 686, 609)

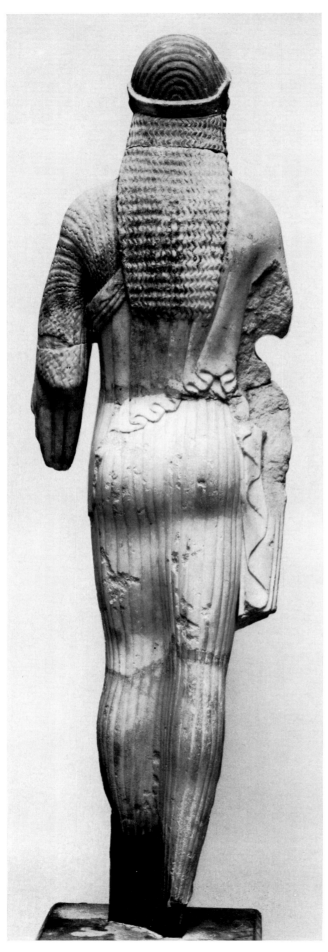

Figs. 573–574 (Athens, Akropolis Museum, no. 685)

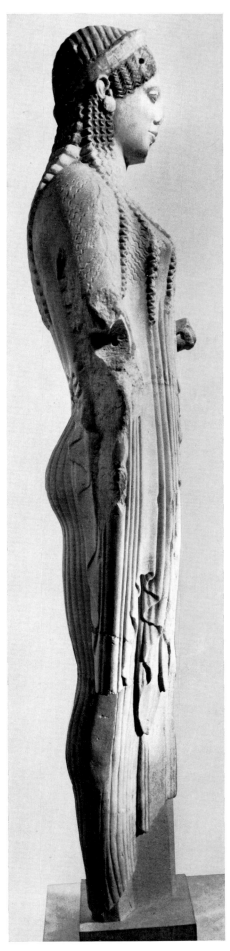

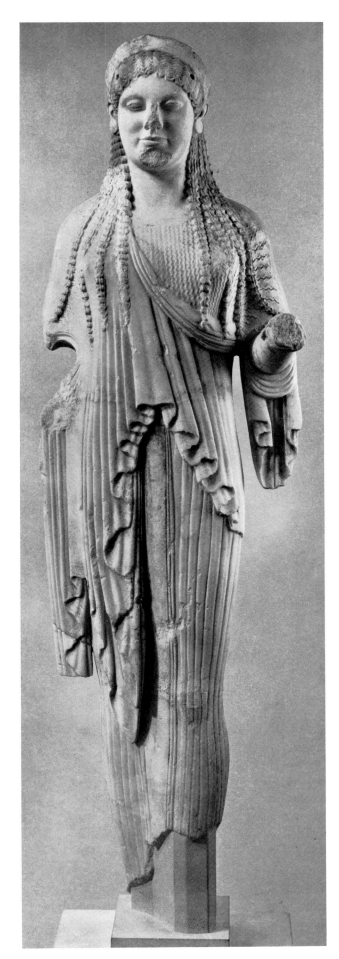

Figs. 575–576 (Athens, Akropolis Museum, no. 685)

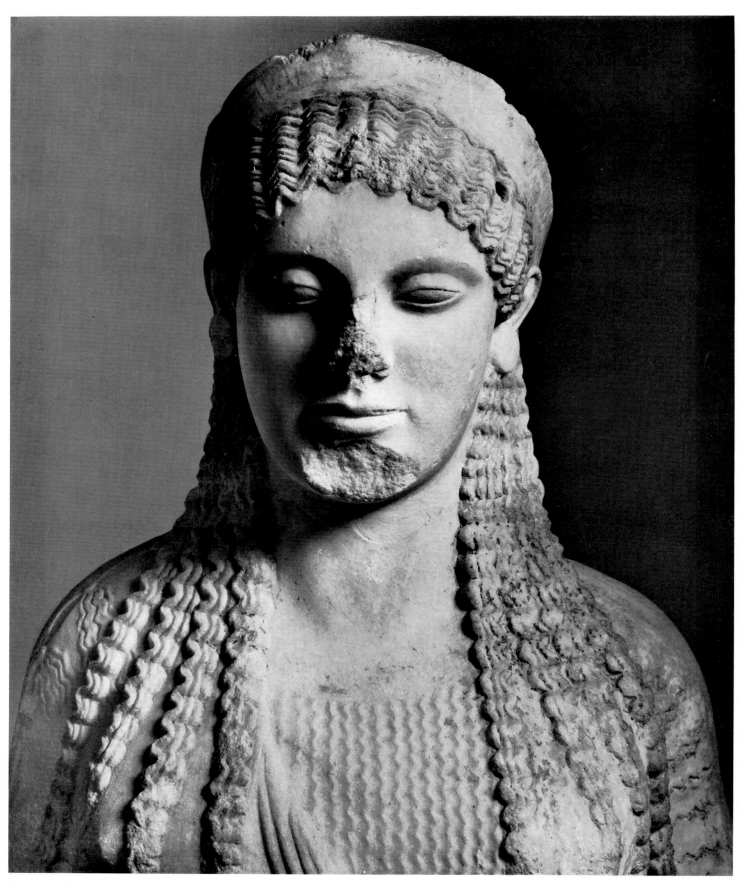

Fig. 577 (Athens, Akropolis Museum, no. 685)

Fig. 578 VI. THE EUTHYDIKOS KORE GROUP

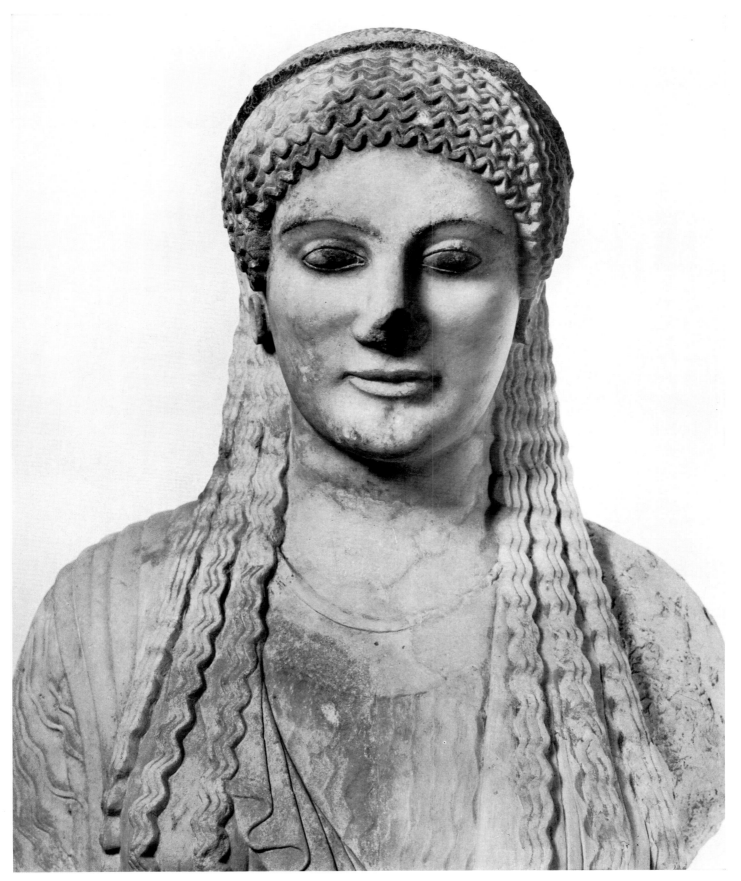

Fig. 578 (Athens, Akropolis Museum, no. 684)

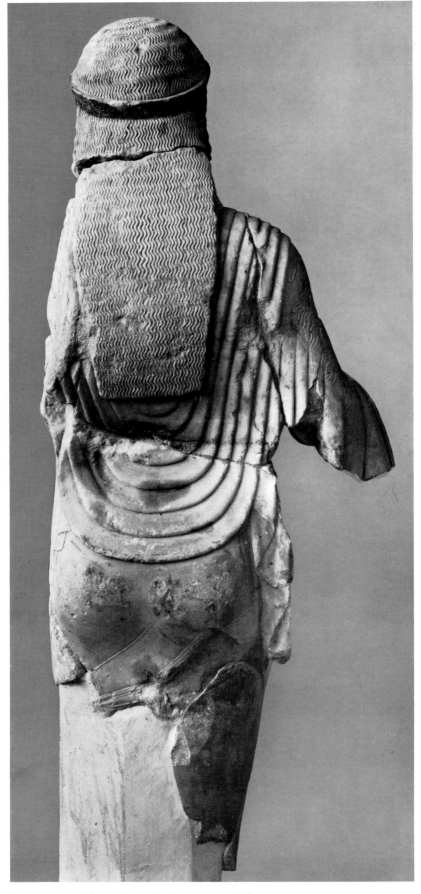

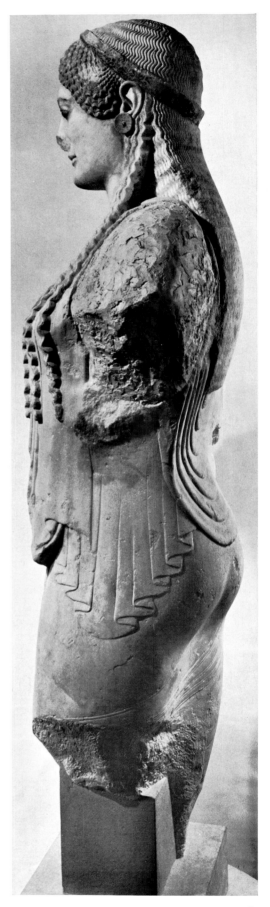

Figs. 579–580 (Athens, Akropolis Museum, no. 684)

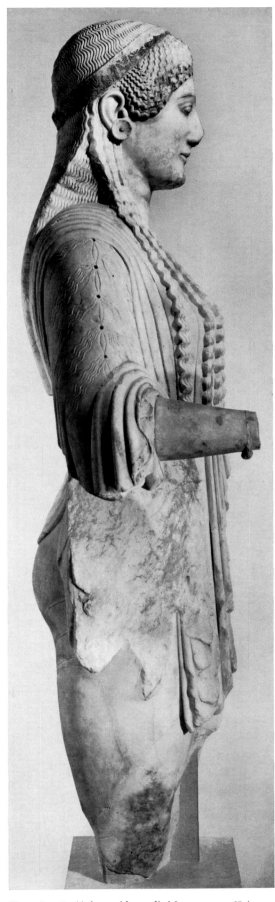
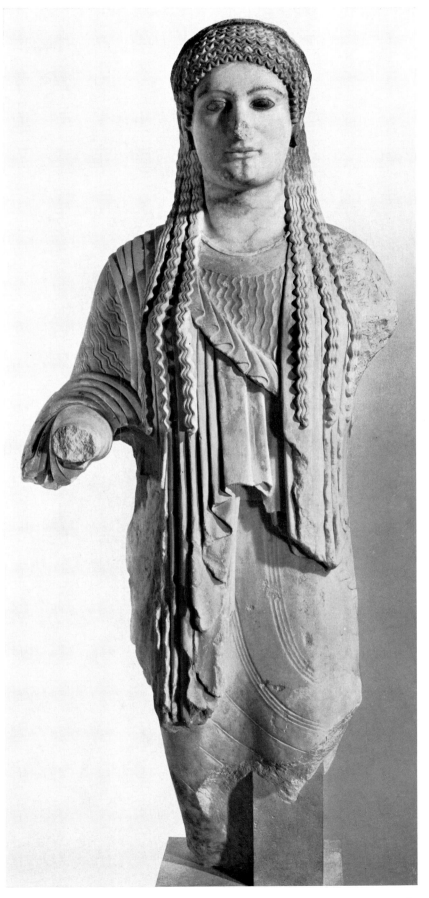

Figs. 581–582 (Athens, Akropolis Museum, no. 684)

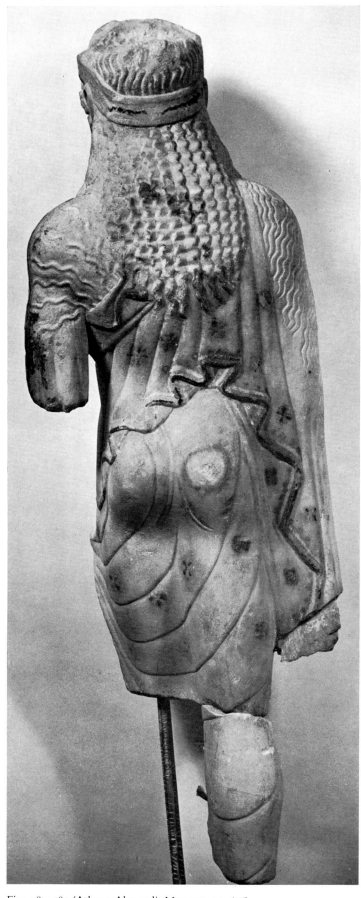
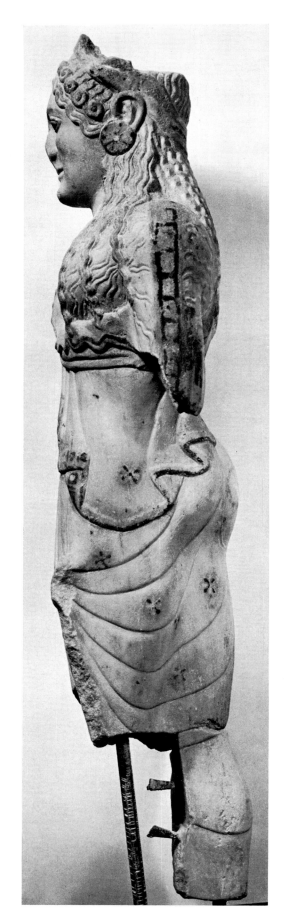

Figs. 583–584 (Athens, Akropolis Museum, no. 676)

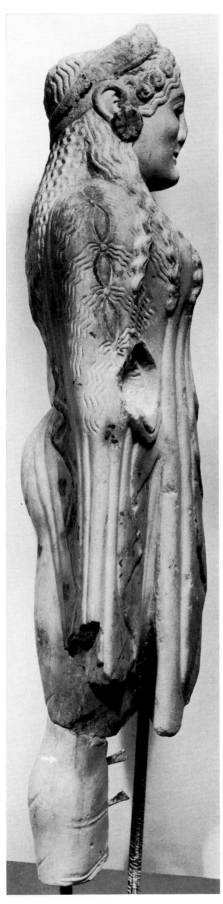
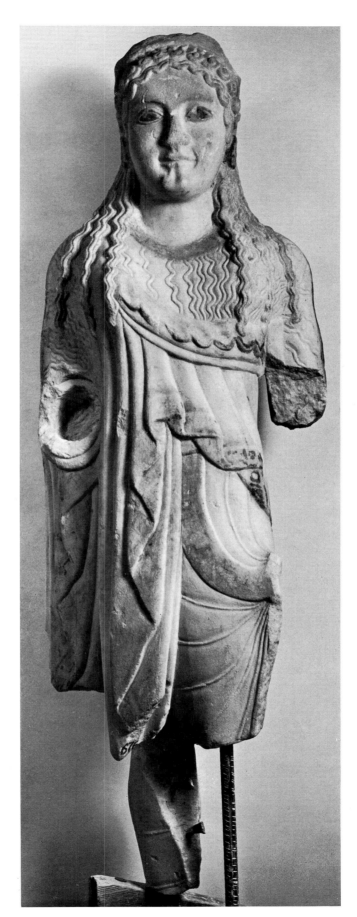

Figs. 585–586 (Athens, Akropolis Museum, no. 676)

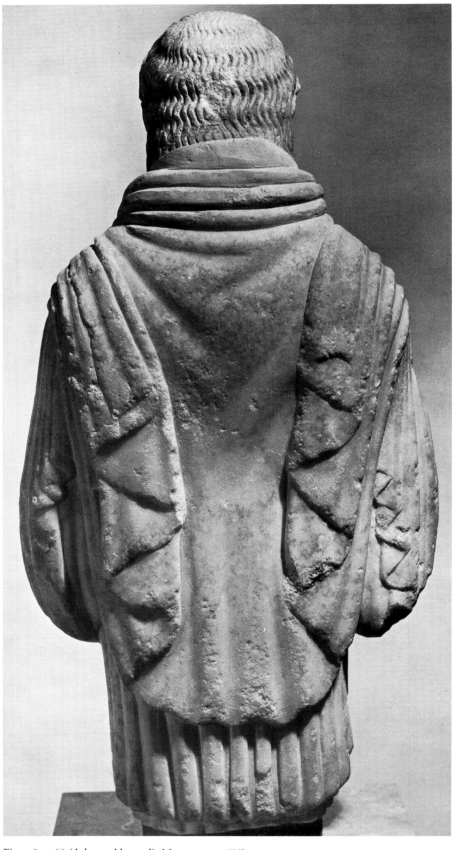

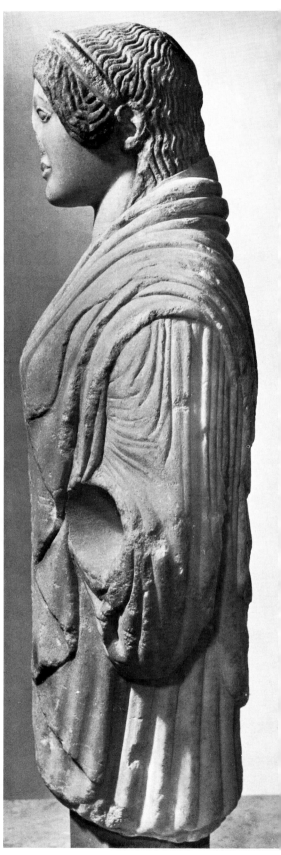

Figs. 587–588 (Athens, Akropolis Museum, no. 688)

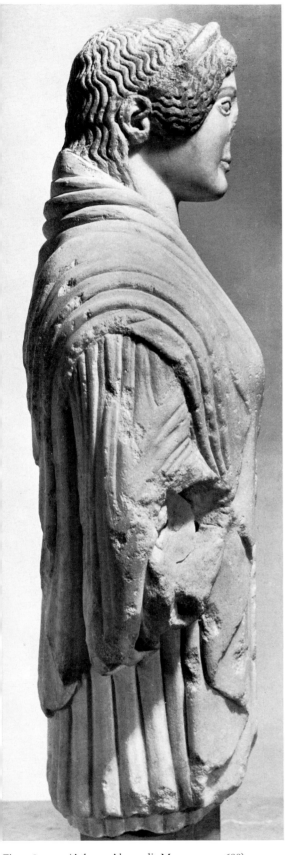
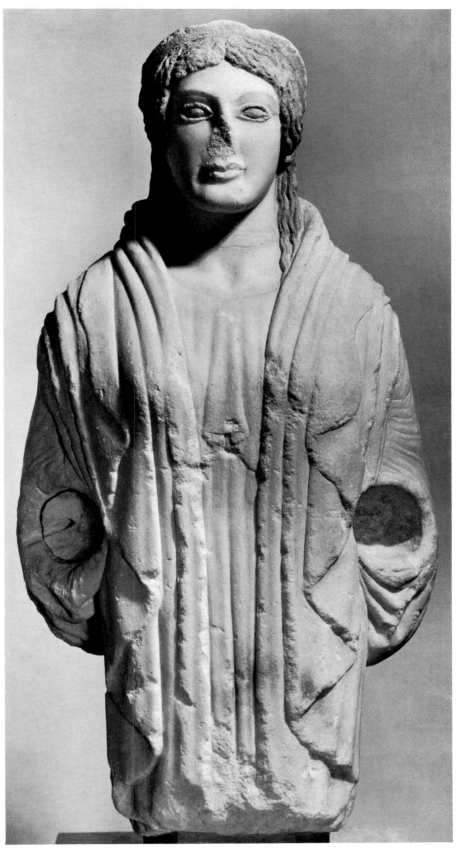

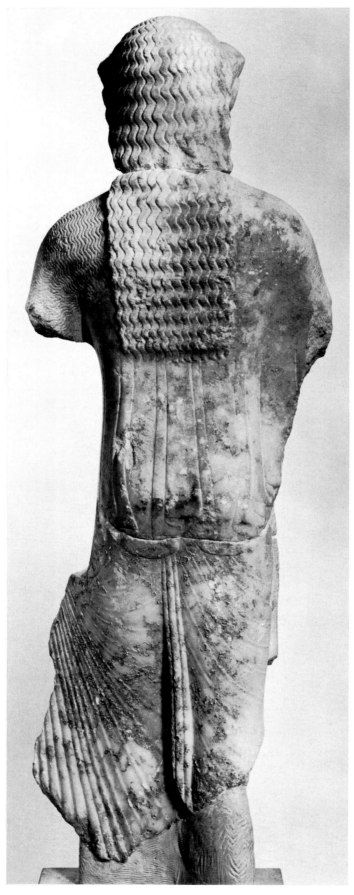
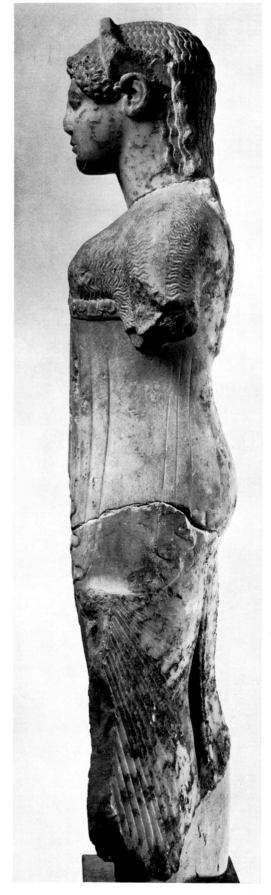

Figs. 591–592 (Athens, National Muuseum, no. 24)

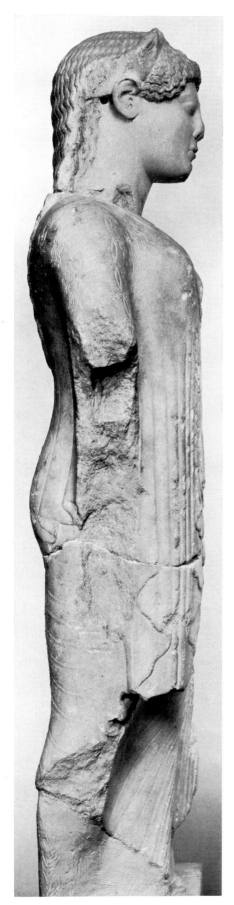
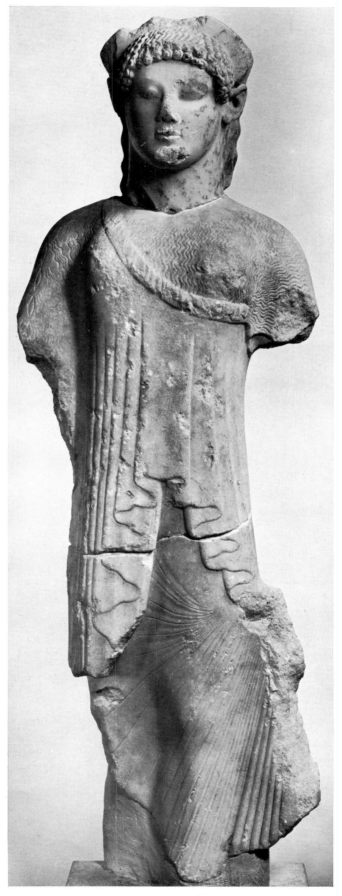

Figs. 593–594 (Athens, Akropolis Museum, no. 24)

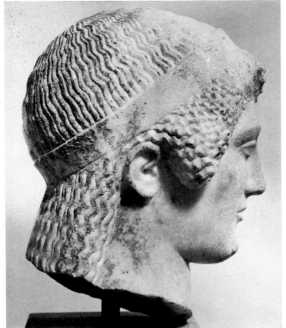
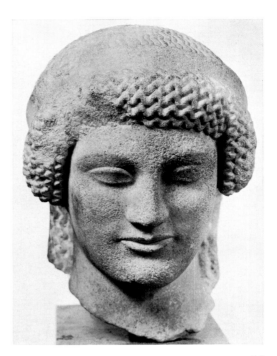

Figs. 595–596 (Athens, National Museum, no. 60) 186

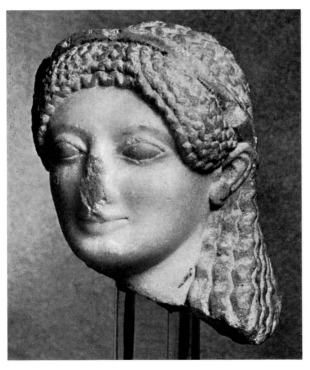
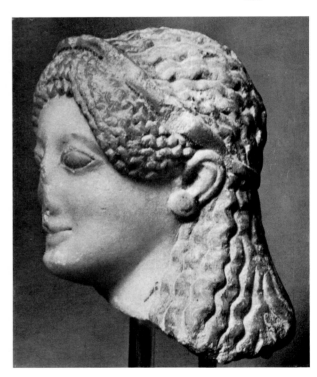

Figs. 597–598 (Athens, Akropolis Museum, no. 641) 187

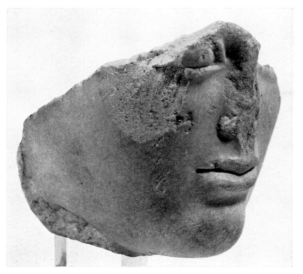
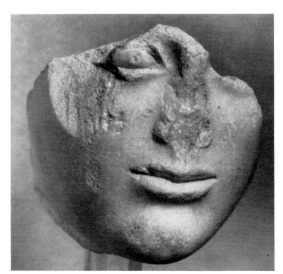

Figs. 599–600 (Athens, Akropolis Museum, no. 634) 188

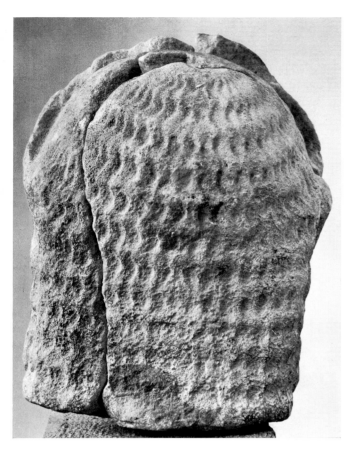

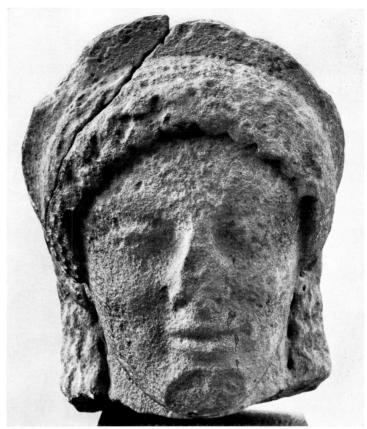

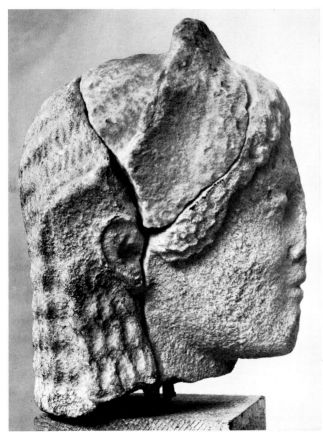

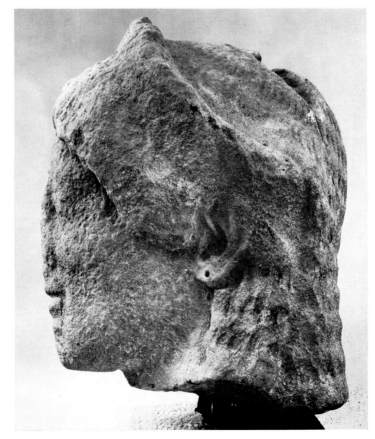

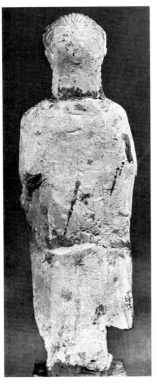
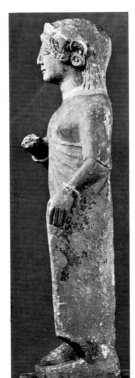
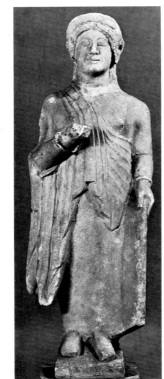
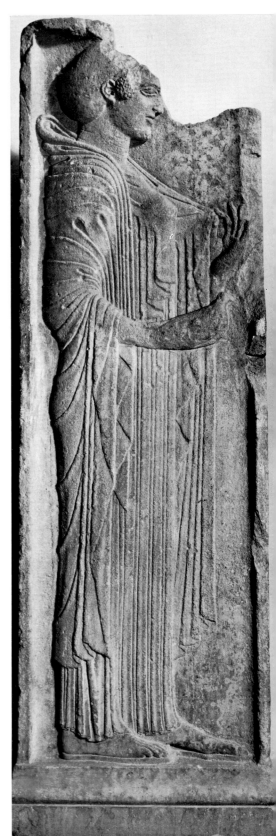

Figs. 605–607 (British Museum) 190

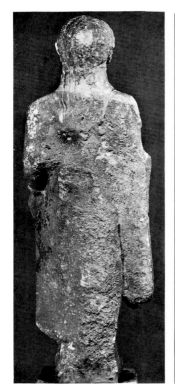
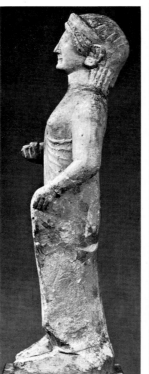
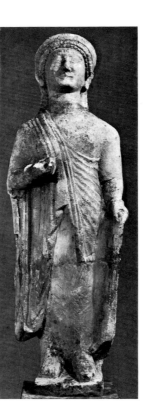

Figs. 608–610 (British Museum) 191 Fig. 611 (Rome, Conservatori Museum) 19

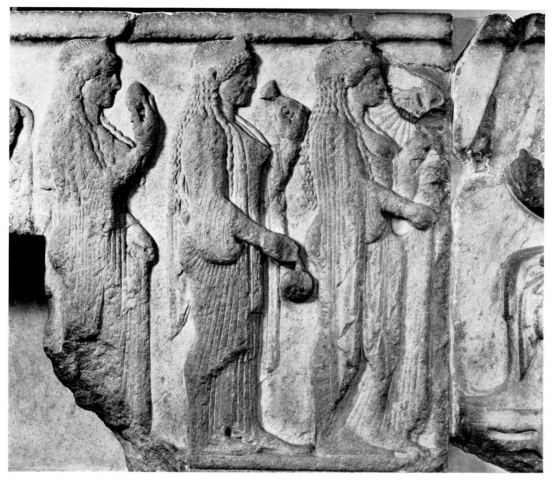

Fig. 612 (British Museum)

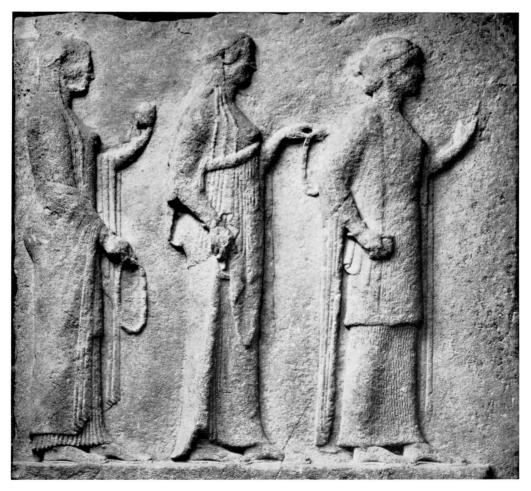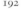

Fig. 613 (Louvre)

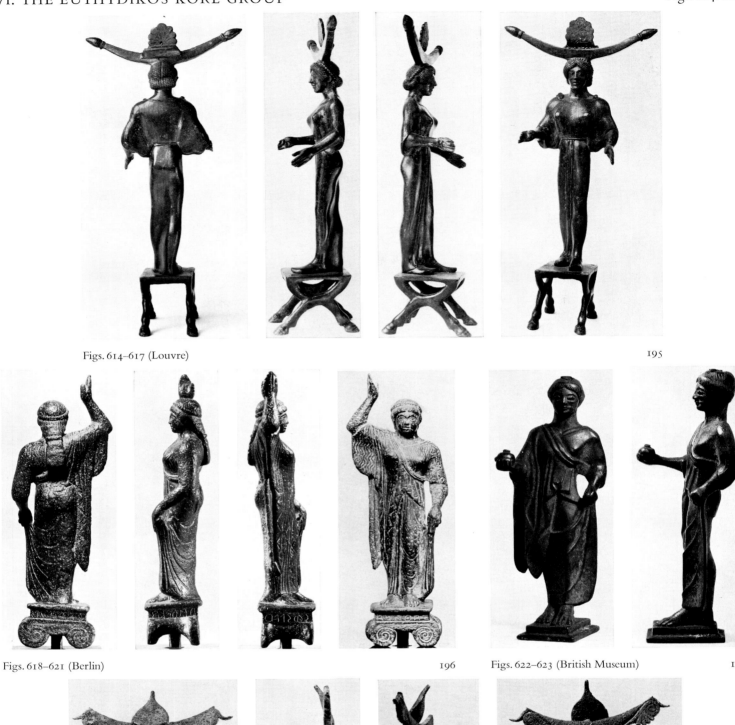

Figs. 614–617 (Louvre)

195

Figs. 618–621 (Berlin) 196 Figs. 622–623 (British Museum) 19

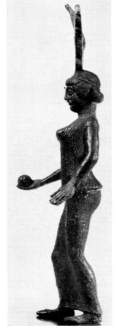
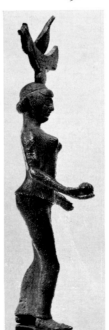
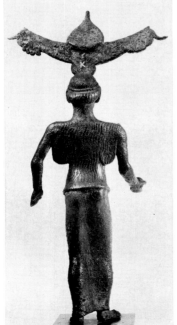
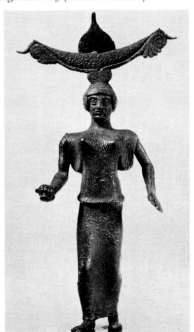

Figs. 624–627 (British Museum)

198

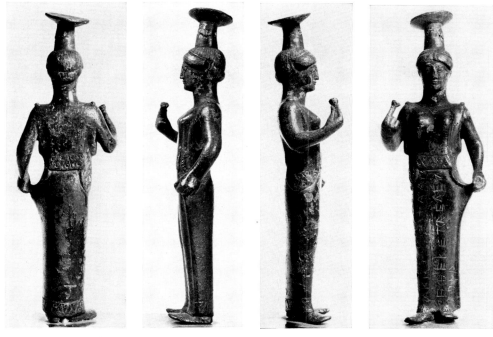

Figs. 628–631 (British Museum) 199

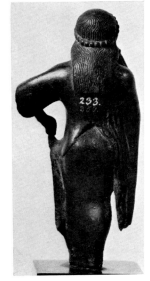
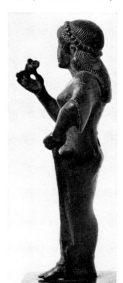
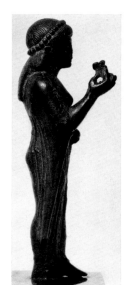
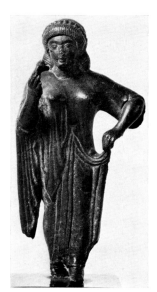
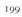
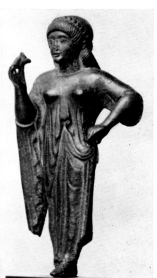

Figs. 632–636 (Vienna) 200

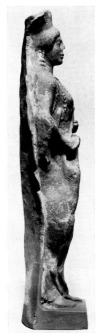
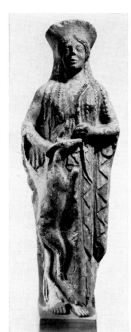
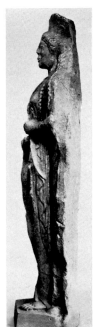
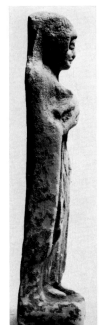
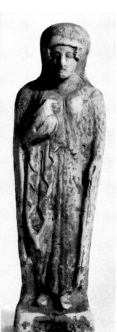

Figs. 637–639 (Athens, National Museum) 201 Figs. 640–641 (Athens, National Museum) 205

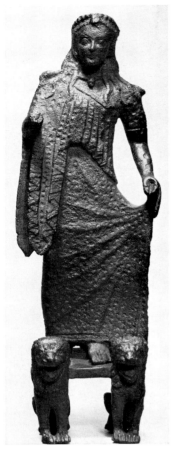
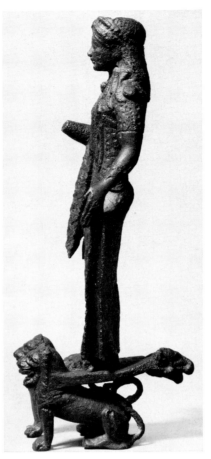
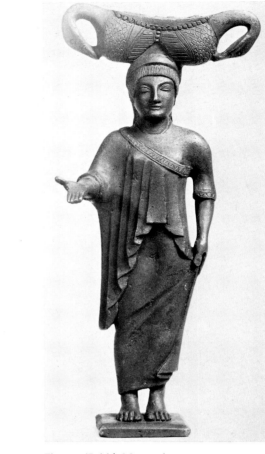

Figs. 642–643 (British Museum) 202 Fig. 644 (British Museum) 203

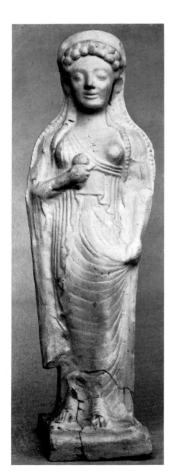
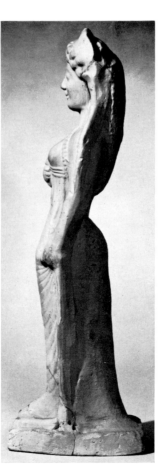
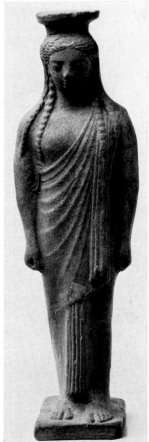

Figs. 645–646 (British Museum) 204 Figs. 647–648 (New York, Metropolitan Museum) 206

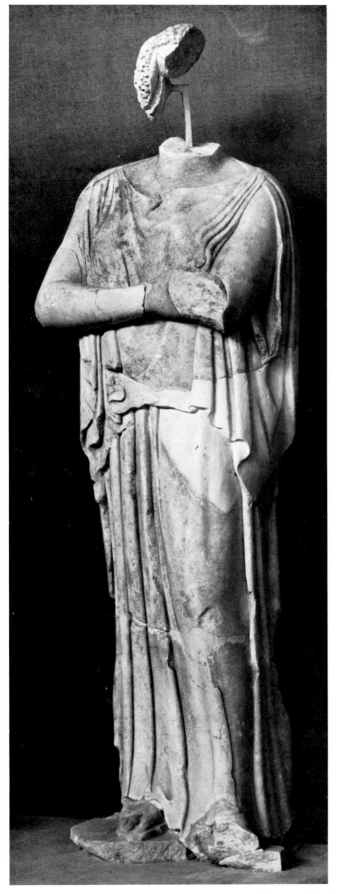
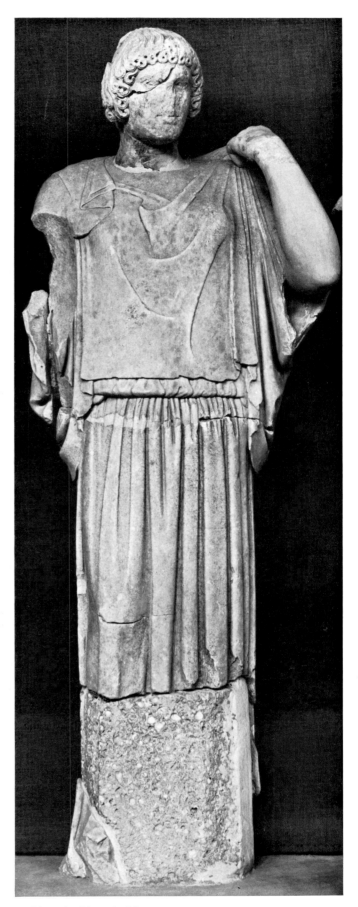

Figs. 649–650 Two statues from the East pediment of the Temple of Zeus at Olympia. Olympia, Museum

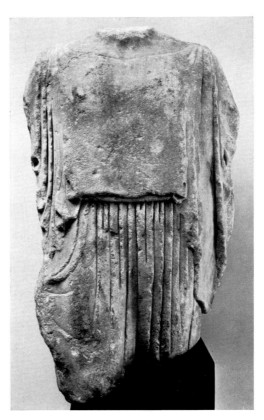

Fig. 651 Statue from Lord Elgin's collection.
Malibu, Cal., J. Paul Getty Museum

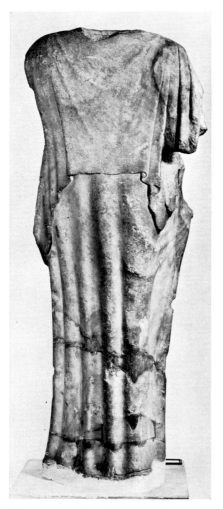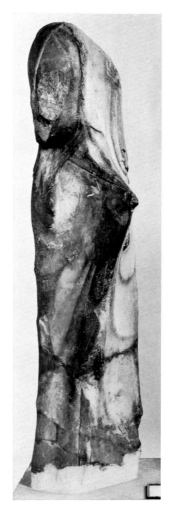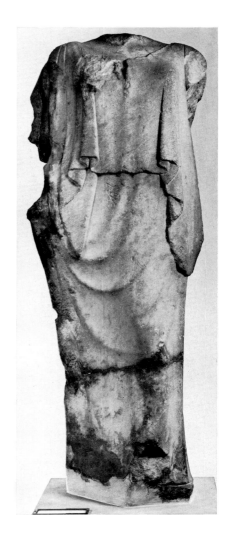

Figs. 652–654 Statue from Xanthos, Lycia. British Museum

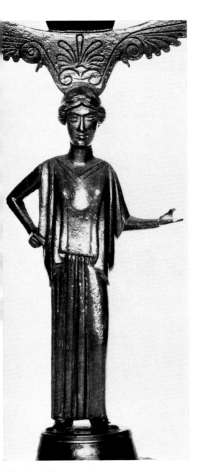

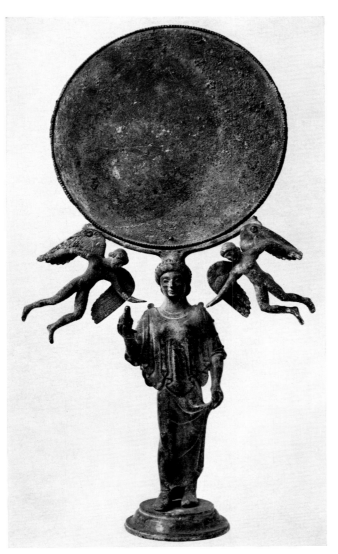

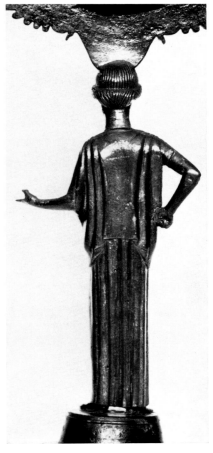

Fig. 655　Bronze mirror support.
Athens, National Museum

Fig. 656　Bronze mirror. Louvre

Fig. 657　Bronze mirror support.
Athens, National Museum

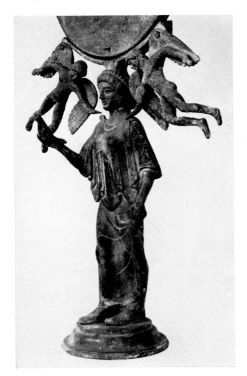

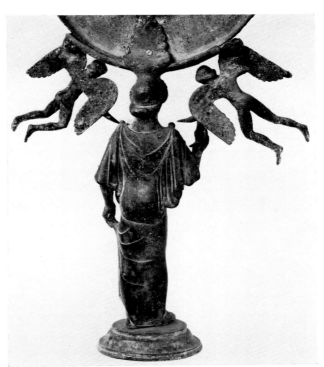

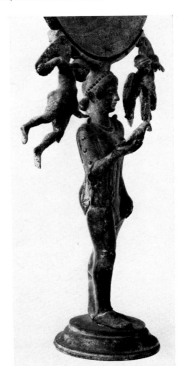

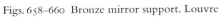

Figs. 658–660　Bronze mirror support. Louvre

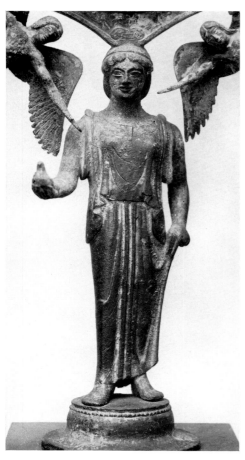

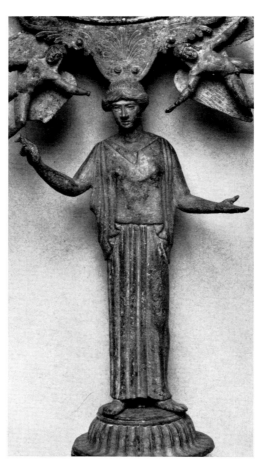

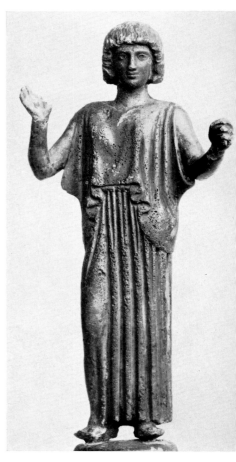

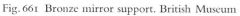

Fig. 661 Bronze mirror support. British Museum Fig. 662 Bronze mirror support. Louvre Fig. 663 Bronze statuette. Berlin, Staatliche Musee

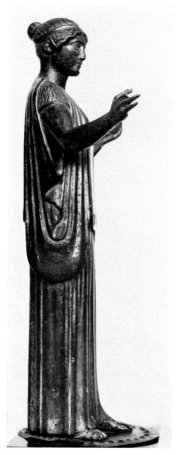

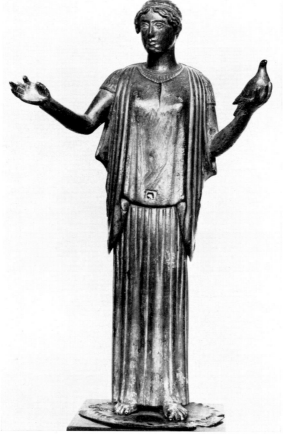

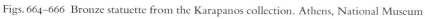

Figs. 664–666 Bronze statuette from the Karapanos collection. Athens, National Museum

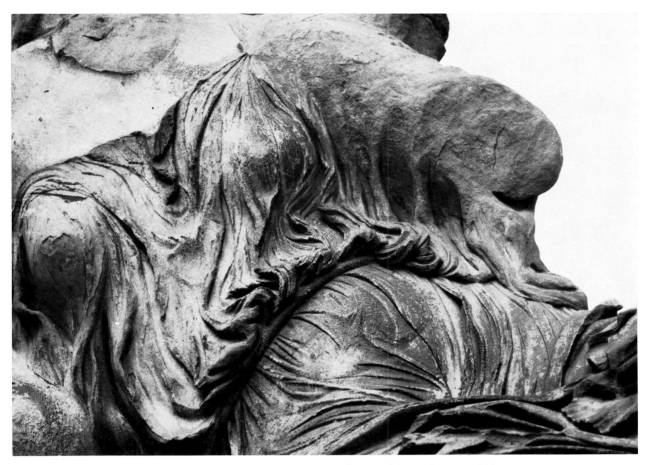

Fig. 667 Detail from the drapery of a reclining figure from the East pediment of the Parthenon. British Museum

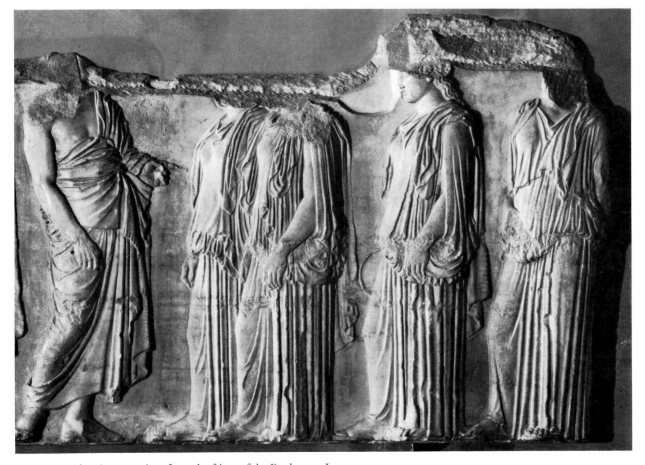

Fig. 668 Maidens in procession, from the frieze of the Parthenon. Louvre

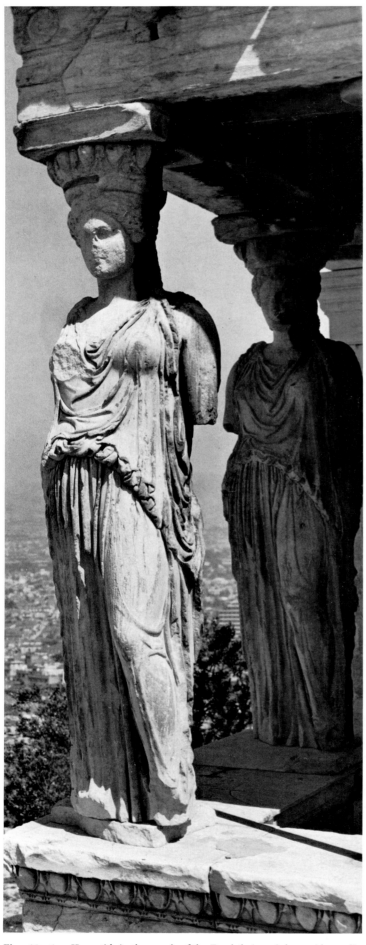
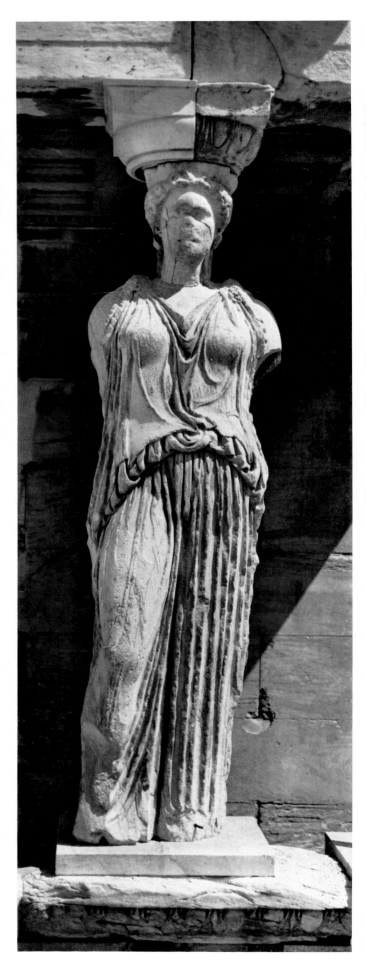

Figs. 669–670 Karyatids in the porch of the Erechtheion. Athens, Akropolis

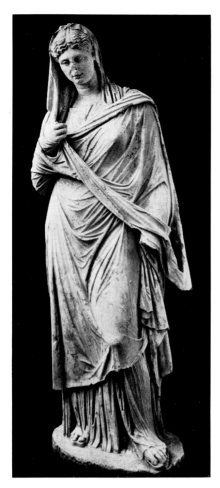

Fig. 671 'Herculaneum Matron' from Aigion,
Peloponnese. Athens, National Museum

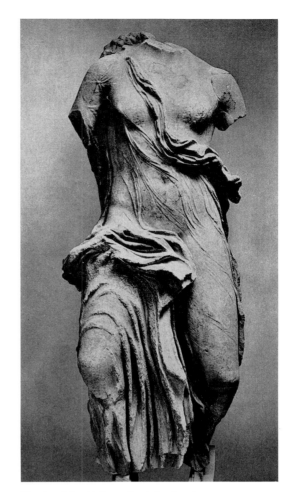

Fig. 672 Nereid from the Athenian Agora.
Athens, Agora Museum

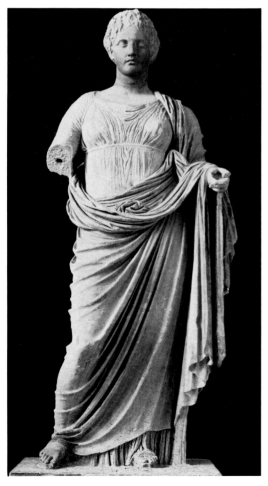

Fig. 673 Statue of Themis from Rhamnous,
signed by Chairestratos. Athens, National Museum

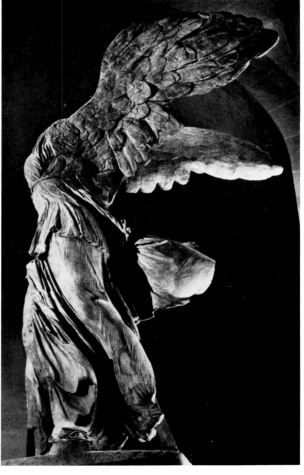

Fig. 674 The Nike of Samothrake. Louvre

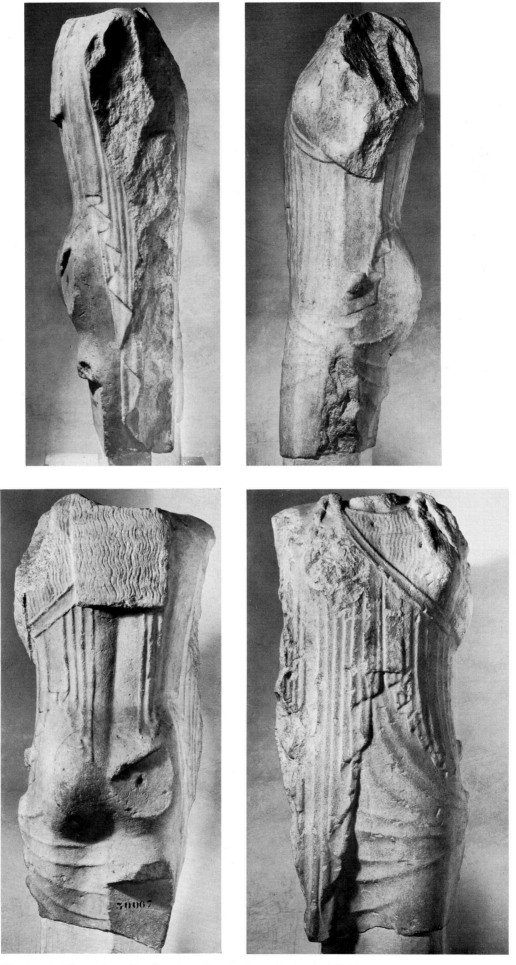

Figs. 675–678 Statue from Castelporziano. Rome, Museo Nazionale delle Terme

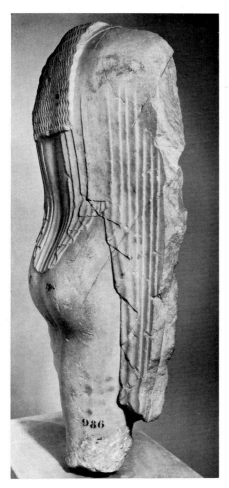
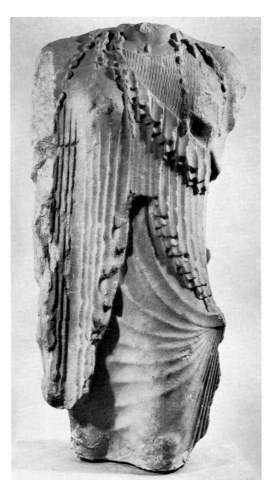
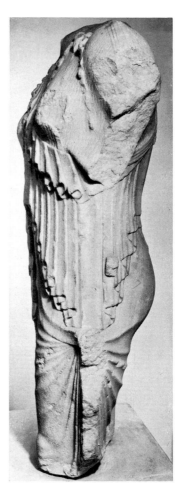

Figs. 679–681 Statue. Rome, Conservatori Museum

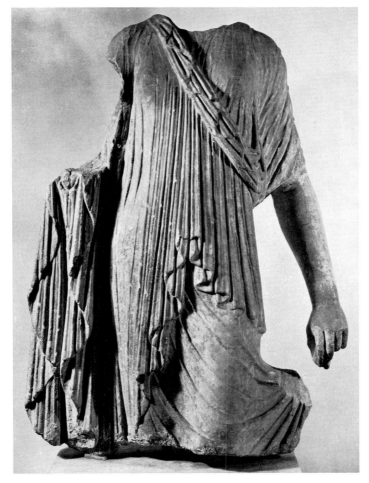

Fig. 682 Statue. Rome, Conservatori Museum

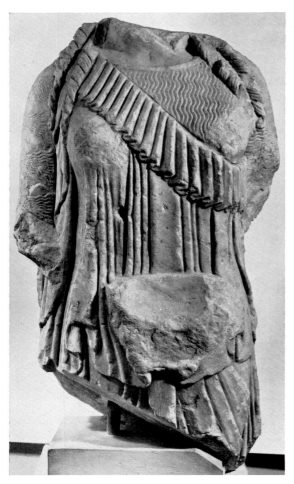
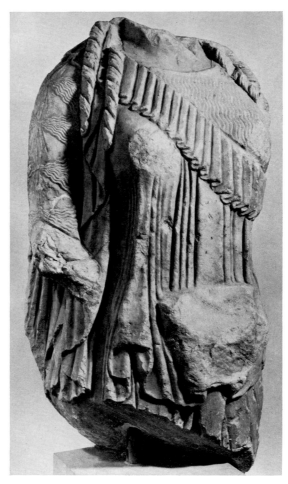
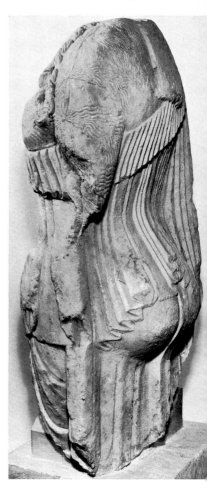

Figs. 683–685 Torso from Eleusis. Eleusis, Museum

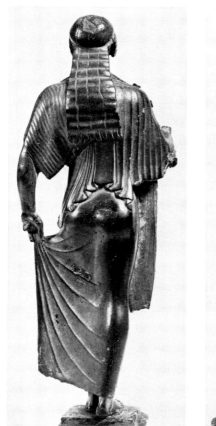
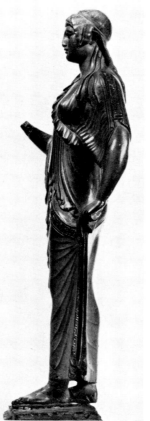
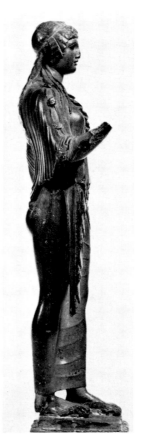
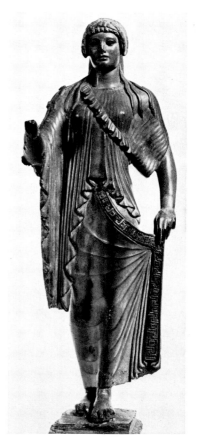

Figs. 686–689 Bronze statuette. British Museum

BIBLIOGRAPHY

LIST OF ILLUSTRATIONS

MUSEUM INDEX

LIST OF INSCRIPTIONS

INDEX OF PERSONS AND PLACES

M

BIBLIOGRAPHY OF THE CHIEF WORKS ON THE DIFFERENT ASPECTS OF ARCHAIC KORAI MENTIONED IN THIS BOOK

Cf. also the separate bibliographies on Technique, on the Akropolis Korai, on the painting of Greek sculptures, and on the chronology of Corinthian vases, pp. 15, 5 f., 14, 25; as well as the references given in the General Introduction and in the descriptions of the individual korai.

Abrahams, E. B., *Greek Dress, a study of the costumes worn in ancient Greece*. London, 1908.

Akurgal, E., *Die Kunst Anatoliens von Homer bis Alexander*, 1961.

— 'The Early period and the Golden Age of Ionia', *A.J.A.*, LXVI, 1962, pp. 369 ff.

Amelung, W., *R.E.*, III, 2, cols. 2309 ff., s.v. Χιτών, and VIII, 2, cols. 1609 ff., s.v. Ἱμάτιον.

Amyx, D. A., *Corinthian Vase-Painting* (forthcoming).

Arena, R., 'Le iscrizioni corinzie su vasi', *Memorie Acc. Naz. dei Lincei*, serie VIII, vol. XIII, 1967, pp. 57 ff.

Barnett, R. D., 'Early Greek and Oriental Ivories', *J.H.S.*, LXVIII, 1948, pp. 1 ff.

Bianchi Bandinelli, R., 'Sculture arcaiche dell'Acropoli, commente ad un catalogo', *Critica d'Arte*, II, 1937, pp. 112 ff.

Bieber, M., 'Der schräge Mantel der archaischen Koren', *J.d.I.*, XXXII, 1917, pp. 99 ff., *Griechische Kleidung*, 1928.

— *Entwicklungsgeschichte der griechischen Tracht*, Berlin, 1924 (a new edition, with F. Eckstein, 1967).

Blümel, C., *Staatliche Museen, Berlin, Katalog der Skulpturen*, II, 1 (1940).

— *Die archaisch-griechischen Skulpturen der Staatlichen Museen zu Berlin*, 1863.

Bluemner, H., *Technologie und Terminologie der Gewerbe und Künste bei Griechen und Römern*, 1874-1887.

Blum, G., in Daremberg and Saglio, *Dictionnaire des antiquités grecques et romaines*, V, s.v. tunica.

Boardman, J., 'Two Archaic Korai in Chios', in *Antike Plastik* (ed. Schuchhardt), I, 1962, pp. 43 ff.

Boulanger, A., in Daremberg and Saglio, *Dictionnaire*, V, s.v. vestis, pp. 765 f.

Bremer, W., *R.E.*, VII, 2 (1912), s.v. Haartracht und Haarschmuck, cols. 2125 ff.

Buschor, E., *Altsamische Standbilder*, II (1934), V (1961).

Caputo, G., 'Tre Xoana . . .', *Mon. ant. dei Lincei*, XXXVII, 1938, pp. 631 ff.

Charbonneaux, J., *Les bronzes grecs*, 1958.

Collignon, M., 'La statuette d'Auxerre', *Mon. Piot*, XX, 1913, pp., 1 ff.

— *Histoire de la sculpture grecque*, I, 1892.

Darsow, W., 'Zur Datierung eines delphischen Karyatidenkopfes', *Ath. Mitt.*, XCIV, 1950, pp. 119 ff.

— 'Zum ionischen Mäntelchen', in *Festschrift Andreas Rumpf*, 1952, pp. 43 ff.

— 'Die Kore des Anaximandros', *J.d.I.*, LXIX, 1954, pp. 101 ff.

Deonna, W., *Dédale ou la statue de la Grèce archaïque*, 1930.

Dickins, G., *Catalogue of the Acropolis Museum*, I, 1912.

Ducat, J., 'Perirrhantéria', *B.C.H.*, LXXXVIII, 1964, pp. 577 ff.

Epeoglou, E., 'Treis kores tes Akropoles' (*Diss. Thessalonike*, 1940).

Erbacher, K., *Griechisches Schuhwerk, eine antiquarische Untersuchung*, 1914.

Eustathios, *Commentarii ad Homeri Iliadem*, p. 1266.

Fink, J., *Die Haartrachten der Griechen in der ersten Hälfte des ersten Jahrtausend vor Chr.* (n.d.).

Graef, B., and Langlotz, E., *Die antiken Vasen von der Akropolis zu Athen*, 1925.

Greifenhagen, A., 'Ein ostgriechisches Elfenbein', in *Jahrbuch der Berliner Museen*, VII, 1965, pp. 132 ff. (on the Ephesian ivories.)

Guarducci, M., *Epigrafia greca*, I, 1967.

Hadaczek, K., 'Der Ohrschmuck der Griechen und Etrusker', in *Abhandlungen des arch.-epigraph. Seminars, Wien*, XIV, 1903.

Harrison, E. B., 'A New Fragment of Akropolis 683', *Hesperia*, XXIX, 1955, pp. 69 ff., pl. 65.

— 'Archaic and Archaistic Sculpture', *The Athenian Agora*, XI, 1965.

Hauser, F., 'Nausikaa', in *Oesterreichische Jahreshefte*, VIII, 1905, p. 33 f. (On the ependytes and chitoniskos.)

Haynes, D. E. L., 'A Pin and Four Buttons from Greece', *British Museum Quarterly*, XXIII, 1960-1961, pp. 48 f.

Haynes, S., 'Zwei archaisch-etruskische Bildwerke aus dem "Isis-Grab" von Vulci', in *Antike Plastik* (ed. W.-H. Schuchhardt), IV, pp. 13 ff.

Heberdey, R., *Altattische Porosskulptur*, 1919.

Herodotos, V, 87 ff.

Heuzey, Jaques, 'Le costume féminin en Grèce à l'époque archaïque', *Gazette des Beaux-Arts*, 1938, 1, pp. 127-148.

Heuzey, L. A., *Histoire du costume antique d'après des études sur le modèle vivant*, 1922.

Heuzey, Léon et Jaques, *Histoire du costume dans l'antiquité, l'Orient, Égypte, Mésopotamie, Syrie, Phénicie*, 1935.

Heydemann, H. G. D., *Antike Marmorbildwerke . . . zu Athen*, 1874.

Higgins, R. A., *Terracottas in the British Museum*, 1954; *Greek Terracottas*, 1967.

Himmelmann-Wildschütz, N., 'Beiträge zur Chronologie der archaischen ostionischen Plastik', in *Istanbuler Mitteilungen*, XV, 1965, pp. 24 ff.

Hogarth, G. D., *Excavations at Ephesos, The Archaic Artemisia*, 1908.

Holwerda, H., 'Altgriechische Tracht', in *Rheinisches Museum für Philologie*, N.F., LVIII, 1903, pp. 525 ff.

— 'Die Tracht der archaischen Gewandfiguren', *J.d.I.*, XIX, 1904, pp. 10 ff.;

Homann-Wedeking, E., *Die Anfänge der griechischen Grossplastik*, 1950. See also under Kyparissis.

Homolle, Th., *De antiquissimis Dianae simulacris deliacis*, Diss., Paris, 1885.

— 'Sur quelques monuments figurés trouvés à Delos', *B.C.H.*, IV, 1880, pp. 32 ff. For some of the illustrations cf. vol. III, 1879.

Hug, A., in *R.E.*, 2te Reihe, II, cols-1741 ff., s.v. Schuh.

Jacobsthal, P., 'The Date of the Ephesian Foundation Deposit', *J.H.S.*, LXXI, 1951, pp. 85 ff.

Jeffery, L. H., *The Local Scripts of Archaic Greece*, 1961.

Jenkins, R. J. H., *Dedalica, A study of Dorian Plastic Art in the Seventh Century B.C.*, 1936.

Kalkmann, A., 'Zur Tracht archaischer Gewandfiguren', *J.d.I.*, XI, 1896, pp. 19 ff.

Kastriotes, *Glypta tou Ethnikou Mouseiou*, 1908.

Kaulen, G., *Daidalika, Werkstätten griechischer Kleinplastik des 7. Jahrhunderts v. Chr.*, 1967.

Kavvadias, P., and Kawerau, G., *Anaskaphai tes Akropoleos, 1885-1890*, Athens, 1907.

Kondoleon, N. M., 'Theräisches', *Ath. Mitt.*, LXXIII, 1958, pp. 117 ff.

Kunze, E., 'Zu den Anfängen der griechischen Plastik', *Ath. Mitt.*, LV, 1930, pp. 141 ff.

— in VII. *Olympiabericht*, 1961, pp. 166 ff.

Kyparissis, N. L., and E. Wedeking, 'Archaische Skulpturen (einst im Theseion)', *Ath. Mitt.*, 63/64, 1938/39, pp. 156 ff.

La Coste-Messelière, P. de, *Fouilles de Delphes*, IV, 1-4, Sculptures.

— 'Les Alcméonides à Delphes', *B.C.H.*, LXX, 1946, pp. 270 ff.

— 'Corés delphiques', *B.C.H.*, LXXVII, 1953, pp. 346 ff.

Lafaye, G., in Daremberg and Saglio, *Dictionnaire des antiquités*, IV, pp. 382 ff., s.v. peplos.

Lamb, Winifred, *Greek and Roman Bronzes*, 1929.

Langlotz, E., *Zur Zeitbestimmung der strengrotfigurischen Vasenmalerei und der gleichzeitigen Plastik*, 1920.

— *Frühgriechische Bildhauerschulen*, 1927.

— 'Die Koren', in H. Schrader, *Die archaischen Marmorbildwerke der Akropolis*, 1939, pp. 3 ff.

Lechat, H., *Au Musée de l'Acropole d'Athènes*, 1903.

— *Études sur la sculpture en Attique avant la ruine de l'Acropole lors de l'invasion de Xerxès*, 1903.

Lepsius, *Griechische Marmorstudien*, 1890.

Lermann, W., *Altgriechische Kunst*, 1907.

Leroux, G., in Daremberg and Saglio, *Dictionnaire*, IV, s.v. pallium, pp. 285 ff.

Lippold, G., 'Die griechische Plastik', *Handbuch der Archäologie*, V, vol. 3, no. 1.

Matz, F., *Geschichte der griechischen Kunst*, I, 1950.

Müller, V., 'Frühe Plastik in Griechenland und Vorderasien, ihre Typenwanderung*, 1929.

— 'The Beginnings of Monumental Sculpture in Greece', *Metropolitan Museum Studies*, V, 2, 936.

von Netoliczka, A., 'Die Manteltracht der archaischen Frauenfiguren', *Oest. Jahr.*, XV, 1912, pp. 253 ff.

Neugebauer, A., *Antike Bronzestatuetten*, 1921.

Neumann, G., *Gesten und Gebärden in der griechischen Kunst*, 1965.

Noack, F., 'Das Gewandproblem in der griechischen Kunstentwicklung', *Neue Jahrbücher für das klass. Altertum*, XXXIII, 1909, pp. 233 ff.

Papaspyridi, S. (Karouzou), *Guide du Musée National, Marbres, Bronzes et Vases*, Athènes, 1927.

Paribeni, E., in *Enciclopedia dell'Arte Antica*, IV, 1961, s.v. Kore, pp. 400 ff.

Payne, H., *Necrocorinthia, A Study of Corinthian Art in the Archaic Period*, 1931.

— *Protokorinthische Vasen*, 1933.

Payne, H., and G. Mackworth Young, *Archaic Marble Sculpture from the Acropolis* (1936).

Pfuhl, E., 'Der schräge Mantel der archaischen Koren', *Ath. Mitt.*, XLVII, 1923, pp. 137 ff.

Philios, D., 'Glypta erga ex Eleusinos', *Eph. arch.*, 1884, cols. 179 ff.

— 'Archaikai kephalai ex Eleusinos', *Eph. arch.*, 1889, cols. 117 ff.

Picard, C., *Manuel d'archéologie grecque, La Sculpture*, I, Période archaïque, 1935, passim.

— in *Fouilles de Delphes*, IV, 2, and 5 (with Coste de La Messellière).

Pottier, E., in Daremberg and Saglio, *Dictionnaire*, I, 2, s.v. crepida, pp. 1557 ff.

Pollux, *Onomastikon*, VII, 42 ff. (ed. E. Dindorf, 1824).

Pryce, F. N., *Catalogue of Sculpture in the British Museum*, I, 1, 1928.

Raubitschek, A. E., 'Early Attic Votive Monuments', *B.S.A.*, XL, 1939-1940, pp. 17 ff.

— *Dedications from the Athenian Akropolis*, 1949.

Reuterswärd, P., *Studien zur Polychromie der Plastik Griechenland und Rom*, 1960.

Richter, G. M. A., *Archaic Greek Art against its Historical Background, A Survey*, 1949.

— *The Sculpture and Sculptors of the Greeks*, new revised ed., 1950, pp. 87 ff.

— *Catalogue of Greek Sculptures in the Metropolitan Museum of Art*, 1954.

— *Kouroi, Archaic Greek Youths*, 2nd ed., 1960.

de Ridder, A., *Catalogue des bronzes trouvés sur l'Acropole d'Athènes*, 1896.

— *Les bronzes antiques du Louvre*, I, 1913, II, 1915.

Santangelo, M., 'Kore marmorea di Taranto', *Boll. d'Arte*, III, 1953, pp. 1 ff.

Schrader, H., *Archaische Marmor-Skulpturen im Akropolis-Museum zu Athen*, 1909. Cf. also under Langlotz.

— *Auswahl archaischer Marmorskulpturen im Akropolis Museum*, 1913.

Smith, A. H., *Catalogue of Sculpture in the British Museum*, I, part 1, 1892.

— 'The Sculpture of the Croesus Temple', in Hogarth, *Excavations at Ephesus* (1908), pp. 293 ff.

Stoop, M. W., 'A Laconian Lady?', *Bulletin van de Vereeniging tot Bevordering der Kennis van de Antieke Beschaving*, te 's-Gravenhage, XXXIX, 1964, pp. 83 ff.

Studniczka, F., 'Beiträge zur Geschichte der altgriechischen Tracht', *Abhandlungen des archäologisch-epigraphischen Seminars der Universität Wien*, VI, 1886.

Sybel, L. von, *Katalog der Skulpturen zu Athen*, 1881.

Thiersch, H., *Ependytes und Ephod, 'Gottesbild und Priesterkleid im alten Vorderasien'*, 1936. See also my p. 12 (on pins).

Thucydides, I, 6.

Walters, H. B., *Catalogue of the Bronzes, Greek, Roman, and Etruscan, in the British Museum*, 1899.

Winter, F., *Die Typen der figürlichen Terrakotten*, I, 1903, 1904.

Zancani Montuoro, P., and Zannotti-Bianco, U., *Heraion alle Foce del Sele*, I, 1951-1954.

Zancani Montuoro, P., 'Lampade arcaica dallo Heraion alla Foce del Sele', *Atti e Memorie della Società Magna Grecia*, III, 1960, pp. 69 ff.

LIST OF ILLUSTRATIONS

Unless otherwise stated the material of the sculptures is marble.

The number put in square brackets after the figure number is my catalogue number.

Where no photographer is mentioned the photograph was sent by the institution without the name of the photographer.

The photographs from publications were made by J. Felbermeyer.

Figs. 98-100 [no. 26]. Terracotta statuette of a mourning woman. Said to be from Boeotia. Nat. Mus., Athens, Hélène Stathatos Collection. (ph: from Mrs. Stathatos)

Figs. 101-102 [no. 27]. Terracotta statuette of a mourning woman from Thera. Santorin Museum. (ph: German Archaeological Inst., Athens)

Fig. 103 [no. 30]. Bronze relief from Prosymna, near Argos. Nat. Mus., Athens, 15131.

Figs. 104-107 [no. 28]. Bronze statuette from Olympia, inv. 3400. Olympia Museum. (ph: German Archaeol. Inst., Athens; from Dr. Kunze)

Fig. 108 [no. 29]. Bronze handle of a mirror, from Corinth. Louvre, MNC1091 (1684).

Figs. 109-112 [no. 31]. Wooden statuette from Palma Monteschiaro, Sicily. Museo Archaeologico, Syracuse, 47134. (ph: from Prof. Barnabo Brea)

Fig. 113 [no. 32]. Gold plaque with a winged Artemis, from Kameiros, Rhodes. British Museum, 1128.

Fig. 114 [no. 34]. Ivory plaque, from the Sanctuary of Artemis Orthia, Sparta. Nat. Mus., Athens, inv. 15502. (ph: Alison Frantz)

Figs. 115-116 [no. 33]. Wooden relief from Samos. Now disintegrated. (ph: German Arch Inst., Athens)

Fig. 117 [no. 35]. Bronze handle from Greece. Louvre, 2645. (ph: M. Chuzeville)

GROUP II

Figs. 118-121 [no. 36]. Limestone head of 'Hera' from Olympia. Olympia Museum. (ph: Alison Frantz (figs. 118, 120, 121); from a cast in the Metropolitan Museum (fig. 119))

Figs. 122-128 [nos. 37, 38]. Two torsos, found presumably in Chios. Chios Museum. (ph: German Archaeological Institute, Istanbul)

Figs. 129-131 [no. 39]. Marble torso from Aigina. Nat. Mus., Athens, 73. (ph: Alison Frantz)

Figs. 132-134 [no. 40]. Torso from Moschato, Attica. Nat. Mus., Athens, 3859. (ph: Alison Frantz)

Figs. 135-138 [no. 41]. Limestone head from Laganello, near Syracuse. Museo Archeologico, Syracuse. (ph: Alison Frantz)

Figs. 139-146 [no. 42]. Statue said to be from Keratea, Attica. Staatliche Museen, Berlin, inv. 1800. (ph: Alison Frantz (figs. 140-142, 144-146) and Staatliche Museen (figs. 139, 143))

Figs. 147-150 [no. 43]. Headless statue, from the Akropolis. Akropolis Museum, Athens, 593. (ph: Alison Frantz)

Figs. 151-154 [no. 44]. Limestone statue from the 'Olive tree' pediment, found on the Akropolis. Akropolis Museum, 52. (ph: Alison Frantz (fig. 152), German Archaeological Institute (fig. 150), courtesy of B. Ashmole (figs. 153-154)

Figs. 155-158 [no. 46]. Upper part of a limestone figure in high relief, from Monte Casale. Museo Archeologico, Syracuse. (ph: Alison Frantz)

Figs. 159-162 [no. 45]. Statue of 'gypsum' from the Poledrara cemetery, Vulci. British Museum, D1. (ph: Alison Frantz)

Figs. 163-165 [no. 47]. Terracotta statuette from Acarnania. Louvre, CA1923. (ph: M. Chuzeville (figs. 163, 164))

Figs. 166-167 [no. 48]. Terracotta statuette from Skillous, Peloponnese. Nat. Mus., Athens, 10125. (ph: Alison Frantz)

Figs. 168-169 [no. 49]. Terracotta statuette from Kameiros, Rhodes. British Museum, B136.

Figs. 170-172 [nos. 50, 51]. Two terracotta statuettes of mourning women, from the Dipylon, Athens. Kerameikos Museum, 45. (ph: Alison Frantz)

Figs. 173-174 [no. 52]. Terracotta statuette, said to be from Tanagra. British Museum, B57.

Figs. 175-182 [nos. 53, 54]. Two wooden statuettes from Palma Montechiara, Sicily. Museo Archeologico, Syracuse, inv. 47136. (ph: Gabinetto Fotografico, Siracusa)

GROUP III

Figs. 183-185 [no. 55]. Statue dedicated by Cheramyes, from Samos. Louvre, inv. 686. (ph: Alison Frantz)

Figs. 186-189 [no. 56]. Statue dedicated by Cheramyes, from Samos. Staatliche Museen, Berlin, inv. 1750. (ph: Alison Frantz (fig. 189); Berlin Museum (figs. 186-188))

Figs. 190-193 [no. 57]. Statue from Miletos. In the Staatliche Museen, Berlin, inv. 1791. (ph: Alison Frantz (figs. 192-193); Berlin Museum (figs. 190-191))

Figs. 194-197 [no. 58]. Statue from the Akropolis, Athens. Akropolis Museum, 619. (ph: Alison Frantz (figs. 195-197); German Archaeological Institute, Athens (fig. 194))

Figs. 198-200 [no. 59]. Upper part of a statue, from the Akropolis, Athens. Akropolis Museum, 677. (ph: Alison Frantz)

Figs. 201-203 [no. 60]. Two fragments of a statue, from Samos. Staatliche Museen, Berlin, inv. 1743. (ph: Alison Frantz)

Figs. 204-205 [no. 61]. Fragment of the lower part of a statue, from Samos. Apotheke of the Heraion of Samos. (ph: Alison Frantz)

Fig. 206 [no. 62]. Lower part of a statue, from Sardes. Manisa Museum. (ph: Sardes Exploration Society)

Figs. 207, 208, 210 [no. 63]. Lower part of a statue dedicated by Anaximandros. From Miletos. Staatliche Museen, Berlin. (ph: Alison Frantz)

Figs. 209, 211 [no. 64]. Fragment of the lower part of a statue, dedicated by Mandrios. From Samos. Staatliche Museen, Berlin, inv. 1740. (ph: Alison Frantz)

Figs. 212, 213 [no. 65]. Front part of the head of a kore, or sphinx, from the Akropolis, Athens. Akropolis Museum, 654. (ph: Alison Frantz)

LIST OF COMPARATIVE ILLUSTRATIONS

fig. d. Woman, on an amphora by the Andokides Painter. In the Staatliche Museen, Berlin. Furtwängler and Reichhold, op. cit., pl. 133.

fig. e. Artemis, on an amphora by Psiax. In the University Museum, Philadelphia. (ph: Pfuhl-Schefold, *Tausend Jahre*, fig. 318)

Plate XVI, fig. a. Maenad on a kylix by the Chelis Painter. In Munich, 2589. (ph: Furtwängler and Reichhold, *Griechische Vasenmalerei*, pl. 43)

fig. b. Chrysothemis, on a pelike by the early Berlin Painter. In the Kunsthistorisches Museum, Vienna, 3725. Furtwängler and Reichhold, op. cit., pl. 72.

fig. c. Woman, on an amphora by the Kleophrades Painter (=Epiktetos II). In Munich, 2305. (ph: Pfuhl-Schefold, *Tausend Jahre*, fig. 373)

fig. d. Woman, on a calyx krater by Euphronios. In the Louvre, G103. (ph: M. Chuzeville)

Plate XVII, fig. a. Kouros from the East pediment of the temple of Apollo at Delphi. Delphi Museum. (ph: *Fouilles de Delphes* IV, 3, pl. hors-texte VI)

fig. b. Relief of a running warrior, from Athens. National Museum, Athens, 1959.

fig. c. Boy running, on a kylix by Oltos. In the British Museum, E8.

fig. d. Ball players, on a statue base found in the Themistoklean wall in 1922. National Museum, Athens, 3476. (ph: Alison Frantz)

Plate XVIII, figs. a, b, c, d. Four metopes from the Athenian Treasury, Delphi. In the Delphi Museum. (ph: Alinari)

fig. a. Theseus and the Minotaur.

fig. b. Theseus and Antiope.

fig. c. Herakles and Kyknos.

fig. d. Greek downing an Amazon.

fig. e. Man, on a kylix by the Brygos Painter. In Würzburg, 479. (ph: Pfuhl-Schefold, *Tausend Jahre*, fig. 423a)

fig. f. Satyrs, on a kylix by the Brygos Painter. In the British Museum, E65. (ph: Pfuhl-Schefold, *Tausend Jahre*, fig. 24)

Plate XIX, fig. a. Athena from the West pediment of the temple of Aphaia, Aegina. In the Glyptothek, Munich. (ph: F. Kaufmann)

fig. b. Hera from a metope of temple E at Selinus. In the Palermo Museum. (ph: Alison Frantz)

fig. c. Demeter, on a kylix by Makron, in the British Museum, E140. (ph: Fürtwangler and Reichhold, *Griechische Vasenmalerei*, pl. 161)

fig. d. Trojan woman, on a kylix by the Kleophrades Painter. In the National Museum, Naples, 2422. (ph: Furtwängler and Reichhold, *Griechische Vasenmalerei*, pl. 34)

fig. e. Artemis, on a psykter by the Pan Painter. In Munich. (ph: Furtwängler and Reichhold, *Griechische Vasenmalerei*, pl. 16)

Plate XX, fig. a. Head of Athena, from the East pediment of the temple of Aphaia at Aigina. In the Glyptothek, Munich. (ph: F. Kaufmann)

fig. b. Head of the Hera shown in fig. b on pl. XIX.

figs. c, d. Head found in the pronaos of the temple E at Selinus. In the Palermo Museum. (ph: Alison Frantz)

figs. e, f. Head of the 'Kritios Boy' from the Akropolis, Athens. In the Akropolis Museum, 698 (ph: German Archaeological Institute, Athens)

Plate XXI, fig. a. Artemis, on a krater by the Niobid Painter, in the Louvre, G34. (ph: Furtwängler and Reichhold, *Griechische Vasenmalerei*, pl. 165)

fig. b. Melousa, on a neck-amphora by the Peleus Painter, in the British Museum, E271. (ph: Furtwängler and Reichhold, *Griechische Vasenmalerie*, pl. 139)

fig. c. Aphrodite and Helen, on an oinochoe by the Heimarmene Painter. In the Vatican. (ph: Furtwängler and Reichhold, *Griechische Vasenmalerei*, pl. 170, 1)

Plate XXII, fig. a. Small limestone statue (The Auxerre kore). Louvre. Cf. figs. 76-79.

fig. b. Terracotta statuette from Tanagra. Museum für Kunst und Gewerbe, Hamburg.

MUSEUM INDEX

Unless otherwise stated the material is marble.

	Page	Cat. No.	Figs.
ATHENS, Agora Museum			
1311. S182 Statue of a 'Nereid'	110	—	672
ATHENS, Akropolis Museum			
All found on the Akropolis			
593 Statue	40	43	147–150
52 Statue from the 'olive tree pediment'	41	44	151–154
619 Statue	47	58	194–197
677 Upper part of a statue	47	59	198–200
654 Head of a statue	49	65	212–213
592 Parts of a perirrhanterion	52	74	235
269+163+164 Lower part of a statue of which the upper part is in the Museum of Lyons	57	89	275–281
669 Upper part of a statue	68	109	328–335
681 'The Antenor Kore', Statue, and base signed by Antenor	69	110	336–340
671 Statue	70	111	341–344
678 Statue	71	112	345–348
679 'The Peplos Kore'	72	113	349–354
660 Head of a statue	72	114	355–357
598 Headless statue	73	115	358–361
682 Statue	73	116	362–367
673 Statue	75	117	368–372
672 Statue	76	118	373–376
670 Statue	76	119	377–380
683 Statue	77	120	381–384
613 Statue	78	121	385–388
680 Statue	78	122	389–393
675 Statue	79	123	394–397
594 Statue	80	124	398–400
615 Statue	81	125	401–404
696+493, etc. Head of a statue and fragments of the body	81	126	405–410
674 Statue	81	127	411–416
643, 307 Head of a statue	82	128	417–419
616 Head of a statue	82	129	420–422
648 Head of a statue	83	130	423–425
661 Head of a statue	83	131	426–428
136 Lower part of a statue	83	132	429–430
510 Bottom of a statue	83	133	431
465 Feet of a statue	84	134	432
475 Bottom of a statue	84	135	433
686+609 'The Euthydikos Kore', Statue	99	180	565–572
685 Statue	100	181	573–577
684 Statue	101	182	578–582

317

	Page	Cat. No.	Figs.
CAIRO, Archaeological Museum			
Statue from Memphis	94	170	540
CAMBRIDGE, Fitzwilliam Museum			
Terracotta head said to be from Cyprus	90	156	501-503
CHIOS, Museum			
225, 226 Two torsos	38	37, 38	122-128
COPENHAGEN, National Museum			
12199 Head from Lindos, Rhodes	53	77	244-247
COPENHAGEN, Ny Carlsberg Glyptotek			
IN1544 Headless statue from Andros	89	152	487-490
CORINTH, Archaeological Museum			
Perirrhanterion with three standing women, from Isthmia	28	5	35, 37
CYPRUS, Nicosia, Archaeological Museum			
Limestone statue	90	154	495-498
CYRENE, Archaeological Museum			
14.008, 14.009 Two statues from the sanctuary of Cyrene	93, 94	168, 169	536-537, 538-539
Two statues found in an ancient quarry in Cyrene	46	56a, 56b	—
DELOS, Museum			
A4064 Headless statue from Delos	88	147	468-471
A4067 Headless statue from Delos	89	149	479-482
A4063 Headless statue from Delos	89	150	476-478
A4945 Head of a statue	104	189	601-604
DELPHI, Museum			
All found at Delphi			
Bronze statuette of the geometric period	21	—	13-15
Fragments of a perirrhanterion	30	11	56
Head of a karyatid ('ex Knidian')	57	86	270-274
Two fragmentary karyatids from the Knidian Treasury	57	87, 88	282, 283
Karyatid from the Siphnian Treasury	66	104	317-320
Two statues from the Eastern pediment of the Siphnian Treasury	67	105	321
Two statues from the Eastern pediment of the Temple of Apollo	67	106, 107	322-326
Athena on a metope from the Treasury of the Athenians	68	108	327
ELEUSIS, Museum			
Archaistic statue	III	—	683-685
GELA, Antiquario			
Terracotta statuette from Gela	96	175	549-551
GRANADA, Spain, Museum			
Bronze statuette from Atarfe	97	179	563-564

LIST OF KORAI WITH INSCRIPTIONS

No. 1. Statue dedicated by Nikandre, from Delos (p. 26)

No. 1a. Statue dedicated by Timonax, from Klaros (p. 26)

No. 2. Statue dedicated by (– –)ron, from the sanctuary of Apollo Ptoios (pp. 26-27)

No. 55. Statue dedicated by Cheramyes, from Samos, in the Louvre (p. 46)

No. 56. Statue dedicated by Cheramyes, from Samos, in Berlin (p. 46)

No. 63. Lower part of a statue inscribed Anaximandro-, from Miletos (p. 48)

No. 64. Lower part of a statue dedicated by Mandrios, from Samos (pp. 48-49)

No. 67. Statue inscribed Philippe, from Samos (p. 49)

No. 68. Statue inscribed Ornithe, from Samos (p. 50)

No. 91. Statue signed by Phaidimos, from Vourva, Attica (pp. 58-59)

No. 110. Statue dedicated by Nearchos, with a base signed by Antenor, from the Athenian akropolis (pp. 69-70)

No. 137. Relief with dedicatory inscription on the base (p. 85)

No. 144. Bronze statuette dedicated by Chimaridas, from Elis (p. 87)

No. 180. Statue dedicated by Euthydikos, from the Athenian akropolis (pp. 99-100)

No. 196. Bronze statuette dedicated by Phillo, from Paestum (p. 106)

No. 199. Bronze statuette dedicated by Aristomache (pp. 106-107)

INDEX OF PERSONS AND PLACES